Philosophy and Design

Pieter E. Vermaas • Peter Kroes
Andrew Light • Steven A. Moore

Philosophy and Design

From Engineering
to Architecture

 Springer

Pieter E. Vermaas
Delft University of Technology
Delft
the Netherlands

Peter Kroes
Delft University of Technology
Delft
the Netherlands

Andrew Light
University of Washington
Seattle
USA

Steven A. Moore
University of Texas
Austin
USA

ISBN 978-1-4020-6590-3 e-ISBN 978-1-4020-6591-0

Library of Congress Control Number: 2007937486

Printed on acid-free paper.

9 8 7 6 5 4 3 2 1

springer.com

Contents

List of Contributors . ix

Design in Engineering and Architecture:
Towards an Integrated Philosophical Understanding 1
Peter Kroes, Andrew Light, Steven A. Moore, and Pieter E. Vermaas

Part I Engineering Design

Design, Use, and the Physical and Intentional
Aspects of Technical Artifacts . 21
Maarten Franssen

Designing is the Construction of Use Plans . 37
Wybo Houkes

The Designer Fallacy and Technological Imagination 51
Don Ihde

Technological Design as an Evolutionary Process 61
Philip Brey

Deciding on Ethical Issues in Engineering Design 77
Anke Van Gorp and Ibo Van de Poel

Morality in Design: Design Ethics and the Morality
of Technological Artifacts . 91
Peter-Paul Verbeek

Thinking about Design: Critical Theory of Technology
and the Design Process . 105
Patrick Feng and Andrew Feenberg

Design Culture and Acceptable Risk 119
Kiyotaka Naoe

Alienability, Rivalry, and Exclusion Cost:
Three Institutional Factors for Design............................. 131
Paul B. Thompson

Part II Emerging Engineering Design

Friends by Design: A Design Philosophy for Personal
Robotics Technology .. 143
John P. Sullins

Beyond Engineering: Software Design as Bridge
over the Culture/Technology Dichotomy 159
Bernhard Rieder and Mirko Tobias Schäfer

Technology Naturalized: A Challenge to Design
for the Human Scale ... 173
Alfred Nordmann

Re-Designing Humankind: The Rise of Cyborgs,
a Desirable Goal?.. 185
Daniela Cerqui and Kevin Warwick

Designing People: A Post-Human Future? 197
Inmaculada de Melo-Martín

Redesigning Man? ... 209
C. T. A. Schmidt

Design: Structure, Process, and Function:
A Systems Methodology Perspective 217
Kristo Miettinen

Co-Designing Social Systems by Designing Technical Artifacts:
A Conceptual Approach .. 233
Ulrich Krohs

Beyond Inevitability: Emphasizing the Role of Intention
and Ethical Responsibility in Engineering Design 247
Kathryn A. Neeley and Heinz C. Luegenbiehl

Design and Responsibility: The Interdependence
of Natural, Artifactual, and Human Systems 259
S. D. Noam Cook

Part III Architectural Design

**Form and Process in the Transformation of the Architect's
Role in Society** . 273
Howard Davis

**Expert Culture, Representation, and Public Choice:
Architectural Renderings as the Editing of Reality** 287
Steven A. Moore and Rebecca Webber

**Diverse Designing: Sorting Out Function
and Intention in Artifacts** . 301
Ted Cavanagh

Design Criteria in Architecture . 317
Joseph C. Pitt

**Cities, Aesthetics, and Human Community: Some Thoughts
on the Limits of Design** . 329
J. Craig Hanks

**Nature, Aesthetic Values, and Urban Design:
Building the Natural City** . 341
Glenn Parsons

Index . 355

List of Contributors

Philip Brey is associate professor of philosophy at the University of Twente and director of its Centre for Philosophy of Technology and Engineering Science. He is also a member of the board of the Society for Philosophy and Technology and the International Society for Ethics and Information Technology. His research focuses on philosophy of technology, and particularly on the philosophy and ethics of information technology.

Ted Cavanagh is an architect with a doctorate in the history of technology and is chair of the School of Architecture at Clemson University, South Carolina. His investigations in the culture of technological innovation focus on historical and contemporary wood construction. His work is both written and built.

Daniela Cerqui is a sociocultural anthropologist interested in the relationship between technology and society (and, more fundamentally, humankind). She teaches at the Institute of Sociology and Anthropology of the University of Lausanne (Switzerland) where she is involved in teaching and research on the new information technologies, and on the 'information society' they are supposed to create. She recently spent two years conducting research in the Department of Cybernetics of the University of Reading.

Noam Cook is a professor of philosophy at San Jose State University. His publications, research and consulting interests focus on social and technological change, the relationship between knowledge and practice, and applied values issues. He was for ten years a consulting researcher at Xerox PARC. Since 1997 he has been a member of the San Francisco Symphony Chorus. (B.A., M.A., San Francisco State University, Ph.D., Massachusetts Institute of Technology).

Howard Davis is Professor of Architecture at the University of Oregon and the author of *The Culture of Building*, concerning the social frameworks of the processes of architectural design and construction. His current research deals with the typology of urban mixed use buildings, and their role in a diverse economy.

Inmaculada de Melo-Martín, Ph.D. Philosophy, M.S. Biology, is a Research Ethicist in the Division of Medical Ethics, Weill Cornell Medical College. She is the author of *Making Babies: Biomedical Technologies, Reproductive Ethics, and*

Public Policy (Kluwer, 1998), and *Taking Biology Seriously: What Biology Can and Cannot Tell Us about Moral and Public Policy Issues* (Rowman and Littlefield, 2005). Her current work focuses on ethical issues related to genetic research.

Andrew Feenberg is Canada Research Chair in Philosophy of Technology in the School of Communication at Simon Fraser University, where he directs the Applied Communication and Technology Lab. He has authored or edited over 10 books, including *Critical Theory of Technology* (Oxford University Press, 1991), *Alternative Modernity* (University of California Press, 1995), *Questioning Technology* (Routledge, 1999*)*, and *Heidegger and Marcuse: The Catastrophe and Redemption of History* (Routledge 2005).

Patrick Feng is an assistant professor in the Faculty of Communication and Culture at The University of Calgary. His research focuses on the social implications of new technologies and the politics of international standards-setting. He has studied the design and use of scientific and technical standards in areas such as information technology, health, and food safety.

Maarten Franssen is associate professor at the Section of Philosophy of Delft University of Technology. He has published on the normativity of functions, the modeling of socio-technical systems and decision methods in engineering design. His broad research interests include theories of rationality and action and their application in the design and implementation of technology, and conceptual and foundational issues in technology related to the notions of system and function.

Craig Hanks is Visiting Associate Professor of Philosophy at the Stevens Institute of Technology for 2006–2007 while on leave from Texas State University. A recipient of six distinguished teaching awards, his publications include work on ethical issues in architecture, biotechnology ethics, philosophy of biology, philosophy of technology, philosophy of art, and political philosophy. His new book *Technological Musings: Reflections on Technology and Value*, and a new edited collection *Technology and Values* will both be published in 2007.

Wybo Houkes is assistant professor at the Subdepartment of History, Philosophy and Technology Studies of Eindhoven University of Technology. He participated in the NWO research program *The Dual Nature of Technical Artifacts* and published on function theory and the role of intentions in artifact use and design. His current research interests include the nature of technological knowledge, the ontology of artifacts and the application of evolutionary theory to technical artifacts.

Don Ihde is Distinguished Professor of Philosophy and Director of the Technoscience Research Group at Stony Brook University in New York, USA. He is the author of twenty authored and edited books, most recently, *Expanding Hermeneutics: Visualism in Science* (1998); *Bodies in Technology* (2003); and with Evan Selinger, *Chasing Technoscience: Matrix for Materiality* (2003). His current work includes research on imaging technologies and the application of advanced imaging and analytic technologies to human science disciplines.

Peter Kroes initiated and helped develop at Delft University of Technology an analytically orientated philosophy of technology that focuses on engineering practices. His main interests are the nature of technical artifacts and socio-technical systems, and theories of functional and artifact kinds.

Ulrich Krohs is *Privatdozent* of philosophy at the University of Hamburg and held a research fellowship at the Konrad Lorenz Institute for Evolution and Cognition Research in Altenberg, Austria. His publications include work on the structure of biological theories and on the concepts of function and design. Current research topics are the justification of function ascriptions in biology, technology and the social sciences, and the relation between experiment, theory, and models of different kind.

Andrew Light is Associate Professor of Philosophy and Public Affairs at the University of Washington. He is co-author, with John O'Neill and Alan Holland, of *Environmental Values* (Routledge, 2007) and co-editor of sixteen books including *The Aesthetics of Everyday Life* (Columbia, 2005) *Moral and Political Reasoning in Environmental Practice* (MIT, 2003), and *Technology and the Good Life?* (Chicago, 2000). He is currently working on a book on ethics and restoration ecology.

Heinz C. Luegenbiehl is Professor of Philosophy and Technology Studies at Rose-Hulman Institute of Technology in Indiana. He has published extensively on engineering ethics and liberal education in engineering education. His current research interests are in the areas of cross-cultural engineering ethics, especially in relation to Asian countries, and on developments toward an international code of engineering ethics.

Kristo Miettinen is a Senior Technical Fellow at ITT Industries Space Systems Division in Rochester, New York. His current technical work in image chain analysis focuses on automated image restoration and enhancement, image distortion parameter estimation, and modeling of image utility and interpretability as a function of engineering parameters.

Steven Moore is the Bartlett Cocke Professor of Architecture and Planning at the University of Texas at Austin where he is Director of the graduate program in Sustainable Design and Co-director of the University of Texas Center for Sustainable Development. Moore is the author of many articles and four books on sustainable architecture and urbanism.

Kiyotaka Naoe is Associate Professor at the Philosophy Department of Tohoku University, Japan. His interests include contemporary continental philosophy and philosophy of science and technology. His recent research is about the phenomenological and ethical aspects of technological actions, especially the relationship between technology and the body.

Kathryn A. Neeley is Associate Professor in the Department of Science, Technology, and Society at the University of Virginia. She is author of *Mary Sommerville: Science, Illumination, and the Female Mind*, published by Cambridge, and co-editor, with David Ollis and Heinz Luegenbiehl, of *Liberal Education for*

21ˢᵗ Century Engineering: Responses to ABET 2000. Her research focus is on the aesthetic dimensions of scientific and engineering practice.

Alfred Nordmann is Professor of Philosophy and History of Science at Darmstadt Technical University. In recent years, he has focused on nanoscience and the convergence of enabling technologies. He wants to understand not only how these might affect society and how they alter the very notion of technology, but views them primarily as a symptom of more general changes in research practice and epistemic values.

Glenn Parsons is a member of the Philosophy department at Ryerson University in Toronto, Canada. His main research interest is the role of scientific knowledge in the aesthetic appreciation of nature. His essays have appeared in the *British Journal of Aesthetics*, the *Journal of Aesthetics and Art Criticism*, and the *Canadian Journal of Philosophy*. He is currently writing a book on the aesthetics of nature.

Joseph C. Pitt is Professor of Philosophy and Adjunct Professor of Science and Technology Studies at Virginia Tech. He graduated from the College of William and Mary, taking his MA and Ph.D. from the University of Western Ontario. He authored three books, *Pictures, Images and Conceptual Change; Galileo, Human Knowledge and the Book of Nature*; and, most recently, *Thinking About Technology*. His research interests concern the impact of technological innovation on scientific change.

Bernhard Rieder is a postdoc researcher and teacher at the Hypermedia Department of Paris 8 University. He worked as a Web developer and published on the relationship between technology and culture. Current research interests include semantic computing, collaborative culture and the epistemology, methodology and ethics of software design.

Mirko Tobias Schäfer is a junior teacher/researcher at Utrecht University at the Department for Media and Culture Studies. He studied theater, film and media studies and communication studies at Vienna University in Austria and digital culture at Utrecht University in the Netherlands. He is currently writing his dissertation on the collective and participatory production in user communities and cultural industries.

Colin Schmidt is a specialist in the Epistemology of artificial and natural intelligence as well as the relation between them. As such, he is interested in Human-Computer Interaction, Humanoid Robotics and novelties in Communication. To further his research agenda he draws on universal notions in the Philosophy of Mind and Language like Intentionality, reference, and categorization. His approach is often anthropological in nature and his methodology is always deliberately probatory and terminological.

John P. Sullins, (Ph.D., Binghamton University (SUNY), 2002) is an associate professor at Sonoma State University in California. His recent research interests are the technologies of Robotics, AI and Artificial Life and how they inform traditional philosophical topics on the questions of life and mind as well as its impact on society and the ethical design of successful autonomous machines.

Paul B. Thompson holds the W.K. Kellogg Chair in Agricultural, Food and Community Ethics at Michigan State University. He is a former President of the Society for Philosophy and Technology. The second edition of his book *Food Biotechnology in Ethical Perspective* appeared in 2007, and a co-edited volume entitled *What Can Nano Learn from Bio? Lessons for Nanotechnology from the Debate over Food Biotechnology and GMOs* is slated for 2008.

Ibo Van de Poel is assistant professor ethics and technology at Delft University of Technology and managing director of the 3TU.Centre for Ethics and Technology. His research focuses on ethical issues in engineering design, technological risks and in R&D networks. For more information, see http://www.tbm.tudelft.nl/webstaf/ibop/.

Anke Van Gorp is researcher and consultant at the Innovation Policy group of TNO-Quality of Life. She has an MSc in Materials Science and Engineering and a PhD in ethics and technology. She has published several articles about ethics and engineering design. Her current interests are ethics and innovation and philosophy of technology.

Peter-Paul Verbeek is associate professor of philosophy at the University of Twente, the Netherlands, and director of the international Master's program *Philosophy of Science, Technology, and Society*. He publishes on human-technology relations, technology design, and the social and cultural roles of technologies. One of his research interests is the moral relevance of technological artifacts and its implications for ethical theory and the ethics of technology design.

Pieter E. Vermaas is researcher at Delft University of Technology, the Netherlands. He published in philosophy of technology on theories of technical functions, on design methodologies and on the use of quantum mechanics in nanotechnology. His current research focuses on functional decomposition, the breakdown of function into subfunctions, in engineering design.

Kevin Warwick is Professor of Cybernetics at the University of Reading, England, where he carries out research in artificial intelligence, control, robotics, and cyborgs. He is also Director of the University KTP Centre, which links the University with Small to Medium Enterprises. As well as publishing 500 research papers, Kevin is perhaps best known for being the first human being with a chip connected to his nervous system.

Rebecca Webber is a graduate of Smith College and a Master of Science in Sustainable Design candidate at the University of Texas. Her research examines how public environmental and energy policies influence the built world.

Design in Engineering and Architecture

Towards an Integrated Philosophical Understanding

Peter Kroes, Andrew Light, Steven A. Moore, and Pieter E. Vermaas

1 Introduction

The present collection of essays provides an overview of current work by philosophers and ethicists on the design process and its products. We have collected a group of essays on topics which are not usually considered together. The volume contains essays on engineering and architecture, focusing on a broad spectrum of items, ranging from cars to software, from nano-particles to cities, and from buildings to human beings. As such the volume trades on the ambiguous meaning inherent in the general term "design" which we will consider in the broadest sense of "changing existing situations into preferred ones."[1] By bringing these diverse essays together, current thinking about design can be presented in all its facets, permitting us to consider the broad category of design, despite its different meanings, as an activity with a common root.

One of the conclusions which can be gleaned from these essays is that new developments in engineering allow for a more integrated understanding of engineering and architectural design, two areas of design which may have been thought to be too far apart to be comparable. But in these chapters engineering is presented as an activity that is not merely concerned with composing material products. Due to the emergence of new technological capabilities and the growth in demands that society puts on the implementations of technology, engineers are forced to consider how the material products they create interact with human agents. For philosophers and ethicists this is a familiar observation. Philosophy of technology, emerging after World War II as an independent field, first concerned with the social impacts of technology, and now more robustly directed toward the

P. Kroes, Delft University of Technology

A. Light, University of Washington

S. A. Moore, University of Texas

P. E. Vermaas, Delft University of Technology

[1] Simon (1972, 55).

P. E. Vermaas et al. (eds.), *Philosophy and Design.*
© Springer 2008

empirical dimensions of the metaphysics and epistemology of specific technologies, has always been focused on the ways in which technology shapes individual human lives and a range of social institutions.[2] This focus has now been extended to the analysis of engineering design itself. Engineering design is identified as a process in which technologies materialize into products, and thus as a process that substantively shapes and reshapes our lives and our societies. The essays in this volume on engineering design in the classical "nuts-and-bolts" sense provide more examples of this phenomenon. In the essays on design in the new emerging technologies, this focus on shaping lives and society becomes even more visible. To take just one example, the convergence of informatics and genetic engineering raise questions not only about the relationship of humans to each other but also about our understanding of what it means to be human.

If these developments of emerging technologies reveal thoroughgoing moral and social dimensions of engineering in general, what follows? No doubt, many things. We will focus here on how these developments push a more robust description of engineering design toward a more accepted description of architectural design. If the gap between these two forms of design can be bridged, then we are on our way to an understanding of a more integrated philosophy of design.

To help to frame the discussion which follows, take for example the growing interest in the design of *socio-technical systems*. Even older forms of these systems, such as the electrical power grid, consisted of material hardware and human agents as an integrated component for the operation of that hardware. Though more recent developments such as cellular telephone networks may not yet represent a difference in kind of system from these older systems, they certainly compound the social dimensions of those systems to an impressive degree.[3] We would argue that a fully responsible design of such systems necessarily requires engineers to pay attention to the human agents and to the social institutions they inhabit, inclusive of technical manuals, company regulations, national or international law, and the larger framework of social capital implied by the production of such systems. The interest of engineers in designing these complexes of hardware and social institutions bring us to architecture. Our contention is that the growing complexity of engineering design reduces the distinction between it and design in architecture. Architects that design our buildings and living environments have been consciously influencing the interaction and social organization of human beings at least since the late 19th century. Their works, and the history of their enterprises, are thus immediately relevant to engineering as it is developing today. In that context this volume seeks to provide an overview of current philosophical and ethical work on design by bridging the literature on design in engineering and architecture. It also provides the means to help practitioners and

[2] See for example several recent anthologies which have come out on philosophy of technology including, Kaplan (2004), Katz, Light, and Thompson (2003), and Scharff and Dusek (2002). A thorough history of philosophy of technology is found in Mitcham (1994). For the recent analytic turn in philosophy of technology see Pitt (2000), Baird (2004), and Kroes and Meijers (2006).

[3] Biometric markers in cell phones may greatly magnify the social dimensions of these systems to create a difference in kind from older technologies. See McGee (2003).

philosophers come to a more integrated understanding of the phenomenon of design. Despite its diverse manifestations in engineering and architecture all design can increasingly be seen as aimed at the same goal: production of our material environment and the way in which we are designed to live in that environment. In the next two sections we will defend this proposition more fully.

2 Engineering and Architecture

Our promise to provide an integrated understanding of the philosophy and ethics of engineering and architectural design trades in part on the current view that these two practices are quite different. Articulating this view and analyzing the nature of the assumed differences is complicated by the fact that there are competing accounts of how these differences arose. As with any historical relationship, contemporary practitioners of both disciplines tell different stories of their estrangement. But professional affiliation is not the only filter of history. In this section we will briefly outline two competing narratives that are thought to separate these two disciplines through differing attitudes toward authorship and organizational structure. What we offer is far from comprehensive but should help to understand better how engineers and architects have positioned themselves within the societies they serve.

2.1 The Dominant Narrative

It is often assumed that engineering and architecture share some conditions of practice but remain inherently different in nature. On this view, engineers make things that work and architects order space, giving visual expression to the built environment. What is common is that both engineers and architects design for material production by others, in response to assignments originating from a third party. Particularly in large projects the third party, or "client," is actually a collection of parties with distinct interests, owners, users, and those who finance, regulate, or insure the products created. However, whether designing large or small artifacts, engineers and architects typically produce designs to meet the goals and requirements of that third party. Unlike fine artists, who generally initiate works in isolation from surrounding social and economic conditions, architects and engineers rarely do so.

As there are disciplinary similarities, so there are clear differences. Obvious differences concern the products designed and, consequently, the types of knowledge involved in production. Engineers typically design things such as consumer goods, machinery, public utilities, and other useful products. Architects design the buildings we live and work in and the public environments created by these buildings. Another marked difference, which we will initially focus on here, is how authorship in engineering and architecture is understood.

In the traditional view architects are taken to be the authors of the products they design. Even when architects, as they must, meet the goals and requirements set by

those who commission them, there is ample interpretive flexibility within the design problem for them to create unique spatial and material compositions. Clients generally expect such an expansive interpretation of the stated design problem. Under certain circumstances buildings and landscapes are commissioned to reflect the architect's personal style and vision as evidenced in prior work. In this context architecture is perceived to be similar to the fine arts. Building owners may seek to enhance their own social position through association with the artistic authority of the architect. Such an understanding of the social context of architectural production is aided by a traditional philosophy of art whereby paintings, sculptures, or other products are designated by a single author. To the philosopher of technology, however, a single author of an architectural product may seem naïve. The client, let alone the many draftsmen, engineers, suppliers, and contractors who contribute skill and knowledge to a project's realization, also contribute to the design process. But whether one prefers the lens of single or multiple authors, the traditional view tempts us toward a vision of the architect as author, either producing a unique vision alone or directing a panoply of other actors assisting in the production of that vision. Such a view may also beg the question of whether architects are responsible for the consequences of their designs in a more substantive way, but this is an issue we will take up later.

Engineers are traditionally viewed as operating in a less publicly recognizable manner. The products they design are characterized by the technological possibilities of their era, and may include decorations peculiar to their period, but nonetheless engineers are typically more anonymous as authors of their work. They may advise those that commission their work about adjusting their expectations, or bring to a project a specific method of designing. But their products are generally oriented by a reductive, rather than expansive, interpretation of the design problem at hand. This is to say that the specific goals and requirements agreed upon at the beginning of the design process tend to limit engineers to coming up with efficient technical solutions to problems. Some pioneering engineers may be known more publicly for their inventions, and countries may even have a few heroic engineers known for public works of national grandeur. But the average technical product will not be recognizable as designed by a particular engineer. A full explanation of the roots of this traditional difference between authorship in engineering and architecture is complex, but we can say here that, on the whole, engineers tend to interpret design problems reductively using quantitative criteria, and architects tend to interpret design problems expansively and to employ qualitative criteria.

A related phenomenon is that the cultures of engineering and architecture have produced different organizational structures that reflect differing values. Architects typically work within firms that are recognizable as architectural firms. This also holds for some engineers, but engineering has also been integrated into larger commercial enterprises that subsume the identity of engineers into the company's identity. Under such conditions large companies have taken over the role of authors of the products designed, such is the case with consumer goods like cars, cellular phones, and sports wear. The relative anonymity of the engineer is related both to the issue of authorship and organizational structure. If one accepts the

notion that engineering is an objective science applied to specific problems, then authorship is concealed. The contribution of the individual designer is suppressed. In this context engineering has been defined as a profession that designs products that meet the goals and requirements agreed upon by those who commission them and nothing more.

Unlike architects, who tend to expand the scope of their design problems to go beyond the everyday, engineers tend to reduce the scope of their design problems to the narrowest possible empirical criteria. This is to say that engineers and architects have intentionally or unintentionally produced distinct "epistemic communities," or attitudes toward what can be known or designed.[4] An example of this phenomenon would be the traffic engineer who expertly designs a street intersection to meet the required flows of automobiles but does not consider the consequences of the design for pedestrians, the natural environment, or urban development patterns because these variables were not specified in the design brief. Engineers are encouraged to become designers that loyally and efficiently carry out the tasks they are set by clients, transferring not only the authorship to the client but also, in the eyes of the engineers themselves, the moral responsibility for the existence and use of what is produced for their employers.[5] In contrast, architects would be far more comfortable with expanding the stated design problem to include these other normative variables because they would be rewarded by their professional culture, if not the client, for doing so.

In part because engineers appear to be more in the position of taking orders rather than assuming authorship, philosophers who work on the ethics of engineering have developed a specific literature justifying "whistle blowing" by engineers. In part this literature attempts to justify standards of professional practice by engineers that can supersede obligations to their employers. Philosophers point to examples such as the explosion of the U.S. space shuttle Challenger as a relevant case. There it is argued that NASA engineers overlooked or ignored claims about design flaws in the "O rings," which sealed the joints between sections of the shuttle's solid rocket boosters, which caused the shuttle to explode on liftoff. Some argue that these engineers should have exercised a larger professional responsibility to protect human safety over the demands to fulfill a mission goal. Regardless of the merits of this claim, our point is that such arguments are thought to require special justification in part because of the limited understanding of the responsibilities of engineers prior to the development of this literature. This limited sense of professional responsibility in turn may extend from the constrained understanding of authorship in engineering as a whole.

In comparison, finding the political content and assessing responsibility for built space is relatively prosaic. For example, the architects of the early 20th century deliberately designed houses for the working class with small kitchens – e.g., Margarete Schütte-Lihotzky's *Frankfurter Küche* and Piet Zwart's Bruynzeel

[4] Guy and Shove (2000, 35).

[5] Van de Poel (2001).

Kitchen – for separating cooking from living and for redefining it as a rationalized and technological activity of 'modern housewives.' Using a similar logic, many historians have argued that Georges Eugène baron Haussmann's boulevards for the new Paris of Louis Napoleon were designed to prevent its inhabitants from easily blocking off parts of their city during a riot. The same argument is made in reference to the design of new university campuses in the U.S. following the student unrest of the 1960s. As such, philosophers have not felt quite as compelled to articulate a unique claim about how architects should exercise some form of professional, moral, or social responsibility, but have simply pointed out the moral and social consequences of the products of architects.

In sum, this narrative grants expansive authorship and public responsibility to architects and relative anonymity to engineers. Our argument is that such reasoning is as much reflected in the evolution of differing organizational structures as determined by them. This version of the story, however, is deceptively simple. There is another way of looking at the relationship between engineering and architecture that adds satisfying complexity.

2.2 The Counter-Narrative

That architects take authorship for their projects, and accept responsibility for them, and that conversely engineers are more anonymous can be historically demonstrated. The problem is that history can also demonstrate the opposite. In the early "heroic" years of modern architecture (1920–30), for example, Ludwig Mies van der Rohe (first director of the *Bauhaus*) could argue with enthusiasm that "Architecture is the will of the age conceived in spatial terms."[6] Only a few years later his successor, Hannes Meyer, was even bolder in arguing that "building is the deliberate organization of the process of life."[7] There is little ambiguity in these statements, and many more like them by other modern architects that could be cited which, collectively, argue in favor of "architectural determinism," the claim that some kind of universal well-being and social justice might be achieved through design. Such determinism carried with it a strong sense of responsibility for the profession of architecture. If there was salvation to be achieved through design, then architects, both individually and collectively, were our redeemers.

But after fifty years of dashed modern aspirations, particularly in North America, the political optimism of the *Bauhaus* came under attack and was ultimately rejected by new generations of postmodern architects whose interests were limited to an apolitical vision of artistic practice that left questions of social and environmental responsibility to others.[8] To be clear, the political intentions of architects were never

[6] Van der Rohe (1990).

[7] Meyer (1990).

[8] Lang (1980). Also see, Larsen (1993).

as fully unified as many historians claim, nor did the architects of the 1970s, '80s and '90s swing *en mass* to limited visual concerns. Rather, a sober view of the state of architecture at the beginning of the 21ˢᵗ century reveals a pluralistic and diverse scene, one where some architects clearly practice as visual artists (these are the so-called "star-architects"), others practice in a corporate context much like engineers (these are technical production firms with names like SOM, RDGB, and BNIM), and a few have become more socially active and engaged than ever (these are firms that see themselves as socio-environmental activists).[9]

A deeper historical inquiry reveals even more about the current situation. Not only do architects and engineers practice in contexts that are increasingly similar, but modern architects have long admired the reductive qualities of engineering practice. For example, rather than distance architecture from engineering practice as many might expect, the early 20ᵗʰ century Swiss-French architect le Corbusier argued that "The Engineer's Aesthetic and Architecture are two things that march together and follow one from the other ..."[10] From his perspective in 1920, le Corbusier saw engineering practice as a model of efficient production, devoid of neoclassical decoration and craft that previously denied the benefits of design-thinking to the masses. Embracing more modern and industrialized modes of production like engineers advocated would not only improve distributive justice but also result in an aesthetic that expressed such changed social values.

Although we tend to assume that building designs in general are the products of architects, they are the first to decry the fact that only two to three percent of housing (in North America) is designed by architects and many types of utilitarian buildings and infrastructure such as roads, bridges and harbors are designed by engineers. Observing the built world through the revealing statistics of the construction industry reveals that architects are far less the authors of the built world than we might think.

In sum, this counter-narrative suggests that it is a mistake to essentialize engineering or architecture. Attitudes and practices related to authorship and organizational structure within both disciplines are now, and always have been, in flux. Our argument is that across the range of practices and firms representing engineering and architecture we can see the two disciplines as increasingly more similar than distinct in relation to the societies that they serve. If one observes how contemporary engineers and architects actually work, we see that authorship and responsibility are more distributed in reality if not in the eyes of the public.

Without pushing on further with which of these two narratives is more accurate, our aim in this volume is to present a range of views on why current developments in engineering and architecture require the development of visions concerning the social responsibilities, ethical practice, and political context of both disciplines. In the past few decades more architects, engineers, and design methodologists have increasingly come to recognize what philosophers have been claiming for some

[9] For example, see Bell (2004).
[10] Le Corbusier (1990).

time now, particularly with regard to engineering, that all design shapes social relations and hence contains an inherent moral and political content. It is to a more robust understanding of this common content that we now turn.

3 Shifting Boundaries

Let us return to engineering design, and to an analysis of its gradual development towards a model more like architectural design, as we identified it in the opening section of this introduction. In the 20th century the institutionalization of a rich variety of engineering design traditions and practices emerged. During the second half of the last century design practices gradually developed that focus on the material product of design and on the broader social system in which these products are supposed to perform their function. For example, with the advent of ergonomics, and the wide dissemination of computers, engineers became systematically involved in problems related to man-machine interactions and in designing human interfaces for their products. But the broadening of the boundaries of the systems that engineers had to deal with did not stop with the inclusion of human agents. Also, with regard to the life-cycle of designed objects, the boundary between products and users has been shifting. Calls for a more environmentally sustainable society, for example, has forced architects and engineers to consider products as items with life cycles that include their production and their disassembly. More recently, with the growing awareness of the vulnerability of large infrastructural systems to cascading failures and terrorist attacks, engineers have further enlarged their professional scope, to include in the systems they study and design, the interaction and social organization of human agents that operate massive technological products. This trend in different engineering fields has led to the emergence of systems engineering as a separate branch of engineering.[11] Originally this new field of engineering focused on the design of complex, large technological systems, and on the organization of technologically complex production processes, including complex design processes. Nowadays there is a growing awareness in this field that systems engineering will have to include human agents and social infrastructures as elements of the designed system.

As we pointed out at the start, design traditions have emerged that focus their attention on technological systems and what are called, by science, technology, and society scholars (STS), and philosophers of technology, socio-technical systems: amalgams of technological objects, agents, and social objects, all of which are necessary to guarantee the functioning of these systems. The crucial role of social infrastructures for the functioning of socio-technical systems may, for example, be illustrated by what happened to civic air transportation in 2001 just after the 9/11 attack on the New York City World Trade Center. The system of civic air transportation temporarily collapsed in part

[11] E.g., Blanchard and Fabrycky (1981) and Miser and Quade (1985).

because an element of its social infrastructure, the insurance of airplanes, stopped functioning. The material infrastructure of this socio-technical system remained in place but this was not sufficient to let it work successfully.

These developments in engineering can be characterized as ones in which the boundaries of the systems designed are no longer drawn solely around individual material products. Engineers must now enlarge their scope by recognizing wider boundaries, including human agents, their behavior, and ultimately their social institutions. As a result, engineers, like architects, are beginning to recognize their responsibility for the design of both material artifacts and the behavior of the agents interacting with those artifacts.

The notion of systems boundaries can also be used to capture an inverse development within architecture. What architects refer to as "building science" has transformed architectural practice in dramatic ways. New digital production techniques and new materials make possible architectural designs that could only be dreamt of a few years ago. In a way, architecture has narrowed its systems boundaries through a new emphasis upon building performance and the physical sciences. This is a development that brings parts of the architectural world much closer to engineering design. Here, as in traditional engineering design, design problems are approached primarily in a reductive, and not in an expansive way.

The turn by engineers from reductive to expansive design considerations produces a design practice which is more likely to resemble the moral and social consequences of architectural practices. Engineers working on socio-technical systems, like the architects of the working class' houses with their small kitchens, are in the business of consciously shaping the way people behave. This shaping of human behavior not only takes place with regard to man-machine interaction but, as argued above, social infrastructure. As molders of human behavior and interaction, engineers will have to think about the normative aspects of their choices on such structures. There they will encounter ethical and political dilemmas that are inherent in any consideration of human behavior. Moreover, the design of the material hardware and social infrastructure of a socio-technical system cannot be easily disentangled. The way in which the material products are technically designed produces constraints on the behavior of individual users and also requires the enactment of social institutions, such as building codes, regulations, and laws, to ensure that the system will function properly.[12] Engineering then becomes a deeply ethical and political practice.

Many design disciplines, other than systems engineering, must now recognize that design always has such social consequences, whether we choose to acknowledge them or not, and that these social consequences affect the success or failure of projects. The call to achieve environmental sustainability provides an illustrative example. Environmental degradation, most analysts now recognize, is as much a social problem as it is a technological one. The heating and cooling of urban buildings, which is linked to the "urban heat island effect," and rates of fossil fuel consumption,

[12] For a specific discussion on the historical development of building codes and their place within socio-technical systems, see Moore (2005).

are just two considerations. In the United States almost every building has its own heating and air-conditioning system. In contrast, many European cities have municipally owned "district" heating and cooling systems that significantly reduce emissions and improve fuel efficiency. The reasoning that lead to the production of such different systems are based, not upon engineering criteria as such, but on different traditions in different countries regarding property rights and the appropriate domain of public services. If the objective of technological development in this example is to successfully solve environmental problems, then designers must learn to think in new ways. In the design of socio-technical systems for environmental sustainability engineers must move, as in architectural practice, toward an expansive understanding of design problems. However, because of that move, engineers will have to confront the larger climate of social responsibility in which their design solutions will be developed and implemented. Some design solutions will be at odds with the broader social climate, and engineers like many architects today, become *de facto* social critics representing a substantial expansion of their professional responsibilities.

So as not to overstate our case, we must acknowledge that part of the expansion of responsibility will be a matter of choice. Many engineers will either ignore such considerations entirely and follow older expectations of the limits of design protocols and practices, or intentionally choose to do "business as usual" and refuse to push the boundaries of the social climate in which they have traditionally worked. Our point is that part of this expansion of responsibility will be imposed from outside by the sheer scale and complexity of the design problem at hand. To take a dramatic example, in the wake of the destruction of the city of New Orleans in 2005 after hurricane Katrina, how could it be possible to redesign the socio-technical system (which, in this case, was a city) without confronting the larger social and political climate that allowed for the growth and development of the city in the first place? One could, we imagine, simply rebuild the system of levies and canals to exactly their pre-Katrina state. But to do so would obviously be irresponsible, and given the likelihood of a similar climactic event in the future, a waste of public money. The engineering community could simply cede the decision on how and what to rebuild to politicians, differing responsibility for the success or failure of the effort to them. Clearly such a solution would also be irresponsible and irrational simply because politicians are not sufficiently trained in the relevant sciences. At some point engineers will either be called upon by politicians and city planners to describe what is possible in a rebuilding effort or else they will advocate certain solutions themselves. In that moment they can either choose to offer a design solution that accepts the goal of sustaining a city of a certain size on the New Orleans site or else reject it as imprudent or irresponsible. In either case, engineers will be implicated in a framework of responsibility for the future citizens of New Orleans whether they like it or not.

The emerging resemblance between the domains of design in engineering and architecture may be developed to a point where both may take advantage of the experiences and methods followed by the other discipline. We have three observations here.

3.1 Design Processes

Our first observation concerns the scope of the design process in architecture and its possible extension to engineering. Even in small projects various stakeholders are involved, some of which will be part of the socio-technical system being designed. One of the tasks of architects is to negotiate with these various stakeholders over the definition of the design problem and offer design solutions. It is seldom the case that one single stakeholder is in complete control of any project, that is, that there is a strict hierarchy between all the stakeholders involved so that the whole design process is steered from one command and control center. In traditional engineering design, focused on the design of technological hardware, these processes of negotiation play a much less dominant role.[13] The assumption is that the material products involved are purely technical in nature and are designed on the basis of the idea that their behavior may be controlled in all relevant aspects.

This is no longer the case for the design of socio-technical systems. If engineers recognize the social dimensions of their practice they may also be in a position to negotiate better among stakeholders on the parameters of individual design problems and the ethical and social dimensions of these problems. As suggested in the New Orleans example, the acceptance by engineers of this role will require that they free themselves from a position of only taking orders from employers. From a traditional engineering ethics perspective this alternative approach raises the problem of "many hands." Is it still possible, if so many stakeholders are involved in defining and solving design problems, to allocate specific responsibilities to the engineers involved when things go wrong? Perhaps or perhaps not. But because of the scale and complexity of many design problems today such a problem cannot be avoided.

3.2 Design Limits

Our second observation, related to the first, concerns the limits of design. Material systems may in principle be designed from the point of view of total design control, along the lines indicated above. For socio-technical systems this is problematic, if not impossible, because the behavior of the agents within the system is generally unpredictable. This is also a well-known aspect of architectural design. Agents that are part of socio-technical systems may redesign parts of the system from within in unforeseen ways.[14] As such, there may be no single vantage point from which complex systems can be designed and controlled. Moreover, if some agents within a system try to change parts of it in predictable ways, the total effect of all these changes at the system level may be unintended and unpredictable. In part this may be

[13] For a possibly dissenting opinion, see the work of Bucciarelli (1994).

[14] For example, see Andrew Feenberg's (1995) now well known example of the "subversive rationalization" of the Minitel in France by users. See also Brand (1994).

due to the complexity of socio-technical systems. Some critics even argue that such systems exhibit a kind of emergent behavior.

A concrete example of this phenomenon is *Wikipedia*, an on-line, free and "open source" encyclopedia that is edited by its users. Although this reference tool was created by the few individuals who comprise the not-for-profit *Wikimedia Foundation* in 2001, responsibility for the content of the encyclopedia rests with the community of users who claim that the interests of human knowledge are best served by the diffusion of responsibility. If true, such properties will raise even more problems regarding the moral and social responsibilities of engineers who participate in such open source systems. Who is morally responsible or politically accountable for negative effects related to the emergent behavior of complex socio-technical systems? Current theories in ethics, with its traditional focus on individual responsibility, may not be suited to deal adequately with such questions. Several new developments in STS and engineering ethics may provide some avenues to address these concerns, which brings us to our third observation.

3.3 Engineering Ethics

Three new developments in engineering ethics, if successfully prosecuted, could help to push the scope of responsibility in engineering design closer to architecture. First, Deborah Johnson and Jameson Wetmore (2007) have suggested that a fruitful starting point for such an engineering ethics can be found in combining STS with practical ethics. They observe that until now thinking in engineering ethics has been based on a separation of technology from its social context and on the idea that technological practices are free from social, political, and cultural values. According to them engineering ethics has mainly addressed the business context of engineering. They identify three core ideas in the STS literature that can transform engineering ethics so that it can more adequately deal with the sort of problems we have been raising:

1. The claim that technology and society co-determine each other which produces a weak form of technological determinism.
2. The long recognized observation in STS of the "socio-technical" nature of all technology.
3. The argument that technological expertise does not derive from value-free knowledge alone, but is partly constituted by social factors.

The claim is that the integration of these core ideas in engineering ethics will allow the field to critique more soundly the claim that technological design is morally value neutral.

A second new approach in engineering ethics is "value-sensitive-design."[15] This approach agrees with the idea that socio-technical systems are the primary unit of

[15] Friedman (1997).

analysis in engineering ethics. Socio-technical systems are by definition value-laden systems and designing such systems is, by definition, a value-laden activity. Value-sensitive-design would explore the consequences of this recognition for engineers. It takes as its starting point the idea that it is possible to pro-actively design social and moral values into technological hardware, for example, designing communication devices so that they safeguard the value of privacy. Such ideas may be familiar in architectural practice but they are relatively new in many engineering domains. One ironic example is the design of household heating appliances in Sweden documented by the social anthropologist Annette Henning. In order to realize the national goal of using more renewable resources for home heating *in lieu* of imported oil, the Swedish government collaborated with industry engineers to design bio-pellet burning stoves and furnaces. Much to the disappointment of all parties, however, this campaign for technological change proved to be unsuccessful because the appliances proved inconsistent with cultural "perceptions of house and home, of private and public space, and male and female space." In response to Henning's findings, the editors of the volume in which this study appears note that "Knowing how to design a heating system that will work mechanically is quite different from knowing how to design a system that users perceive as responsive to their domestic practices and values."[16]

A third new approach for engineering ethics could be derived from recent developments in architectural practice itself. Earlier we briefly discussed the need for the justification of whistleblowers in engineering to unmask design practices that, in the name of efficiency, may ultimately prove to be harmful to citizens or the environment. In this context we can understand a whistleblower as a member of a system but also a citizen of the society served. Part of the recognition of the whistle-blower is that citizenship demands a higher order of loyalty than membership of a government agency or firm.

In the world of architecture some have likened Prince Charles to a kind of whistleblower at least in the sense that his activism in the preservation of historic architecture and urban patterns answers to a larger sense of responsibility to the public. But, as the Prince of Wales, Charles is both more than a citizen and less than a participant. He is a privileged observer of the system from the outside. The phenomenon of the "citizen-architect" may, then, provide a better exemplar for engineering practice. In Germany, Peter Hubner; in England, Rodney Hatch; and in the United States, the late Samuel Mockbee (of the Rural Studio), Sergio Palleroni (of the BaSiC Initiative), and Brian Bell (of Design Corps) are such citizen-architects who are engaged in what they call "community design." These design practitioners argue that their authority to design public facilities derives not from their status as licensed professionals but from the local communities in which they build. Rather than resent the eclipse of artistic autonomy that accompanies community design, these designers tend to see expressions of local values as the source of creativity, not its suppression. Design, in their view, is an inclusive social process in which

[16] See Henning (2005).

people decide how they want to live – it is not an autonomous process in which experts define problems and hand down answers from above. These practitioners are not simply populist order-takers committed to turning technocratic hierarchies upside down. Rather, they are highly skilled architects who hold that design excellence depends upon the creative synergy between the abstract knowledge of the expert and the local knowledge of the user. At its best, value-sensitive-design is not simply the accommodation of local values in the designers' vision of the future, but a transactional process in which designers and citizens depend upon each others' knowledge in the production of a better world.

In sum we believe that design practices in general will improve in proportion to the degree we can distinguish between *efficient* and *successful* technological systems. For any system to succeed it must be sustained – which is to say continually renovated over time – by the citizens whom the system serves and who in turn serve it.

4 The Essays

The ordering of essays in this volume is chosen to reflect the integrated understanding of engineering and architecture as we have characterized it here. The first part contains nine essays on engineering designing in the traditional "nuts-and-bolts" sense. These essays are authored by philosophers of technology and together provide an overview of current philosophical analyses of technology aimed at establishing that engineering is more than an activity only concerned with composing material products. Having been written within different philosophical traditions and with different aims, all nine essays relate engineering design and its products to ethical, political, and societal issues. The section opens with four essays by Maarten Franssen, Wybo Houkes, Don Ihde, and Philip Brey. These essays have in common a focus on the relationship between the products of designing and the intentions of their designers, their direct users, and the communities of consumers that determine their continued existence. The positions argued for diverge, sometimes radically, concerning the influence that the original intentions of designers can have on the characteristics of the products. Yet, regardless of these differences and regardless of whether the focus is on individual products and design process, or on more collective historical developments in technology, a recurrent theme is that for understanding design and its products, a wider focus is needed than one that is limited to the products themselves.

These essays are followed by chapters from Anke Van Gorp and Ibo Van de Poel, Peter-Paul Verbeek, Patrick Feng and Andrew Feenberg, Kiyotaka Naoe, and Paul B. Thompson. All of these essays enrich the analyses of engineering design with more explicit normative perspectives. The focus in these essays ranges again over a wide spectrum, from ethical decisions taken in individual design process, to the way engineering can alter society by changing the economic characteristics of various goods. These essays make clear the position of many, if not most, philosophers of technology that engineering, like architecture, shapes our lives and our societies – a conclusion that becomes unavoidable when new forms of engineering are considered.

The second part of the volume contains ten essays on engineering design in its novel forms as it is currently emerging. From a technological perspective the split between these two parts may be clear; from a philosophical standpoint there is a more gradual distinction since the ethical, political, and societal claims that can be made when considering these emerging forms of engineering design can often be made through more traditional philosophical approaches. Yet, the current novelties in engineering also bring new issues to the table, or older ones in more lucid forms. Bioengineering and genetic engineering, for instance, raise a whole new avenue of issues concerning what it is to be human, when the by now realistic possibility of reengineering ourselves in considered.

In the three first essays of the second part – those by John P. Sullins, Bernhard Rieder and Mirko Tobias Schäfer, and Alfred Nordmann – designing in three such emerging engineering technologies are analyzed, showing how, respectively, robotics, software engineering, genetic engineering and nanotechnology encroach upon and change our thinking and evaluation of technology as it has been shaped by the more classical forms of technology. Bioengineering and genetic engineering applied to or envisage to be applied to humans, set apart the next three essays by Daniela Cerqui and Kevin Warwick, Inmaculada de Melo-Martín, and C.T.A. Schmidt. These range from a full acceptance and embrace of our trans-human future (especially as exemplified by Warwick's work), to the articulation of a range of serious objections to a future engineered humanity. The final four essays by Kristo Miettinen, Ulrich Krohs, Kathryn A. Neeley and Heinz C. Luegenbiehl, and Noam Cook, bring us to the designing of socio-technical systems. These essays argue for a systemic approach to technological design. Within design practices, technical artifacts are not to be taken as objects on their own, but as elements of wider systems that not only contain technical elements, but also human beings and social elements. Only in this way it will be possible to take due account in engineering design of the close relationships between technical artifacts, human agents, and social contexts.

Finally, the emerging shifting focus in engineering design from technological products proper to socio-technical systems, provides the link between engineering and architecture and to the third part of the volume containing six essays on architectural design. Here, several authors take up the question of the future of architectural design, urban aesthetics, and civic engagement in the context of newly emerging architectural forms. The first four essays by Howard Davis, by Steven A. Moore and Rebecca Webber, by Ted Cavanagh and by Joseph C. Pitt are historical, empirical, and philosophical in scope. Davis finds that in the 19th century the process of designing buildings became separated from the process of building them. Using empirical methods, Moore and Webber reinforce Davis' historical evidence by examining the masked politics found in the technology of linear perspective. Taken together, the three authors agree that the abstraction of architects and citizens from the material conditions of building has had negative consequences that can be countered only by innovations in design practice. Cavanagh and Pitt, although from differing perspectives, argue against the notion that we can generalize about the various environmental design disciplines or that any particular discipline can successfully exercise a universal approach. In sum, all of these authors argue that successful, or

good, design is situated in a particular social and ecological context. The last two essays by Graig Hanks and by Glenn Parsons take up the problem of how we should effectively evaluate the aesthetics of built space, as an extension of models of civic engagement and natural functions. Together, these essays provide a comprehensive overview of the promise of a more unified approach of understanding the combined architectural and engineering design aspects of built spaces.[17]

References

Baird, D., 2004, *Thing Knowledge: A Philosophy of Scientific Instruments*, University of California Press, Berkeley, CA.

Bell, B., ed., 2004, *Good Deeds, Good Design: Community Service Through Architecture*, Princeton Architectural Press, New York.

Blanchard, B. S., and Fabrycky, W. J., 1981, *Systems Engineering and Analysis*, Prentice-Hall, Englewood Cliffs, NJ.

Brand, S., 1994, *How Buildings Learn: What Happens After They're Built*, Viking, New York.

Bucciarelli, L. L., 1994, *Designing Engineers*, MIT Press, Cambridge, MA.

Feenberg, A., 1995, *Alternative Modernity: The Technical Turn in Philosophy and Social Theory*, University of California Press, Berkeley, CA.

Friedman, B., ed., 1997, *Human values and the design of computer technology*, Cambridge University Press and CSLI, Stanford University, New York.

Guy, S., and Shove, E., 2000, *A Sociology of Energy, Buildings, and the Environment: Constructing Knowledge, Designing Practice*, Routledge, London.

Henning, A., 2005, Equal couples in equal houses: cultural perspectives on Swedish solar and bio-pellet heating design, in: S. Guy and S. A. Moore, eds., *Sustainable Architectures: Natures and Cultures in Europe and North America*, Routlege/Spon, London, pp. 89–103.

Johnson, D. G., and Wetmore, J. M., 2007, STS and ethics: implications for engineering ethics, in: *New Handbook of Science and Technology Studies*, M. Lynch, O. Amsterdamska, and E. Hackett, eds., MIT Press. In press, Cambridge, MA.

Kaplan, D. M., ed., 2004, *Readings in the Philosophy of Technology*, MD, Rowman and Littlefield Publishers, Lanham.

Katz, E., Light, A., and Thompson, W., eds., 2003, *Controlling Technology*, Prometheus Books, Amherst, NY.

Kroes, P. A., and Meijers, A., 2006, Introduction: The dual nature of technical artefacts, *Stud. Hist. Phil. Sci.* **37**(1):1–4, which introduced a special issue on philosophy of technical artifacts.

Lang, J., 1980, The built environment and social behavior: architectural determinism re-examined, *VIA* **4**:146–153.

Larsen, M. S., 1993, *Behind the Postmodern Façade: Architectural change in late twentieth-century America*, University of California Press, Berkeley, CA.

Le Corbusier, 1990, Towards a new architecture: guiding principals, in: *Programs and Manifestoes on 20th-century Architecture*, U. Conrads, ed., MIT Press, Cambridge, MA, p. 59.

McGee, G., 2003, *Beyond Genetics*, Harper Collins, New York.

Meyer, H., 1990, Building, in: *Programs and Manifestoes on 20th-century Architecture*, U. Conrads, ed., MIT Press, Cambridge, MA, p. 120.

[17] We gratefully acknowledge assistance of Miranda Aldham-Breary and Merel Schrijver in preparing this volume.

Miser, H. J., and Quade, E. S., 1985, *Handbook of Systems Analysis: Overview of Uses, Procedures, Applications and Practices*, Wiley, Chichester.

Mitcham, C., 1994, *Thinking through Technology: The Path between Engineering and Philosophy*, The University of Chicago Press, Chicago.

Moore, S. A., 2005, Building codes, in *The Encyclopedia of Science, Technology and Ethics*, Carl Mitcham, ed., Macmillan, New York, pp. 262–266.

Pitt, J. C., 2000, *Thinking about Technology: Foundations of the Philosophy of Technology*, Seven Bridges Press, New York.

Scharff, R. C., and Dusek, V., eds., 2002, *Philosophy of Technology: The Technological Condition*, Blackwell, Malden, MA.

Simon, H., 1972, *The Sciences of the Artificial*, MIT Press, Cambridge, MA.

Van de Poel, I., 2001, Investigating ethical issues in engineering design, *Sci. Eng. Eth.* **7**: 429–446.

Van der Rohe, L., 1990, Working theses, in *Programs and Manifestoes on 20th-century Architecture*, U. Conrads, ed., MIT Press, Cambridge, MA, p. 74.

Part I
Engineering Design

Design, Use, and the Physical and Intentional Aspects of Technical Artifacts

It has been argued that technical artifacts are a special category of objects that require a combination of the physical and intentional 'descriptions of the world'. In this chapter, I question this point of view. Any object can figure in the intentional actions of some person, for example as being used for a purpose. A more interesting question is whether there is a unique most adequate way of intentionally describing a technical artifact as what it is for, or, in other words, to what extent the character of an object as a particular sort of technical artifact is fixed. In this contribution I argue against the view that it is fixed. What an artifact is for generally depends both on what it was designed for and on what it is being used for. A consequence of this view is that the metaphysical status of technical artifacts, in the form of a precise answer to the question what sort of artifact it is, or whether it is or is not an artifact of some particular kind, is vague or indeterminate in cases where its use does not match its design. This, however, is precisely the sort of metaphysical vagueness that pervades the intentional conceptualization, as can be illustrated by arguments from the writings of Parfit and Davidson.

1 Artifacts and Natural Objects

The lilies of the field may not toil or spin, but many animals do, and among all animals members of the species *Homo sapiens* are notorious for considering the furniture of the natural world too sparse to their liking. Due to *Homo faber*'s diligent tool-making, the world now contains a great many material objects that are man-made objects or artifacts. This is not to say that everything that is man-made is a material object. Rules, instructions, and organizational schemes, for either men or machines, are not, and they form a special, elusive category that merits more philosophical attention than I can give in this paper. I will, therefore, ignore that category completely and restrict my discussion to the category of material artifacts.

M. Franssen, Delft University of Technology

P. E. Vermaas et al. (eds.), *Philosophy and Design.*
© Springer 2008

Likewise, not everything that results from humankind's creative interference with its environment is an artifact. The waste products of this interference, such as exhaust fumes or sawdust, are not. One cannot, therefore, single out artifacts from the totality of material objects by defining them as those objects that have come into existence through the interference of people. Such a loose characterization would also include accidental objects like broken-off twigs or rocks or our body's waste products among the artifacts. An artifact does not just come into existence through the causal mediation of people; it is created through an intentional act. The category waste products shows, however, that this is still too loose a definition. To be a 'true' artifact, the object must not only come into existence as the result of an intentional act, the act's intention must be to create precisely this object, taking into account the limits that skill and knowledge put on this precision.

For most artifacts, certainly the ones that we call *technical* artifacts, this can be put even more strongly: they are not merely intentionally created, they are created with a specific *purpose* in mind. Put like this, however, it is not clear how this amounts to a stronger claim. In every intentional act there is some purpose involved, in the sense of a state of the world that the actor is aiming to realize through the act. The point is that technical artifacts are created with a purpose in mind that transcends the designer's act of creation, a purpose that clings to the artifact, so to speak, after its creator has left the stage. This is indeed how we conceptualize technical artifacts in everyday life: our toolbox is filled with objects that we think of as *being* screwdrivers, wrenches, and so forth. The 'for-ness' clinging to technical artifacts eludes the physical description of nature. Technical artifacts remain physical objects that are subject to the laws of nature like any material object in the universe. Additionally, however, unlike ordinary natural objects, their being 'for a purpose' gives them an intentional 'side', since purposes are things entertained by persons having intentionality. Consequently, to describe artifacts 'adequately' or 'fully', both the physical and the intentional aspects have to be accounted for, or brought into play.

This may all seem straightforward, but what is not so straightforward is how these two aspects have to be brought into play, or what determines whether a description in which the physical and the intentional aspects have both been brought into play is 'adequate', or what an adequate description says about the artifact it describes. These are the questions that I wish to address in this chapter. In the account that I draw up in this chapter, in my attempt to answer these questions, I will emphasize the role of the artifact's user as well as the artifact's designer. The designer of an artifact may be considered to have a privileged position as far as the form of and the adequacy of a description of an artifact is concerned, because he or she, supposedly, is the first to draft one. This is not, however, a view that I will defend in this chapter, or at least not without consider-able reservation.

The plan of this chapter is as follows. In the next section, I argue that the physical and intentional descriptions are not complementary but that the former is contained in the latter. In section 3, I argue that the for-ness of a technical artifact is determined both by its design and by its use. In section 4, I discuss the seemingly

problematic consequence of this position that what sort of artifact an object is need not have a definite answer, and I argue that this form of indeterminacy is an inescapable feature of the intentional conceptualization. In the final section, I use this feature of the intentional conceptualization to give some arguments against the view that the priority in deciding what an artifact is for rests with the designer.

2 Physical and Intentional Descriptions

A first problem regarding these issues is whether the notions of 'physical' and 'intentional' in relation to the description of objects are sufficiently clear. The distinctions sketched above have been taken up in the 'Dual Nature of Technical Artifacts' research programme developed at Delft University of Technology. In a recent overview, the programme's basic starting point is phrased as the claim that "technical artifacts [are] 'hybrid' objects that can only be described adequately in a way that somehow combines the physical and intentional conceptualisations of the world".[1] This way of putting things appears to be based on the idea that there are two, alternative or complementary, conceptualizations of the world, the physical and the intentional conceptualization, a view that considerably sharpens the mere distinction between physical and intentional aspects of technical artifacts. If a contrast is introduced between the physical and intentional conceptualizations of the world rather than between physical and intentional aspects or between the physical and intentional vocabularies or idioms, the physical conceptualization must be seen as being contained in the intentional conceptualization, or the intentional description as being hooked onto the physical description. In the intentional 'conceptualization of the world', if we are to retain for a moment this terminology, the physical description of the world is presupposed. The world remains populated with physical objects that have properties like spatio-temporal location, velocity, and weight; but something is added to this: mental states, which consist of beliefs and desires, and actions. The beliefs and desires are partly about these physical objects, and the actions partly involve the intentional manipulation of physical objects. (This is probably not as an idealist metaphysicist would have it, but since such metaphysics have lost much of their popularity nowadays, I will ignore this point.) This is not unlike the extension of the physical conceptualization of the world going from a microlevel description to a macrolevel description. For example, when describing water at the macrolevel, the vocabulary is extended with the notion of boiling and freezing, but the notions of mass, velocity, and so forth, used at the microlevel are retained.[2] Nothing is lost that has no meaning at the macrolevel, although not all concepts may retain their

[1] Kroes and Meijers (2006, 2).

[2] The historical development is of course in the opposite direction, from macrolevel to microlevel description. During this development, the vocabulary used is contracted to retain only the 'primary' properties that are necessary for a complete description of the world.

usefulness at the macrolevel. If one holds to a reductionist view, macrolevel phenomena can even be described using the microlevel vocabulary exclusively.[3]

Similarly, as regards the physical and the intentional vocabularies, for certain happenings in the world we have a 'macrolevel' intentional description, whereas the same happenings would in principle allow a 'microlevel' description using only the physical vocabulary. On the face of it, there is just as little reason to expect a conflict between the two descriptions as there is a conflict between physical macrolevel and microlevel descriptions of one and the same phenomenon. Nevertheless, the availability of the physical and intentional vocabularies alongside each other has raised various philosophical problems, of which the most relevant here are, first, how descriptions in one vocabulary are related to descriptions in the other where they obviously meet, i.e., in the human body, more particularly in the brain, and second, how determinate or exact are intentional descriptions. Philosophical questions concerning the nature of artifacts are tied up with both these issues. In this chapter, I will only address the second of how determinate or exact intentional descriptions are.

The intentional idiom is part of our vocabulary because we have a use for it. There is nothing mysterious in the fact that this use applies to artifacts. What is less obvious is in what precise way the intentional vocabulary applies to artifacts. How exactly is the for-ness of artifacts accounted for in the intentional vocabulary?

Basic words in the intentional vocabulary are belief, desire, action, purpose, goal, expectation, want. They are the terms of folk psychology and apply to human beings, or to persons. Person itself is, of course, also a prime term in the basic intentional vocabulary. Now any physical object can be an object of a belief, or a desire, or an expectation, and so forth. Would this count as the object being described, partially perhaps, within the intentional vocabulary? This seems gratuitous. Human beings have beliefs and expectations about everything that we know to exist, that is, after all, what our knowledge comes to, and about much that does not exist besides. So this would not be a very interesting result. Another possibility is that objects can be described intentionally rather than physically, just as human beings can be described intentionally in parallel to being described physically.[4] It seems that, when it is claimed that an artifact can be presented as a mere physical object but can additionally or alternatively be described as being for a particular purpose, such a double description, analogous to the double description of specimens of *Homo sapiens*, is what is meant.

The 'Dual Nature' claim about artifacts can then be rephrased as the claim that neither any physical description nor an intentional description in the above sense, however much extended, adequately or fully describes the kind of object that an

[3] I ignore the case of quantum mechanics here. It can be argued that classical physics and quantum physics do indeed represent two competing conceptualizations of the world. This is generally seen . to pose a problem of considerable philosophical depth, which 75 years of discussion have not been able to solve.

[4] 'Physically' must here be understood in the broad sense that includes biochemical and physiological descriptions of humans as biological organisms.

artifact is. The trouble is that for any object in the universe known to us we can easily come up with a description of it that employs the intentional vocabulary. 'The object I am thinking of right now' would be a good candidate. This is the mirror image of the earlier observation that everything we know of can figure in the content of a mental state. What is more, these descriptions say something true that is missing in the physical description of the same object or situation. Physical descriptions of Alpha Centauri will adequately describe this star as far as predictions about its position in the sky or its radiation spectrum are concerned, but they will not catch the aspect that I am thinking of Alpha Centauri just now, or that I failed to spot Alpha Centauri when I last looked for it. The claim that a mere physical description of an object does not include what we have in mind for it seems a truism. At the same time, a mere intentional description comes very cheap. Just like artifacts, our descriptions are meant to serve certain purposes. What we are looking for is rather a description that somehow addresses the for-ness of the object qua artifact.

3 Use and Design as Ontologically Differentiating

One candidate for such a description is the following: 'Object x can be used to or is currently being used to realize outcome y.' In this form it is not obvious that this description makes use of the intentional vocabulary. The one intentional word is 'use'. To bring out the intentionality more clearly, the description can be analyzed as consisting of two parts: one stating that object x is part of an arrangement that, given certain circumstances, will result in the realization of outcome y, and another part stating that it was or is some person's or persons' intentional action to organize and control the arrangement and/or the circumstances. Someone selected this object rather than another one, or no object at all, because of a desire for a particular result and expectations concerning the coming about of this result. For simplicity's sake I will assume that the situation was or is intended just like that, meaning that the result that obtains was or is the intended result and that it obtained or obtains in the way foreseen. In this account, the intentional part of the description is not a necessary part of the description of the artifact and can be cut loose without difficulty. What would be left would be a purely physical description of a behavior or a disposition to behave by a physical object. The for-ness of this object would not be addressed.

A problem with this description is, therefore, that it is, again, too loose. It fails to apply to artifacts in particular. It may apply to anything that enters the sphere of human action, or at least potential human action. If artifacts are in this sense 'for something', then so is any ordinary object, artificial or natural or human, that we use for a purpose. This stone is for cracking a nut with; the pebbles that Little Tom Thumb dropped on the ground were for finding his way back home; the magician's assistant is for diverting the attention of the audience.[5] Is the for-ness in these cases

[5] I owe the last example to Jesse Hughes.

not just as necessary an aspect of the object – something that a full description should include – as the for-ness of an electric drill?

This is what the 'Dual Nature' thesis seems to deny. It holds that the electric drill *is* for something in a way that Little Tom Thumb's pebbles are not. A description that leaves the for-ness of the drill out and that merely lists the drill's physical characteristics misses something that is essential to it. What sets technical artifacts like an electric drill apart from other objects that are used for a purpose, or are part of an arrangement that serves a purpose, is that they are designed to serve a purpose. This additional aspect gives us another candidate for the intentional description of an artifact that addresses properly its for-ness: 'Object x has been designed and made in order to be used to realize outcome y.' This description makes x straight-forwardly the object of an intentional action: some person or persons did the designing or the making. Someone chose the composition of the whole object out of components, and the materials and the forms of the components, such that it would show certain behavior in certain conditions. Again for simplicity's sake I assume that the designer intended a precise form of use or, more formally, a use plan,[6] up until the final – intended – result. It is the realization of this outcome that the artifact was designed and made *for*. Note that this description only applies to *technical* artifacts. There are many artifacts that are designed and/or made for a purpose, but not a purpose that includes their being *used* for something. Examples are works of art but also test pieces. The for-ness of artifacts in general has there-fore a wider scope than the for-ness of technical artifacts.

This candidate, however, also faces the problem that the description is true of much more objects than the likes of an electric drill in full working order. For a start, technical artifacts break down, wear, deteriorate, they can even change beyond recognition, although the continuity with the original artifact is such that we must speak of the same object. Few would deny that a drill with a burned-out fuse is still for drilling holes, but for many artifacts that were once made for a particular use it seems far-fetched to claim that, whatever the state they are in, they are still 'for that purpose'. Secondly, artifacts may have been designed and made for a particular purpose whereas they are actually used for a totally different purpose. Examples are a tire made into a garden swing, or pipe cleaners used as toys for tinkering.

To recapitulate, the thesis at issue holds that a description in the intentional vocabulary, making explicit its for-ness, catches an essential aspect of technical artifacts, something that is missed in any merely physical description. Moreover, this necessity exists only for a subclass of all things that are used for a purpose, since otherwise everything would potentially be a technical artifact, and the term would be in danger of losing its meaning. We can quite literally use just about everything to achieve some goal. NASA used the planet Jupiter to launch the space vehicle Galileo on a course that will bring it beyond the solar system. For the famous determination of the path of light in a gravitational field in 1919, both the sun and the moon were used, and readers of Tintin will know that a solar eclipse

[6] Houkes et al. (2002).

can equally be used to escape from being burnt at the stake. So the for-ness of technical artifacts is essential to them, rather than accidental, as it supposedly is in the cases where mere objects are used for a purpose. That, at least, is what the 'Dual Nature' theory seems to accept. The essentiality lies in the fact that technical artifacts have been designed and made for the purpose that they are used for.

The difficulties, then, are the following: first, it seems overly dismissive to say of a particular natural object that the fact that it is used by someone for a purpose is of less importance for our conception of this object than the fact that some technical artifact is used for a purpose, which happens to be the purpose that another agent had in mind earlier when making the artifact. It seems a type-token distinction is at work here that is not articulated in the 'Dual Nature' programme. The fact that a particular stone is used to crack a nut does not affect the stone as a representative of the natural kind stone, whereas with technical artifacts we are nearly always dealing with representatives of historical kinds. Almost any representative of this historical kind would have served my purpose just as well, but not every representative of the natural kind stone would have served just as well for cracking the nut.[7] Therefore, it seems that the property of being used is not essential to the stone, qua representative of the kind stone, whereas it can more easily be taken to be essential to the nutcracker, qua representative of the artifact kind nutcracker.

Second, if the for-ness of artifacts is analyzed exclusively from the perspective of their being *designed* for a purpose, this would mean that many artifacts, including artifact types, are *for* some purpose although their use will not serve this purpose, or their use, as a type or as a token, is aimed at some entirely different purpose. Figure 1 indicates the various sets of arbitrary objects that can be related to a human purpose *x*.

The fact that the use we can make of objects is quite independent of the previous history of these objects will, however, not easily be dismissed. Nor will the fact that

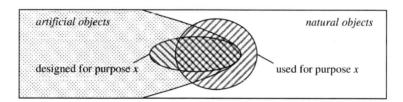

Fig. 1 The relations between the sets of natural objects, of artificial object, of objects designed for a purpose x, and of objects used for a purpose x

[7] 'Almost', because of the possibility of malfunctioning items. Additionally, it depends on the narrowness of the delineation of the historical kind in question whether other representatives would serve just as well. Elsewhere I have emphasized the importance of clearly distinguishing between functionally defined artifact kinds, like 'knife', and much more narrowly defined, in terms of structural and design-historical features, artifact kinds or types, like 'eight-inch chef's knife from the firm Zwilling J.A. Henckels'. See my (2006) and (2008) papers.

the representation that is an artificial object's birth certificate, so to speak, cannot be guaranteed to hold true forever. In other words, a dual nature can be ascribed to technical artifacts, but this duality is rather that they involve intentionality in two different ways: they are made for a purpose (by someone) *and* they serve a purpose (someone's purpose). In 'fully' describing what an object is for, both aspects have to be taken into account. This is not a problem for the group of 'typical' artifacts, objects that are (successfully) used for the purpose for which they were designed. Problems arise when an object is designed for a purpose but is not used, or not even fit to be used, for this purpose, or when an object is used for a purpose, or fit to be used thus, but was not designed for this purpose.

There is an interesting relation between this 'dual intentional nature' and the difficulty of finding a comprehensive definition of the notion of function for technical artifacts and biological organs and traits. Desiderata for such a definition are that it should be able to grant a function to a completely new artifact (an 'is being used for' aspect) as well as to a malfunctioning artifact (an 'has been made for' aspect). There is a connection, although the connection is not as straightforward as might seem at first glance, between, on the one hand, the 'is used for' aspect and what are called system functions, and, on the other hand, between the 'has been made for' aspect and etiological functions or proper functions. I will not, however, elaborate this point here.[8] I have, until now, deliberately avoided the word 'function' so as not to complicate the issues central to this chapter with the philosophical conundrum of giving an adequate account of this term.[9]

Given that the 'is being or can be used for' and 'has been designed and made for' sides of artifacts can be distinguished as in principle independent aspects, what would it mean to claim that they must both be taken into account in a description of artifacts? Must an adequate description of any artifact take them both into account at the same time? One may wonder why, for an object that is being used for a purpose, the historical side matters at all. Why are we not satisfied with claiming that when an object is put to a use, the purpose it is being used for is what it is for, and that any prior use that has been made of it is irrelevant? Obviously, an artifact's history is highly relevant for finding out for what purposes an artifact can be used. The designer of an artifact knows at least one way the artifact can be used, and the object's history as a designed artifact tells the user that it has this usefulness.[10] Concerning the question what the artifact *is* for, however, it is unclear why the original designer should be given the right to determine this. If anyone puts a particular object, be it an artifact or a natural object, to use, this person becomes in a sense the designer of a system figuring the object. He or she discerns certain

[8] The source text for system functions is Cummins (1975); the most comprehensive etiological theory of function is Millikan (1984), in which the notion of proper function is defined as a technical term.

[9] See, for an introduction into the difficulties of defining function, in particular focusing on artifact function, Preston (1998) and Vermaas and Houkes (2003).

[10] Cf. Houkes (2006).

properties in the object – most probably on the original designer's instruction, but that is not relevant for the point at issue, since it need not necessarily go like that – and then makes use of these properties to realize a particular outcome.

4 The Metaphysics of Artifacts

If this view is adopted, it seems that what an object is for becomes a very flippant sort of thing. A bottle that I use temporarily as the support for a stick at the top of which I am fastening something, changes from being for containing liquids to being for holding a stick upright and then back again to being for containing liquids. If we think of an artifact as something that definitely *is* for something, as a defining property, this seems unacceptable. However, we do accept it in the case of natural objects that we use for a purpose. This stone was not for anything, it is now for cracking a nut, and it will again be not for anything in a few minutes time. I may want to crack another nut in a moment, but I can pick up any other available stone for this, in complete disregard of the first stone's ephemeral existence as a nut-cracker. Similarly I could pick another bottle for the next stick. Indeed, as far as the purpose of holding a stick upright is concerned, it does not matter whether the bottles are artifacts and in that sense already 'for something'. They are chosen because they have the right physical properties, just as the stones have the right physical properties for the job of cracking a nut. If bottles grew on trees, that would be just as fine: and indeed, in some countries bottles, i.e., things having the right properties for containing liquids and for keeping sticks upright, do grow on trees. How much do we gain by claiming that bottles – our bottles, made of glass or plastic – essentially are for containing liquids and that gourds essentially are natural objects that, accidentally, can be used for containing liquids?

This capricious metaphysics is a problem only if we interpret the 'being for something' of artifacts as the *being* something, essentially, similar to the way certain objects *are* stones or electrons, and consider particular artifacts as *being* screwdrivers, drills, and so forth, essentially. But must we? To maintain that we must is at odds with the character of the intentional idiom. The universal terms occurring in this idiom do not figure in strict, exceptionless laws, comparable to the laws of nature, that determine whether or not we have cut the intentional realm 'at the joints'. Natural-kind terms refer to objects that all share certain properties, which serve to define them and that figure in the laws to which each and every representative of the kind answers. This is not so for artifacts. Whatever we would take as the defining characteristic of a particular artifact kind or functional kind, it would be the case that certain objects, even artificial objects, would fit the description that we do not consider as such, and that objects that we consider as specimens of the artifact kind do not posses the defining characteristic. For newly designed specimens of a specific artifact kind, the defining characteristics must sometimes be reinterpreted. The status of a Phillips screwdriver as a screwdriver is not contested, but a Phillips screwdrivers does not drive traditional screws, and a traditional

screwdriver drives, with difficulty, only some crosshead screws. This simple example shows that the conditions in which an artifact is meant to show a specific physical behavior are, in a sense, part of its characteristics.

For the technologically sophisticated artifacts of modern culture, the claim that certain objects that we do not consider as specimens of such artifacts would still fit their defining description is, of course, highly theoretical. It is difficult to imagine an object that has the capacity to function as a television set or a satellite while not being designed as a television set or a satellite. However, this does not imply that it is possible to delineate the kinds of television sets or satellites similarly to the way natural kinds are delineated. Hardly any other object would react in the same way as a current television set does to the physical input for which these television sets are designed, but future television sets may operate quite differently in connection with related changes in future broadcasting methods.

The extension of terms form the intentional vocabulary is, therefore, determined by fiat, rather than by behavior falling under strict laws. Compare, in this respect, Derek Parfit's account of what a person is.[11] How exactly Parfit explicates the notion of a person is not relevant here. What is relevant is the fact that in his account, as inevitably in any account, the boundaries of personhood are not in all circumstances clear. Sometimes a particular person's question 'Will that still be me?' or 'Will that mean my death?' is indeterminate. Parfit's examples are perhaps contrived, involving perfect replicas being made while the original is destroyed or brains being split after which each half is transplanted into a different body. But take a more realistic event: as a result of a car accident Geoffrey suffers severe brain damage, and when he recovers it turns out that he has lost all his previous memories. He has to start conscious life anew. Should we say that a person – Geoffrey – died in that car accident? Parfit calls such questions *empty questions*.

In the same way the question 'What is this object for?' may sometimes be an empty question, even for an object that is, purely historically, a (technical) artifact. A screwdriver's hilt from which the shaft has come loose, a single cogwheel from an old alarm clock, are they for anything, even though no-one would deny that they were made for a definite purpose and have been used for that purpose. However we may answer the question, the answer does not add to what is worth knowing about the object.[12]

Thus one should not take the functional terms used to refer to technical artifacts too seriously in a metaphysical sense. Calling something a screwdriver should be seen as shorthand for 'the thing that was made to drive screws', or (less often) for 'the thing I use to drive screws', rather than for 'the thing that *is* a screwdriver'. Technical artifacts are a lot like persons in this respect, or rather persons in an imaginary world where no moral laws forbid us from brainwashing, molding and transforming people

[11] Parfit (1984, part III).

[12] Note that this question, when posed by an archaeologist concerning an excavated object, is never an empty question, since in this case the question's aim is to increase our incomplete knowledge of the practices and ways of life of a vanished culture.

as we think fit. Artifacts come into being as useful objects and at a certain moment their life of being useful ends, although afterwards a physical object remains. Their 'memory' can be erased and they can be diverted toward serving a completely different purpose. They can occasionally play the part of being something else, with the associated danger of identifying too much with this role. Just as we do not, normally, run into difficulties when we say that this *is* Geoffrey, we do not, normally, run into difficulties when we say that a particular artifact *is* a screwdriver, and so we are lured into believing that the artifact *is* a screwdriver in precisely the same way as the material of its shaft *is* metal. Nevertheless, abnormal cases in which we would no longer be so sure can, for both persons and artifacts, be imagined with equally little difficulty.

5 No Privileged Role for Designers

What light, finally, does the indeterminateness of the 'being' of technical artifacts, as I describe it, throw on the role of the designer of such artifacts? I distinguish two aspects of this role. The 'Dual Nature' program gives the designer the (heroic) task of "bridging the gap" between the physical and intentional descriptions by bringing together the function and structure of an artifact. Is this way of putting it compatible with the relation between the physical and the intentional idioms as I sketched it? Second, the designer may be thought to determine the ontological status of an artifact through creating it. If what the designer did was designing an electric drill, how can the product of this design act not *be* an electric drill?

Concerning the first question, I have already stressed that there is no gap to be bridged between the physical and the intentional vocabularies. Among my intentional states are all my beliefs about the physical world. I believe, for example, that the stone at my feet will hold together when I grasp it with my hand, that it can be lifted by me from the ground by exerting a force with my arm, that it can be projected forward by exerting still more force with my arm while loosening my hand's hold on it, that it then will impact on the skull of the attacker in front of me instead of passing right through the skull, and so forth, all contributing to my action of picking up the stone to defend myself. A designer likewise concatenates a great many of such beliefs to come to a decision about how to construct a specific artifact. None of these beliefs is of a different sort than any of the commonplace beliefs that an arbitrary human being has concerning the surrounding world, nor is the final decision of a different sort.

It might be objected that what the designer and my distressed self are doing has to be described using the intentional idiom, but does not itself consist (partly) in applying it. This objection misfires, however. With the possible exception of low-level components, a designer will entertain, among the beliefs contributing to the design concept, beliefs about how the artifact-to-be will be handled and manipulated by its future users. Likewise I can decide to pick up a stone not to throw it at my attacker right away but to scare him off, ascribing to him similar beliefs about the stone, of what I can do with it and what it will do to him, as I entertain myself.

Instead of standing in opposition to it, the physical idiom is part and parcel of the intentional idiom, partly articulating the content of our own beliefs directly and partly articulating the content of the beliefs we ascribe to others, such that the two vocabularies can become thoroughly mixed ('I know that she believes that he claims that tomatoes are poisonous'; 'Leaving this cigarette butt here will make her believe that he has been here', and so forth).

The contribution of the physical as well as the (purely) intentional idioms in all our doings, in permanently shifting weights, is reflected in the fact that, rather then just two descriptions of artifacts – an intentional and a physical – we entertain a myriad of them, many of which contains elements of both vocabularies. What I have in front of me is a long metal blade, sharp as a knife, stuck in a polished piece of ivory; it is an instrument that will cut through most organic material when pressed upon the material; it is a knife; it is the knife my grandfather bought in Spain; it is the one thing that should never be sold while I live; it is a thing that will cut through human flesh without much force being necessary; it will be recognized as such by other people and is therefore fit to scare away intruders; it is a thing that scares me bit because someone has actually been killed with it; it is an instrument that must be handled with care because it easily slits through whatever contains it; it has often been wetted and is now markedly thinner than it originally was is; it is a thing that will be spoilt completely when put in a dishwasher; and so forth.

If an object is a technical artifact, in the sense of being designed for a purpose, or to be used for a purpose, then among these descriptions there is at least one that expresses this. If the design has been successful, that is, if the resulting artifact can be used for the purpose for which it was designed, there is a matching description that expresses this, and a matching description of the object's properties in virtue of which it can be so used. However, this description, or at least a very similar one, can also be true of an object that has not been designed for the purpose, or has not been designed at all. If the object is or has actually been used for this purpose, there is again a matching description. Any nomologically possible combination of these descriptions might apply to a particular object, but these combinations do not by far exhaust the set of all true descriptions of the object in question, nor the set of all descriptions that mix the physical and the intentional idiom.

On the other hand, it should be stressed that none of these descriptions is implied by the single, exhaustive 'purely physical' description of the object. This is so even for the description stating that the object can be used for the purpose y, provided this purpose is described non-intentionally as the realization of physical state y. The use of an object refers to the typical circumstances that obtain in the environment in which humans act, and to particular capabilities of the typical human user, and neither of these are contained in the physical description of the object itself. Only if the use made of the object can be specified in the form of a specific sequence of manipulations, described in purely physical terms, would such a 'useful for' claim be derivable from the physical description of the object.

The multiplicity of descriptions for the objects that play a role in our life is closely related to the multiplicity of valid descriptions for human actions. This is a

point emphasized by the philosopher Donald Davidson.[13] According to Davidson, the physical description of the world, including the world of man, sees it as made up of events, linked by causal relations. With respect to human life, these events are the movements of hand and feet, the contractions of muscles in the chest, the throat and the tongue, and the face. This is the dynamic extension of the static description in terms of material objects. Mirroring the fact that some of these objects play a role in human actions, some of these events are actions, meaning that another description is available for them, not in the language of cause and effect and natural laws, but in that of the intentional idiom. In this idiom they are described as intentional acts, originating in certain desires and in certain beliefs about the possible satisfaction of these desires. The pouting of the lips is the kissing of a friend, the intricate turning movements of arms and hands holding fast to various objects is the making of a cake, the intent staring at tiny black spots on a surface is the reading of a book. Crucial in Davidson's account is that never does only one intentional description fit the physical event. The kissing of the friend is also the congratulating her on her marriage; the making of the cake is also the killing of the husband with one of the ingredients, the reading of the book is also the preparation for next weeks exam. An act need not be intentional under all of the descriptions that apply to it. In fact it hardly ever is. The wife need not have intended to kill her husband; she only meant to make him ill for a time, or she did not know that poison was mixed in with one of the ingredients, or there was no poison but she did not know that her husband was extremely allergic to one of the more common ingredients.

Analogous to what was said above for the case of artifacts and objects used for a purpose, action descriptions are underdetermined by the physical description of the underlying event, and many different events can realize the same action. Striking forcefully at a log with a sharp object fastened to the end of a stick can be the action of chopping wood for the fireplace, or the action of venting anger, or the action of posing for a photo to be used in commercial advertising. Similarly, one can vent one's anger by striking away with one's axe, or by smashing plates against the wall, or by attacking the object of one's anger. Of course, action descriptions and physical descriptions of events mutually constrain each other, just as the physical properties of objects and the uses they can be put to mutually constrain each other. Having one's eyes fixed at a bundle of white sheets with black ink marks on them for an hour can be the action of reading a book, or of preparing for an exam; it cannot be the action of eating a sandwich.[14]

Davidson's account of actions can help us to understand why a designer cannot be seen as the 'owner' of the artifact designed by her, in the sense of being the one to determine what the artifact essentially *is*. The designing of an artifact is an

[13] Davidson (1980), especially essays 8–10.

[14] An analysis of these constraints is, of course, an important topic of research for the philosophy of action and for the philosophy and methodology of engineering. It is not, however, a subject that belongs in the present contribution, which focuses on conceptual and metaphysical issues, nor could I even remotely do justice to it in this limited space.

intentional action. A purely physical description of this event lists the movement of fingers, hands, feet, and, most of all, the firing of brain cells, and additionally the appearance of light patterns on computer screens, of patterns of zero-type voltage and one-type voltage in computer memories, and of ink marks on sheets of paper. This is the least interesting description of all. Another description, the one favored, presumably, by the designer herself, is that of the designing of a new game console: but if that game console is going to blow the mind of many a young fellow, then designing such a device is also something she did, at precisely that moment. If the console, after having been banned by most governments, finds wide application as an instrument of torture in the murky police stations of several Central-Asian countries, then designing an instrument of torture is also something the designer did, at that same moment. Of course, designing an instrument of torture is not something the designer did intentionally, but it is something she *did*, since her action was intentional under some description.

There are no general criteria that can designate one of these descriptions is being more accurate, or more 'true', than another. It is a matter of convenience, or convention, which one is singled out for the identification of the designed artifact. This extends to the way malfunctioning artifacts are described. Some authors, taking their point of departure in the system-function account of Cummins, hold that an object that does not have the physical capacity to show the behavior required for a particular purpose is *ipso facto* not a specimen of the functional kind associated with that purpose.[15] Suppose that another designer designs a new television and, due to a mistaken specification, in all manufactured products a specific components blow immediately after being connected to the socket. On the system-function account, these objects would not be television sets. However, to conclude that designing a television set was not what this designer did seems counterintuitive. Attempts at repair that let the designer be "under the impression that he is designing a television set" or "imagining himself to be designing a television set" seem contrived. Here as well, convenience and convention come in to play to say how much an object's physical properties and design history may deviate from an operational device for its classification as a particular functional kind to be justified.

Let me not be misunderstood, in thus setting limits to the role of the designing engineer in determining what an artifact is, in my view concerning the activity of technical design. What designers and engineers do is, technically, very different from what ordinary people do, even when tinkering. The amount of knowledge, the sources of this knowledge, the testing, redesigning, and retesting are all absent from everyday life. Metaphysically, however, technical artifacts and the act of designing them do not pose any challenges that have not already been with us, or at least with the philosophically inclined among us, since before the Stone Age.

[15] For biological functions, see, e.g., Wouters (2005) and Davies (2001). For technical functions, see, e.g., Thomasson (2003).

References

Cummins, R., 1975, Functional analysis, *J. Phil.* **72**:741–764.

Davidson, D., 1980, *Essays on Actions and Events*, Oxford University Press, Oxford.

Davies, P. S., 2001, *Norms of Nature*, MIT Press, Cambridge, MA.

Franssen, M., 2006, The normativity of artifacts, *Stud. Hist. Phil. Sci.* **37**:42–57.

Franssen, M., 2008, The inherent normativity of functions in biology and technology, in: *Functions and More: Comparative Philosophy of Technical Artifacts and Biological Organisms, Vienna Series in Theoretical Biology*, U. Krohs and P.A. Kroes, eds., MIT Press, Cambridge, MA., forthcoming.

Houkes, W., 2006, Knowledge of artifact functions, *Stud. Hist. Phil. Sci.* **37**:102–113.

Houkes, W., Vermaas, P. E., Dorst, C., and de Vries, M. J., 2002, Design and use as plans: an action-theoretic account, *Des. Stud.* **23**:303–320.

Kroes, P., and Meijers, A., 2006, The dual nature of technical artifacts, *Stud. Hist. Phil. Sci.* **37**:1–4 (introduction to a special issue).

Millikan, R. G., 1984, *Language, Thought, and Other Biological Categories*, MIT Press, Cambridge, MA.

Parfit, D., 1984, *Reasons and Persons*, Oxford University Press, Oxford.

Preston, B., 1998, Why is a wing like a spoon? a pluralist theory of function., *J. Phil.* **95**:215–254.

Thomasson, A. L., 2003, Realism and human kinds, *Phil. Phen. Res.* **67**:580–609.

Vermaas, P. E., and Houkes, W. N., 2003, Ascribing functions to technical artifacts: a challenge to etiological accounts of functions. *Brit. J. Phil. Sci.* **54**:261–289.

Wouters, A., 2005, The function debate in philosophy, *Act. Biotheor.* **53**:123–151.

Designing is the Construction of Use Plans

Wybo Houkes

Abstract In this chapter, I argue for an intentionalist reconstruction of artifact design, called the "use-plan analysis." In it, design crucially involves the construction and communication of a use plan. After presenting an outline of the use-plan analysis, I show that it can be used to accommodate four aspects of the phenomenology of artifact use and design: creative use, serendipity, the unread manual, and unknown designers; and I briefly indicate how the analysis facilitates the evaluation of artifact use and design. From this, I conclude that the use-plan analysis provides a phenomenologically viable, evaluatively useful, intentionalist account of use and design.

1 Introduction

Designing is of vital importance for every human society – from early tool-users to heavily technology-dependent contemporary societies. The products of designing range from skyscrapers to microchips and weather satellites to wicker baskets. Yet accounts of design, especially within analytical philosophy, are as rare as Siberian tigers – and not nearly as actively searched out.

In this contribution, I do not aim to set this straight by giving a complete analysis, let alone a clear-cut definition of designing. Instead, I present a framework for understanding at least one important type of designing, namely that of run-of-the-mill consumer utensils, such as cars and toothbrushes. This use-plan analysis starts from the seemingly trivial observation that designing is, like scientific research or swimming, an activity. One may therefore apply to designing resources drawn from one branch of analytical philosophy, namely philosophy of action. This discipline is mainly concerned with understanding *intentional* actions, i.e., actions that express purposefulness and deliberation.

W. Houkes, Eindhoven University of Technology

P. E. Vermaas et al. (eds.), *Philosophy and Design.*
© Springer 2008

I present in section 2 an analysis of designing, and, more cursorily, using, as an intentional action involving *use plans* for material objects. Here I aim at clarity and conciseness, not at completeness. Many details of the use-plan analysis, developed in close cooperation with Pieter Vermaas, and of its application are omitted here and can be found elsewhere (Houkes et al., 2002; Houkes and Vermaas, 2004; Vermaas and Houkes, 2006; Houkes and Vermaas, 2006).

The presentation is followed by a preliminary assessment of the use-plan analysis, again aimed at clarity rather than completeness. In section 3, I show how the use-plan analysis provides a phenomenologically viable framework for understanding designing by accommodating four aspects of artifact design and use. These aspects are presented as criticisms, because they appear to offer grounds for objections against the use-plan analysis, and for accepting alternative accounts. I then show the phenomenological mettle of the use-plan analysis by responding to all four criticisms. Some of these responses show, in addition, the primary advantage of the use-plan analysis, namely that it may be employed to evaluate using and designing. In section 4, I briefly sum up these evaluative features, and I conclude that the use-plan analysis provides a phenomenologically viable, evaluatively useful, intentionalist account of designing.

2 The Use-Plan Analysis of Designing

The use-plan analysis of designing is an action-theoretical account developed by Pieter Vermaas and myself and presented in several publications (Houkes et al., 2002; Houkes and Vermaas, 2004; Vermaas and Houkes, 2006; Houkes and Vermaas, 2006).[1] Central to this analysis is the notion of a use plan for an artifact: a series of actions, including deliberate manipulations of the artifact which are considered by an agent for achieving a certain goal.

As an example, consider a prototypical designed object or artifact: a car. Driving a car is an activity that is typically purposeful and that always involves several contributory actions. These actions may be rather trivial, such as sitting in the driver's seat, or relatively complicated, such as operating the clutch. Yet several such actions are involved in driving a car. Moreover, this set of actions is typically structured as an ordering. Some actions, such as fastening one's seat belt and checking the fuel level, may be taken in any order; other actions, however, such as engaging the clutch and shifting gears, need to be taken in strict succession. Actions when driving a car may be conditional for other actions and conditioned by other actions: one has to open a car door to switch on the radio, which in turn enables the selection of a different radio station. That the actions comprised by driving are structured as orderings, partial or complete, and by conditionals means that driving can be understood in

[1] The use-plan analysis is similar to at least one characterization found in design methodology (Hubka and Eder, 1998) and resembles others (e.g., Roozenburg and Eekels, 1995). For lack of space, neither these similarities nor the equally significant differences will be discussed here.

terms of a plan – a structured, temporally extended series of (considered) actions.[2] Many plans, but not all, involve deliberate manipulations of material objects other than our own bodies. Such plans may be called *use plans* for these objects. Thus, the typical series of actions starting with opening a car door and leading to the release of the hand brake may be called the use plan of a car, but also of a car door and a hand brake, and perhaps of the engine and the spark plugs. In contrast, walking through a park may involve a plan, e.g., for meeting people, but analyzing this activity as involving a use plan for the grass would make the notion of a use plan virtually all-encompassing and therefore uninteresting. Whether use plans can be distinguished from plans in general in any precise way need not concern us here.

Of more interest is the source of the structure of use plans: *why* do some actions in driving a car need to be taken in strict succession, whereas the order of other actions is arbitrary? It may be difficult to recognize this as a genuine question, mainly because the answer is so obvious: if some actions are taken in a different order, one has little hope of achieving the goal of driving one's car, whereas the order of other actions is irrelevant for achieving this goal. Thus, the structure of the use plan for an artifact ultimately depends on the goal to which using the artifact is supposed to contribute. If you want to use a car for driving, releasing the hand brake at some point, but not too soon, is crucial; if you only want to listen to the car radio in your garage, releasing the hand brake is at best unnecessary.

Borrowing a term from philosophical action theory, the structure of use plans may be said to depend on *practical rationality*,[3] a value that encompasses at least effectiveness and efficiency. Some, but certainly not all structure of plans derives from this value. Opening the door for a passenger before opening the driver's door may be necessary to be a polite driver, but it is hardly needed to be an effective driver. Similarly, fastening the seat belt before setting the car into motion may be required for safe driving, but it does not improve the effectiveness of one's driving. As a first approximation, the use-plan analysis does not include values such as safety and politeness. Use plans are sufficiently structured by effectiveness and efficiency alone to warrant this approximation for the moment.

As may be clear from the above, using an artifact can be characterized as executing a use plan for that artifact. Thus, you use a car when you execute the typical plan of opening the door, starting the engine, releasing the hand brake, etc.; but baking an egg on your car's bonnet in the center of Death Valley also counts as use of a car, although an atypical use plan is executed.

Characterizing designing in terms of use plans is marginally more complicated. On the use-plan analysis, designing primarily and necessarily involves constructing a use plan and communicating this plan to other agents.[4] Thus, designing is the

[2] See Bratman (1987) and Pollock (1995) for general action-theoretical analyses of plans.

[3] "Practical rationality" is only one of a number of semi-technical terms introduced by philosophers to analyze reasoning that is related to actions rather than beliefs. "Instrumental rationality" and "means-end rationality" are other terms. For the purposes of this chapter, the various terms are mutually substitutable: their differences (if any) are too fine-grained to matter.

[4] A designer might only communicate the use plan to him- or herself by committing the plan to memory. Such "personal" designing is a borderline case of the use-plan analysis.

source of the use plans available to agents in a community: designers think up use-plans and communicate them, typically to other agents, to help these agents to achieve their (the other agents') goals. Schematically, designing starts with a goal; after which a use plan, consisting of an ordered sequence of actions by which the goal can be achieved, is developed and communicated. Typically the plan includes manipulations of artificial objects. And typically some of the objects to be manipulated do not yet exist, in which case the designers go on to describe the objects concerned and the way in which they can be manufactured. The latter activity may be called *product designing*, which is nested within a broader activity called *plan designing* (Houkes et al., 2002). This analysis emphasizes the "instrumental" or "goal-oriented" aspect of designing over its "productive" or "object-oriented" aspect. Product designing is secondary, since the product is selected or described for its role in executing the plan, and it is optional, since an agent who constructs a use plan that only involves existing artifacts and/or natural objects satisfies all conditions for (plan) designing. Thus, labeling an activity "designing" generally presupposes the existence of a use plan and a group of prospective users.

The emphasis on plans over production carries over to the interaction between designers and users. The goal of designing is to assist users in achieving their goals; to this effect, designers construct use-plans that may be executed by users and, possibly, previously non-existent objects to be manipulated. To achieve their goal of assisting users, designers should not merely hand over these objects – and they usually do not. Typically, new artifacts come in boxes and wrappings accompanied by handbooks with pictures and texts, which communicate how the artifacts are to be used and for what purpose, or vendors, trainers, and commercials may show how artifacts should be used. This is readily explained by the use-plan analysis. In it, designers need to communicate the actions and goals that constitute the plan, unless the use-plan may be assumed to be familiar to the potential users. Without implicit or explicit communication of the plan, designing fails to be of assistance to others, and can be evaluated as (practically) irrational.

Before closing this brief overview, two remarks are in order.

One, the use-plan analysis is intentionalist in the sense that it refers explicitly to the mental states, beliefs, desires, and/or intentions, of designers and users; in executing a use plan, users act more or less "in accordance with" designer intentions. Intentionalist analyses of use, design, and artifact functions have several major problems, including the indeterminacy of intentions.[5] It is, for instance, unclear whether users act "in accordance with" designer's intentions by merely buying their products. The use-plan analysis overcomes these problems by focusing on more structured mental states, namely plans, which have a broad belief base, and by requiring communication of these plans.

[5] Naïve intentionalism regarding using and designing may be a polemical starting point for anti-intentionalist accounts rather than a position held by actual persons. Intentionalist analyses of artifact functions are found in, e.g., Neander (1991) and McLaughlin (2001); Vermaas and Houkes (2006) identify problems for such analyses and develop a use-plan analysis of functions to solve these problems.

Two, the use-plan analysis is primarily a reconstruction that retrospectively models the beliefs held by, the decisions made by, and the actions taken by a rational designer, in order to satisfy the standards of practical rationality. In doing this, the use-plan analysis ignores many aspects of actual designing: among other things, it does not consider the interaction between designers and manufacturers; it merely touches upon the role of safety regulations and standards in designing; and it has nothing to say about teamwork in designing. This is not to say, however, that the analysis is completely insensitive to the phenomenology of using and designing, as I will show in the next section.

3 Accounting for Actual Use and Design

In this section, I consider four objections against the use-plan analysis. All of these objections are inspired by the phenomenology of artifact use and design, and by existing anti-intentionalist accounts of these activities, philosophical or otherwise. However, for the sake of clarity, I have schematized and increased the critical portent of the phenomena discussed to such an extent that the objections only resemble points raised in the literature; I have largely omitted references to avoid possible straw-man fallacies. The goal of this section is, in any case, not to polemicize against existing or possible anti-intentionalist accounts, but to show how the use-plan analysis provides a phenomenologically viable framework for understanding designing.

3.1 Creative Use

It may be objected against any account of artifact use that centers on designer's intentions, that actual use is not necessarily or even typically related to the efforts of designers (e.g., Preston, 2003). In many cases, users have invented new ways to use existing artifacts, have modified the artifacts accordingly, and have communicated alleged successes to others. Examples range from the rustic to the revolting: the use of beer to keep slugs from eating garden vegetables has been discovered and communicated by various gardeners, and is currently promoted by organic gardeners, not by any brewing company; and it is unlikely that any airplane manufacturer imagined, let alone promoted the idea, that some of its products could be used as flying bombs as in the 9/11 terrorist attacks.

In all of these cases, part of the use-plan analysis applies: agents construct and communicate use plans, which may then be executed or rejected by others, for instance on the basis of their effectiveness. Yet the plan-constructing agents are not designers, but users. Thus, the objection targets the use-plan analysis insofar as it exclusively reserves plan construction for designers, which it does explicitly.

Phrased in this way, the objection may immediately be turned into a response. Creative use does not show that designer's intentions are irrelevant for actual use. Instead, it shows that agents who typically use artifacts can occasionally, or even regularly, be designers, i.e., the constructors and communicators of use plans. The use-plan analysis concerns *roles*, and does not make any claims about which agents may play these roles. Just as agents engaged in designing, say civil engineers, are typically also engaged in using artifacts, for example when driving to their work or brushing their teeth, so agents who are typically engaged in using can occasionally or regularly engage in designing. In the examples given above, the creative users were designers by definition: in constructing and communicating a use plan, they have fulfilled all the conditions for playing this role.

This does not mean, however, that there is no distinction between agents who occasionally engage in designing and those who do so on a daily basis. Apart from relevant experience and expertise, which may improve the quality of the designed use plans, it is an elementary social fact that some agents are *professionally* engaged in designing, and other agents are not. Contemporary societies are characterized by a multitude of divisions of labors and specializations; that between professional designers and, for want of a better term, "consumers" is one such division. This social mechanism does not make designing by consumers impossible; it does not make the use plans produced by professional designers rational by definition; and it does not preclude "consumer designers" from producing rational use plans. However, the distinction between professional and non-professional designers shows up in several normative notions, such as that of "improper" use, which serve to privilege – socially and legally, if not rationally – some use plans over others. These notions, and the tension between the rational reconstruction and the social mechanism, form the backbone of the use-plan analysis as an evaluative framework for artifact use and design. In section 4, I list the basic elements of this evaluative framework, and indicate some further ramifications.[6]

3.2 Serendipity

Another objection may target the description of the design process given in section 2. Actual designing is not a linear process. Designers do not start with a user goal, which is then translated into specifications, which are subsequently and successively satisfied by constructing a use plan or a material object with particular physical features. In reality, designers switch back and forth between specifications, plan

[6] Many anti-intentionalist accounts of artifact use and design, most notably constructivist accounts in Science and Technology Studies, lack evaluative notions such as "expertise" and "properness", or lack ways of relating such notions to values such as practical rationality. Recently, a similar lack has been noted by prominent researchers in this tradition, most notably Collins and Evans (2003).

designing and product designing, continuously reframing the problem that they are trying to solve, testing solutions in various stages of development, etc.[7] Here, I consider only one way in which the use-plan analysis may fail to match design practice; the response to this criticism also applies to many other alleged failures.

In some cases, the end product of designing does not satisfy its original goal, but it may be successful nonetheless. One familiar example of such an "unplanned product" is a type of glue, developed by Spencer Silver, which did not turn out to be the looked-for strong adhesive, but a very weak one. This unsuccessful product was later, and by another designer, found to be very effective for another application, namely for removable self-stick notes, and so effective that it became the basis for one of the most successful office products of recent times.

These serendipity effects in designing seem to undermine the intentionalist basis of the use-plan analysis. The end product has only a tenuous relation to the original designer's intentions: the product does not turn out to be what the designer expected. Still, these unintended products exist, they are successfully marketed and used, and they may be as common as "as-predicted" products.

In response, it should be noted that serendipity only undermines some naïve intentionalist accounts, namely those which emphasize a designer's *original* intentions. There is no need for an intentionalist account of designing to be this restrictive: as long as there is a clear basis for selecting some mental states of the designer, or other agents, as focal points of the analysis, intentions may change. The basis for determining the relevant intentions for the use-plan analysis, is provided by the requirement of communication: different use plans may have been constructed, or just entertained, at different points in the actual design process, but only communicated use plans add to the resources available to users. These users may be, and in the case of components typically are, designers of other artifacts (Vermaas, 2006).

In the self-stick notes case, the use-plan in which Silver's material was to be a type of glue *was* communicated, and it provided the basis for evaluating the material as a failure. Then, a different use plan was constructed, in which the existing material played a different role; this plan was effective, and it was communicated to users of the end product, namely self-stick removable notes. Both the construction of the "glue" plan and the material, and that of the "self-stick removable" plan count as designing on the use-plan analysis; the plans can be easily distinguished, and they explain the change in the evaluation of the product. That one component of reusable self-stick notes was previously an unsuccessful type of glue is irrelevant for evaluating its use for these notes.

[7] There is a rich body of literature in design methodology that tries to represent designing as (very loopy) flowcharts. The phenomenology of designing suggests that any such chart is an impoverished representation, because of the reframing described in the main text; see, e.g., Schön (1987) and Bucciarelli (1994) for examples from various types of engineering design.

3.3 The Unread Manual

Following up on the serendipity response, one may target the communicative aspect of the use-plan analysis. In this analysis, designer's intentions – structured as a use plan – are the content of some communicative act, meant to address the community of users. Perhaps this account may be developed in sufficient detail, for instance by applying a Gricean theory of communication. But this, so the objection goes, would be a waste of effort. Even if designers attempt to communicate their intentions or plans clearly, and if this communication can be analyzed in some sophisticated manner, no user is interested anyway. Studies into user behavior show time and again that users do not read manuals or pay much attention to any other form of elaborate verbal communication. Yet if use plans are such extensively structured patterns of action, elaborate verbal communication seems to be the only way to communicate them. So whatever analysis is chosen for the communicative actions of designers, it is inappropriate. No-one is listening on the other side of the line.

This objection may be strengthened by a positive account of artifact use and design. Users do not need to pay attention to the communicative efforts of designers, because they already know how to use the vast majority of artifacts that they encounter. Beds, teapots, toast, and newspapers – to give some examples from daybreak onwards – do not come with manuals, nor do users often consult any other information regarding their use. All of these artifacts play their role in an existing, well-established practice. Designers seem to have little freedom to deviate from these practices: designing is not just constrained by physical (im)possibilities, standards and regulations, it is also constrained by traditional patterns of use. For many artifacts, especially simple ones such as teapots and toothbrushes, designers seem to have little choice but to adopt the familiar use plan, because users will execute this plan anyway.

In combination, unread manuals and inflexible existing practices suggest that communicating a use plans is like trying to steer a whale: the only way to pretend one has achieved success and to avoid frustration is to follow the whale's lead and direct it to where it was headed anyway. The use-plan analysis appears to ascribe to designers an unrealistic amount of freedom and authority.

The response is two-sided. First, it may be pointed out that designers are much more effective, and creative, in communicating their use plans to users than suggested above. Manuals are far from the only communication means available, and designers actively search for ever more effective means to promote or discourage user behavior. Commercials and advertisements often focus on the novel features of artifacts, and show users employing these features – which is a clever way of communicating changes or additions to the traditional use plan. Many products guide user behavior by their designed physical features, in ways that the users may not even be aware of.[8] Of course, users can ignore this communication and continue

[8] Well-known examples are speed bumps and the heavy hotel key described by Latour (1991).

to use an artifact in the established way, or refuse to use a novel artifact. But these failures do not detract from the many successful communications of new use plans: most people in fact use their car or toaster exactly as described in the manual.

This leaves the steering-the-whale point untouched. Perhaps designers just follow the users' lead and (superfluously) communicate the traditional use plan. However, the source of the use plans communicated by the designers, and their success in changing user behavior, is not of primary importance to the use-plan analysis. What matters is the justification and communication of these plans: designers should guarantee the rationality of the plans, meaning that they could, in principle, underwrite and endorse existing plans with some small changes.[9] This may decrease the practical impact of their communicative efforts, but it does not affect their evaluative relevance. If an artifact fails to work as expected, and a user complains to the manufacturer, the latter may in some cases point out that the user failed to conform to changes in the use plan. Suppose, for instance, that someone trades in her old car for a new type, exactly the same as the old apart from its being outfitted with a catalytic converter. The driver uses the car exactly as her old one, including filling it with leaded fuel. If she then would complain to the car dealer, after some time, about the poor performance of the car, it might be pointed out to her that she used the car incorrectly: she should have changed her use plan to one that included filling the tank with unleaded fuel, because the use of leaded fuel clogged the converter and reduced the performance of the car.

That poor performance, related to changes in the use plan, may be blamed on the user does not, of course, discharge designers and manufacturers from the responsibility of communicating such changes to the users: if the car owner described above had no way of knowing that she was to use unleaded fuel, she cannot be blamed for the poor performance of her car. However, that designers have this communicative responsibility vindicates the use-plan analysis instead of undermining it.[10]

3.4 Unknown Designers

Many artifacts, such as camera cell phones, are state-of-the-art gadgets. These are typically manufactured by companies that clearly communicate, and legally protect, the origins of the artifacts and their use plans. Yet the origins of many other artifacts

[9] An agent who adopts an existing use plan and communicates it without making any changes in either the plan or the artifacts involved is not a designer, neither intuitively nor on the use-plan analysis.

[10] Real-life cases are considerably more complicated than suggested by either the use-plan analysis as described here, or by accounts that emphasize the inertia of practices. Take, for instance, recent lawsuits regarding certain types of "light" cigarettes. Here, the responsibility of manufacturers to communicate that these cigarettes are as detrimental to the smoker's health as other types must be weighed against the responsibility of users to care for their own health, common knowledge regarding the effects of smoking, etc. The use-plan analysis may provide a framework for analyzing such cases; it does not offer an easy way to make decisions regarding them.

and plans are less well advertised. Pots, rafts, and hairpins have seen scores of generations of use, and were undoubtedly designed first by some agent or, possibly, by several agents simultaneously. But archaeology is not an exact science in the sense that it can pinpoint the precise moment and the identity and intentions of the original designer of these time-honored utensils.

More importantly, establishing these facts may be of historical interest, but it is irrelevant from a practical perspective. Some of us know how to use rafts, for various purposes, and they know how to instruct others in their use, wherever, whenever and by whomever rafts were originally designed. Neither the designer's identity nor his or her intentions appear to have any relevance for evaluating and understanding the existing practice of rafting.[11] And the reason is not that the designer's intentions are as yet unknown, but that they would be irrelevant even if they were somehow revealed.

There are two reasons why this observation about artifact use may be acknowledged without giving up intentionalism. One is a phenomenon that might be called epistemic or evaluative screening. Throughout history, people have used pots, rafts, and hairpins, often successfully and sometimes unsuccessfully. Such successful use provides evidence for the rationality of a use plan, evidence that is at least as strong as the considerations that might have guided the designer (Houkes, 2006). This means that, as far as the quality of the use plan is concerned, the designer's communications have become largely irrelevant. Initially, users might have relied on the designer's word that using an artifact in a certain way would be effective, but this testimonial evidence has been supplemented and replaced by the experience of users. However, as long as the executed use plan matches the designed one, the original communication still determines the use of the artifact, and the evaluation of this use, albeit indirectly. Of course, generations of users will typically change the way of using traditional artifacts; but this creative-use phenomenon was already found not to undermine intentionalism.[12]

There is another reason why unknown designers do not threaten use-plan intentionalism. Toothbrushes, to give one example, have been in use for some time. Yet most people do not use a toothbrush that has been passed down the generations. This "paradox" is easily resolved by distinguishing an artifact type from individual artifact tokens: I bought the token standing in a glass in my bathroom some months ago, while the type has been in existence for a significantly longer time. And distinctions do not end there. In any well-stocked drugstore or supermarket, you have a choice between several types of toothbrushes. These may differ in the stiffness of their hairs (ranging from "soft", through "medium", to "hard"); they may or may not have an adjustable head; they come in different age categories (ranging from

[11] This argument suggests an anti-intentionalist account of the history of technology that stresses the way in which practices of artifact use have gradually emerged, stabilized, adapted and/or disappeared in the course of time. Such accounts of the history of technology often take an evolutionist form (see, e.g., Basalla, 1988).

[12] Note that, if the user of an artifact constructs and communicates a different use plan, she counts as a designer, but her testimonial evidence is, again, rapidly screened-off and replaced by user experience with the new use plan.

"baby" to "adult") and in different colors. And for any of these varieties, several brands may be available. Not all of these differences affect the use of the tooth-brush: you may just as effectively use a yellow one as a red one. Yet some differences are relevant: brushing a baby's teeth with a hard adult brush is assumed to damage the baby's newly formed enamel, which makes brushing ineffective in the long run. Thus, there is a practically relevant distinction between toothbrushes as a general *kind*, several *types* of toothbrushes currently available, and individual *tokens* bought and used by consumers. The unknown-designer phenomenon is only promi-nent on the level of (some) artifact kinds; it does not, in general, apply to artifact types. For each type available in stores, its origin is clear: there is a manufacturer who communicates the use plan of this toothbrush-type and who takes responsibility for the rationality of this plan.

Thus, the unknown-designer phenomenon is accounted for in different ways, on different levels: at the level of artifact kinds, its impact is minimized by pointing out the effects of epistemic and evaluative screening-off, which show that designer's intentions are not irrelevant, but just screened off by supplementary sources of evidence. At the level of artifact types and tokens, the phenomenon was argued not to play a large role, designer's and manufacturer's intentions are communicated and they are evaluatively relevant.

4 An Evaluative Conclusion

In this chapter, I have presented the use-plan analysis of artifact use and design. In this use-plan analysis, design crucially involves the construction and communication of a use plan. I have argued that the use-plan analysis is intentionalist: it emphasizes the mental states of designers and users in reconstructing their activities. Furthermore, I have shown how the use-plan analysis can accommodate four aspects of the phenomenology of artifact use and design that, at first glance, appear to ground objections to it: creative use, serendipity, the unread manual, and unknown designers.

Furthermore, I have indicated that the analysis provides a framework for evaluating artifact use and design. As presented here, this framework rests upon three evalua-tive notions: rationality, properness, and expertise. The central element is practical rationality. Plans can be evaluated in terms of their rationality, and because use and design can be analyzed in terms of plans, the standards of rationality also apply to those actions. The value of rationality is hardly comprehensive, since designing and using are not evaluated just in terms of effectiveness and efficiency; other values, such as safety and durability, have not been addressed in this paper. A value that *was* covered earlier is the notion of (im)proper use. This value cannot be derived from that of rationality: on the use-plan analysis, any use plan that answers to the standards of practical rationality is 'acceptable' in the important sense of being effective and efficient. One can, however, add to the evaluative framework a distinction between professional and non-professional (re-)designing. As described in section 3.1,

this distinction reflects a division of labour that exists in most contemporary societies. Thus, use plans constructed by professional designers are socially and legally privileged over those constructed by non-professional designers although, again, improper use, based on "non-professional" plans, may be highly effective. By adding a third element, one may go beyond treating the division of labour as a brute social fact: one may take professional designers as experts. Yet on the use-plan analysis, their expertise does not primarily concern products, but rather ways of effectively realizing goals. That professional designers are often taken as experts is shown by reliance on their testimony: when asked why they believe that a new car can be used effectively for personal transportation, most people would probably reply that it has been designed for this purpose. Typically, this expertise becomes superfluous after a while: when someone is asked why she believes that her five-year old car can be used effectively for personal transportation, she would probably refer to her own experience in using it rather than to its being designed for transportation purposes. This change in evidence indicates that the relation between designers and users is not merely social, but social-epistemic (Houkes, 2006), and therefore an appropriate topic for further evaluative inquiry.

The evaluative framework presented above is far from complete, but it does contain several notions that are practically relevant and that cannot be found in other philosophical analyses of designing. Therefore, I conclude that the use-plan analysis provides a phenomenologically viable and evaluatively useful account of artifact use and design, in which intentions play a vital role.

References

Basalla, G., 1988, *The Evolution of Technology*, Cambridge University Press, Cambridge.

Bratman, M., 1987, *Intentions, Plans and Practical Reasons*, Harvard University Press, Cambridge, MA.

Bucciarelli, L. L., 1994, *Designing Engineers*, MIT Press, Cambridge, MA.

Collins, H. M., and Evans, R., 2003, The third wave of science studies: studies of expertise and experience, *Soc. Stud. Sci.* **32**:235–296.

Houkes, W., 2006, Knowledge of artifact functions, *Stud. Hist. Phil. Sci.* **37**:102–113.

Houkes, W., Vermaas, P. E., Dorst, K., and de Vries, M. J., 2002, Design and use as plans: an action-theoretical account, *Des. Stud.* **23**:303–320.

Houkes, W., and Vermaas, P. E., 2004, Actions versus functions: a plea for an alternative metaphysics of artefacts, *Monist* **87**:52–71.

Houkes, W., and Vermaas, P. E., 2006, Planning behavior: technical design as design of use plans, in: *User Behavior and Technology Development*, P. P. C. C. Verbeek and A. F. L. Slob, eds., Springer, Dordrecht, pp. 203–210.

Hubka, V., and Eder, W. E., 1998, *Theory of Technical Systems: A Total Concept Theory for Engineering Design*, Springer, Berlin.

Latour, B., 1991, Technology is society made durable, in: *A Sociology of Monsters: Essays on Power, Technology and Domination*, J. Law, ed., Routledge, London, pp. 103–131.

McLaughlin, P., 2001, *What Functions Explain*, Cambridge University Press, Cambridge.

Neander, K., 1991, The teleological notion of 'function', *Aust. J. Phil.* **69**:454–468.

Pollock, J., 1995, *Cognitive Carpentry: A Blueprint for How to Build A Person*, MIT Press, Cambridge, MA.

Preston, B., 2003, Of marigold beer: a reply to Vermaas and Houkes, *Brit. J. Phil. Sci.* **54**:601–612.

Roozenburg, N. F. M., and Eekels, J., 1995, *Product Design: Fundamentals and Methods*, John Wiley & Sons, Chichester.

Schön, D. A., 1987, *Educating the Reflective Practitioner*, Basic Books, New York.

Vermaas, P. E., and Houkes, W., 2006, Technical functions: a drawbridge between the intentional and structural natures of technical artifacts, *Stud. Hist. Phil. Sci.* **37**:5–18.

Vermaas, P. E., 2006, The physical connection: engineering function ascriptions to technical artefacts and their components, *Stud. Hist. Phil. Sci.* **37**:62–75.

The Designer Fallacy and Technological Imagination

Don Ihde

Abstract Most literary critics have abandoned the notion that the meaning of a text lies in the intention of the author and have called this the "intentional fallacy." I hold that there is a parallel found in many interpretations of technology design and call it the "designer fallacy." This chapter, through examining a wide series of historical technology designs, deconstructs the utility of a simple designer-plastic material-ultimate use model and suggests that one must take into account unintended uses and consequences, the constraints and potentials of materiality, and cultural contexts, which often are complex and multistable. I outline a complex, interactive account of design interpretation.

Earlier in the 20th century, literary theorists developed the notion of an "intentional fallacy." This was the notion that the meaning of a text lay with the author's intentions – if these could be uncovered, then the meaning of the text was established. One can easily see how, if this is the only true way to establish meaning, there could be difficulties. What if the author was long dead? Or, even if living, how could one tell that the author was himself or herself telling the truth? What of unintended meanings, or meanings which fit but were not thought of in advance? Thus, the intentional fallacy recognizes such difficulties and cannot be considered an adequate account of interpretation.

I hold that there is a parallel 'fallacy' which is at least implicit in the history of technology design. In simple form, the "designer fallacy," as I shall call it, is the notion that a designer can design into a technology, its purposes and uses. In turn, this fallacy implies some degree of material neutrality or plasticity in the object, over which the designer has control. In short, the designer fallacy is 'deistic' in its 18th century sense, that the designer-god, working with plastic material, creates a machine or artifact which seems 'intelligent' by design – and performs in its designed way. Instead, I hold, the design process operates in very different ways, ways which imply a much more complex set of inter-relations between any designer, the materials which make the technology possible, and the uses to which

D. Ihde, Stony Brook University

P. E. Vermaas et al. (eds.), *Philosophy and Design.*
© Springer 2008

any technologies may be put. Ultimately I am after a deconstruction of the individualistic notion of design which permeates both the literary and technological versions of the fallacy. First, some examples of simple designer fallacies: Thomas Edison, the great late 19th-early 20th century American inventor, was among the first to design and invent a machine to reproduce sounds – the phonograph. The machine, at first, was a mechanical device which consisted of a speaking tube into which someone would speak; this was attached to a sensitive diaphragm which would reverberate with the sound waves coming into the tube and the diaphragm, in turn, was connected to a crystal needle which would trace the wave patterns onto a rotating roll covered with tinfoil. As the crank was turned, the speaker sounding into the tube, a 'record' was made on the foil. The same machine, played back, would reverse the process and one could hear, well enough to understand and recognize the sounds, originally inscribed on the roller – "Mary had a little lamb...." (Nyre, 2003, 89–90)

Here, the designer intent was to reproduce sounds. But the intent, at this stage, remained ambiguous and the primary possible use of this machine was drawn from the resultant capacities which emerged, more than from any pre-planned single use. It could be a rather primitive dictation machine. Clearly, it would have restricted use since the number of play-backs was very limited due to the softness of the foil – the play-back would remain intelligible for only one or two times. In spite of this, the machine was advertised in the typically glowing rhetoric of technological promise of the late 19th century. It was advertised as "The miracle of the 19th Century," a machine that speaks:

> It will Talk, Sing, Laugh, Crow, Whistle, Repeat cornet solos, imitating the Human Voice, enunciating and pronouncing every word perfectly, IN EVERY KNOWN LANGUAGE." (Nyre, 2003, 89)

If one, with the anachronistic insight of knowing anything about the subsequent history of recordings, read back to Edison's early machines, one might have predicted that one early dominant use of recording devices would quickly evolve into music recording, which in turn, also transformed a number of musical practices. For example, early recording devices could record for only three and a half to four minutes of time – thus the music played must be three and a half to four minutes long, a traditional length for the 'popular song' which persisted well past the time of early recording devices. The new machine calls for new practices, but in this case not 'intended' ones.

The phonograph came later than the telephone, invented at least once by Alexander Graham Bell. Here the designer intent was for an amplifying device capable of transmitting a voice over distance, and intended as a prosthetic technology for the hard-of-hearing (Bell's mother). The early antecedent of "chat" on the internet, the party line on which all the neighbors 'chatted' was not foreseen, let alone the subsequent telephone wiring of early 20th century America.

Even the typewriter was first designed as a prosthetic technology aiding blind or myopic people by allowing them to produce clear script. Instead, as Friedrich Kittler has pointed out, the typewriter become, dominantly, a business machine and one which transformed the secretary of the late 19th century from male to female

(male secretaries often refused to adopt to this 'machine' which they thought deskilled their handwork, but young women, seeking both a public role and pre-skilled with keyboard or piano skills, easily found a new role)! (Kittler, 1990) The designer fallacy also plays a role in Langdon Winner's best-known story, "Do artifacts have politics?" (1986). This article traces the history of Robert Moses' designs for the bridges over the parkways of Long Island. Winner claims that Moses' ulterior intention was to keep the lower classes and races out of Long Island's pristine growing suburbs. Thus he deliberately designed low bridges which would prevent large trucks and double decker buses from using the parkways. In one sense, there was some success with this material strategy if one looks at the demographics of the early 20th century – but a counter-strategy defeated whatever politics were first employed. The Eisenhower Interstate development of the 1950s called for all interstate highways to have high bridges so that trucks – including those carrying ballistic missiles for the Cold War – could clear them, thus opening the way for what we Long Islanders call our "longest parking lots" of multi-laned highways. The Cold War trumps suburban protection.[1]

The language and notion of 'intent,' while still dominant, is inverted by Edward Tenner's well-known book, *Why Things Bite Back: Technology and the Revenge of Unintended Consequences* (1996). Tenner catalogues and classifies an enormous number of technologies, presumably designed for certain uses, which end up having disastrous or contrary unintended consequences. He spoofs Toffler's notion of the paperless society, where, "making paper copies of anything is a primitive use of [electronic word processing] machines and violates their very spirit (quoted Toffler, 1970, ix), in light of the higher-papered society of today." (Tenner, 1996, ix) Or, something as simple as a home security system, designed to increase security, he contends subverts security by producing false alarms and overwhelming police ability to respond, "In Philadelphia, on 3,000 of 157,000 calls from automatic security systems over three years were real; by diverting the full-time equivalent of fifty-eight police officers for useless calls, the systems may have promoted crime elsewhere." (Tenner, 1996, 7) Tenner's examples are of *unintended*, but also of *unpredictable* effects. The patterns being traced here apply equally to simple and complex technologies. I have lived through the long term claim of virtually infinitely free energy to be produced from nuclear sources, through the Three Mile Island near melt-down situation, to the closing of Long Island's Shoreham nuclear plant, designed as part of this trajectory of designer intent, but which to date has ended in a colossal, 4,000,000,000 U.S. dollar 'technology museum' which as yet has no use.

From the comparatively simple examples above, one can note that designer intent may be subverted, become a minor use, or not result in uses in line with intended ends at all. In addition, with unintended consequences the theme becomes the unpredictability of the uses of technologies. But, there remains a persistence of

[1] In discussion, it was pointed out that there is a difference between initial design intent, and subsequent design modification, but the argument I am making is that in neither case is there simple designer control over outcomes.

the designer fallacy, that in some way 'intent' determines, however successfully or unsuccessfully, outcomes. My argument is directed *against* this framing and description of the design project. What I hope to establish is a description which recognizes much more complex relations between designers, technologies and the ultimate uses of technologies in variable social and cultural situations. My approach is descriptivist in a sense parallel to those in science studies and the history of science which eschew end results over the examination of development in process (Kuhn, Latour, Pickering). I will open the way to my counter-thesis by looking at several variations upon technologies and the embedded ways in which these function. Again, I am arguing against an individualistic notion of design, and for a more complex set of relations between multiple inputs into developing technologies and for multiple, multistable possibilities for any single technology.

First, I want to show something of how technologies are differently *embedded* in different cultural contexts. My first example is the windmill – a device which like a pinwheel turns with the wind. The most ancient example, according to Lynn White, Jr., is to be found in India, a wind-driven prayer wheel or 'automated praying device.' (White, Jr., 1971) There were, and continue to be, hand-driven prayer wheels, rotating drums on a hand-held handle, which can have written prayers on the surfaces which are then spun with the prayers presumably being sent outwards. The 'automated' prayer wheel of the wind driven device lets 'nature' do the work. Later, in Mesopotamia, larger versions of the windmill occurred in the 9th century. These devices were used to provide power for such applications as milling. Moving to Europe, 'windmill fields' were developed to help pump out the lowlands of Holland in the 9th century in an early 'technological revolution' of larger-scale power use. Finally, today, we are moving into the argument phase of wind-generated energy, well accepted and in place in Denmark, which produces nearly 20% of its energy from windmill farms. In England and the USA, such windmill farms, proposed for off-shore or mountain ridge sites, are undergoing technology assessment battles along NIMBY [not-in-my-back-yard] lines.

Abstractly, one can argue that these are all the 'same' technology, wind driven devices to supply different powers, but each example is differently culturally embedded. The need to have relatively constant praying is quite different from the need to have renewable energy, and to call each a different 'use' is to abstract from the complexity of the cultural background. The 'same' technology is embedded differently in the different historical-cultural settings. But this is also to say that the 'same' technology can fit into different contexts and is *field located*.

A closer look, however, also shows that what I have called the 'same' technology, is also materially different in each context. The Indian wind-driven prayer wheel is a relatively small device, whereas the Danish and contemporary high-tech windmill is up to a 100 meters tall; and the former responds to the speed of the wind with faster or slower revolutions, whereas the latter turns at the same speed through self-governing blade adjustment. Both entail what Andrew Pickering calls a process of "tuning" and a "dance of agency" in the development process. (Pickering, 1995)

In design, the "tuning" and "dance of agency" can often turn around 'designer intent.' Bruno Latour has made the familiar post-it example famous in *Science in*

Action The designer, experimenting with the material properties of various glues, accidentally as it were, produced a glue which would stick only temporarily – thus seemingly a failure in terms of 'designed glues.' But, instead of simply casting aside the new propertied invention, the designer began to think of possible new uses and chanced upon the idea of page marks for hymn books. (Latour, 1987, 140) Thus, a new use, both unintended and unplanned, led to what today is a massive market for Post-It products. One could say, were one to adopt Latourean language, that the non-human here transformed the human (designer) with its actant, material behavior! I have frequently employed a similar example. Take the million year old 'hand-axe,' the chipped tool from pre-modern hominids which is usually thought to be a scraper and butchering tool, although no one knows the possible uses which could be many, and the small, sharp earlier-thought-to-be-detrius chips from the hand-axe, which are now recognized to have been used for cutting and even, possibly, surgery, and we get an archaic version of the Post-It story.

Allow a quick pause with respect to the designer-intent model of technological development: it should appear by now that the 'designer fallacy' may well be the rule rather than the exception. While it may be the case that some technologies have come into being and performed as 'intended' by their designers (I admit, I can think of none which have served solely in this way), there would seem to be none which can not be subverted to other, to unintended, or unsuspected uses and results. This is frequently the case for an initial design and even more so for later modified designs. Moreover, whether simple or complex, the same indeterminacy seems to apply. As artifactual, technologies seem potentially to contain *multiple uses or trajectories of development*. If even the simplest artifact, an Achculcan hand axe, can be used for multiple purposes, it differs little in outcome from the purposely designed multi-task tool, the Swiss Army Knife. Indeed, multi-tasking may be an emergent pattern for contemporary technologies. Some have begun to hold that the trajectory of multi-tasking for information technologies, is toward a single big and a single small multi-tasking instrument. The mobile technology which, like the Swiss Army Knife, is a cell phone, digital camera, bar-code reader, email device, etc., etc. is the single small multi-tasking technology, while the large home entertainment unit (TV, DVD, computer screen, etc., etc.) connected to the economic, entertainment, communications dimensions of life, is the big multi-tasking instrument; and while much of this remains technofantasy, it is plausible technofantasy.

Fantasy, however, is one type of *imagination* which also plays a role in, behind, and throughout design activity. I think a case can be made that in the high Middle Ages, a form of technofantasy began to emerge which, at first slowly, but with acceleration, began to shape the form of culture in Europe, which in turn pointed towards the saturated technological culture of today. Lynn White, Jr. has argued that there was something of a technological revolution which occurred in this period. The construction of high-standing Gothic cathedrals called for machines and architectural techniques not employed previously. Admittedly borrowing interculturally from, first the Moorish styles which entered Europe no later than the 10th century, but taking these to greater extremes, Chartres, Notre Dame, Cologne, all borrowed flying buttresses and glass-stone frillery. What might not be

noted, however, was a similar shift in imagery in the world of fantasy. The fantasy paintings of the Bruegels remained largely 'organic' or 'animal-like' fantasies. Devils, dragons, demons, large monsters, clearly were 'biomorphic' however fantastical. But by the 13th century, machines began to play fantasy roles. Roger Bacon described fantasy machines, such as self-propelled ships, underwater craft, flying machines and other impossible-to-build machines for the times, machines which were later 'visualized' in the 15th century by da Vinci in his notebooks (discovered and publicized by the Futurists in the 1920s). I am hinting that a specific mode of technology imagination or fantasy began to take hold. This probably was a life-world reflection, since many of the radical new machines which began to appear and be developed in Europe had earlier, in other forms, come from the multicultural trade, journeys, and experiences of the cross-cultural exchanges between Islamic culture, the Mongolian invasions, and the post-Marco Polo adventures to the Far East. Lynn White, Jr., Joseph Needham, and others began to recognize this cross-cultural trade of technologies by the middle of the 20th century. Spices, gunpowder, the compass, silk, windmills, as previously mentioned, all migrated to Medieval Europe, and were adapted and developed. Optics, better known by Al Hazen (1038) than the West, ended up on a trajectory of lens making which led to the optical inventions of the telescope and microscope which drove the early scientific revolution, instrumental technologies provided the infrastructure of science itself.

All of this today is relatively common tender. But it needs to be seen in the light of the 'designer fallacy' I am addressing here. Each new invention which came into Europe, often first a matter of fascination, became adapted into new uses and developments. While China invented gunpowder, it did not successfully produce a *cannon!* But by the Thirty Years War, cannons were being used to demolish French castles at the rate of dozens per week. (DeLanda, 1991) It is with this observation that I will now begin my move away from the 'designer fallacy.'

However some material capacity comes to human awareness (discovered by accident, through experiment, through found discovery, or – I suspect rarely – planned out from design) once that capacity is emergent and clear, some possible 'trajectory' is suggested. One could say, the explosiveness of gunpowder "suggests" uses. But, those uses will also be likely to be culture-relative, at least at first. Long before the cannon, feudalism had produced the land-castle system, wherein the lords who were to protect the populace had built defensive keeps. A many centuries-long form of contest centered on strategies of defense with supplies and means of defending against the attackers, a strategy which tended for a time to favor the well stocked and designed castle. Siege machinery, too, grew in complexity over the centuries, in an evolution from Roman times with trebuchets, catapults, and the like. None of these engines, however, could easily breach walls – which the cannon could do.

In terms of design history, the cannon is in a sense pre-modern. No one knows who 'invented' the cannon, although many attempts to create a workable cannon were made, including the production of early, fire hardened wooden cannon barrels (not too successful). The cult of the individual designer had not yet come into being.

Visiting Meissen in Germany recently, my guide, Professor Bernhardt Irrgang, pointed out that the cathedral there had a room for the architects, and while names of leading architects were sometimes known, the name actually served as something of a 'school' of such and such an architect – the same was often true for Renaissance artists. The room or office was for the whole entourage assigned the task of keeping the cathedral in repair. As Foucault has pointed out, the same frequently applied to authors – individual authors came into being with modernity, thus pointing to an even deeper connection between the "intentional" and the "designer" fallacies.

Let us now return to the designer problem and begin re-casting it. I wish to focus upon two interstices in a three part relation. The first interstice, in simplest form, is that between the designer-inventor, or including subsequent designers and materiality. What is at play is a set of interactions between the designer(s) and the materials being worked with – it is a two-way relationship within which the "accommodations" and "resistances" Pickering speaks of, come into play. (Pickering, 1995)

My beginning example is the long fantasized desire of humans for flight. The Icarus story, with its technologies of bird feathers and wax, is clearly fantasy only. Similarly, Roger Bacon's and later Leonardo da Vinci's descriptions of flying machines also remain in the imaginary realm, although da Vinci's recognition of the curved wing shape of birds was a step in the right direction. Almost everyone has seen documentaries on early flight experiments, usually comic with films of flying contraptions – human powered – and their subsequent falls and crashes. But, note, once again, the serious experimentation begins with that Industrial Century, the 19th.

From the beginning, it was recognized that wings had to be both light and strong, and the design was at first biomorphic in that bird wings, and sometimes batwings, served as the pattern. Yet, how clumsy the designs seem in retrospect! Gliders began to succeed to some degree, with much experimentation of light materials, wood or bamboo, and glued linen or other light cloth. Interestingly, the reluctance to follow the fantasy trajectory of human powered flight gave way to the recognition of the need for a light-weight power source which historically we recognize as the internal combustion engine plus 'screw' or propeller. The Wright brothers' flying machine was a hybrid conglomeration of many technologies. The Wright brothers were experienced light weight technologists – bicycle makers – who adapted from windmill technologies, a propeller for driving through air rather than being driven by the wind. Then making wing and control designs, some modified from other's attempts, they eventually produced the first powered flights (I ignore the historical controversies around who actually first flew, since there were many contenders). What we really have in this history is a competitive 'dance of agency' through trials and failures, until finally the small success which launched the trajectory of human+machine flight. From 1903 to the present century, development has seen flight move away from biomorphic designs towards ever more variations of flight which are less and less like those of flight's origins. The simplest example is that of a fixed wing over a flexible and moveable wing. Flight, originally fantasized as embodied human flight, has never really materialized, its closest actualization

probably is that of hang-gliding and its kin, which flight is restricted to lovers of extreme sports. The one bicycle-technology, propeller driven, light-weight aircraft, flown by a trained cyclist, which successfully flew across the English Channel, was hardly anything like birdlike grace in form, even if actually human powered. But with mylar skin, and weighing in at only pounds, it was a culmination of a trajectory towards lightness which was the material need for this approximation of flying. What I am trying to point out, is that one does not find anything like sheer plasticity of the material, over which the designer has anything like a transparency of control. Rather, one finds a process of interrogation of materiality and experimentation with it, which results – sometimes – in fortunate results.

The second interstice would, under the designer fallacy model, be the 'uses' to which the invention, the technology, is put. Maintaining the analogy to literary practices, this would be reader response, or responses. What results from the literary or technological product? In the case of my flight example, the proliferation of uses is historically clear – there is something like an actualization of a possibility tree. In less than a decade, airplanes were beginning to be used militarily, by World War I, there were inter-airplane "dog fights", bomb dropping, reconnaissance; equally early, commercial developments began; recreational uses with the "barnstormers" and stunt fliers; races, distance breaking flights such as Lindberg's over the Atlantic, and the like. And, in each use, changes in previous practices occurred. By World War II, the *Blitzkreig* employed its own version of "Shock and Awe" with Stuka dive bombers, to the present, where unmanned Predators and 'smart bombs' are employed, displacing what was once trench warfare or disciplined regiments marching at one another. I need not follow each of these trajectories, but it is clear that Orville and Wilbur neither foresaw the speed or the diversity of their invention's results. And, just as the interrelation of designer and materiality contains an indeterminate set of accommodations and resistances, through which may be produced a result never simply planned, so with the results and the indeterminacy of multiple uses.

I have tried to show that the designer-materiality interstice is such that the inter-relation of designer-materiality precludes any simple notion of control or transparency over the simply plastic or passivity of the material. Instead, the interaction is exploratory, and interactive. In the second, now artifactual-use interstice, the designer has even less control or impact, rather the user(s) now play the more important role. The indeterminacy here is multistable in terms of the possible range of uses fantasized or actualized. One particular set of interesting examples comes from the ingenious ways in which technologies may be defeated – defeasibility uses. Video surveillance cameras, for example, may be disabled by laser pointers flashed into the lenses. Hardened steel steering wheel anti-theft devices, precisely because hardened steel is vulnerable to fast-freeze brittleness, can easily be broken when sprayed with a freeze spray. Slightly more complex are the 'wars' between police determined to trap speeders with radar, now laser speed detection devices and the 'insurgencies' which develop technologies to detect radar signals or confuse laser reading devices. And so go the multiple directions from same, different, or differently used technologies.

We are now in a position to draw a few conclusions from this examination of designer fallacies. First, in spite of language concerning designer capacity in textbooks – recognizably there in engineering, architecture, and other design textbooks – I am attempting to show that the design situation is considerably more complex and less transparent than it is usually taken to be. Both the designer-materiality relation, and the artifact-user relations are complex and multistable. While it is clear that a new technology, when put to use, produces changes in practices – all of the examples show that – these practices are not of any simple 'deterministic' pattern. The results are indeterminate but definite, but also multiple and diverse. Moreover, *both* intended results and unintended results are unpredictable in any simple way, and yet results are produced. And, finally, what emerges from this examination looks much more like an inter-relational interpretation of a human-technology-uses model in which the human, material, and practices all undergo dynamic changes. If this is the case, then there are also implications for designer education. One of these is that the design process must be seen to be fallibilistic and contingent. Some worry that this recognition may be demotivating – but it could also be a call for a more cooperative, mutually co-critical approach as well.

I am also implicitly suggesting that the re-descriptions which have arisen out of the past several decades of work in the history and philosophy of science, the new sociologies of science, and cultural and science studies, which undertake careful case studies of developments in technologies, give hints of the complexities suggested.[2]

References

DeLanda, M., 1991, *War in the Age of Intelligent Machines*, Swerve Editions, Zone Press, New York, pp. 12–14.

Kittler, F., 1990, The mechanized philosopher, in: *Looking after Nietzsche*, L. A. Rickels, ed., SUNY Press, Albany, NY.

Latour, B., 1987, *Science in Action*, Harvard University Press, Cambridge, MA.

Nyre, L., 2003, *Fidelity Matters: Sound Media and Realism in the 20th Century*, Doctoral Dissertation, Department of Media Studies, University of Bergen, Volda University College, Norway.

Pickering, A., 1995, *The Mangle of Practice: Time, Agency, and Science*, University of Chicago Press, Chicago, p. 102.

Tenner, E., 1996, *Why things Bite Back: Technology and the Revenge of Unintended Consequences*, Alfred Knopf, New York.

Toffler, A., 1970, *Future Shock*, Bantam, New York.

White, Jr., L., 1971, Cultural climates and technological advance in the Middle Ages, *Viator* 2:171–201.

Winner, L., 1986, Do artifacts have politics?, in: *The Whale and the Reactor*, L. Winner, ed., University of Chicago Press, Chicago, pp. 19–39.

[2] Reproduced – with slight changes – with permission of Palgrave Macmillan from Ihde, D., 2006, The designers fallacy and technological imagination, in: *Defining Technological Literacy: Towards an Epistemological Framework*, Dakers, J. R., Palgrave Macmillan, New York, pp. 121–131.

Technological Design as an Evolutionary Process

Philip Brey

The evolution of technical artifacts is often seen as radically different from the evolution of biological species. Technical artifacts are normally understood to result from the purposive intelligence of designers whereas biological species and organisms are held to have resulted from evolution by natural selection. But could it be that technology, too, is really the outcome of evolutionary processes rather than intelligent design? Recent decades have seen the emergence of evolutionary theories of technology, which use concepts and principles drawn from evolutionary biology to describe and explain processes of technological innovation and technological change. In this chapter, I will focus on three prominent theories, by George Basalla, Joel Mokyr and Robert Aunger, and I will investigate to what extent these theories present a truly evolutionary account of technological innovation and change. In the end, I aim to analyze how these theories construe technological design: as a blind evolutionary process, a purposive activity of designers, or a mixture of both.

1 Design and Evolution

Before evolutionary theory presented an alternative viewpoint, it was almost universally believed that biological organisms are creations of an intelligent maker – a God. For centuries, this belief played a central role in a major type of argument for the existence of a God, the Argument from Design. Arguments from Design come in different forms but all revolve around the belief that there must be a God or Intelligent Creator because organisms in nature are too complex and sophisticated to have occurred randomly or naturally.

The most famous Argument from Design is the Watch Argument presented by theologian William Paley in 1802. Paley's argument starts with the premise that living organisms and organs have the same kind of complexity and purposiveness as designed artifacts. An eye, for example, is an intricate organ for vision in precisely the same way that a telescope is an intricate artifact for assisting vision. Paley next

P. Brey, University of Twente

P. E. Vermaas et al. (eds.), *Philosophy and Design.*
© Springer 2008

argues that if one finds complex artifacts like a telescope or watch on the ground, one would not believe for a moment that it was the product of natural forces, but rather believe that it must have had a maker. But, Paley argues, since human organs and organisms have the same kind of complexity and purposiveness as such human-made artifacts, it is only plausible to assume that they, too, must have had a designer, or maker, who intentionally created them and gave them a functionality or use.

In his famous exposition of the theory of evolution, *The Blind Watchmaker*, Richard Dawkins explains that the theory of evolution by natural selection provides a compelling alternative to Paley's account. The complexity and functionality found in living beings, Dawkins argues, can be explained as the outcome of a long process in which less complex organic systems gain complexity and functionality in a series of steps involving small variations and selection of the fittest (best-adapted) systems. Dawkins concludes that an explanation of organic life requires no appeal to a creator or designer, but only to blind processes of natural selection. Natural selection, he claims, is completely different from purposive design since it "has no purpose in mind. It has no vision, no foresight, no sight at all. It does not plan for the future. It has no vision, no foresight, no sight at all. If it can be said to play the role of watchmaker in nature, it is the *blind* watchmaker." (Dawkins, 1986, 5). The theory of evolution is now well-established in science, and the Argument from Design has become discredited as a result, although it is still used in religious theories of biological life, as in creationism, creation science, and more recently, the theory of Intelligent Design (Dembsky, 1999).

As a result of the new scientific orthodoxy, the origins of organisms and of artifacts are nowadays seen as radically different: blind natural selection versus the purposive, forward-looking, and intelligent activity of designers. In this chapter, I will question whether this radical difference in origins can be sustained. I will not do this by revisiting the Argument from Design, but by questioning whether designed artifacts are best explained as resulting from purposive design rather than evolutionary processes. Recent decades have seen the emergence of evolutionary theories of technology, which use concepts and principles drawn from evolutionary biology to describe and explain processes of technological innovation and technological change (see Ziman (2000) for an overview). In what follows, I aim to investigate to what extent these theories present a truly evolutionary account of technological innovation and change and to analyze how they construe technological design: as a blind evolutionary process, a purposive activity of designers, or a little bit of both.

2 Evolutionary Theories of Technology and Evolutionary Biology

In this section, I will briefly introduce contemporary evolutionary approaches to technology, after which I will analyze the conditions that must be met for a theory of technology to be genuinely evolutionary and the extent to which this requires adoption of central principles of evolutionary biology.

Evolutionary theories of technology have gained in prominence since the 1980s. Such theories use concepts and analogies from evolutionary biology to explain technological change and innovation. Part of the inspiration of these theories can be found in previous extensions of evolutionary theory into new realms, such as evolutionary economics (Andersen, 1994; Dopfer, 2005) and evolutionary epistemology (Hahlweg and Hooker, 1989; Callebaut and Pinxten, 1987). Another source of inspiration is found in the more general attempt to construct at a universal theory of evolution that transcends biological evolution. Such a theory, which incorporates ideas from evolutionary epistemology, has alternatively been called universal selection theory or universal Darwinism (Cziko, 1995; Dennett, 1995). The central claim of Universal Darwinism is that Darwinian principles of evolution by natural selection do not just underlie biological processes but underlie all creativity, and are key to the achievement of all functional order. So biological evolution is just a particular instance of a more general phenomenon of evolution by selection.

A prominent approach that incorporates ideas of universal selection theory is the memetic approach to cultural evolution initiated by Richard Dawkins (1976) and since then developed by a number of advocates (Blackmore, 1999; Aunger, 2000; 2002). According to memetic theory, human culture is realized and transmitted through cultural units called memes, which are units of meaning that can express any culturally determined idea, behavior, or design. Memes are like genes in that they can replicate and can be transmitted, and they compete with other memes for survival according to Darwinian principles.

A variety of evolutionary approaches to technological change and innovation now exist. Some of these approaches are more explicitly evolutionary, whereas others make use of concepts of evolutionary biology in a loose way. The influential SCOT approach in the science and technology studies (STS) is an example of the latter (Bijker, Hughes, and Pinch, 1987). In this approach, the development of technological artifacts is claimed to consist of semi-evolutionary processes of variation and selection, in which technology developers design and produce different kinds of artifacts and selection takes place between them by buyers and other actors.

More consistently evolutionary theories of technology make more systematic use of concepts and principles of evolutionary theory for the analysis and explanation of processes of technological change and innovation. In the subsequent three sections, I will analyze three prominent evolutionary theories of technological change and innovation, that have been developed by George Basalla, Joel Mokyr, and Robert Aunger, respectively. Before this, however, I will first briefly outline the main concepts and principles of the theory of evolution itself, as it has been developed in evolutionary biology, and relate them to technology.

The contemporary theory of evolution adheres to three basic principles and assumes that biological species evolve through natural selection. Evolution is the increasing adaptedness of species to their environment, and natural selection is the process by which natural conditions favor hereditable traits of organisms that confer the greatest fitness to the organisms that carry them. This idea of evolution by natural selection is often claimed to rest on three principles: phenotypic variation, heritability, and differential fitness.

1. *Phenotypic variation.* This is the idea that all individuals of a particular species show variation in their behavioral, morphological and/or physiological traits – their 'phenotype'. For example, individual wolves may differ in their hair color, tail length, bone density, aggressiveness, sexual prowess, visual acuity, and so forth.
2. *Heritability.* This is the idea that a part of the variation between individuals in a species is heritable, meaning that some of that variation will be passed on from one generation to the next. In other words, offspring will tend to resemble their parents more than they do other individuals in the population. For example, if visual acuity is a heritable trait in wolves, then the offspring of a particular wolf with high visual acuity will have a higher than average tendency to have high visual acuity.
3. *Differential fitness.* This is the idea that some individuals of a particular species are better adapted to their environment than others and therefore have greater chances of survival and reproduction. That is, individuals in a species differ in their fitness, or their propensity to reproduce (leave offspring). For example, wolves with high visual acuity will tend to leave more offspring than wolves with low visual acuity because high visual acuity is a trait that leads to better adaptation to the environment by wolves, and therefore the trait of high visual acuity will tend to proliferate in future generations of wolves.

The result of these three principles, then, is evolution by natural selection: traits that enhance fitness proliferate in future generations, and individuals in a species are increasingly equipped with such traits. This is assuming that the local environment in which selection takes place remains the same. If the local environment changes, then traits that were previously fitness-enhancing may become less so, and other traits may come to enhance fitness. Such a change in the environment merely alters the course of evolution; the same underlying principles of natural selection remain at work.

The above three principles are the core principles of biological evolution formulated by Darwin in his Origins of Species (1859). Two additional principles specify underlying mechanisms for the processes described in these three principles. One specifies the underlying mechanism of heritability, which, genetics has taught us, is genetic reproduction:

4. *Genetic reproduction.* Inheritance of traits takes place through reproduction of genes.

Another one elaborates the underlying mechanisms driving variation:

5. *Mutation and recombination.* Two principal factors are responsible for the creation of variants: mutation, accidental changes in genomes, and recombination, the crossing between alleles, on which genes are situated, during meiotic cell division.

A sixth important principle of evolutionary biology is already implicit in the previous ones:

6. *Blindness.* Variation and selection are blind processes, meaning that they do not depend on foresight or learning. Put differently, they are nonteleological processes, not the result of any goals or aims but merely the result of conditions in the natural environment.

With these principles, we can now see what it would take for a theory of technology to be an evolutionary theory in a direct sense. Obviously, the evolution of technology is not a biological process since technical artifacts are not biological species. So an evolutionary theory of technology cannot be part of evolutionary biology. Instead, a theory of technology can only be evolutionary in an analogous sense: by assuming that technological change and innovation depend on principles that are strongly analogous to the principles underlying biological evolution. That is, there must be a structural similarity between the two processes through which most or all of the above principles apply to technological change, albeit in a modified form. The more principles apply, the more strongly evolutionary the theory is. The most important principles are the first three, because they are the core principles of evolutionary theory. Theories of technology that employ at least two principles that are analogous to these three core principles may be called weakly analogous to biological evolution, whereas theories that employ all three and at least one of the three peripheral principles may be called strongly analogous.

3 George Basalla's Theory

In his book *The Evolution of Technology*, historian of technology George Basalla presents an evolutionary theory of technological change that aims to explain technological innovation, including the emergence of novel artifacts, and the process by which society makes a selection between available artifacts (Basalla, 1988). Basalla considers his notion of technological evolution to be an "analogy" or "metaphor". He claims "Metaphors and analogies are at the heart of all extended analytical or critical thought." (1988, 3). Basalla holds that metaphors and analogies can be helpful in constructing novel scientific analyses and explanations.

Basalla argues that the proper object of analysis of a theory of technological change is the artifact, since artifacts are normally the outcome of innovative technological activity. He then likens artifact types to species and individual artifacts of a particular type to members of a species (1988, 137). Artifacts are hence to be likened to phenotypes. He claims that variation within artifact types clearly exists: there are many different kinds of hammers, steam engines, or automobiles. There is also a kind of inheritance between artifacts, Basalla claims. That is, artifacts may be followed by subsequent generations of the same artifact, or similar artifacts. The main difference here is that artifacts do not reproduce; they are reproduced by human makers. However, Basalla holds the resulting process of reproduction to be similar to the process of inheritance. Basalla also claims that selective pressures operate on artifacts, and that some are selected to be used and reproduced, whereas others are discarded. He believes that this process of selection can be analyzed with reference of traits of artifacts that make a better or poorer fit to conditions in their environment. He argues that four kinds of factors are involved in the selection of artifacts: economic, military, social, and cultural. These factors do not operate on artifacts directly, but on humans who select artifacts. Their actions are determined by "economic

constraints, military demands, ideological pressures, political manipulation, and the power of cultural values, fashions, and fads." (139). It can hence be said that artifacts have a differential fitness relative to such constraints.

Basalla holds that the mechanism by which new variants of artifacts are created is not the mechanism of mutation and recombination. It is usually a mechanism involving conscious human choices. Likewise, the selection of artifacts is not a blind process, as it also involves human choice. Basalla claims that the selection of artifacts is similar to artificial selection, the selection of phenotypes in animal and plant breeding, and less similar to natural selection. As he claims, "Variant artifacts do not arise from the chance recombination of certain crucial constituent parts but are the result of a conscious process in which human taste and judgment are exercised in the pursuit of some biological, technological, psychological, social, economic, or cultural goal." (1988, 136). It must be admitted that human choices are constrained by economic, military, social, and cultural factors over which human beings do not have complete control. Even so, Basalla holds that the involvement of conscious, goal-directed choices by human beings introduces a disanalogy between technological and biological evolution. Another disanalogy exists, Basalla holds, regarding the notion of species and interbreeding. Artifact types can be combined quite easily to produce new types, meaning that artifact types can interbreed easily, whereas different biological species usually do not interbreed (1988, 137). A final disanalogy between Basalla's theory and the theory of evolution is that there is no unit of reproduction similar to the gene in Basalla's theory; it is artifacts, or phenotypes, rather than genes, and genotypes, that are reproduced.

To sum up, Basalla's theory of the evolution of technological artifacts exploits a number of similarities between biological and technological evolution while also admitting to a number of dissimilarities. Basalla appears to claim that analogous versions of the principles of variation, inheritance, and differential fitness apply to technological evolution, while the principles of genetic reproduction, mutation and recombination, and blindness do not apply. In his theory, technological innovation is hence weakly but not strongly analogous to biological evolution. Inheritance in artifacts is construed as the tendency of successive generations of artifacts to resemble previous generations. Variation and selection are not blind but involve conscious human agents making purposeful choices: choices regarding the creation of novelty and regarding the selection of artifacts.

4 Joel Mokyr's Theory

Economic historian Joel Mokyr has presented an evolutionary theory of technology that does not focus on the evolution of artifacts, as in Basalla's theory, but on the evolution of technological knowledge (Mokyr, 1996; 1998; 1999; 2000a; b). More precisely, he has presented an evolutionary theory of techniques, or technological know-how, mirroring Gilbert Ryle's famous distinction between knowledge "how" and knowledge "that". Mokyr is critical of evolutionary approaches that take artifacts

as the unit of selection, like Basalla's, because he holds that technological change is better analyzed as a change in techniques than as a change in artifacts. New techniques for washing one's hands, training animals, or navigating the stars may not involve any artifacts at all. Moreover, he claims, many artifacts are meaningless without specific instructions, and only gain their identity when a series of "how-to" instructions are attached to them. Mokyr's theory has been inspired by developments in evolutionary epistemology, as well as by evolutionary approaches to economics. Mokyr's aim is to develop an evolutionary framework that is helpful in analyzing the fundamental causes of technological change. Like Basalla, he believes that evolutionary biology provides a useful "analogy" or "metaphor" to this effect.

Following Gilbert Ryle, Mokyr makes a distinction between "how" knowledge and "what" knowledge. He argues that society has developed two basic kinds of knowledge to help it cope with the world. The first kind is what he calls "useful knowledge". This is "what" knowledge that resides either in people's minds or in storage devices from which it can be retrieved. Useful knowledge consists of observations and classifications of natural phenomena, and regularities and laws that make sense of these phenomena. It includes scientific knowledge, but also engineering knowledge, including quantitative empirical relations between properties and variables. Mokyr calls the total set of useful knowledge about the world in human minds and storage devices Ω (Omega). Next to useful knowledge, there are techniques, which are a form of "how" knowledge. Techniques are sets of instructions, or recipes, that tell the user how to manipulate aspects of the environment to attain a desirable outcome. Like "useful knowledge", techniques reside in people's brains and in storage devices. For example, a "how to" manual is a codified set of techniques. Many techniques, however, are tacit and unconscious. Mokyr calls the total set of techniques that exist in a society λ (Lambda). Mokyr believes in the primacy of "useful knowledge" over techniques, or of Ω over λ. That is, he believes that there usually is a dependency of techniques on what-knowledge that has made the technique possible. For instance, he believes that the technique of bicycle riding is in some way dependent on the mechanical principles of bicycle riding that made the production of bicycles possible. Techniques, in Mokyr's analysis, are the end-product of knowledge in Ω. Ω defines what a society knows, and λ what it can do.

Mokyr likens "useful knowledge" to the genotype and techniques to the phenotype. He believes that an evolutionary theory of technology must in some way capture the genotype-phenotype distinction by including a distinction between some underlying structure that constrains a manifested entity. In technology, the underlying structure is Ω and the manifested entity is λ. There are mappings between Ω and λ when one or more elements in Ω give rise to one or more elements in λ. For example, the now-defunct humoral theory of disease gave rise to a series of medical techniques, including the bleeding and purging of patients suffering from fever. Mokyr admits that the relation between Ω and λ deviates in several ways from the genotype-phenotype relationship. For instance, a gene and the phenotypic trait it gives rise to must be part of the same carrying organism. But if an individual masters a technique, he need not be knowledgeable of the "useful knowledge" that formed the basis of it, and this knowledge may be stored in other minds or storage devices, or may even have been lost.

Techniques, Mokyr claims, are subjected to selective pressures. When a technique has been used, its outcome is evaluated using a set of selection criteria that detemine whether it will be used again or not. This, he holds, is similar to the way in which selection criteria pick living specimens and decide whether they survive and reproduce. He does not hold it to be important whether this selection occurs by the same human agent who used a technique previously or by other human agents. Agents may again select techniques that they have used previously, and other agents may learn or imitate techniques, which is also a form of selection. When a technique is selected again, it is reproduced, in Mokyr's terminology. So reproduction of techniques may take place through learning and imitation, or through reselection by a human agent. Mokyr points out that the analogy between biological selection and the selection of techniques breaks down on an important point: selection of techniques is not blind, but is performed by conscious units, firms and households that do the selecting. Humans are, in this model, not the selected but the selectors. Mokyr claims there is also selection between elements of Ω. Here it is not their perceived usefulness but their perceived truth or veracity that determines whether they are conserved, and whether they are used to create techniques. Their truth is tested by established rules in society, for instance rules of science.

Mokyr is not fully clear on the conditions that create variation (or "innovation"). He calls the creation of new "useful knowledge" mutation, and defines such mutations as "discoveries about natural phenomena", but does not specify a mechanism for it. He does suggest that the creation of new techniques often results from new combinations of knowledge in Ω. He refers to the possibility of a general drive in human agents to devote resources to innovation, but does not develop this idea. Moreover, new techniques need not result from new (combinations of) knowledge. Techniques can also change through experience and learning by doing, or may emerge from "pure novelty" like mutations. The use of new techniques may also influence the set of "useful knowledge". For instance, the invention of telescopes impacted knowledge of astronomy, and early steam engines influenced the development of theoretical physics. So technological evolution, in Mokyr's theory, may also involve Lamarckian feedback mechanisms from phenotype to genotype, or from λ to Ω.

Mokyr's theory, like Basalla's, holds that the basic three ideas of Darwinism apply in some form to technological change. There is phenotypic variation between techniques, techniques have differential fitness, and there is some form of heritability in that subsequent generations of techniques tend to resemble their predecessors. Unlike Basalla, Mokyr upholds the genotype-phenotype distinction by putting what-knowledge and how-knowledge in those two roles and assuming there is a mapping-relation from what-knowledge to techniques. He is therefore able to adhere to some principle of genetic reproduction, according to which most techniques depend on underlying knowledge, and their reproduction often depends on the presence of this knowledge. Mokyr is also able, better than Basalla, to adhere to a principle of mutation and recombination. Mutations occur to Ω, through new discoveries, and knowledge in Ω may be combined in new ways to yield new techniques. This analogy breaks down, to some extent, since techniques may also mutate and subsequently reproduce without any changes in underlying knowledge.

Mokyr thus takes the analogy between biological evolution and technological change considerably farther than Basalla, and presents an account on which technological change is strongly analogous to biological evolution, although disanalogies are also present. Mokyr does not adhere to the principle of blindness, since he holds that variation and selection are driven by conscious human agents. In Basalla's theory it was artifacts that were the object of variation, reproduction, and selection by humans. In Mokyr's theory, the object is techniques, which are a type of knowledge. In both cases, the trajectory of these objects may be described in evolutionary terms, but is nevertheless the immediate result of human deliberation and purposive action.

5 Robert Aunger's Theory

Anthropologist Robert Aunger has developed an account of technological change within the context of memetics (Aunger, 2002). Memetics is an evolutionary approach to culture that was initially proposed by evolutionary biologist Richard Dawkins (1976). Dawkins claimed that culture might have its own evolutionary mechanism, separate from that of biological evolution, and that it is dependent on basic units of propagation similar to genes, which he called "memes". A meme is the basic meaningful unit of culture and the basic unit of cultural inheritance. Memes are akin to ideas. The religious concept of heaven, the Newtonian concept of gravitation, the notion of a scarf, the notion of a semicolon, the idea of a handshake, all these are memes, or complexes of memes. Memes are capable of reproduction, and are subjected to Darwinian processes of blind variation and selection. They compete with each other in an environment of other ideas, and human biological needs, that determine whether they will be selected and survive in their hosts, or be copied by other hosts and hence spread throughout a population. Importantly, memeticists believe that the basic selection mechanism for memes is not conscious, and involves forces that are beyond the control of individual agents.

The analogy between biological evolution and cultural evolution thus goes all the way: all six principles of biological evolution outlined in section 2 are also thought to apply to cultural evolution, in some form. However, there is debate on whether a genotype-phenotype distinction applies to memetics. Dawkins claimed that this distinction does not hold in memetics, because selective pressures operate directly on memes. Memes are like genes that carry phenotypic traits on their sleeves. Memetic evolution on this conception is Lamarckian, because it upholds the heritability of acquired traits (new memes). Others have claimed that a genotype-phenotype distinction is tenable for memes. If memes are ideas in the mind, then their phenotypic expression may be a realization or manifestation of this idea. This phenotypic expression may be an artifact or behavior. For example, a recipe for a cake in someone's mind is a set of memes, and a cake baked according to this recipe the memetic phenotype. Likewise, the remembered idea of a song may be a set of memes, while the performance of a song is the phenotype. On this view, selective

pressures do not operate directly on memes, but indirectly, on their phenotypic expressions. In this debate, Aunger largely follows Dawkins's idea that memes are both genotypic and phenotypic. He moreover holds that memes are brain structures, or ideas in the brain.

Aunger holds that a theory of technological change should focus on memes and artifacts. He holds, like Basalla, that artifacts evolve. However, he claims they evolve through interaction with mental artifacts, or memes. Aunger hypothesizes a process of coevolution between memes and artifacts. He claims that this process of coevolution involves "two lines of inheritance working together, feeding off each other in a positive fashion," and that it is responsible for the "incredible dynamicism of cultural modification in modern Western societies" (2002, 277). Aunger emphasizes that artifacts do not have a single role in meme-artifact coevolution. Artifacts sometimes function as phenotypes, that are the focus of selective pressures. But they may also function as vehicles or interactors for memes, as signal templates, or even as replicators, as in computer viruses and nanites (self-replicating pieces of nanotechnology). Different relations with memes are established in these different roles of artifacts. In all cases, however, there is coevolution: memes give rise to artifacts, and artifacts may feed back to memes and alter them or generate new ones. Both memes and artifacts are subjected to their own selective pressures.

Aunger sums up his theory of technological change as follows: "New artifact types are created through *invention*, or random mutations in form. This starts a new evolutionary lineage. *Innovations*, on the other hand, are modifications of these inventions through the recombination of parts. ... Such single-step recombinations between artifact lineages ("combinatorial chemistry") can rapidly produce complexity. Over time, an artifact lineage can therefore show evidence of cumulative selection (variation with descent) and manifest an adaptive design with greater and greater power to transform the environment. Simultaneously there is a process of mental evolution in know-how that can be described as Darwinian." (2002, 299). Aunger holds that the production of artifacts is first simulated in the mind, in which different varieties of artifacts are "tried out" for their competitive advantage. This process of mental trial and error may recur at the level of research and development within a firm, and then again in the marketplace. So it is the interaction of two Darwinian processes, "of descent with modification in the body of knowledge available to a society relevant to the production of some artifact, as well as the embodied modifications in the artifact itself – that must be modeled for a complete understanding of technological evolution." (2002, 299–300). Aunger notes that precise models of the interaction between memes and artifacts will still have to be developed.

Aunger's theory incorporates an analogue of most principles of biological evolution, and he therefore conceives of technological change as strongly analogous to biological evolution. Auger adopts principles of variation, inheritance, and differential fitness for memes and artifacts that strongly mirror those in biology. He holds that the relation between memes and artifacts sometimes resembles the genotype-phenotype relation, but claims that memes and artifacts may also have a different relation to each other. When this relation occurs, the principle of genetic reproduction seems to apply. Aunger moreover assumes that the invention of new memes and artifacts

may be described as mutation, and that some process of recombination also occurs, when a combination of memes gives rise to new artifacts.

Unlike Basalla's and Mokyr's theories, Aunger adheres to the blindness principle: he holds that the basic processes of meme and artifact variation and selection are not properly understood as conscious and goal-driven, even if conscious decisions and goals play a role in them. This is, indeed, a basic tenet of memetics: the evolution of memes, or ideas, is not explained as the result of conscious cognitive processes and actions by human agents, but rather as a process of blind variation and selection of memes in human beings who function as passive hosts to this process. Memetics therefore takes Darwinism significantly farther than Darwin ever did: even the watch found by William Paley turns out to be not the result of conscious design but rather the result of blind variation and selection. Just like biological organisms, memeticists hold, human-made artifacts are the result of processes of evolution by natural selection.

6 Designers and Technological Evolution

What, according to these three evolutionary theories of technology, is the nature of engineering design? I will start with answering this question for Basalla's and Mokyr's theories, which, unlike Aunger's, construe technological change as dependent on the conscious deliberation and foresight of human agents. On their view, then, evolutionary processes are not necessarily blind, and the design of technology is part of an evolutionary process while simultaneously involving foresight by designers. Their view seems to run counter to the blindness principle outlined in section 2. However, as I will now argue, this principle is too strong in its current form even for biological evolution and therefore needs to be modified. Evolutionary processes of variation and selection sometimes do involve foresight and conscious choice.

Natural selection is often contrasted with artificial selection, which is the selection by humans of animal and plant phenotypes, which creates new breeds within a species, and may even yield a species. The dog is a domesticated species upon which artificial selection has been worked for thousands of years, resulting in hundreds of different breeds. Clearly, these breeds are the result of processes of variation and selection that resemble natural selection in every way, except that they involve human foresight and choice working in conjunction with "natural" processes of variation and selection. Yet, does the dependency of the evolution of dogs on human foresight really differentiate it from ordinary, natural evolution?

Closer consideration shows that in natural selection, foresight and choice also frequently play a major role, because natural selection often depends on intentional, forward-looking actions by animals and humans. Animals select their mate, predators select their prey, and animals choose the immediate environment in which they live and the things and animals with which they interact, and parents choose which offspring they give the most food or are most protective of. These choices are generally

guided by expectations about the future. They are a large factor in the processes of selection, variation, and reproduction that occur in natural selection.

It may be objected that there still is a major difference between artificial and natural selection: artificial selection is selection with the explicit aim to grow or breed certain species with predefined properties (phenotypic traits), whereas the foresight in natural selection is not similarly aimed at designing the traits of offspring. A rabbit breeder may successfully breed a rabbit with a white body, black head and red eyes, but it would seem that two rabbits in the wild do not mate because they aim to realize offspring with certain phenotypic properties. Rather, they mate because they lust for each other and desire to copulate.[1]

In spite of this difference, however, there is no reason why artificial selection could not be described using the same concepts and principles used in natural selection accounts. In both cases, selection involves both forward-looking intelligence and events that involve no foresight. A rabbit breeder cannot completely control the circumstances that determine the phenotype or genotype of new generations of rabbits, so his foresight is just part of the explanation of why a bred rabbit looks the way it does. Conversely, an explanation of why a certain generation of rabbits in the wild has the phenotypic traits it does may include, amongst others reference to the intentional states of parent rabbits, predators, and other animals that played a role in selection.

In the evolution of technology, a designer or maker has the same relation to technical artifacts as a breeder has to the animals he breeds. The designer attempts to create a certain artifact with desired properties, but is not in full control of the outcome. Concrete artifacts are a compromise between the designer's ideals and the contingencies of the physical and social world through and in which the designer operates. While a designer is not fully in control of the outcome of his designing activity, he is even less in control of the success of his artifact once let loose in the environment, i.e., the marketplace and the world of users. Once a certain brand of artifacts leaves the factory, it is the intentions and choices of sellers, users, regulators, and others, as well as random events, that determine whether it successful as a brand (or species) and whether it proliferates.

In the evolutionary process of variation and selection, the designer is the main agent of variation. He produces new types of artifacts, after which various selection constraints in the environment determine whether they are successful. In the production of these variations, forward-looking intelligence has a large role, much greater than it has in the production of new variants in biological evolution. In contrast, the designer's forward-looking intelligence normally has a much less significant role in subsequent selection. As many product designers have found out the hard way, it is often very difficult to predict or control which products will be successful in the marketplace.

[1] It may occur that humans consciously or unconsciously select a certain mate to generate offspring with certain phenotypic properties, but this does not seem to be a major factor in mate selection. Possibly, such considerations also play a role in mate selection by animals.

A product designer may, however, attempt to control the selection process, by controlling the environment in which his products operate. He may for instance attempt to require or encourage that a certain type of product is only used in pre-specified contexts or by pre-specified users. He may also attempt to alter the contexts of use in which products operate, or alter the traits of users. He may for example offer training to users, or encourage such training, or he may recommend that adaptations are made to the environment in which the product is used. The designer's main ways of controlling the environment include the authoring of manuals and direct communication with suppliers or users. As such, a designer may project his forward-looking intelligence beyond the artifact itself to also influence the conditions under which selection takes place. His actions are like those of a parent who prescribes where his children can go and whom they can associate with, and who eliminates risks and dangers in the environment so that his children have the best chance of succeeding in the world.

In Basalla's and Mokyr's approach, I conclude, design can be understood as the process of creating variants in an evolutionary process of variation and selection. Designers use forward-looking intelligence in the creation of new variants, but new variants (artifacts) are not wholly determined by the designer's vision, but also by the everyday constraints under which designers operate. Designers and others may also use forward-looking intelligence in trying to influence the selection process. However, their efforts are ultimately part of an evolutionary process that cannot be controlled by any party.

By contrast, in Aunger's memetic theory of technological change, neither variation nor selection involve forward-looking intelligence, as he holds that even design, or innovation, involves random mutation of form. This is the result of a radical vision of cognition according to which cognitive processes are themselves processes of variation and selection of memes over which human beings have no real control, since they are subconscious processes driven by the laws of memetics. In the language of memetics, designers are "meme fountains": along with artists and scientists, they are people who happen to be good at producing new memes or integrating existing ones. The new memes they produce are designs of technical artifacts.

Let me finally come to an evaluative question: which perspective on design and technological innovation is right? Is it Aunger's radical approach, in which designers are mere pawns in an evolutionary process? Is it the traditional, non-evolutionary approach in which designs spring from the creativity and intelligence of designers? Or is it Basalla's or Mokyr's approach, located somewhere in between? I want to suggest that there may be more than one valid conceptual framework in which to analyze design and innovation. If the purpose is to explain the presence of certain features or functions in an artifact, then it may be most useful to highlight the intentions of designers. For example, it can be explained that the panhandle is curved because the designer wanted the pan to have an easy grip. This kind of explanation is called an *intentional explanation*, as it explains things or events as the product of human intentions. If the purpose is to explain technological change, then too many constraints are at work besides the intentions of designers or innovators, and one should resort to a *causal* (or *structural* or *functional*) *explanation* that references to structural features or mechanisms at work in producing such change (Little, 1991). The claim of evolutionary theorists of

technology are that such mechanisms are evolutionary, in a broad sense, and should inherit part of the vocabulary and laws of evolutionary biology.

In Basalla's and Mokyr's approaches, the resulting evolutionary explanations are underpinned in part by intentional explanations: they are macro-analyses that can be related to micro-analyses which include individuals such as designers and users who have intentions, desires and beliefs, and act on them. In Aunger's approach, however, the micro-level of analysis includes no intentional agents but agents with minds that are themselves subjected to blind variation and selection. Put differently, Basalla and Mokyr still treat the mind as an *intentional black box* (Haugeland, 1981), an entity that has intentions and generates ideas and requires no further explanation, whereas Aunger, correctly or incorrectly, reduces the mind to a non-intentional, non-forwardlooking process of meme variation and selection.

7 Conclusion

In this chapter, I aimed to examine whether the evolution of technical artifacts is radically different from the evolution of biological species, and whether designed artifacts are best explained as resulting from the purposive intelligence of designers or instead from a process akin to biological evolution. I discussed evolutionary theories of technology by George Basalla, Joel Mokyr, and Robert Aunger, and examined whether they qualified as genuinely evolutionary theories. I concluded that on Basalla's account, technological innovation and change are weakly analogous to biological evolution, whereas on Mokyr's and Aunger's account, they are strongly analogous.

Although I have not demonstrated the validity of evolutionary approaches to technology, I hope to have convinced the reader that such approaches are worth taking seriously. Evolutionary approaches to technology present us with a vision of design in which the intentions and beliefs of designers and others are at best only part of the explanation of processes of technological innovation and change. They yield a conception of designers as initiators of new variants that then undergo selection in society. Designers are agents of mutation and recombination in the production of new variants. They have partial, but no complete, control over this production process. The success of the variants they produce in the subsequent selection process, or their fitness, can only be predicted or controlled by designers to a very limited extent. This perspective on design and innovation is worth developing further, as it may help us better understand the role of designers in technological innovation and the conditions under which technological innovation is successful.

References

Andersen, E., ed., 1994, *Evolutionary Economics: Post-Schumpeterian Contributions*, Pinter Publishers, London.
Aunger, R., 2002, *The Electric Meme*, Free Press, New York.

Aunger, R., ed., 2000, *Darwinizing Culture. The Status of Memetics as a Science*, Oxford University Press, Oxford.

Basalla, G., 1988, *The Evolution of Technology*, Cambridge University Press, Cambridge.

Bijker, W., Pinch, T., and Hughes, T., eds., 1987, *The Social Construction of Technological Systems: New Directions in the Sociology and History of Technology*, MIT Press, Cambridge, MA.

Blackmore, S., 1999, *The Meme Machine*, Oxford University Press, Oxford.

Callebaut, W., and Pinxten, R., eds., 1987, *Evolutionary Epistemology: A Multiparadigm Program*, Reidel, Dordrecht.

Cziko, G., 1995, *Without Miracles: Universal Selection Theory and the Second Darwinian Revolution*, MIT Press, Cambridge, MA.

Darwin, C., 1859, *On the Origin of Species by Means of Natural Selection*, Murray, London.

Dawkins, R., 1976, *The Selfish Gene*, Oxford University Press, Oxford.

Dawkins, R., 1986, *The Blind Watchmaker*, Norton, New York.

Dembsky, W. (1999). *Intelligent Design: The Bridge Between Science and Theology*, InterVarsity Press, Downers Grove.

Dennett, D., 1995, *Darwin's Dangerous Idea: Evolution and the Meanings of Life*, Simon and Schuster, New York.

Dopfer, K., ed., 2005, *The Evolutionary Foundations of Economics*, Cambridge University Press, Cambridge.

Hahlweg, K., and Hooker, C., eds., 1989, *Issues in Evolutionary Epistemology*, SUNY Press, Albany, NY.

Haugeland, J., 1981, The nature and plausibility of cognitivism, in: *Mind Design*, J. Haugeland, ed., MIT Press, Cambridge, MA, pp. 243–281.

Little, D., 1991, *Varieties of Social Explanation*, Westview Press, Boulder, CO.

Mokyr, J., 1996, Evolution and technological change: a new metaphor for economic history, in: *Technological Change*, R. Fox, ed., Harwood Publishers, London.

Mokyr, J., 1998, Induced technical innovation and medical history: an evolutionary approach, *J. Evol. Econ.* **8**:119–137.

Mokyr, J., 1999, Invention and rebellion: why do innovations occur at all? an evolutionary approach, in: *Minorities and Economic Growth*, E. Brezis and P. Temin, eds., Elsevier Publishers, Amsterdam, pp. 179–203.

Mokyr, J., 2000a, Innovation and selection in evolutionary models of technology: some definitional issues, in: *Technological Innovation as an Evolutionary Process*, J. Ziman, ed., Cambridge University Press, Cambridge.

Mokyr, J., 2000b, Knowledge, technology, and economic growth during the industrial revolution, in: *Productivity, Technology and Economic Growth*, B. Van Ark, S. Kuipers, and G. Kuper, eds., Kluwer/Springer, The Hague.

Paley, W., 1802, *Natural theology: Or, Evidences of the Existence and Attributes of the Deity, Collected from the Appearances of Nature*, J. Faulder, London.

Ziman, J., ed., 2000, *Technological Innovation as an Evolutionary Process*, Cambridge University Press, Cambridge.

Deciding on Ethical Issues in Engineering Design

Anke Van Gorp and Ibo Van de Poel

Abstract Engineers make decisions concerning ethical issues like safety and sustainability in design processes. We argue that the way in which engineers deal with such ethical issues depends on the kind of design process they carry out. Vincenti distinguishes between normal and radical design. In normal design processes the operational principle and normal configuration are given, in radical design processes they are not given. We present four case-studies of actual design processes: two processes of normal design and two of radical design. We show that in the normal design processes, engineers use what we call regulative frameworks to make ethical decisions. Regulative frameworks consist of legislation and technical standards, and interpretations thereof by certifying organizations. Operationalizations of ethical criteria are given in these regulative frameworks. Regulative frameworks also define some minimal requirements on safety and sustainability that the product should meet. In the radical design processes, such frameworks are absent or difficult to apply. Morally warranted trust in engineers can therefore not be based on regulative frameworks in the case of radical design; for radical design a different basis is needed on which to base such trust.

1 Introduction

Engineering design is fraught with the need to make ethically relevant choices. Suppose, for example, that you are designing a printer/copier. During the design process, a choice will be made as to whether the printer/copier will be able to print two sided or not. Once a choice is made for two sided printing and copying, an additional choice needs to be made about the default properties. If two sided printing is the default option, users have to make an explicit choice to print one sided. This default option will probably save a lot of paper compared with a printer/copier that can only print on one side. While the environmental effects of saving paper by

A. Van Gorp, TNO Quality of Life

I. Van de Poel, Delft University of Technology

printing two sided copies for a single printer/copier are limited, the global effects for the total number of printers/copiers in use is enormous. As paper is produced from wood, a reduction in paper use will also reduce the amount of wood used. The production of paper, the transportation of wood and the transportation of paper all require energy. The amount of energy used in the process will also be reduced and the total reduction in resources used will be significant on a global scale.

This example shows that decisions made during the design phase of a product, that might seem trivial during that phase, can have large environmental effects. Such environmental effects are ethically relevant because protecting the environment and sustainability are moral issues. Looking at sustainability questions such as: what is our responsibility towards future generations? and do ecosystems have intrinsic value? need to be answered. When engineers make decisions about sustainability during a design process they implicitly take a stance on these issues. For example if the one sided option is chosen for the printer/copier then future generations will probably have to deal with more environmental problems because more (fossil) energy and trees have been used.

We will call certain issues ethical if moral values are at stake. The central moral values we focus on in this contribution are safety and sustainability. In the case of the printer/copier, the moral value of sustainability seems to require unequivocally the choice for a device for which two sided printing is the default option. Often, however, moral values will come into conflict during a design process: the option that is the safest for example, might not be the most sustainable one (cf. Van de Poel, 2001; Van Gorp and Van de Poel, 2001). In such cases, trade-offs between different moral values have to be made. How to make such trade-offs in an acceptable way is in itself an ethical issue.

In this paper, we argue that there is an important difference in the way engineers deal with ethical issues in normal and radical design processes.[1] More specifically, our claim is that engineers use regulative frameworks to decide on ethical issues in normal design, while in radical design processes such frameworks are absent or inapplicable. To substantiate this claim, we present four case studies of design processes: two normal and two radical. The two normal design processes were one, designing piping and equipment for the chemical industry and two, designing a bridge. The two radical design processes were one, designing a sustainable lightweight car and two, designing a lightweight trailer to transport sand. These case studies were carried out by one of the authors (Van Gorp, 2005). The methods used for data collection included observing design teams, reading design documents and interviewing engineers.

In the following section we will present Vincenti's distinction between normal and radical design and introduce the notion of a regulative framework. Descriptions of the four case studies are given in section three. We end the paper with a discussion and conclusions including the moral implications of the results.

[1] See Van de Poel and Van Gorp (2006) for a comparable claim. The claim we make here is more specific, and we present some new cases.

2 Design Type and Regulative Framework

2.1 *Design Type: Normal Versus Radical Design*

Vincenti (1990; 1992) uses two dimensions to characterize design processes: design hierarchy and design type. Here we focus on design type because earlier research suggests that this is important for how engineers deal with ethical issues (Van de Poel and Van Gorp, 2006). Vincenti (1990) uses the terms "operational principle" and "normal configuration" to indicate what normal design as opposed to radical design is. "Operational principle" is a term introduced by Polanyi (1962). It refers to how a device works. For example, incandescent light bulbs and fluorescent lights have different operational principles. In a light bulb a tungsten wire conducts the electrical current. This heats up the wire: electrons are excited and emit light as they fall back. In fluorescent lights a large voltage passed between two electrodes travels through a gas creating a kind of plasma. Electrons from mercury atoms in the tube are excited and emit ultraviolet light. Phosphorus powder on the glass transfers the ultraviolet into visible light by electrons being excited and emitting light in the visible range when falling back. So although both types of lights give light they have different operational principles.

Normal configuration is described by Vincenti as: '… the general shape and arrangement that are commonly agreed to best embody the operational principle.' (1990, 209). We interpret the general shape and arrangement to include the kind of material that is used. Vincenti does not include the materials explicitly but the materials used in a design are very important for the shape of parts and the product. Moreover, using different materials, for example plastics instead of steel, often requires new types of knowledge to produce a product and new methods to test it. The use of such new knowledge and methods is typical for radical design compared to normal design.

According to Vincenti's definition, in normal design both the operational principle and normal configuration are kept the same as in previous designs. In radical design, the operational principle and/or normal configuration are unknown or a decision has been made not to use the conventional operational principle and/or normal configuration.

2.2 *Regulative Framework*

For most products, a system of regulations and formal rules exists that can be used to govern design decisions, including decisions on ethical issues like safety and sustainability. Van Gorp (2005) has introduced the term regulative framework for the system of norms and rules that applies to a class of technical

products with a specific function. A regulative framework consists of all relevant regulation, national and international legislation, technical standards and rules for controlling and certifying products.[2] A regulative framework is socially sanctioned, for example by a national or supra-national parliament such as the European parliament or by organizations that approve standards. Besides the technical standards and legislation, interpretations of legislation and technical standards also form part of the regulative framework. Interpretations of standards and legislation can be provided by the controlling and certifying organizations and by engineering societies for example, during the courses they organize for engineers on state of the art design practices. Informal rules and company-specific rules are not part of the regulative framework.

There are various EU directives for a broad range of products.[3] This includes for example the Directive Machinery 98/37/EC, which covers all machinery with moving parts. Another important directive is the Low Voltage Equipment Directive 73/23/EC, which covers all equipment with a voltage between 50 and 1000 DC and 75 and 1500 AC.

EU directives have to be implemented in national law within the EU. It is, therefore, to be expected that all EU countries will have national laws implementing the EU directives. All these directives refer to technical standards such as the EU codes.[4] If these standards, or national standards if the EU codes are not available yet, are followed in design processes, then compliance with the directive is assumed. The European Committee for Standardization (CEN) is responsible for formulating the standards. CEN has committees for formulating standards on subjects ranging from chemistry, to food, consumer products, construction, transport and packaging (www.cenorm.be).[5]

[2] In Van de Poel and Van Gorp (2006) we use the concept 'normative framework' introduced by Grunwald (2000; 2001). The normative framework is different from the regulative framework because the normative framework has to meet certain normative criteria.

[3] The main goal of standardization in the EU is to ensure a free market and to remove technical barriers for trade within the EU (European Committee, 1999). Besides the goal of supporting a free market, standardization 'promotes safety, allows interoperability of products, systems and services, and promotes common technical understanding' (www.cenorm.be).

[4] In the US, the following terminological distinction is often made between codes and standards: codes are legal requirements that are enforced by a governmental body to protect safety, health and other relevant values; standards are not mandatory; they are usually regarded as recommendations (Hunter, 1997). EU codes are not legally enforced. If EU codes have been applied the design is assumed to comply with the relevant directive. In the mentioned US terminology, EU codes are therefore technical standards.

[5] A full description of the cases can be found in Van Gorp (2005).

3 Case-Studies

3.1 Piping and Equipment

The studied design process for pipes and pressure vessels for chemical plants was a case of normal design: the operational principles and normal configurations were known and used.

After disasters like Bhopal, Seveso and recently the severe contamination of a Chinese river with benzene following an explosion in a chemical installation, it is not difficult to support the idea that safety in chemical installations is an ethical issue. In the case studied, the decisions regarding safety that engineers made during the design process ranged from decisions about safety valves, load scenarios, required material properties, to safety distances between pressure vessels. The engineers used the existing regulative framework to help them make decisions concerning safety, and believed that designing according to the regulative framework produced safe installations.

The regulative framework for pipes and pressure vessels used in the Netherlands is based on the European Pressure Equipment Directive (PED) (European directive 97/23/EC). Certification organizations, called Notified Bodies, are appointed in each EU country to check whether new designs and refurbishments comply with PED regulations. Approved designs obtain a CE mark.

Other regulations that are part of the regulative framework are those encompassing environmental regulations and regulations regarding noise and smell. Such regulations are commonly used to regulate the outcome of the design process: an installation should perform within the limits of allowed noise levels and emissions.

The relevant legislation and regulations make references to standards, which are therefore also part of the regulative framework. The organizations that formulate standards differ in different countries. Standards can be formulated by professional organizations, e.g., the American Society of Mechanical Engineers (ASME), industry, e.g., *Regels* in the Netherlands or by governmental institutions, e.g., British Standards. Standards are usually written rules for good design practice that, if used correctly, should protect the health and safety of persons and protect the environment. Standards are often prescriptive; they prescribe the use of certain hardware and calculations. In some countries, the application of a certain standards is required by law. In many states of the United States, the application of the ASME standards for pressure vessels and piping is required by law. In the EU, the use of EU standards during the design process of pipelines and pressure vessels leads to an assumption that the design conforms to the PED.

Despite the existence of an extensive regulative framework for pipes and pressurize vessels some elements of choice remain for the design engineers and for their customers. Due to the existence of a variety of safety standards for pipes and pressurize vessels the design engineers and their customers need to choose which of the standards to apply. Additionally the regulative framework does not cover all the safety choices that need to be made during the early phases of the design

process. Where such choices are not mandated safety becomes the responsibility of the design engineers and their customers. For example, the design engineers in the case study mentioned that accident and load scenarios are not defined in the European standards and legislation for pipes and pressure vessels, even if the PED requires that a risk analysis is carried out. According to the engineers they usually referred to company standards for load and accident scenarios in such cases, or, if these are not available, discussed the issue with their customer or asked advice from the national notified body.

3.2 Bridge

Our second case concerned the preliminary construction design phase for an arched bridge over the Amsterdam-Rijncanal in Amsterdam. This case was an instance of normal design because the operational principle and normal configuration of arched bridges are well-known and were used when designing this bridge.

Several ethical questions about the safety and sustainability of the bridge were encountered by the engineers. The collapse of a bridge can cause deaths and injuries so decisions that influence the chances of the bridge collapsing are ethically relevant. Moreover, the construction industry is prone to accidents in which people are killed or seriously injured on the construction site, and the Netherlands is no exception. During the design process of a bridge decisions are made that influence construction site safety and risks that workers face during construction. Safety of the bridge covered several different aspects: safety during use, safety during construction, and safety for ships passing under the bridge.[6]

Most of the decisions concerning safety during use of the bridge were made using a regulative framework for bridge building that is based on the Dutch building decree. The building decree is detailed and contains prescriptions for, for example, strength calculations. The building decree refers to standards, for example, the Dutch standard for concrete and steel bridges (NEN 6723, 1995 and NEN 6788, 1995, respectively). Although the bridge regulative framework covers most of the decisions that need to be made concerning bridge safety and sustainability of the construction, it does not cover all decisions. An example of a safety issue that is not covered is misuse. In the case of the Amsterdam bridge people could climb onto the arches of the bridge because the arches were not very steep. The design engineers had to decide whether or not to do something to prevent people from climbing onto and walking on the bridge arches.

The regulative framework concerning safety during bridge construction is based on two European directives: 89/391/EC (working conditions) and 92/57/EC (health and safety on construction sites). The European directives are incorporated in

[6] We will not focus on obstructing ships on the canal, an elaboration of this can be found in Van Gorp (2005).

Dutch legislation in the working conditions decree (Arbeidsomstandighedenbesluit version February 2004). This decree requires a health and safety plan to be made for the construction of a bridge, and the design engineers, contractors and customers are held responsible for different parts of the health and safety plan. During the design phase, a design health and safety coordinator has to list and evaluate all risks. There are more substantial rules for working conditions but the design team did not know the exact content of these rules. They believed that compliance with these substantial rules was part of the responsibilities of the contractor, because the contractor is the employer at the building site. In fact, compliance to the rules is the responsibility of the employer and the employee in the working conditions decree. Thus there is a regulative framework for working conditions but this regulative framework was not used during the design process because the design engineers did not consider it part of their responsibility to address working condition issues arising during construction in any substantive way. The engineers only made the required list of risks during construction.

3.3 Lightweight Car

The DutchEVO, a very light, sustainable family city car was designed at Delft University of Technology. The empty weight of the car was set at a maximum of 400 kg. At present European family cars usually weigh about 1200 kg; even the two seater Smart has an empty mass of 720 kg. The design requirement to produce a sustainable car with an empty mass of less than 400 kg led to a radical design process. It was not certain whether the normal configuration for a car could be used; this was something that had to be decided on during the design process. Eventually, a standard engine was chosen but the floor structure, the side panels and the doors were very different from those of regular cars.

Ethical issues related to safety and sustainability were encountered by the design engineers. First, the light car will always have higher acceleration in a crash with a heavier car and is, therefore, less safe than the heavier car for people inside the car. Second, it is not possible to incorporate all usual active and passive safety systems in a car of 400 kg. With regard to car safety the tests performed by EuroNCAP[7] are an important element of the regulative framework concerning cars in the EU. However, it was not possible to design a light car and still aim at very good results on the EuroNCAP crash tests. After an analysis of these crash tests, the design team decided that these crash tests lead to heavy cars that make people feel safe in their car. Cars performing well in EuroNCAP tests do not necessarily protect people well in all kinds of crashes, for example in crashes into trees or lampposts. Therefore the design team rejected the EuroNCAP crash tests. Third, the design team based part of their ideas about sustainability on the Brundtland definition of sustainable

[7] EuroNCAP is a cooperative of different European consumer and governmental organizations.

development, i.e., "development that meets the needs of the present without compromising the ability of future generations to meet their own needs" (WCED, 1987, 43). However, it is unclear whether cars can be considered to be sustainable under this definition. The Brundtland definition is usually interpreted as referring to basic needs only, and the question is whether personal transportation is a basic need of people. Fourth, sustainability was operationalized mainly as using less energy by making the car lightweight but other operationalizations can also be defended, for example, that a sustainable car is a recyclable car. Fifth, the design team also wanted the car to be "emotionally sustainable". By this they meant that people should get more satisfaction from the car than merely being able to use it to go from A to B. The team wanted to stimulate a caring relationship between car and owner, to promote long-term ownership rather than people 'throwing away' their car after a few years, and they wanted the car to be fun to drive. This can be at odds with the other part of sustainability because if people really like to drive a car, then they might use the car for distances that they would normally walk or cycle. This would increase energy use no matter how light the car is.

Decisions about safety and sustainability were made based on internal design team norms. These norms were developed during the design process. An example of an internal design norm was that when choosing between different options the lighter option should be chosen. Another internal design team norm was that for making driving in traffic safe, the driver of the car should feel a little vulnerable. These internal design team norms were based on the education of the engineers in the design team, their previous design experience[8] and their personal experience. The norm that the car should make the driver feel a little vulnerable was based on the personal experience of design team members that they tended to take more risks in modern cars than for example in a Citroën 2Cheveux.

3.4 Trailer

The second radical design case study was a preliminary design and feasibility study for a light composite trailer with a new loading/unloading system. This was a radical design process: the normal configuration and operational principle were changed because a new loading/unloading system was included in the design and a composite material was used to meet the demand for a light trailer.

An important ethical issue in trailer design is safety. In this case, a safe trailer was operationalized by the design engineers as a structurally reliable trailer: this means a trailer that will not fail during use. When designing a "normal" trailer there is a regulative framework that can be used that incorporates rules on maximum

[8] Most of the design team members were bachelor, master and graduate students therefore their design experience was very limited. The project leader was an experienced car designer and two other more experienced designers worked for the project.

loads on the axles, maximum heights, pneumatic springs, turning circles and the safety guards that should be in place to prevent cyclists and pedestrians from going under the wheels of a truck. Trucks have to be certified as meeting certain safety standards before they are allowed to be driving on the roads in the Netherlands.

The engineers used only two requirements of this regulative framework, the maximum allowed weights and the maximum allowed heights as specified in the framework. They decided not to familiarize themselves with the rest of the framework because they did not consider it relevant for their design task, i.e., the design of a reliable lightweight trailer using composite materials. Moreover, the design engineers realized that all parts of the regulative framework that included references to material properties had been written with the idea that the product would be made of metal.

All other decisions concerning safety were based on internal design team norms. These norms were based on the type and level of education of the engineers, more than half of them had a Master's degree in aerospace engineering, and of the design experience of the engineers and of the engineering company involved. Within the engineering company there was a lot of experience with lightweight design and the use of fiber reinforced plastic composites. This experience had led to company norms regarding what constituted a good and safe design. For example, an internal norm on good lightweight design was that material should only be added to places where loads were supported. Another example was that, when making a design out of composite materials, a new configuration needs to be made, it is not sufficient to copy a configuration used for non-composite materials. Personal experience did not play a large role in this design process.

With the operationalization of safety as structural reliability, the engineers neglected traffic safety. They only felt responsible for designing a reliable construction. Within the company, no one had experience with traffic safety measures and therefore there were no internal company norms relating to traffic safety. Nevertheless, many of the important ethical issues regarding trailers are related to traffic safety. People can be killed in accidents with trucks and trailers, for example cyclists or pedestrians can be run over if a truck driver fails to see them when turning a corner. Moreover, the engineers decided where the heavy and stiff elements of the trailer should be situated. This decision influences traffic safety because it determines the elements that will hit other traffic participants during a collision (Van der Burg and Van Gorp, 2005).

4 Discussion and Conclusion

The case studies show a clear difference between how ethical issues are dealt with in normal and in radical design. In the case of normal design, ethically relevant choices were made on the basis of existing regulative frameworks, arising from regulations and standards. Operationalizations of ethically relevant criteria were defined as part of these regulative frameworks. The frameworks also served to

define some minimal requirements on safety and sustainability that a product should meet. In the cases of radical design, the lightweight car and the lightweight composite trailer, decisions with respect to ethically relevant issues were made primarily on the basis of internal design team norms.

Three further observations can be made. One, in the cases of normal design, the regulative framework did not cover all ethically relevant issues. The engineers or their customers had to make some ethically relevant decisions that went beyond the existing framework, for example which accident scenarios to take into account in the design of piping and pressure equipment. Two, sometimes the regulative framework was not deemed relevant in a design process because the design engineers believed that taking into account these frameworks was outside their specific responsibility as design engineers. In the bridge case (normal design), the engineers did not consider the framework related to work conditions. In the trailer case (radical design), the engineers took into account only part of the framework on trailers. Three, with respect to radical design, even if internal design team norms played a predominant part in ethically relevant decisions made during a radical design process, regulative frameworks still played a role, in the sense that the values, like safety and sustainability, contained in regulative frameworks were still considered to be very important.[9]

The cases reveal a number of reasons why regulative frameworks are not, or not entirely, applied in radical design. One reason is that frameworks cannot be applied because application sometimes leads to recommendations that are, from a technical point of view, senseless. In the case studies, the inapplicability of existing frameworks was partly due to the use of new materials. Some concepts in a regulative framework loose their applicability if another material is used. For example, when a design that is usually made in homogeneous metals is made in composite materials some of the material properties cannot be determined in the ways prescribed by the relevant framework. With composite materials stresses will vary in the different parts constituting the composite. The notion "the stress in the material" as stated in current regulative frameworks looses its meaning because the different parts of a composite will be subjected to different stresses and speaking of "*the* stress in the material" thus becomes meaningless. The consequence of this is that all guidelines and calculation rules referring to stresses will be inapplicable for a product made in a composite.

Earlier, we defined a regulative framework as the set of rules and norms that applies to a class of technical products with the same function. However, as the composite example shows, some of the rules and norms of a regulative framework are specific for a certain material. Some rules may also be specific for a certain hardware configuration or an operational principle. Conversely, other rules or norms, like the need to take into account safety considerations, are so general that they are still applicable and relevant for products made of a different material, or

[9] Note that in the trailer case the engineers thought that safety was important but they defined safety very narrowly as structural reliability.

with a different normal configuration or operational principle. So while parts of a regulative framework often become inapplicable in radical design, other parts may still be applicable and relevant.

Another reason why existing regulative frameworks were not used in the radical design cases, especially in the lightweight car case, was that the engineers rejected, for moral reasons, parts of the framework in particular the EuroNCAP crash tests. These crash tests were considered morally inadequate because they stress the safety of people inside the car at the cost of sustainability and the fuel efficiency of a car. Note that in this kind of situation, the causal arrow can be reversed. Considering a regulative framework at the start of the design process can cause design engineers to reject parts of it and to develop a more radical design.

It is likely that the differences between how ethical issues are dealt with in normal and radical design holds beyond the four case studies presented here. Regulative frameworks exist for most products. The use of such frameworks can be required by law, or, if that is not the case, following the framework is often interpreted as compliance with the requirements of the law.[10] This legal or semi-legal status of regulative frameworks is clearly a strong incentive to use such frameworks to make ethically relevant choices in design.

In radical design, however, regulative frameworks often become partly inapplicable. In our case studies we found one particular reason for this to happen: the use of another type of material. One might expect, that a design that is either based on a new operational principle or a new normal configuration, or both, will often cause parts of an existing regulative framework to become inapplicable. However, in general, the general goals of a regulative framework, like safety, will still be relevant in the case of radical design. Yet specific operationalizations or prescriptions designed to promote safety will often become inapplicable or contradictory. For example, designing an automatically guided vehicle using the existing regulative framework on traffic would lead to contradictions and strange situations. In the current regulative framework pertaining to traffic safety a vehicle should always have a driver but the goal of designing an automatically guided vehicle is to design a vehicle that can move safely without a driver.[11] One goal of the traffic safety regulative framework is to achieve safe vehicles and safe traffic flows and this higher level goal is still relevant for the design of automatically guided vehicles. So the rationale behind the regulative framework remains important but most of the legislation and standards contained in the traffic regulative framework will not be applicable in the case of an automatically guided vehicle.

If a design team or a customer rejects, parts of, a regulative framework because they think that the regulative framework leads to morally unacceptable products, this can lead to the rethinking of normal configurations and operational principles.

[10] The latter leaves open the possibility to meet the law by other means than following the regulative framework.

[11] Because Dutch legislation requires vehicles in public space to have a driver, special social arrangements need to be made to carry out tests with automatically guided vehicles.

Some more detailed and prescriptive parts of regulative frameworks are formulated with certain operational principles and normal configurations in mind. If a design team thinks that these parts lead to morally unacceptable products, then they will rethink the normal configurations and operational principles as was done in the lightweight car case. Rejecting, parts of, regulative frameworks can lead to the design process becoming radical.

From the foregoing it can be concluded that even if a regulative framework is available to guide, parts of, a radical design process, it will be rejected or not be, completely, applicable. This would mean that, in general, a regulative framework cannot, or can only be partly, used in radical designs to help design engineers decide on ethical issues. Engineers in these circumstances will, in general, refer more to internal design team norms. If such norms do not exist, then norms will be developed during the design process. The design team members will use their field of education, design experience and personal experience to develop such internal design team norms.

We want to end our contribution by briefly sketching the moral relevance of our findings. Some engineers maintain that technology is morally neutral and that no ethical decisions are made during design. We have provided ample (empirical) evidence why this position is mistaken. Nevertheless, the distinction between normal and radical design is relevant for how moral considerations are taken into account during design. In normal design, moral considerations are embedded in the regulative frameworks that are used for making ethically relevant considerations. Such moral considerations are introduced during the formulation, and reformulation, of such regulative frameworks at the level of the engineering community and society. So even if individual design engineers are unaware of the moral issues in their design process, or are not inclined to take into account moral considerations, such considerations enter the design process through existing regulative frameworks. This mechanism is absent in the case of radical design. Therefore, whether and how moral considerations are taken into account depends to a large degree on the design engineers themselves. The moral responsibility of the design engineers for the products they design, as a result, becomes larger (cf. Van de Poel and Van Gorp, 2006). Sometimes, this might mean that relevant ethical issues are neglected, as with respect to traffic safety in the trailer case. Conversely, it might also lead to more attention for moral issues than found in normal design. In the lightweight car case, for example, the design engineers chose a radical design at least partly on moral grounds.

The distinction between normal and radical design is also relevant for the grounds on which the public can have morally warranted trust in the work of engineers and the resulting products (Van Gorp, 2005). Regulative frameworks are usually socially sanctioned; they are the result of recognized and socially legitimatized processes of decision-making. Therefore, such frameworks can provide grounds for morally warranted trust in engineering and in technical products. In radical design, this basis for trust is lacking. This raises the question of what the trust placed in engineers by the rest of society can be based on in such situations. We will not try to answer this question in detail here, but we will mention one possibility: in such situations trust

might require engineers to take into account different possible perspectives and thus to look beyond their internal design team norms (Van Gorp, 2005).

Although it might seem to follow that in general radical design is morally more dubious than normal design, radical design can be morally warranted in situations where good reasons exist to doubt the moral adequacy of a current regulative framework. Take the case of crash safety regulations for example; at present these tend to focus on people inside the car, paying little attention to other unprotected road and pavement users such as cyclists and pedestrians (cf. Van Gorp, 2005).[12]

References

Arbeidsomstandighedenbesluit, 2004, SdU Uitgevers, The Hague.

European Committee, 1999, Guide to the implementation of directives based on New Approach and Global Approach, Brussels.

Grunwald, A., 2000, Against over-estimating the role of ethics in technology development, *Sci. Eng. Eth.* **6**(2):181–196.

Grunwald, A., 2001, The application of ethics to engineering and the engineer's moral responsibility: perspectives for a research agenda, *Sci. Eng. Eth.* **7**(3):415–428.

Hunter, Th. A., 1997, Designing to Codes and Standards, in: *ASM Handbook*, G.E. Dieter and S. Lampman, eds., pp. 66–71.

Polanyi, M., 1962, *Personal Knowledge*, University of Chicago Press, Chicago.

Van de Poel, I. R., 2001, Investigating ethical issues in engineering design, *Sci. Eng. Eth.* **7**(3):429–446.

Van de Poel, I. R., and Van Gorp, A. C., 2006, The need for ethical reflection in engineering design; the relevance of type of design and design hierarchy, *Sci. Technol. Hum. Valu.* **31**(3):333–360.

Van der Burg, S., and Van Gorp, A., 2005, Understanding moral responsibility in the design of trailers, *Sci. Eng. Eth.* **11**(2):235–256.

Van Gorp, A., and Van de Poel, I., 2001, Ethical considerations in engineering design processes, *IEEE Technol. Soc. Mag.* **21**(3):15–22.

Van Gorp, A. C., 2005, *Ethical Issues in Engineering Design; Safety and Sustainability*, Simon Stevin Series in the Philosophy of Technology, Delft.

Vincenti, W. G., 1990, *What Engineers Know and How They Know It*, John Hopkins University Press, Baltimore and London.

Vincenti, W. G., 1992, Engineering knowledge, type of design, and level of hierarchy: further thoughts about what engineers know …, in: *Technological Development and Science in the Industrial Age*, P. Kroes and M. Bakker, eds., Kluwer, Dordrecht, pp. 17–34.

World Commission on Environment and Development [WCED], 1987, *Our Common Future*, Oxford University Press, New York and Oxford.

[12] We would like to thank all the cooperating design engineers and companies. We also wish to thank Pieter Vermaas for his valuable comments.

Morality in Design

Design Ethics and the Morality of Technological Artifacts

Peter-Paul Verbeek

Abstract A core issue in the philosophy of technology has been the non-neutrality of technology. Most scholars in the field agree that technologies actively help to shape culture and society, rather than being neutral means for realizing human ends. How to take seriously this non-neutrality of technology in ethics? Engineering ethics mainly focuses on the moral decisions and responsibilities of designers, and remains too external to the moral significance of technologies themselves. Yet, analyses of the non-neutrality of technology make it plausible to ascribe some morality to artifacts. First of all, technologies substantially contribute to the coming about of actions and of decisions about how to act. Second, their role cannot be entirely reduced to the intentions behind their design and use. This paper investigates what these observations imply for ethical theory, and for the ethics of design.

1 Expanding the Ethics of Technology

In our technological culture, ethical issues regarding technology are receiving ever more attention and weight. A few decades ago, normative reflection on technology was highly abstract, criticizing 'technology' as such, and its impact on society and culture, like the advent of a 'one-dimensional man' (Marcuse), 'mass-rule' (Jaspers), and 'mastery and control over nature' (Heidegger). Over time, normative reflection has sought closer contact with technologies themselves. Not only did applied fields like ethics of information technologies and ethics of biomedical technology come into being; the ethics of technology has also started to reflect on the very design of technologies. Branches like engineering ethics and ethics of design aim to provide engineers and designers with vocabularies, concepts and theories that they can use to make responsible decisions in the practice of technology development.

This movement toward more contact with technologies themselves can be taken one step further. In its current form, engineering ethics and the ethics of design tend

P.-P. Verbeek, University of Twente

P. E. Vermaas et al. (eds.), *Philosophy and Design.*
© Springer 2008

to follow a somewhat externalist approach to technology. The main focus is on the importance of taking individual responsibility ('whistle blowing') to prevent technological disasters, and on methods that can be used to assess and balance the risks accompanying new technologies. Favorite cases studies concern technologies which have caused a lot of problems that could have been prevented by responsible actions of engineers, like the exploding space shuttle "Challenger", or the Ford Pinto with its rupturing gas tank in crashes over 25 miles per hour. Case studies like these approach technology in a merely instrumental way. They address technologies in terms of their functionality: technologies are designed to do something, and if they fail to do so properly, they are badly designed. What such case studies fail to take into account are the impacts of such technologies on our moral decisions and actions, and on the quality of our lives.

When technologies are used, they always help to shape the context in which they fulfill their function. They help to shape human actions and perceptions, and create new practices and ways of living. This phenomenon has been analyzed as 'technological mediation': technologies mediate the experiences and practices of their users (Latour, 1992; Ihde, 1990; Verbeek, 2005). Such technological mediations have at least as much moral relevance as technological risks and disaster prevention. Technologies help to shape the quality of our lives and, more importantly, they help to shape our moral actions and decisions. Cell phones, e.g., contribute explicitly to the nature of our communications and interactions; and technologies like obstetric ultrasound play active roles in the decisions we make regarding unborn life. In order to address the moral aspects of technology development adequately, the ethics of technology should expand its approach to technology to include technological mediation and its moral relevance, enabling designers to take responsibility for the quality of the functioning of their designs, and for the built-in morality. In this chapter I will first explore how this moral relevance of technological devices can be conceptualized. After that, I will elaborate how it can be incorporated in the ethics of technology.

2 Do Artifacts have Morality?

The question of the moral significance of technological artifacts has been playing a role on the backbenches of the philosophy of technology for quite some time now. As early as 1986 Langdon Winner asked himself: "Do artifacts have politics?" This question was grounded in his analysis of a number of 'racist' overpasses in New York, which were deliberately built so low that only cars could pass beneath them, but not buses, thus preventing the dark-skinned population, unable to afford a car, from accessing the beach (Winner, 1986). Bruno Latour (1992) subsequently argued that artifacts are bearers of morality as they constantly help people to take all kinds of moral decisions. For example, he shows that the moral decision of how fast one drives is often delegated to a speed bump in the road with the script 'slow down before reaching me'. Anyone complaining about deteriorating morality,

according to Latour, should use their eyes better, as the objects around us are crammed with morality.[1]

Many of our actions and interpretations of the world are co-shaped by the technologies we use. Telephones mediate the way we communicate with others, cars help to determine the acceptable distance from home to work, thermometers co-shape our experience of health and disease, and antenatal diagnostic technologies generate difficult questions regarding pregnancy and abortion. This mediating role of technologies also pertains to actions and decisions we usually call 'moral', ranging from the driving speed we find morally acceptable to our decisions about unborn life. If ethics is about the question 'how to act', and technologies help to answer this question, technologies appear to do ethics, or at least to help us to do so. Analogously to Winner's claim that artifacts have politics, therefore, the conclusion seems justified that artifacts have morality: technologies play an active role in moral action and decision-making.

How can we understand this material morality? Does it actually imply that artifacts can be considered moral agents? In ethical theory, to qualify as a moral agent at least requires the possession of *intentionality* and some degree of *freedom*. In order to be held morally accountable for an action, an agent needs to have the intention to act in a specific way, and the freedom to realize this intention. Both requirements seem problematic with respect to artifacts, at least, at first sight. Artifacts, after all, do not seem to be able to form intentions, and neither do they possess any form of autonomy. Yet, both requirements for moral agency deserve further analysis.

2.1 Technological Intentionality

At a first glance, it might seem absurd to speak about artifacts in terms of intentionality. A closer inspection of what we mean by 'intentionality' in relation to what artifacts actually 'do', however, makes it possible to attribute a specific form of intentionality to artifacts. To show this, it is important to make a distinction here between two aspects of 'intentionality.' One, intentionality entails the ability to *form intentions*, and two, this forming of intentions can be considered something *original* or *spontaneous* in the sense that it literally 'springs from' or is 'originated by' the agent possessing intentionality. Both aspects of intentionality will appear not to be as alien to technological artifacts as at first they might seem.

First, the 'mediation approach' to technology, already mentioned above, makes it possible to attribute to artifacts the ability to form intentions. In this approach, technologies are analyzed in terms of their mediating roles in relations between humans and reality. The core idea is that technologies, when used, always establish a relation between users and their environment. Technologies enable us to perform

[1] For other analyses of the moral relevance of technological artifacts, see Borgmann (1995) and Achterhuis (1995).

actions and have experiences that were scarcely possible before, and in doing so, they also help us to shape *how* we act and experience things. Technologies are not neutral instruments or intermediaries, but active mediators that help shape the relation between people and reality. This mediation has two directions: one pragmatic, concerning action, and the other hermeneutic, concerning interpretation.

Latour's work offers many examples of the pragmatic dimension of technological mediation. With Madeleine Akrich, he coined the term 'script' to indicate that artifacts can prescribe specific actions, just like the script of a film or play which prescribes who does what and when (Latour, 1992; Akrich, 1992). The speed bump mentioned above, for instance, embodies the script 'slow down before reaching me'. Everyday life is loaded with examples of technologies that help to shape our actions. In Dutch supermarkets, shopping carts are equipped with a coin lock, to encourage users to put the cart back in place rather than leaving it at the parking lot. Recently, carts have been introduced with a wheel lock blocking the wheels when the cart is moved outside a designated area, thus preventing it from being stolen.

Don Ihde's work concerns the hermeneutic dimension of technological mediation. Ihde analyzes the structure of the relations between human beings and technological artifacts, and investigates how technologies help to shape, on the basis of these relations, human perceptions and interpretations of reality (e.g., Ihde, 1990; 1998). A good example to illustrate this hermeneutic intentionality, which I have already briefly elaborated elsewhere (see Verbeek, 2006), is obstetrical ultrasound. This technology is not simply a functional means to make visible an unborn child in the womb. It actively helps to shape the way the unborn child is seen in human experience, and in doing so it informs the choices his or her expecting parents make. Because of the ways in which ultrasound mediates the relations between the fetus and the future parents, it constitutes both the fetus and parents in specific ways.

Ultrasound brings about a number of 'translations' of the relations between expecting parents and the fetus, while mediating their visual contact. One, ultrasound isolates the fetus from the female body. In doing so, it creates a new ontological status of the fetus, as a separate living being rather than forming a unity with his or her mother. This creates the space to make decisions about the fetus apart from the pregnant woman in whose body it is growing. Two, ultrasound places the fetus in a context of medical norms. It makes visible defects of the neural tube, and makes it possible to measure the thickness of the fetal neck fold, which gives an indication of the risk that the child will suffer from Down's Syndrome. In doing so, ultrasound translates pregnancy into a medical process; the fetus into a possible patient; and congenital defects into preventable suffering. As a result, pregnancy becomes a process of choices: the choice to have tests like neck fold measurements done at all, and the choice of what to do if anything is 'wrong'. Moreover, parents are constituted as decision-makers regarding the life of their unborn child. To be sure, the role of ultrasound is ambivalent here: on the one hand it may encourage abortion, making it possible to prevent suffering; on the other hand it may discourage abortion, enhancing emotional bonds between parents and the unborn child by visualizing 'fetal personhood'.

In all of these examples, artifacts are active: they help to shape human actions, interpretations, and decisions, which would have been different without the artifact. To be sure, artifacts do not have intentions like human beings do, because they cannot *deliberately* do something. But their lack of consciousness does not take away the fact that artifacts can have intentions in the literal sense of the Latin word 'intendere', which means 'to direct', 'to direct one's course', 'to direct one's mind'. The intentionality of artifacts is to be found in their directing role in the actions and experiences of human beings. Technological mediation, therefore, can be seen as a specific, material form of intentionality.

With regard to the second aspect of intentionality, the 'originality' of intentions, a similar argumentation can be given. For even though artifacts evidently cannot form intentions entirely on their own, again because of their lack of consciousness, their mediating roles cannot be entirely reduced to the intentions of their designers and users either. Otherwise, the intentionalities of artifacts would be a variant of what Searle denoted 'derived intentionality' (Searle, 1983), entirely reducible to human intentionalities. Quite often, technologies mediate human actions and experiences without human beings having told them to do so. Some technologies, for instance, are used in different ways from those their designers envisaged. The first cars, which only made 15 km/h, were used primarily for sport, and for medical purposes; driving at a speed of 15 km/h was considered to create an environment of 'thin air', which was supposed be healthy for people with lung diseases. Only after cars were interpreted as a means for providing long distance transport did the car get to play its current role in the division between labor and leisure (Baudet, 1986). In this case, unexpected mediations come about in specific use contexts. But unforeseen mediations can also emerge when technologies are used as intended. The very fact that the introduction of mobile phones has led to changes in youth culture – such as that young people appear to make ever less appointments with each other, since everyone can call and be called at any time and place – was not intended by the designers of the cell phone, even though it is used here in precisely the context the designers had envisaged.

It seems plausible, then, to attribute a specific form of intentionality to artifacts. This 'material' form of intentionality is quite different from human intentionality, in that it cannot exist without human intentionalities supporting it. Only within the relations between human beings and reality can artifacts play their 'intending' mediating roles. When mediating the relations between humans and reality, artifacts help to constitute both the objects in reality that are experienced or acted upon and the subjects that are experiencing and acting. This implies that the subjects who act or make decisions about actions are never purely human, but rather a complex blend of humanity and technology. When making a decision about abortion on the basis of technologically mediated knowledge about the chances that the child will suffer from a serious disease, this decision is not 'purely' human, but neither is it entirely induced by technology. The very situation of having to make this decision and the very ways in which the decision is made, are co-shaped by technological artifacts. Without these technologies, either there would not be a situation of choice, or the decision would be made on the basis of a different relation to the situation. At the same time, the

technologies involved do not *determine* human decisions here. Moral decision-making is a joint effort of human beings and technological artifacts.

Strictly speaking, then, there is no such thing as 'technological intentionality'; intentionality is always a hybrid affair, involving both human and nonhuman intentions, or, better, 'composite intentions' with intentionality distributed over the human and the nonhuman elements in human-technology-world relationships. Rather than being 'derived' from human agents, this intentionality comes about in associations between humans and nonhumans. For that reason, it could be called 'hybrid intentionality', or 'distributed intentionality'.

2.2 Technology and Freedom

What about the second requirement for moral agency we discerned at the beginning of this chapter: freedom, or even autonomy? Now that we have concluded that artifacts may have some form of intentionality, can we also say that they have *freedom*? Obviously not. Again, freedom requires the possession of a mind, which artifacts do not have. Technologies, therefore, cannot be free agents like human beings are. Nevertheless there are good arguments not to exclude artifacts entirely from the realm of freedom that is required for moral agency. In order to show this, I will first elaborate that human freedom in moral decision-making is never absolute, but always bound to the specific situations in which decisions are to be made, including their material infrastructure. Second, I will argue that in the human-technology associations that embody hybrid intentionality, freedom should also be seen as distributed over the human and nonhuman elements in the associations.

Even though freedom is obviously needed to be accountable for one's actions, the thoroughly technologically mediated character of our daily lives makes it difficult to take freedom as an absolute criterion for moral agency. After all, as became clear above, technologies play an important role in virtually every moral decision we make. The decision how fast to drive and therefore how much risk to run of harming other people is always mediated by the lay-out of the road, the power of the engine of the car, the presence or absence of speed bumps and speed camera's, et cetera. The decision to have surgery or not is most often mediated by all kinds of imaging technologies, blood tests et cetera, which help us to constitute the body in specific ways, thus organizing specific situations of choice.

To be sure, moral agency does not necessarily require complete autonomy. Some degree of freedom can be enough to be held morally accountable for an action. And not all freedom is taken away by technological mediations, as the examples of abortion and driving speed make clear. In these examples, human behavior is not determined by technology, but rather co-shaped by it, with humans still being able to reflect on their behavior and make decisions about it. This does not take away the fact, however, that most mediations, like those provided by speed bumps and by the presence of ultrasound scanners as a common option in medical practice, occur in a pre-reflexive manner, and can in no way be escaped in moral decision-making. The moral dilemmas

of whether or not to have an abortion and of how fast to drive would not exist in the same way without the technologies involved in these practices, such dilemma's are rather *shaped* by these technologies. Technologies cannot be defined away from our daily lives. The concept of freedom presupposes a form of sovereignty with respect to technology that human beings simply no longer possess.

This conclusion can be read in two distinct ways. The first is that mediation has nothing to do with morality whatsoever. If moral agency requires freedom and technological mediation limits or even annihilates human freedom, only non-technologically mediated situations leave room for morality. Technological artifacts are unable to make moral decisions, and technology-induced human behavior has a non-moral character. A good example of this criticism are the commonly heard negative reactions to explicit behavior-steering technologies like speed limiters in cars. Usually, the resistance against such technologies is supported by two kinds of arguments. One, there is the fear that human freedom is threatened and that democracy is exchanged for technocracy. Should all human actions be guided by technology, the criticism goes, the outcome would be a technocratic society in which moral problems are solved by machines instead of people. Two, there is the charge of immorality or, at best, amorality. Actions not the product of our own free will but induced by technology can not be described as 'moral'; and, what is worse, behavior-steering technologies might create a form of moral laziness that is fatal to the moral abilities of citizens.

These criticisms are deeply problematic. The analyses of technological mediation given above show that human actions are *always* mediated. To phrase it in Latour's words: "Without technological detours, the properly human cannot exist. (…) Morality is no more human than technology, in the sense that it would originate from an already constituted human who would be master of itself as well as of the universe. Let us say that it traverses the world and, like technology, that it engenders in its wake forms of humanity, choices of subjectivity, modes of objectification, various types of attachment." (Latour, 2002). This is precisely what opponents of speed limitation forget. Also without speed limiters, the actions of drivers are continually mediated: indeed, cars can easily exceed speed limits and because our roads are so wide and the bends so gentle that we can drive too fast, we are constantly invited to explore the space between the accelerator and the floor. Therefore, giving the inevitable technological mediations a desirable form rather than rejecting outright the idea of a 'moralized technology' in fact attests to a sense of responsibility.

The conclusion that mediation and morality are at odds with each other, therefore, is not satisfying. It is virtually impossible to think of any morally relevant situation in which technology does not play a role. And it would be throwing out the baby with the bathwater to conclude that there is no room for morality and moral judgments in all situations in which technologies play a role. Therefore, an alternative solution is needed of the apparent tension between technological mediation and ethics. Rather than taking absolute freedom as a prerequisite for moral agency, we need to reinterpret freedom as an agent's ability to relate to what determines him or her. Human actions always take place in a stubborn reality, and for this

reason, absolute freedom can only be attained by ignoring reality, and therefore by giving up the possibility to act at all. Freedom is not a lack of forces and constraints; it rather is the existential space human beings have within which to realize their existence. Humans have a relation to their own existence and to the ways in which this is co-shaped by the material culture in which it takes place. The material situatedness of human existence *creates* specific forms of freedom, rather than impedes them. Freedom exists in the possibilities that are opened up for human beings to have a relationship with the environment in which they live and to which they are bound.

This redefinition of freedom, to be sure, still leaves no room to actually attribute freedom to technological artifacts. But it does take artifacts back into the realm of freedom, rather than excluding them from it altogether. On the one hand, after all, they help to *constitute* freedom, by providing the material environment in which human existence takes place and takes its form. And on the other hand, artifacts can enter associations with human beings, while these associations, consisting partly of material artifacts, are the places where freedom is to be located. For even though freedom is never absolute but always gets shaped by technological and contextual mediations, these very mediations also create the space for moral decision-making. Just like intentionality, freedom also appears to be a hybrid affair, most often located in associations of humans and artifacts.

2.3 Conclusion: Materiality and Moral Agency

This expansion of the concepts of intentionality and freedom might raise the question if we really need to fiddle with such fundamental ethical concepts to understand the moral relevance of technological artifacts. In order to show that the answer to this question is yes, we can connect to an example elaborated by Latour: the debate between the National Rifle Association in the USA and its opponents. In this debate, those opposing the virtually unlimited availability of guns in the USA use the slogan "Guns Kill People", while the NRA replies with the slogan "Guns don't kill people; people kill people" (Latour, 1999, 176).

The NRA position seems to be most in line with mainstream thinking about ethics. If someone is shot, nobody would ever think about keeping the gun responsible for this. Yet, the anti-gun position evidently also has a point here: in a society without guns, fewer fights would result in murder. A gun is not a mere instrument, a medium for the free will of human beings; it helps to define situations and agents by offering specific possibilities for action. A gun constitutes the person holding the gun as a potential gunman and his or her adversary as a potential lethal victim. Without denying the importance of human responsibility in any way, this example illustrates that when a person is shot, agency should not be located exclusively in either the gun or the person shooting, but in the assembly of both.

The example, therefore, illustrates that we need to develop a new perspective of both concepts. It does not imply that artifacts can 'have' intentionality and

freedom, just like humans are supposed to have. Rather, the example shows that (1) intentionality is hardly ever a purely human affair, but most often a matter of human-technology associations; and (2) freedom should not be understood as the absence of 'external' influences on agents, but as a practice of *dealing* with such influences or mediations.

3 Designing Material Moralities

This analysis of the moral agency of technological artifacts has important implications for the ethics of technology and technology design. First, the mediation approach to technology makes clear that moral issues regarding technology development comprise more than weighing technological risks and preventing disasters, however important these activities are. What is also at stake when technologies are introduced in society are the ways in which these technologies will mediate human actions and experiences, thus helping to form our moral decisions and our quality of life. The ethics of technology design, therefore, should also occupy itself with taking responsibility for the future mediating roles of technologies-in-design.

Moreover, our analysis of technological mediation shows that, even without explicit moral reflection, technology design is inherently a moral activity. Designers, by designing artifacts that will inevitably play a mediating role in people's actions and experience, are thus helping to shape (moral) decisions and practices. Designers 'materialize morality'; they are 'doing ethics by other means' (cf. Verbeek, 2006). This conclusion makes it even more urgent to expand the scope of the ethics of technology to include the moral dimensions of the artifacts themselves, and to try and give shape to these dimensions in a responsible way.

3.1 Designing as Combining Agencies

In practice, however, taking this responsibility runs into a number of serious problems. One, to 'build in' particular mediations, or to eliminate undesirable ones, it is necessary to predict what mediating roles technologies-in-design will play in their future use contexts, while there is no univocal relationship between the activities of designers and the eventual mediating role of the products they design. Technological mediations are no intrinsic qualities of technologies, but are brought about in complex interactions between designers, users, and the technologies. As became clear above, technologies can be used in unforeseen ways, and therefore are able to play unforeseen mediating roles. The energy-saving light bulb is another example of this, having actually resulted in increased energy consumption since such bulbs often appear to be used in places previously left unlit, such as in the garden or on the façade of a house, thereby canceling out their economizing effect (Steg, 1999; Weegink, 1996). Moreover, unintentional and unexpected forms of mediation can arise when technologies

are used in the way their designers intended. A good example is the revolving door which keeps out both cold air and wheelchair users. In short, designers play a seminal role in realizing particular forms of mediation, but not the only role. Users with their interpretations and forms of appropriation also have a part to play; and so do technologies, which give rise to unintended and unanticipated forms of mediation. These complicated relations between technologies, designers, and users in the mediation of actions and interpretations are illustrated in figure 1.

The figure makes clear that in all human actions, and all interpretations informing moral decisions, three forms of agency are at work: (1) the agency of the human being performing the action or making the moral decision, in interaction with the technology, and also appropriating the technological artifact in a specific way; (2) the agency of the designer who, either implicitly or in explicit delegations, gives a specific shape to the artifact used, and thus helps to shape the eventual mediating role of the artifact; and (3) the agency of the artifact mediating human actions and decisions, sometimes in unforeseen ways. Taking responsibility for technological mediation, therefore, comes down to entering into an interaction with the agency of future users and the artifact-in-design, rather than acting as a 'prime mover' (cf. Smith, 2003).

The fundamental unpredictability of the mediating role of technology that follows from this does not imply that designers are by definition unequipped to deal with it. In order to cope with the unpredictability and complexity of technological mediation, it is important to seek links between the design context and the future use context. Design specifications should be derived from the product's intended function and from an informed prediction of the product's mediating roles and a moral assessment of these roles. A key tool to bring about this coupling of design context and use context, however trivial it may sound, is the designer's moral imagination. A designer can include the product's mediating role in his or her moral assessment during the design phase by trying to imagine the ways the technology-in-design could be used and by shaping user operations and interpretations from that perspective. Performing a mediation analysis (cf. Verbeek, 2006) can form a good basis for doing this. It cannot be guaranteed that designers will be able to anticipate all relevant mediations in this way, but it is the maximum designers can do to take responsibility for the mediating roles of their products.

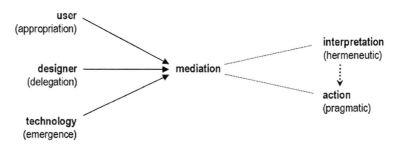

Fig. 1 Origins of technological mediation

3.2 Taking Mediation into Ethics

There are two ways to take mediation analyses into the ethics of technology and design. One, they can be used to develop moral assessments of technologies in terms of their mediating roles in human practices and experiences. Two, the conclusion that artifacts do have a specific form of morality also shifts ethics from the domain of language to that of materiality. When artifacts have moral relevance and embody a specific form of moral agency, ethics cannot only occupy itself with developing conceptual frameworks for moral reflection, but should also engage in the development of the material environments that helps to form moral action and decision-making. Hans Achterhuis has called this the 'moralization of technology' (Achterhuis, 1995).

The first way to take mediation into ethics is closest to common practices in the ethics of technology. It comes down to an augmentation of the current focus on risk assessment and disaster prevention. Rather than focusing on the acceptability and preventability of negative consequences of the introduction of new technologies, it aims to assess the impact of the mediating capacities of technologies-in-design for human practices and experiences. When an action-ethical approach is followed, moral reflection is directed at the question of whether the actions resulting from specific technological mediations can be morally justified. This reflection can take place along deontological or consequentialist lines. But in many cases, a virtue-ethical or life-ethical approach is at least as fruitful for assessing technological mediations, focusing on the quality of the *practices* that are introduced by the mediating technologies, and their implications for the kind of life we are living. It is not only the impact of mediation on specific human actions that is important then, but also the ways in which mediating technologies help to constitute human beings, the world they experience, and the ways they act in this world. To return to the example of ultrasound again: rather than merely assessing the impact of routine ultrasound scans in obstetrical health care in terms of safety and abortion rates, a life-ethical approach would try to assess the quality of the practices that arise around ultrasound scanning, in which the fetus and its expecting parents are constituted in specific ways, as possible patients versus decision-makers, and in specific relations to each other, i.e., in situations of choice.

The second way to augment the ethics of technology with the approach of technological mediation is to *assess* mediations, and to try to help *shape* them. Rather than working from an external standpoint *vis-à-vis* technology, aiming at rejecting or accepting new technologies, the ethics of technology should aim to *accompany* technological developments (Hottois), experimenting with mediations and finding ways to discuss and assess how one might deal with these mediations, and what kinds of living-with-technology are to be preferred. Deliberately building mediations into technological artifacts is a controversial thing to do, however. Behavior-steering technologies are seldom welcomed cordially, as the regular destruction of speed cameras illustrates.[2] However, since we have seen that *all*

[2] For a closer analysis of behavior-steering technologies see Verbeek and Slob (2006).

technologies inevitably mediate human-world relations, thus shaping moral actions and decisions, this should not imply that ethics should refrain from explicitly designing mediations into artifacts. It rather shows that ethics should deal with these mediations in a responsible way, and try to help design technologies with morally justifiable mediating capacities.

The contested nature of behavior-steering technology makes clear that such 'materializations of morality' cannot be left to the responsibility of individual designers. The actions and decisions of designers always have public consequences, and therefore these decisions and their consequences should be subject to public decision-making. The products of the designing work then literally become 'public things', in the sense of *res publica*, as recently elaborated by Latour (2005). 'Res', the Latin word for 'thing', also meant 'gathering place', or 'that which assembles', and even indicated a specific form of parliament. 'Things' can thus be interpreted as entities that gather people and other things around them, uniting them and making them differ. Seen in this way, technological artifacts not only help to shape our lives and our subjectivities, they should also be approached as foci around which humans gather in order to discuss and assess their concerns about the ways in which these things contribute to their existence. These are precisely the places where the morality of design should be located.[3]

References

Achterhuis, H., 1995, De moralisering van de apparaten, *Socialisme en Democratie* **52**(1):3–12.
Akrich, M., 1992, The de-scription of technical objects, in: *Shaping Technology / Building Society*, W. E. Bijker and J. Law, eds., MIT Press, Cambridge, MA, pp. 205–224.
Baudet, H., 1986, *Een vertrouwde wereld: 100 jaar innovatie in Nederland*, Bert Bakker, Amsterdam.
Borgmann, A., 1995, The moral significance of the material culture, in: *Technology and the Politics of Knowledge*, A. Feenberg and A. Hannay, eds., Indiana University Press, Bloomington/Minneapolis, pp. 85–93.
Ihde, D., 1990, *Technology and the Lifeworld*, Indiana University Press, Bloomington/Minneapolis.
Ihde, D., 1998, *Expanding Hermeneutics*, Northwestern University Press, Evanston, IL.
Latour, B., 1992, Where are the missing masses? the sociology of a few mundane artifacts, in: *Shaping Technology / Building Society*, W. E. Bijker and J. Law, eds., MIT Press, Cambridge, MA, pp. 225–258.
Latour, B., 1999. *Pandora's Hope: Essays on the Reality of Science Studies*, Harvard University Press, Harvard.
Latour, B., 2002, Morality and technology: the end of the means, *Theor., Cult. & Soc.* **19**(5–6):247–260.
Latour, B, 2005, From *Realpolitik* to *Dingpolitik*: or how to make things public, in: *Making Things Public: Atmospheres of Democracy*, B. Latour and P. Weibel, eds., MIT Press, Cambridge, MA, pp. 4–31.
Searle, J. R., 1983, *Intentionality: An Essay in the Philosophy of Mind*, Cambridge University Press, Cambridge.

[3] This article was written with financial support from NWO, the Netherlands Organization for Scientific Research (innovational research incentive, "veni" track').

Smith, A., 2003, Do you believe in ethics? Latour and Ihde in the trenches of the sciences wars, in: *Chasing Technoscience: Matrix for Materiality*, D. Ihde and E. Selinger, eds., Indiana University Press, Bloomington/Indianapolis, pp. 182–194.

Steg, L., 1999, *Verspilde Energie? Wat Doen en Laten Nederlanders voor het Milieu*, Sociaal en Cultureel Planbureau, The Hague (SCP Cahier no. 156).

Verbeek, P. P., 2005, *What Things Do: Philosophical Reflections on Technology, Agency, and Design*, Penn State University Press, University Park, PA.

Verbeek, P. P., 2006, Materializing morality: design ethics and technological mediation, *Sci., Technol., and Hum. Valu.* **31**(3):361–380.

Verbeek, P. P., and Slob, A., 2006, *User Behavior and Technology Development: Shaping Sustainable Relations between Consumers and Technologies*, vol. 20 of *Eco-Efficiency in Industry and Science*, Springer, Dordrecht.

Weegink, R. J., 1996, *Basisonderzoek Elektriciteitsverbruik Kleinverbruikers BEK'95*, EnergieNed, Arnhem.

Winner, L., 1986, Do artifacts have politics?, in: *The Whale and the Reactor*, L. Winner, ed., University of Chicago Press, Chicago, pp. 19–39.

Thinking About Design

Critical Theory of Technology and the Design Process

Patrick Feng and Andrew Feenberg

1 Introduction

In this chapter we offer a framework for thinking about the design of technology. Our approach draws on critical perspectives from both social theory and science and technology studies (STS). We understand design to be the process of consciously shaping an artifact to adapt it to specific goals and environments. Our framework conceptualizes design as a process whereby technical and social considerations converge to produce concrete devices that fit specific contexts. How this happens – and the possibility that it might happen differently – is a crucial point for philosophers and other students of technology to consider.

To date, design studies have been focused predominantly on the work of what we might call proximate designers, while work in the field of STS has focused on the role of non-designers such as clients, stakeholders, and other socially relevant groups.[1] However, little attention has been paid to ways in which historical choices and cultural assumptions about technology shape the design process. Our goal is to address this oversight. We begin by posing a seemingly simple question: is design intentional? A review of the literature draws our attention to at least three possible levels of analysis: that of proximate designers, the immediate design environment, and broader society. We then present a critical theory of technology that provides a non-deterministic, non-essentialist approach to the study of technology. We argue that critical theory, with its emphasis on examining taken-for-granted assumptions, offers a theoretical space for thinking differently about design. Finally, we discuss the possibilities opened up by critical theory and some of the obstacles that stand in the way of realizing a richer world of design.

P. Feng, University of Calgary

A. Feenberg, Simon Fraser University

[1] Woodhouse and Patton (2004) define *proximate designers* as those professionals closest to the design process: engineers, architects, draftsmen, graphical artists, and so on.

P. E. Vermaas et al. (eds.), *Philosophy and Design.*
© Springer 2008

2 Design and Intentionality

Design is typically conceived of as a purposeful activity, and so intentionality seems to be built into the very definition of the term. But is design really intentional? Put another way: to what extent do designers' intentions shape the artifacts they produce? A review of the literature reveals three general perspectives: first, there are those who see designers as having a great deal of control over the design process; second, there are those who see designers as being highly constrained and therefore unable to translate their goals and intentions into products; finally, there are those who see design as a function of the broader culture. This last perspective throws into question the very notion of intentionality by problematizing the distinction between designers and society-at-large.

2.1 Strong Intentionality: Designers are Powerful

The idea of achieving something "by design" suggests that designers have a great deal of power. It suggests – contrary to technological determinism – that people *can* steer technological development. Furthermore, it rests on the assumption that intentionality plays a significant role in design: that by consciously deciding on a course of action one can design better. The work of Norman (1988) provides a good exemplar of this perspective.

Norman sees a strong link between better designers and better design. For example, he places much of the blame for "bad design" on the fact that design work is "not done by professional designers, it is done by engineers, programmers, and managers" (1988, 156). Similarly, he places much of the responsibility for "good design" on professional designers: "[i]f an error is possible, someone will make it. The designer must assume that all possible errors will occur and design so as to minimize the chance of the error in the first place, or its effects once it gets made" (1988, 36). In this view, designers are powerful – it is, after all, *their* knowledge and *their* values that determine the shape of our technologies.

Like others in the strong intentionality camp, Norman assumes that a sharp division of labor between designers and the public is essential to good design. While he acknowledges that manufacturers, store owners, consumers, and others may have competing demands, he believes that "[n]onetheless, the designer may be able to satisfy everyone" (1988, 28). He thus sidesteps issues of conflict and power, and, while Norman sometimes calls for participation from non-designers – "[d]esign teams really need vocal advocates for the people who will ultimately use the interface" (1988, 156) – he does so in a way that makes clear it is the designers who are in charge. Users, when they are mentioned at all, are assumed to be largely passive recipients of technology.

The result is that Norman and authors like him assume that designers' intentions are expressed through design. His prescription for improving design is to have better, more enlightened designers. While this viewpoint has merit in

challenging the notion that technological development is pre-determined, it also has several shortcomings. These include a lack of attention to diversity and conflict among user groups, to the constraints designers face "on the ground," and to the cultural conditions presupposed by the designers' work. Moreover, this viewpoint presupposes a sharp distinction between intended and unintended consequences that is highly problematic.[2]

The strong intentionality approach views proximate designers as key actors in the design process. This approach shows a certain affinity for an instrumentalist philosophy of technology in which technology is viewed as neutral means to human ends. The role of the designer is to assess the various demands being made of technology – demands that are deemed external to the design process – and then, using her expertise, to optimize according to those demands. Consequently, design is viewed as being primarily technical in nature. This view has been challenged in recent years by approaches (most notably from STS) that emphasize the social contingency of design.

2.2 Weak Intentionality: Designers are Constrained

While some authors see designers as powerful, others suggest the opposite, i.e., designers are constrained by a variety of factors: economic, political, institutional, social, and cultural. Within such constraints, designers are thought to have varying degrees of autonomy. Consider the following three examples.

Noble (1977) provides an example of a neo-Marxist analysis of labor relations and corporate growth. Arguing that the rise of corporate capitalism in America went hand-in-hand with the wedding of science and engineering to industry, Noble shows that workers increasingly lost their autonomy as management became increasingly of a "science."[3] New fields of study such as industrial relations were meant to be "the means by which farsighted industrial leaders strove to adjust – or to give the appearance of adjusting – industrial reality to the needs of workers, to

[2] Winner (1986) questions the whole notion of "unintended consequences," contending that in many cases it is not helpful to fixate on whether someone "intended" to do another person harm: "[r]ather one must say that the technological deck has been stacked in advance to favor certain social interests and that some people were bound to receive a better hand than others" (26). For this reason, we prefer Sclove's (1995) term of "non-focal effects," as it draws attention to the fact that the "effects" of technology depend, first of all, on what one chooses to focus on or ignore in one's analysis.

[3] Compare this with Chandler's (1977) explanation of why managerial capitalism arose in America during the 19th century. While Noble explains the rise of management as an intentional move by corporations to gain greater control over labor, Chandler presents it as a necessary and inevitable step in the evolution of American businesses, a step precipitated by the arrival of new "revolutionary" technologies. Thus, while Noble seeks to point out the *power relations* underlying changes within corporate America, Chandler seeks to *obscure* them by appealing to the necessity of technological progress.

defuse hostile criticism and isolate irreconcilable radicals by making the workers' side of capitalism more livable" (1977, 290). While not specifically about design, Noble's book suggests that workers of all sorts, including designers, have little ability to follow their own intentions where these conflict with corporate interests. Of course, there is still room for some choice in design (e.g., what color to paint the car), but truly radical design alternatives are excluded by corporate control.

Others are less totalizing in their analysis. In his analysis of a high tech firm, for example, Kunda (1993) argues there is room for maneuvering and resistance, even as corporate control over workers becomes more subtle and insidious. He shows that constraints imposed on workers need not be explicit. Indeed, while "self-management" may be the catch phrase in today's knowledge economy, the demands of management hang heavy in the air of modern companies, even if they are never directly articulated by managers. Quoting from a company career development booklet, Kunda points out how responsibility for managing performance is shifted from management to workers:

> In our complex and ever changing HT [hi-tech] environment there is often the temptation to abdicate responsibility and place the blame for your lack of job clarity or results on 'the organization' or on 'management.' But if you really value your energies and talents, you will make it your responsibility 'to self' that you utilize them well. (1993, 57)

In such an environment, designers who start out thinking they have complete autonomy may find themselves constrained by the intricate web of norms and expectations of the corporate culture.[4]

Finally, Bucciarelli (1994) provides an optimistic view of constrained design. In his account constraints mainly stem from negotiating with co-workers. His analysis, while not exactly ignoring questions of political-economy or organizational control, generally skirts these concerns, focusing instead on how design teams come to agree on a "good design." Bucciarelli continually talks about negotiation between designers, suggesting that interests and intentions are central to his conception of design; if there are constraints on the designers in his story, these arise from having to work with other members of a design team to get a job done – a lesser constraint than, for example, external market pressures. In general, Bucciarelli assumes that despite numerous and often conflicting constraints, designers do have a significant degree of autonomy.

The weak intentionality approach views design as a complicated set of negotiations between proximate designers and those in the immediate design environment, i.e., clients, corporate executives, and other stakeholders. Institutional rules and organizational culture often play a role in this line of analysis. This approach is congruent

[4] Downey's (1998) ethnography of engineering students nicely illustrates this tension. He notes how students in a CAD/CAM class were presented with conflicting stories: on the one hand, they were told "[m]achines are slaves – they're dumb, they're stupid" (135). Yet, just a few days later – after considerable frustration with a lab project – students were told "[y]ou are also a slave to the computer" (137). Caught between these contradictory statements, these students began to question how much control they really had over the machine.

with certain approaches in STS such as social constructivism and actor-network theory, where designers are viewed as influential actors engaged in conflict and negotiation with other interested actors.

2.3 Questioning Intentionality: Designers and Society-at-large

Finally, some authors relate design to broader socio-cultural trends, thus questioning the whole notion of intentionality. A good example of this approach is Edwards' (1996) history of computer development during the Cold War. In his book *The Closed World*, Edwards argues that "American weapons and American culture cannot be understood in isolation from each other" (1996, 7). He shows how academic, military, industrial, and popular cultures intermeshed in the "closed world" of Cold War ideology.

Edwards defines a *closed world* as "a radically bounded scene of conflict, an inescapably self-referential space where every thought, word, and action is ultimately directed back toward a central struggle" (1996, 12). In such a world, it is questionable whether anyone truly has agency. How, for instance, could a designer escape from the values and assumptions of Cold War ideology and propose an alternative design? The closed-world discourse of the Cold War framed everything in terms of containment: the aim was to contain communism by protecting and enlarging the boundaries of the so-called free world. Within this discursive space, notions about what kinds of technologies would be necessary or desirable took on specific characteristics: increasing military precision required "a theory of human psychology commensurable with the theory of machines" (1996, 20); automation, "getting the man out of the loop", and integration, "making those who remained more efficient", were the answers provided by psychologists and other academics. Edwards concludes that the material and symbolic significance of computers is intimately connected to Cold War politics; indeed, Cold War politics is embedded in the machines computer scientists built during the past half-century.

A similar blurring of lines between designers and society-at-large can be seen in Abbate's (1999) study of the anarchic beginnings of the Internet. She argues that the "invention" of this technology was not an isolated, one-time event: "the meaning of the Internet had to be invented – and constantly reinvented – at the same time as the technology itself" (1999, 6). Her view of Internet history suggests there was no "master plan": the sources of its design are not to be found in any one place but are distributed among individuals and groups that, though loosely linked by a common culture, may not even be aware of each other.

This third approach is under-represented in contemporary studies of design. It conforms neither to the instrumentalist assumptions of the strong intentionality thesis nor to the weak intentionality thesis that is compatible with the methods of STS. Instead, a sociology of culture is presupposed which must then be combined with a philosophy of technology open to cultural considerations. Design is not only a strategic contest between interested actors and social groups, it is also a function of

the way in which things appear to be "natural" to the designer. This insight shifts our attention away from proximate designers to the background assumptions that are at work in broader culture. We will explain this approach in the second half of this chapter.

2.4 Designers: Strong or Weak?

With these perspectives in mind, let us reconsider the role of designers in shaping technology. If designers are strong, then we would expect their views to be the key factor in determining the form of technologies. On the other hand, if designers are weak, then their role would be merely to implement out the views of others; devices would simply reflect the values of influential actors rather than those of the design team. Clearly, there are circumstances that can be accurately described by each of these positions. Designers do have a substantial influence on the design process and sometimes control the outcome. Nevertheless, to focus too much on those closest to the design process is to miss the larger political-economic and cultural structure within which their activities take place.

The intervention of non-technical influences on design takes the form of external pressures but it is also internal to the technical sphere itself. What appears technically rational to the designer is a function of many things, including her training and the codified outcomes of technological choices made in the past under various social influences. In other words, even when engaging in "purely technical" activities, designers are guided by rules that are culturally specific and value-laden.[5] Design thus invariably exhibits social bias. This bias is part and parcel of designing since optimizing for a given situation requires taking social concerns such as cost, compatibility, and so on into account. These social concerns, in turn, presuppose certain "facts" about the social world; they naturalize prior value judgments that are anything but natural, and how these past judgments were made is forgotten. It is this taken-for-grantedness to which critical theory draws attention.

3 Critical Theory of Technology

We have explained how the traditional design studies literature tends to focus on the work of proximate designers, conceptualizing design as an instrumental activity. Recent work in the field of STS brings in elements of the social by focusing on the

[5] An example of this is when designers make use of scientific and technical standards in their work. To the designer, these standards appear neutral and unproblematic: they represent established guidelines and best practices within their design community. However, as numerous STS studies have shown, the making of such standards are as much political as they are technical in nature: technical standards are never "purely technical" (Bowker and Star, 2000).

actions and strategies of social groups close to the design process. What is missing in both these accounts is an acknowledgement of how past technologies and practices – our technical heritage, if you will – shapes current design. As a result, the impact of historical and cultural developments on the design of technology has been under-theorized. Critical theory attempts to address this oversight.

3.1 Critical Theory Compared to Existing Approaches

A number of STS scholars have looked at the issue of design. From the many approaches employed, two have emerged to prominence: social construction of technology (SCOT) and actor-network theory (ANT). Briefly, SCOT theorists argue that technologies are contested and contingent, the outcome of battles between various social groups, each with its own vested interests. To understand a design one should trace the history of a specific technology's development and look for the influence of relevant social groups. Similarly, ANT theorists argue that technologies are contingent, the result of strategies and tactics employed by key actors in bringing together a stable network of people and devices in which a new technology will succeed.

Critical theory shifts attention away from the micro-level analysis of construc-tivist technology studies to the macro-level. We take the fact that technologies are socially constructed to be self-evident. However, whereas SCOT is focused on uncovering *which social groups* were most influential in shaping the design of a particular technology, and ANT is focused on the *strategies employed by various actors* in the design of a particular technology, we are interested in the *broader cultural values and practices* that surround a particular technology. Put another way, our focus is less on specific social groups or the strategies they employ and more on what *cultural resources* were brought into play in the design process (see table 1).

Table 1 Three theoretical perspectives on design

Theoretical perspective	Focus	How is design conceptualized?	Where is power located?
Traditional design studies	Proximate designers	Design as a technical task	Micro-level (*negotiations between key actors*)
Constructivist studies of technology	Designers and related actors / interest groups	Design as a political task	Micro- and meso-levels (*structured interac-tions between actors within an existing power hierarchy*)
Critical theory of technology	Culture, broader society	Design embedded in history and culture	Macro-level (*influence of tradition and culture on design practices*)

Feenberg (1999; 2002) has developed this approach as "instrumentalization theory." This is a critical version of constructivism that understands technology as designed to conform not just to the interests or plans of actors, but also to the cultural background of the society. That background provides some of the decision rules under which technically underdetermined design choices are made. This background takes two forms: beliefs and practices of the everyday lifeworld, and culturally biased knowledge sedimented in technical disciplines shaped by a history of technical choices. The cultural study of technology must therefore operate at two levels, the level of the basic technical operations and the level of the current power relations or socio-cultural conditions that specify definite designs.

To give an example, consider a simple technology: the bicycle. Anyone who has spent time in Holland knows that the bicycle is an important mode of transportation in Dutch cities – far more so than in most North American cities. Bike lanes are prominent features in Dutch cities and bicyclists co-exist peacefully with motorists. This contrasts with North American cities, where cyclists must fight with motorists for use of the road. Furthermore, the everyday use of bicycles is a technological practice that is supported by another technology, the "Dutch road," which extensively incorporates bike lanes and, just as importantly, social expectations about the proper use of bicycles.[6]

What is of interest to us here is the dominant meaning attached to a particular device, in this case a roadway: in Holland, it is accepted that bicycles and bicyclists are "legitimate" users of the road (indeed, cyclists commonly have the right-of-way); in North America, these same devices and people are oddities, either grudgingly accepted or met with hostility by the road's primary users, motorists. No one doubts that cars dominate the roadways of North American cities. In North America, the word "road" brings to mind cars; in Holland, the same word brings to mind both cars and bicycles.

Our claim is that the "naturalness" of the interpretation of a particular device within a given social context is singularly important. The fact that a person living in Amsterdam is inclined to think of cyclists as natural users of roadways – while a person living in Atlanta does not – matters. It matters because this taken-for-granted understanding – what in essence is "culture" – becomes a background condition to the design of technology. Neither SCOT nor ANT pay much attention to these background conditions, choosing to focus instead on the actions of specific actors or groups of actors.[7] Yet, to understand the ways in which technological design may be biased one needs to look at this broader context.

[6] Dutch bicycles are typically designed for everyday transportation without many of the bells and whistles of North American bicycles, which often seem more designed for hobbyist use. This illustrates once again the way in which devices are expected and constructed to fit into dominant understandings of what a technology is and how it is supposed to work. In addition, as Pinch and Bijker (1987) show in their study of bicycle development, the variety of styles one sees today reflects differences in opinion among designers and users as to what values are most important in a bicycle (e.g., fashion vs. comfort or speed vs. safety).

[7] In their original formulation of SCOT, Pinch and Bijker (1987) posited an examination of the "wider context" as the third and final step in their analysis. However, few SCOT theorists have followed through with this promise. We would also suggest that it makes a difference whether one begins one's analysis with the "wider context" or ends with it as an afterthought.

3.2 *Instrumentalization Theory*

We now turn to a more detailed exposition of the instrumentalization theory. The starting point is the notion of *technical element*. By this we mean the most elementary technical ideas and corresponding simple implementations that go into building devices and performing technical operations. Anthropologists conjecture that the ability to think of objects as means, the upright stance and opposable thumb together form a constellation that predisposes human beings to engage technically with the environment. In this humans achieve an exorbitant development of potentials exhibited in small ways by other higher mammals. The starting point of this basic technical orientation is imaginative and perceptual: humans can see and formulate technical possibilities where other animals cannot. These most basic technical insights consist in the identification of "technical elements," affordances or useful properties of things.

What is involved in perceiving a technical element? Two things are necessary: first, the world must be understood in terms of the possibilities it offers to goal oriented action; second, the subject of that action must conceive itself as such, that is, as a detached manipulator of things. The technical disposition of such a subject and the manner in which it conceives its objects constitutes the "primary instrumentalization." *Primary instrumentalization* proceeds by decontextualizing objects and simplifying them to highlight those qualities by which they are assigned a function.[8] There appears to be very little of a social character about such technical insight and elements can be employed in a very wide variety of social contexts. In this sense they are relatively neutral with respect to different social values. Nevertheless, a detailed study would reveal in each case some sort of minimal social contingency controlling selection and implementation even in the simplest form. Where technical elements emerge in the context of complex technical traditions, they presuppose the results of past social and cultural shaping of technical practice and so may carry with them quite a bit of social content.

Technical elements are at first notional but achieve realization in transformations of objects. In the process, social constraints of a more complex nature than simple goals shape the elements. This is the "secondary instrumentalization" in which the elements are given socially acceptable form and combined to make a technical device. *Secondary instrumentalization* proceeds by reorienting and integrating the simplified objects into a given natural and social environment. Design is the process in which relatively neutral technical elements are arranged to form a strongly biased concrete device, one that fits a specific social context. The relationship between technical elements and devices is depicted in figure 1.

An example will help to make the distinction clear. Consider the design of an everyday object such as the refrigerator. To make a refrigerator, engineers work with basic components such as electric circuits and motors, insulation, gases of a special

[8] For a more detailed account of instrumentalization theory see Feenberg (1999), especially pp. 202–208.

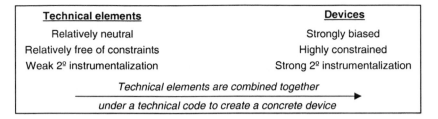

Fig. 1 Relationship between technical elements and concrete devices

type, and so on, combining them in complex ways for generating and storing cold. Each of these technologies can be broken down into even simpler decontextualized and simplified elements drawn from nature. This the level at which the primary instrumentalization is preponderant, taking the form of sheer technical insight.

However, even though these technical issues have been so thoroughly simplified and extracted from all contexts, knowledge of the components is still insufficient to completely determine design. There remain important questions such as what size to build the refrigerator, which are settled not on technical terms but rather on the basis of social principles (e.g., in terms of the likely needs of a standard family). Even the consideration of family size is not fully determining: in countries where shopping is done daily, on foot, refrigerators tend to be smaller than in those where shopping is done weekly by automobile. Thus, on essential matters, the technical design of this artifact depends on the social design of society. The refrigerator seamlessly combines these two entirely different registers of phenomena.

The two aspects of technique have a complex relationship. No implementation of a technical element is possible without some minimum secondary instrumentalization contextualizing it. Very little is required at first, perhaps no more than a socially sanctioned goal of a very general sort. Once the technical actor begins to combine these elements, more and more constraints weigh on design decisions. Some of these constraints have to do with compatibility between the various components of the new device and between the new device and other features of the technical environment. Some have to do with natural hazards or requirements that will affect the device. Others have to do with ethical-legal or aesthetic dimensions of the surrounding social world. The role of the secondary instrumentalization grows constantly as we follow an invention from its earliest beginnings through the successive stages in which it is developed and concretized in a device that circulates socially. Indeed, even after the release of a new device to the public, it is still subject to further secondary instrumentalizations through user initiative and regulation.

The iterative character of secondary instrumentalizations explains why we have a tendency to view technology in abstraction from society. It is true that technical elements are not much affected by social constraints, but we must not interpret fully developed technologies in terms of the stripped down primary instrumentalization of the initial technical elements from which they are made.

3.3 Design Spaces and Technical Codes

In all cases certain aspects of a device's design will vary depending on various sorts of demands while others will remain invariant. Those aspects that do not change include many that are invisible to the user, e.g., the type of components used, and others that have been standardized. What remains is a set of design possibilities – ways in which technical elements can be combined to create a workable device. We shall call this set of technically feasible possibilities the *design space*. It is from this set of possibilities that a "best" design will ultimately be selected.

Note that what is "technically feasible" depends on both the technology in question and on past history. Every design community inherits from its predecessors certain practices, assumptions, and ways of viewing the world. This "technical heritage" is at least as influential on design as any vested interest or lobby group. While in theory there may be hundreds of technically feasible design options for a particular technology, in practice professional designers typically consider only a small subset. Many technically feasible options are non-starters for reasons so obvious that they need no social justification – they are simply dismissed out of hand. These forgotten options are precisely the ones researchers should look at, if they wish to reveal the taken-for-granted assumptions and values that are part of the "black box" of technological design. As we have argued, the choice of "best" design is never a purely technical matter: designs are always underdetermined, and it is only through the application of the secondary instrumentalization that the actual form of a device is resolved.

Note that the set of available design options becomes progressively smaller as one moves "down" the design process, i.e., as more and more social requirements are added. Sometimes, however, it is possible for the black box of technological design to be reopened; when this happens, the design space for a particular device is suddenly enlarged. Controversies are one way to re-open the black box. Consider again the example of the refrigerator: at one point in time, the idea of using CFCs was not even a design question; it was simply the way things were done. However, when environmentalists made the case that CFCs were a danger to the ozone layer, this taken-for-granted assumption was made visible, and the question of "how to cool this device?" was put back on the design table.

The secondary instrumentalization exhibits significant regularities over long periods in whole societies. Standard ways of understanding individual devices and classes of devices emerge. Many of these standards reflect specific social demands that have succeeded in shaping design. These social standards form what we call the *technical code* of the device in question. In the example of the refrigerator, the technical code determines size as a function of the social principles governing family size. In other cases the technical code has a clearly political function, as in the deskilling and mechanization of labor during the industrial revolution. Labor process theory shows that the technical code prevailing in these transformations of work responded to problems of capitalist control of the labor force (Noble, 1977).

Technical codes are sometimes explicitly formulated as design requirements or policies, but often they are implicit in culture and training and need to be extracted

from their context through sociological analysis. In either case, the researcher must formulate the technical code in an ideal typical manner as a norm governing design. The formulation of the norm as such helps to identify the process of translation between the discourse and practice of technologists and social, cultural, or political facts articulated in other discourses. This continual process of translation between technical and social is fraught with difficulty but nevertheless largely effective. In the end, this line of analysis allows the researcher to follow the evolution of a specific technology from technical elements through various design options to, finally, a concrete device (see figure 2).

In the language of technology studies, technical codes may be conceived as the rule under which "black boxing" occurs. At the end of the development process of a technology, when it finally assumes its standard configuration, we know "what" it is; it acquires an essence.[9] This essence is of course revisable but only with difficulty compared to the original very fluid situation of the first innovative attempts to make the device. The technical code prescribes some important aspects of the standard configuration, specifically, those which translate between social demands and technical requirements.

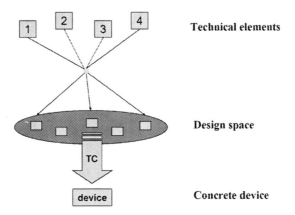

Fig. 2 Schematic diagram showing relationship between technical elements, design space, and a concrete device or technology. *In Critical Theory of Technology*, a technical code (TC) is what enables the selection of a "best" design from a multitude of design possibilities. Exactly how this code is selected and applied is an empirical question, which will vary depending on the case being studied. The researcher's task is to draw out the TC from a particular context through sociological analysis.

[9] Note that we do not mean "essence" in a Heideggerian sense, nor do we mean it in the ahistorical sense that essentialist philosophers of technology posit. The "essence" here is *specific* to a particular device within a particular social context. When the work of designing is done and all the technical elements have been combined together under a technical code to produce a concrete device, that device has an essence insofar as it reflects the particular values, demands, and social environment that figured in its design.

4 Conclusion: Towards the Realization of Design Possibilities

We began this chapter by asking questions about the role of intentionality within the design process. Specifically, we have suggested that the path from designers' intentions to the design of products is not a straightforward one. Though on the surface designers may seem like powerful actors, they are caught in the same web of constraints confronting other actors. Designers do not work in a vacuum. And all too often design demands, implicitly or explicitly, that new devices fit with established ways of being. In other words, designers must accommodate themselves to existing social worlds, which implies submitting to existing power relations and hierarchies. The stifling effect of such passive coercion is a significant obstacle to the realization of alternative designs.

We then outlined a critical theory of technology and explained how a greater focus on the historical and cultural conditions underlying the design process could help illuminate paths to different kinds of design. Technical elements, which in principle could be combined in any number of ways to form a device, are brought together under the constraints of a technical code to produce a concrete device that "fits" a specific social context. Moreover, designers are influenced by what has gone before: yesterday's tools inform today's designs, even when yesterday's tools may have been less than optimal.[10] This means that of the many technically feasible options available in the design space, only a small percentage are ever realized. We have argued that the process of resolving technically underdetermined choices should be the focal point of a philosophy of design. We have also argued that, rather than understanding this process solely in terms of the interests or strategies of specific actors (à la SCOT and ANT), we should look at the values and practices that are taken-for-granted in the broader culture.

If we understand technologies to be underdetermined, then the question facing society is not whether to accept or reject technology, but rather how alternative values can be brought into the design process so that the technical codes that determine design are humane and liberating rather than oppressive and controlling. An important first step in this process is to acknowledge that neither proximate designers nor the immediate design environment are decisive in determining the outcome of complex design processes. Instead, people's taken-for-granted assumptions about the forms and meanings of specific technologies – what we have called here our technical heritage – are crucial. Critical theory of technology draws attention to these background assumptions and asks that the researcher take these seriously. Our hope is that by *questioning* technology vigorously we can help open a space for *designing* technology differently.

[10] See, for instance, David's (1985) classic study on the QWERTY keyboard and how, despite being less than optimal in terms of layout and typing efficiency, it has remained the *de facto* standard for keyboards all over the world.

References

Abbate, J., 1999, *Inventing the Internet*, MIT Press, Cambridge, MA.

Bowker, G. C., and Star, S. L., 2000, *Sorting Things Out: Classification and Its Consequences*, MIT Press, Cambridge, MA.

Bucciarelli, L. L., 1994, *Designing Engineers*, MIT Press, Cambridge, MA.

Chandler, A. D., 1977, *The Visible Hand: The Managerial Revolution in American Business*, Belknap Press, Cambridge, MA.

David, P. A., 1985, Clio and the economics of QWERTY, *Am. Econ. Rev.* **72**(2):332–337.

Downey, G., 1998, *The Machine in Me: An Anthropologist Sits Among Computer Engineers*, Routledge, NJ.

Edwards, P., 1996, *The Closed World: Computers and the Politics of Discourse in Cold War America*, MIT Press, Cambridge, MA.

Feenberg, A., 1999, *Questioning Technology*, Routledge, New York.

Feenberg, A., 2002, *Transforming Technology: A Critical Theory Revisited*, Oxford University Press, Oxford.

Kunda, G., 1993, *Engineering Culture: Control and Commitment in a High Tech Culture*, Temple University Press, Philadelphia.

Noble, D., 1977, *America by Design: Science, Technology, and the Rise of Corporate Capitalism*, Alfred A. Knopf, New York.

Norman, D., 1988, *The Design of Everyday Things*, Basic Books, New York.

Pinch, T., and Bijker, W. E., 1987, The social construction of facts and artifacts, in: *The Social Construction of Technological Systems: New Directions in the Sociology and History of Technology*, W. E. Bijker, T. P. Hughes, and T. Pinch, eds., MIT Press, Cambridge, MA.

Sclove, R., 1995, *Democracy and Technology*, Guilford Press, New York.

Winner, L., 1986, *The Whale and the Reactor: A Search for Limits in an Age of High Technology*, University of Chicago Press, Chicago.

Woodhouse, E., and Patton, J. W., 2004, Introduction: design by society: science and technology studies and the social shaping of design, *Des. Issues* **20**(3):1–12.

Design Culture and Acceptable Risk

Kiyotaka Naoe

Abstract Technological design is usually considered as a process of stipulating target functions. Technological artifacts are, however, not determined entirely by the intent of the engineers who designed them: they unavoidably contain unpredictable and uncertain characters that transcend engineers' intent, and they cannot be understood purely from a functionalist perspective. In aviation, for example, the smooth implementation of a flight is ensured by a system that includes pilots interacting with each other and with a suite of technological devices. Emphasizing the human aspect of technological designs, this article presents a theoretical framework that takes socio-cultural aspects of technology as the primary for a philosophical, ethical analysis. An analysis of the acceptability of risks shows that the reliability of a technology is determined by the reliability of the technological decisions, eventually the existence of a reliable technological culture. So the task of the ethics of risks is to provide ways to reform our technology culture.

1 Introduction

Presently, the problem of how to deal with the risks posed by technology is growing in importance.

Engineering is often considered as a cultural activity, i.e., an activity that people undertake within a social context. Thus, the ethics of engineering and those concerning risks are to be found within this cultural process. However, risk is also considered as quantifiable and objective, particularly in scientific risk analysis. Moreover, since the situations with which risk analysis is concerned are complicated in nature and involve uncertainty to some extent, a complete optimization of technology cannot be expected and the rationality of risk analysis must correspond to "bounded rationality." This might remind us of the well-known conflict between cultural relativism and naïve positivism. However, in this chapter, I adopt a different path by avoiding referring to this conflict, i.e., avoiding referring to the under- or overestimation of risk analysis. Therefore, I focus on the problem of the acceptability of risks.

K. Naoe, Tohoku University

P. E. Vermaas et al. (eds.), *Philosophy and Design.*
© Springer 2008

As an introduction to the following discussion, let us focus on the statement made by E. S. Ferguson. In "Engineering and the Mind's Eye" (1992), while discussing computer-assisted design (CAD), he states that "numerical calculations always embody human judgment":

> The precise outcome of the [design] process cannot be deduced from its initial goal. [...] Computerized illusions of certainty do not reduce the quantity or the quality of human judgment required in successful design. To accomplish a design of any considerable complexity [...] requires a continuous stream of calculations, judgments, and compromises that should only be made by engineers experienced in the kind of system being designed. (Ferguson, 1992, 37)

Man tends to distinguish traditional techniques supported by human expertise and skills from modern technology supported by science. Such expertise and skills, which are usually not visually or verbally articulated, are replaced by or translated into scientific knowledge. However, in reality, they are not entirely removed from modern technology (hereafter, referred to as "technology" unless otherwise indicated). As in the case of CAD, they remain as constitutive elements, even though they are partly objectified and thoroughly modified in modern technological procedures. Ferguson calls this kind of knowledge the "mind's eye" or "intuitive sense." Initially, this "mind's eye" seems to be purely personal in nature. However, when analyzed from a reflective viewpoint, one can identify some cultural "style" that is strongly connected to it; this is because a calculation or judgment is made on the basis of the accumulation of tacit information and tacit understanding. Therefore, it is possible to state that in technology, certain cultural elements are incorporated. If technology, which is considered to exist within a social and cultural context, is characterized as "technology in culture," these cultural elements incorporated in technology can be characterized as "culture in technology." We will also refer to these cultural aspects of technology as "technical culture" in a wide and narrow sense, respectively (this distinction will be indicated clearly only if it is necessary).

From this perspective, we can discuss the problem of acceptability of risks within a cultural context, without denying the need for scientific analysis. The following are some of the issues that need to be addressed: how a particular risk is recognized as risk; how some risks are considered to be acceptable in a society; in which cases do people regard such acceptance risks as reasonable; and so on. Studying the acceptability of risk from this perspective, I seek in this chapter to consider the problem of risk within the "ethos of technology" and consequently find answers to practical and ethical debates regarding technology. In this manner, the technical culture of a society, or of an organization, will be discussed critically, thereby paving the way for an inquiry about the public nature of technology.

In section 2, I will review the Challenger space shuttle accident in order to discuss the notion of acceptability more concretely and show that it is deeply rooted in technical culture (in the narrow sense). In sections 3 and 4, I generalize this notion to technology as a whole and indicate that the reliability of technology depends on that of technical culture. In section 5, I focus on technology in culture i.e., technical culture in the wide sense. Based on the examination of the Ford Pinto case, I create a discussion where the definition and reliability of design is not only concerned with engineers but also with society at large. Finally, in section 6,

I further explore the notion of public determination of technology. Highlighting the limitations of technological design and the engineer's responsibility, I suggest a possibility of a narrative ethics that can be devoted to the improvement of design culture, or technical culture in general.

2 The Case of the Challenger Accident

First, let us examine the case of the explosion of the space shuttle Challenger in 1986; this is an important case for textbooks on the ethics of technology. The Challenger exploded immediately after lifting off from the Kennedy Space Center, killing all the seven crew members aboard the shuttle. In the ensuing investigation, the O-rings that seal the joints in the shuttle's solid rocket boosters were identified as the direct cause of the accident. Descriptions in textbooks identify two issues: 1) Roger Boisjoly, an engineer with Morton Thiokol, the engineering firm that was involved in the manu facturing of the boosters, had previously identified this problem and reported the risk to his supervisors; in fact, on the night prior to launch, he had suggested that the mission be delayed. 2) He was ultimately overruled by a management decision that was eventually responsible for the accident. In other words, the responsible behavior of Boisjoly, who doggedly continued to raise the problem, and the actions and attitudes of Morton Thiokol and the NASA management, who prioritized the schedule and proceeded with the launch though they were aware of the risk involved, can be depicted as the "professional ethics of engineers" versus the "logic of management." The above analysis presents the ethical issues regarding the responsibility of experts, honest and unbiased inquiries, reliability, and the conflict between engineers and their organizations (e.g., Harris et al., 1995, 4 ff.).

However, ethnographical research by the sociologist Diane Vaughan (1996), who carefully reviewed the extensive testimony of individuals involved in the accident, and the debates by Harry Collins and Trevor Pinch (1998) based on that research raised different issues.

To avoid any misunderstanding, it should be noted that Morton Thiokol and the NASA engineers were not unaware of the risk surrounding the joints. Rather, they were well aware of the problem and had dealt with it for a number of years. However, as Vaughan et al. pointed out, a) what they sought was not absolute certainty but an "acceptable" solution. That is, complete sealing requires unlimited time and expense, and even assuming that this is achieved, if its integration with the other parts is lacking, the stability and safety of the entire system would still not necessarily be ensured. In general, technology invariably involves some incompleteness as it depends on various factors and deviations arising in situations. However, determining which of these factors or deviations is definitive at that moment is only possible through a system of experience and knowledge. In the abovementioned case, the engineers of NASA and Morton Thiokol, who partly shared common views based on a common intellectual "horizon," decided to "go ahead" with the launch because the effects of the O-ring damage were within workable limits owing to redundancy. In addition, b) by definition, conflicts between the

technical opinions of engineers is normal, and generally, whichever of these conflicting views is considered valid from the perspective of this intellectual horizon is deemed the "winner." Boisjoly and the others were unable to present persuasive data regarding the reduction in the elasticity of the O-rings at low temperatures; moreover, their data analysis was rife with inconsistencies. Thus, the engineers of Morton Thiokol and NASA concluded that the opinions of Boisjoly and the others were not supported by adequate data. In other words, their opinions lacked the validity required to reverse a decision under the conditions that a technological discussion at NASA must fulfill.

Based on the above facts, the descriptions provided in the textbooks are extremely simplified depictions, and it seems to be mere hindsight that judges the processes from the perspective of the result, i.e., the failure. First, the engineers of Morton Thiokol and NASA believed that, despite the uncertainties, the joint was an acceptable risk. Their managerial decision-making was rule-based, i.e., no rule was violated. The launch decision was, so to speak, the outcome of a strict technical discussion (see Vaughan, 1996, 336). Second, there were no absolute criteria regarding the validity of technical knowledge, i.e., the validity of technological knowledge is dependent on the situation. In other words, technological knowledge is situated in nature. Third, typically, though a "technical culture" that is shared by engineers determines the nature of the technical discussions regarding the validity of technical knowledge, irrespective of the existence of biases, this technical culture, or culture in technology, is often taken for granted. As a cognitive basal stratum, certain systems of experienced implicit (and explicit) knowledge are a part of this culture, and based on this technical culture, the engineers arrived at a consensus with regard to determining acceptability. After the path was adopted, Vaughan stated that "the launch decision resulted not from managerial wrongdoing, but from structural factors that impinged on the decision making, resulting in a tragic mistake" (Vaughan, 1996, 335). However, it is clear that these "structural factors" do not refer to the factors concerning the physical structure of the space shuttle; rather, they refer to the factors concerning NASA's organizational culture. As can be observed from the above discussion, although the Challenger's case initially appears to be a moral issue of engineers, at its core, it is an issue regarding the sanity of technical culture.[1]

[1] M. Davis, for example, insists on a "wrongdoing" (self-deception) in the attitude of R. Lund, Vice President of Engineering at Morton Thiokol. Lund had initially supported Boisjoly's position; however, during the pre-launch caucus, he changed his mind following the advice of J. Mason, Senior Vice President at Morton Thiokol, "It's time to take off your engineering hat and put on your management hat" (Davis, 1989). However, in her detailed analysis, by citing the evidences presented in the caucus by Thiokol Vice President J. Kilminster et al., Vaughan describes Mason's decision as being typical of cases where engineering disagreements could not be resolved by data that drew everyone to a consensus. "Someone has to collect that information from both sides and made a judgment." (Vaughan, 1996, 315 ff.). If this was the case, although by all considerations, Lund found himself in an extremely difficult position, one should consider his decision as an act of neglecting his loyalty toward engineering and replacing it with management logics. Based on this, it would be possible to argue that this is not an issue of personal morals but rather one of structure.

3 Organizational Accidents

Such a determination of the acceptability of risk on the basis of technical culture is typical to technology in general. In other words, it is neither specific to technology accompanied by enormous risk and uncertainty, similar to the case of the space shuttle Challenger, nor to the design process of technology. In fact, a culturally, or experientially, dependent nature is a fundamental characteristic of technical knowledge. Extremely similar situations are also observed with regard to more established technologies and in instances of management and operation of technical systems. In these cases, cultural determination does not involve technical discussions and calculations, but involves practical human-artifact relationships. Above all, embodied tacit knowledge plays an important role in these cases.

For example, with regard to the cockpit of an aircraft, large control devices as seen in the past are considered to be outdated. However, during take-off and landing and in emergency events, the existence of several people in the vicinity can be extremely significant in handling the situation and sharing the burden of making appropriate decisions. For instance, with regard to a large control device, the pilot's action to lower the gear lever for the landing gear is subconsciously noticed by the copilot, who is informed by his counterpart that the pilot is controlling the aircraft. Such an "awareness of the situation" obviously serves to develop natural communication between the pilot and copilot. In this example, the mechanical control serves as the medium for a message; therefore, the synchrony of intersubjective communication and action through mechanical media, training, and teamwork permits the smooth operation of the overall system (Norman, 1993, 139 ff.).

This case reveals that the human aspect of a technological system, which is latent in usual situations, becomes evident in the case of emergency events. In current engineering practices, the involvement of humans in mechanical systems is generally believed to cause human error; therefore, it is preferred to maintain as little human involvement as possible. Conversely, humans are indispensable for rectifying problems and errors that occur constantly. Humans, in a sense, use artifacts and one another as extensions of their knowledge system, or rather their own body. In fact, one could suggest that a technological system is created through the interaction of humans and devices (cf. Hutchins, 1995; Norman, 1993). Thus, when increased workload or decline in proficiency negatively affects human reliability, automation through machinery does not increase the safety and reliability of a human-artifact system. Lisanne Bainbridge termed such situations as the "ironies of automation" (Bainbridge, 1987).

Humans design, produce, and manage complex systems. Thus, when a major accident occurs, the individuals who made the mistakes are often held responsible. The morals of engineers and an awareness of themselves as professionals is assumed to ensue, although these morals and the types of behavior that they comprise are the actions of human beings who are acting rationally in pursuit of optimality (cf. Renn et al., 2001). However, the problem now is that a vast majority

of knowledge has become routine, and even if this knowledge was once accompanied by careful consideration, it is no longer perceived as such. Nonetheless, acts are committed in accordance with the knowledge "in hand" (Schutz, 1970); therefore, we are usually unable to identify "dis-situated" or disembodied subjects. Moreover, dealing with this knowledge is difficult; this is because if one does not adopt a retrospective viewpoint by asking the question "why," it is not thematized in this manner (Schutz, 1970). Such knowledge allows the smooth and reliable operation of a system; however, it is also fraught with the possibility of a reduction in the reliability of the system with regard to certain aspects such as safety and product quality. The reliability of a system depends upon the reliability of the technical culture. In this context, James Reason noted the "latent conditions" in an organization that induce errors such as the unsuitableness of design, i.e., lacking consideration of human factors, and inadequate direction; accordingly, he proffered the concept of "organizational accidents" (Reason, 1997). Again, the issue here is regarding the improvement in culture and organization. Therefore, the nature of culture, i.e., embodied knowledge, and the nature of the corresponding designs, organizations, and systems, will be examined in the next section.

4 Normalization of Deviance

Let us again return to the example of the Challenger accident. With regard to the launch decision, Collins and Pinch merely observed the familiar scenario in which "one opinion won and another lost"; engineers "looked at all the evidence they could, used their best technical standards, and came up with a recommendation" (Collins and Pinch 1998, 55). However, the conclusion that everything that was possible was done cannot be arrived at based on the above description of the situation, i.e., winning or losing the debate. Such a discussion is merely a kind of afterthought and relativism. With regard to deciding what is right or wrong, they posit that the discussion must further delve into the situation. Vaughan, as cited previously, noted the "normalization of deviance" with regard to the structural factors that cause an accident. In the Challenger accident, no explicit infractions were necessarily committed. Rather, an activity that could be considered to be natural in an organization was responsible for the accident. In this case, since the criteria for the conditions that a discussion by the engineers must fulfill were rigidly applied, there is little scope for recognizing any such deviance; however, this encouraged a definitive situation. Therefore, we can proceed to a discussion on normativity in technical culture.

The fact that introducing and following "rules" and regulations are not needed to improve society is already apparent from the paradoxical situation mentioned above. In order to apply rules and regulations appropriately, it is important to understand their interpretation in advance; this is because a rule itself does not determine whether it is applicable to a particular situation. Moreover, a severe restriction on the scope for action by rules and regulations in the pursuit of safety will result in

people committing infractions on a regular basis. Therefore, contrary to the intent, this may lead to increased risk (Reason, 1997, 50).

Assuming that the above argument holds true, the next issue that we must consider is whether or not the individuals involved exercised "due care." However, questions on what due care implies are certain to arise immediately. In the case of the Challenger accident, we can identify a problem regarding the burden of proof. NASA engineers were conservative as a rule, what was usually done, and continued to demand a proof of safety with respect to Morton Thiokol; this emphasized the practicality of the design. In contrast, the tables were turned when Boisjoly and the others raised concerns immediately before the launch, and NASA demanded that they prove the existence of danger. Therefore, what kind of suspicion is reasonable with regard to such a "risk" that has yet to have an effect, what proof should be demanded in that case, and what decision should be taken in accordance with the given rules are the questions that fall under the concept of due care. Thus, this situation is accompanied by demands for normativity that transcend specific circumstances.

Here, we will avoid dwelling on individual measures to achieve improvement. However, when due care is generally required, besides the concerns regarding what comprises due care, determining who makes the decision is critical. For example, with regard to product reliability, the problem is whether it is appropriate that engineers with specialized knowledge determine a design with strict application methods such that they are not responsible for the outcome and the consumers bear those costs (Velasquez, 2005, 110). If done so, this is merely a kind of paternalism. Thus, keeping the design setting in mind, we will expand the scope of our discussion to "technology in culture" and examine the public nature of technology within it.

5 Historical Nature of Design

In general, design can be considered to be a process of stipulating target functions and proposing structures to implement those functions. This goal-orientatedness is considered to be a characteristic of technical knowledge. However, at the same time, it expresses the fact that technology is incorporated within a wider social context, for example, through markets or individual customers, etc. In this case, the relationship between society and design could still be perceived as that between social needs and optimal solutions. This view should not be understood from narrow perspectives. When examined from viewpoints such as due care with respect to safety and environment, the nature of social and cultural regulation extends to the design process as a whole, i.e., it is not merely restricted to direct functions but incorporates secondary functions, etc.

Here, let us consider the Ford Pinto case as an example. Despite the usual depiction in textbooks on engineering ethics, this case shows that the assessment of the uncertainty and incompleteness of technology includes a valuation beyond

technology in the narrow sense. This case is usually explained as follows. In the late 1970s, the Pinto, a compact car designed by Ford, was developed in a short period of time to compete with competitors' compact models. Since style was prioritized, the car had a potential flaw in terms of design, in case of a collision, the gas tank could rupture if it were struck from behind. Regardless of the fact that Ford could have made improvements at the cost of just $11 per car, the company was attacked for continuing to manufacture the car based on its cost-benefit analysis until 1978, when new regulations became mandatory.

In most of the textbook descriptions, Ford is blamed for its "profits come first" approach that was grounded in its cost-benefit analysis. However, as some writers point out, despite the fact that Ford's analysis was malformulated, it is not evident whether this analysis was really the decisive ground of its (mis)conduct (Birsch, 1994).[2] Although this particular problem is beyond the scope of this chapter, I would like to use this case to highlight the issue concerning the definition of "safety." Obviously, an automobile cannot by nature guarantee complete safety; moreover, one cannot expect the same level of safety from a compact car as from a conventional large-sized car. In addition, the Ford Pinto is not said to have failed the safety regulations at the time (although there are some people who hold the view that this was a gray area). However, as Richard De George also noted, the reason Ford was attacked was not because of such facts but because, despite the existence of technological solutions, the company was negligent with respect to a risk that should have generally been avoided, i.e., explosion of the gas tank (De Georg,e 1994). Moreover, writers have also highlighted a background in which, amidst the consumer movements of the 1960s and the establishment of the National Highway Traffic Safety Administration (NHTSA) in response to these movements, people's awareness with respect to automobile accidents was shifting from the driver's responsibility for the accident to the manufacturer's responsibility for providing adequate safety (Saito, 2005). Given these views, a part of the reason for Ford's response was assumed to be that the company did not believe that people would be willing to pay for eliminating such a risk and that it could not have predicted that ignoring this willingness would invite a backlash in the future (Harris et al., 1995). I elaborate on this point in the discussion on the research of the history of technology.

If the above debate is an appropriate depiction of this case, determining what "safety" implies would not be primarily dictated by technology but by various other factors such as cost and human trust and desires. Such a social decision is embedded in design. Therefore, if we define the automobile as a form of mass transportation, the assessment of what is valued technologically or what items are risks is conducted on the basis of such a definition. In the words of De George, the decision to accept risk is "not only an engineering decision" but "also a managerial decision, and probably, even more appropriately, a social decision" (1994, 186).

[2]The validity and scope of risk assessment needs a deliberate analysis. This is an exhaustive task and will not be undertaken here.

A similar argument could be made with regard to other features and values of technology. Thus, a definite social context is an aspect of technical designs; however, in most instances, it is taken for granted and therefore often overlooked. Only amidst changes in circumstances or in the face of opposition, as in the case of the Ford Pinto, does this social or political nature become evident as a rule; thereafter, the design would be modified and re-embedded within a new context. It is important to note that such transformations of design are not made from a functionalistic perspective. Transformations of design occur within the public sphere and not within a narrow economic sphere, in which functions are considered to be efficiently adapted on the basis of the needs of the market or customers. Barrier-free design is another noteworthy example for this discussion. The former designs that chiefly took non-handicapped people into account come to be realized, for example, through the civil rights movement, as barriers that prevented the handicapped from social participation. From a reflective viewpoint, we can clearly observe the discriminative structure included implicitly in the former designs, and accordingly, the value of justice has been incorporated into the new designs. This transformation clearly reveals the political nature of technical designs. Design is also a historical entity that is developed by many people including engineers, managers, and laypersons.

6 Unintended Results and Public Nature

As mentioned in the previous section, design can be considered as a process of stipulating target functions. Considering the facts that technological design embodies social needs and relationships and that it creates a new social order (see the examples given above),[3] it would be possible to state that designing artifacts means simultaneously designing and defining the order of our world. In a sense, it is similar to a "legislative act" (Winner, 1986, 29). However, the power of this "legislation" is limited since one cannot presuppose the perfect predictability or analytical separability of means and ends. We must also note that the identification of objectives with "the intent of the designer" and of designing processes with the implementation of that design is problematic. As evident from the discussion above, this is because the dimension of what items will be established as objectives as well as what is emphasized in the process of design and what is viewed as secondary are dictated on the basis of culture, or routine knowledge that is often taken for granted. This is strongly associated with the assessment of the uncertainty and incompleteness of technology.

[3] The problem of technical mediation demands a separate study and is beyond the scope of this chapter. For an example from classical literature, see E. Cassirer (1985). "Tool carries out the same function in the sphere of object that can be found in the sphere of logics: it is as it were 'termimus medicus' which is grasped in the objective conception (gegenständliche Anschauung), not in mere thinking" (ibid., 61).

First, besides directly intended objectives, there could be latent secondary intentions that can cause unexpected results. For example, when a designer unintentionally designs an artifact that is primarily meant for non-handicapped people, it might be dangerous for the disabled and therefore result in them feeling discriminated against.

Second, the results of technology are not primary; instead, they accompany numerous effects and side effects. Technology exceeds the intent of the designer, resulting in unintended and unpredictable by-products. In the words of Tenner, technology "bites back" (1996). Results of technology cannot be controlled completely. In the context of risk analysis, with respect to the problem of side effects, a "risk trade-off" is often insisted, i.e., comparing the possibility and weight of a target risk with those of a potential risk that will take its place and determining whether an action should be performed. However, the effects of technology that should be valued can only be determined within the cultural and social context.

Third, changes in the context incorporated in the design and the significance of that technology as a result of the transformations in lifestyle due to technology and other factors are also important. As Don Ihde states, all technologies are double-edged because they have "ambiguous, multistable possibilities" (1999, 44) that exceed the intent of the designer. He terms this phenomenon "designer fallacy" that is modeled on the phenomenon of intentional fallacy in literature. Such instances result in changes in the assessment criteria with regard to risk and the features of technology.

Therefore, the question that arises is: Who should be responsible for this decision? Since no one can manage the technological uncertainties, the question of what overall benefits does a particular technology produce should not be assessed paternalistically and decided solely by engineers. Rather, this question should be determined in public by analyzing it from a larger number of perspectives without being limited to a narrow technical perspective. In this case, the engineers cannot possess all the rights and responsibilities, and the perspectives of non-engineers must be incorporated. This is the reason (Shrader-Frechette, 1994, 94) for advocating the principle of "giving priority to third-party or public responsibilities in situations of uncertainty."

At the beginning of this chapter, I mentioned "culture in technology"; however, the existence of such a system of experiential knowledge implies that it will serve as a barrier that prevents the participation of people who do not share that system. Thus, it should be accepted that in our present society, experts have a monopoly on technological matters. There appears to be an asymmetrical relationship of dominance versus subordination between experts and laypersons. However, such a culture cannot be closed to both matters of fact and normative demands.

On the one hand, as claimed in risk theory, experts have noted the "risk-perception bias" of laypersons. In this case, experts often point to "literacy" in the sense of the capacity to understand science and technology. The thought is that acceptance without bias is only possible by redistributing knowledge, i.e., educating the public and enabling them to acquire the ability to understand modern science and technology "correctly". On the other hand, if one disregards this barrier,

participation in discussions will remain at the most a formality to obtain consent. As evident from this discussion, the situation is instead one of "cultural friction." In other words, due to the differences between the systems of relevance of experts and non-experts, the matters that are considered problematic by non-experts are not viewed as problems by experts. Therefore, what is needed in the first place is "literacy" on the side of engineer's: literacy in the sense of a competency in understanding and responding to the questions raised by laypersons. This could be termed as the engineer's "responsiveness" to the public.

In order to further clarify this, I use the metaphor of a narrative or novel written by many authors, in this case, engineers, managers, laypersons, etc. In this sense, the current master narrative would be that of the engineers. What is required is a rewriting of the narrative of design through mutual recognition between experts and non-experts. This implies that both of them recognize each other in the dialogue as co-authors of the narrative, i.e., as agents with the rights and obligations to ask and answer (responsibility). Trust, identity (on both the sides), and solidarity are founded on the basis of such mutual recognition. Consequently, this shall act as a foundation for the improvement of technical culture in general, or what can be called design culture.

7 Conclusion

We can concretely elucidate "culture within technology" and discern technology as a social and cultural activity by focusing on "acceptability". In general, the history of technology is not only a history of creations or choices but a history of the acceptances of the former and the oblivescence of the latter. Various decisions, interpretations, and valuations are embedded in the history of technology; they are sedimented and taken for granted. In a sense, technology is a narrative given by many people including laypersons. Thus, technological activities are conducted on this historical basis. For example, the reliability of a technology is determined by the reliability of the technological decisions and eventually the existence of a reliable technological culture. Therefore, particularly in organizations, this depends on the cultural and social relations; the same can be said about risk.

We shall undertake a detailed discussion on this issue in the future; however, with regard to the ethics of risks, we can state that the moral of the individual engineer and the moral rules of the engineering profession are not the only central, although not incidental, problems. When designing some artifacts, engineers expect numerous effects, side effects, and possible influences. In this context, in order to recognize engineers as qualified personnel, it is imperative that they are competent in appropriately understanding and responding to the questions of laypersons. Responsibility, in this sense, is the basis for ethics. Based on this approach, we can move beyond the dichotomy of scientifically quantified risk, the bias of non-experts, and the cultural relativism of risks. Thus far, we have emphasized "culture in technology" and "technology in culture"; however, this does not imply that we

should not continue to observe from a descriptive point of view. It is at every step. Design through mutual recognition between experts and non-experts engaged in dialogues is one such way. Technology and its risks are central to our discussion of human well-being.

References

Bainbridge, L., 1987, Ironies of automation, in: *New Technology and Human Error*, J. Rasmussen, K. Duncan, and J. Leplat, eds., Wiley, Chichester.

Birsch, D., 1994, Product safety, cost-benefit-analysis, and the Ford Pinto case, in: *The Ford Pinto Case*, D. Birsch and J. H. Fielder, eds., SUNY Press, Albany, NY.

Cassirer, E., 1985, Form und Technik, in: *Symbol, Technik, Sprache*, W. Orth, ed., Felix Meiner, Verlag, Hamburg (originally published in 1933).

Collins, H., and Pinch, T., 1998, *The Golem at Large*, Cambridge UP, Cambridge.

Davis, M., 1989, Explaining wrongdoing, *J. of Social Phil.* **20**(1&2):74–90.

De George, R. T., 1994, Ethical responsibilities of engineers in large organizations: The Pinto case, in: *The Ford Pinto Case*, D. Birsch and J. H. Fielder, eds., SUNY Press, Albany, NY.

Ferguson, E. S., 1992, *Engineering and the Mind's Eye*, MIT Press, Cambridge, MA.

Harris, C., Pritchard, M., and Rabins, M., 1995, *Engineering Ethics: Concepts and Cases*, Wadsworth, Belmont, CA.

Hutchins, E., 1995, How a cockpit remember its speed?, *Cogn. Sci.* **19**(2):265–283.

Ihde, D., 1999, Technology and prognostic predicaments, *AI & Soc.* **13**:44–51.

Norman, D. A., 1993, *Things that Make us Smart*, Perseus Books, Reading, MA.

Renn, O., Jaeger, C. C., Rosa, E. A., and Webler, T., 2001, The rational actor paradigm in risk theories, in: *Risk in the Modern Age*, M. J. Cohen, ed., Palgrave, London.

Reason, J., 1997, *Managing the Risks of Organizational Accidents*, Ashgate, Hampshire.

Saito, N., 2005, *What is Techno-Literacy?* (in Japanese), Kodansha, Tokyo.

Schutz, A., 1970, *Reflections on the Problem of Relevance*, R. M. Zaner, ed., Yale UP, New Haven.

Shrader-Frechette, K., 1994, *Ethics of Scientific Research*, Rowman & Littlefield, Boston.

Tenner, E., 1996, *Why Things Bite Back*, Vintage Books, New York.

Velasquez, M. G., 2005, The ethics of consumer production, in: *Business Ethics*, Vol. 3, F. Allhoff and A. Vaidya, eds., SAGE Publications, Thousand Oaks.

Vaughan, D., 1996, *The Challenger Launch Decision*, University of Chicago Press, Chicago.

Winner, L., 1986, *The Whale and the Reactor*, University of Chicago Press, Chicago.

Alienability, Rivalry, and Exclusion Cost

Three Institutional Factors for Design

Paul B. Thompson

Twentieth century social science developed penetrating analyses of formal and informal institutions on many levels, yet both philosophers and specialists in design have yet to avail themselves of the implications that these analyses have for understanding the technological transformation of the material world. Three ideas from institutional theory are particularly relevant to technical change. Exclusion cost refers to the effort that must be expended to prevent others from usurping or interfering in one's use or disposal of a given good or resource. Alienability refers to the ability to tangibly extricate a good or resource from one setting, making it available for exchange relations. Rivalry refers to the degree and character of compatibility in various uses for goods. These concepts allow us to pose questions that have been asked by Herbert Marcuse, and Langdon Winner in a more pointed way: if technology is in part responsible for the shape of our institutions, and if institutional change in the sphere of law and custom can be subjected to philosophical critique and democratic guidance, why should not technology be subjected to the same critique and guidance? Specifically, why should not technical designers account for factors such as exclusion cost, alienability, and rivalry in considering alternative designs? Why should not the developers of technology also be socially and politically accountable for consequences accruing from alterations in alienability, rivalry, or exclusion cost?

1 Institutions and Institutional Change

Institutions are standing practices or patterns of human activity that can be described in terms of rule-governed behavior. *Formal* institutions are those that are explicitly articulated as rules, and that are reproduced and enforced by organized social entities, especially the state. Hence, formal institutions are laws and public policies. *Informal* institutions are standing practices that subsist on the basis of

P. B. Thompson, Michigan State University

P. E. Vermaas et al. (eds.), *Philosophy and Design.*
© Springer 2008

common knowledge, tradition, and culture. They are reproduced through legend, lore, apprenticeship, imitation, and perhaps all manner of common experience. Their enforcement mechanisms can include approbation, praise, shunning, or group inclusion but consist mainly in the way that they constitute the framework for successfully negotiating the most basic tasks in social life (Commons, 1931). Although vague, this simple set of definitions provides a basis for interpreting the last millennium of European history as the gradual displacement of informal institutions by formal regimes of law and policy.

Philosophers of the Enlightenment and early Modern Age were deeply complicit in this displacement, typically viewing formal institutions as superior in virtue of their capacity for explicit articulation, widespread application, and critical evaluation. A rule that cannot be clearly stated cannot be criticized or justified, much less enacted by a civil authority, even if it can be reliably followed by those who are appropriately socialized. Perhaps philosophers' predilection for argument, demonstration, and verbal disputation disposed them to regard formal institutions as inherently rational, or perhaps we should say, as C. B. MacPherson (1962) did, that those interests most consonant with the evolution of property rights and state authority naturally aligned themselves with philosophers who were advocating explicit, rational evaluation of society's rules. For present purposes, the key point to notice is the underlying and largely implicit connection between formal, state-based institutions and modern conceptualizations of rationality and right.

The philosophical bias in favor of formal institutions declined in the Romantic period, as philosophy begins to pine for a lost sense of belonging and community solidarity. In 1897 the German sociologist Ferdinand Tonnies theorized modernization as a transition from *Gemeinschaft* to *Gesellschaft*, and in 1914 Max Weber characterized it as a process of rationalization toward increasingly bureaucratic decision-making. Weber and Tonnies (along with Marx, of course,) provide the backdrop for the first wave in 20th century German philosophy of technology, a movement of thought that includes such diverse figures as Martin Heidegger, Theodor Adorno, and Herbert Marcuse. Although their political orientations were often antithetical, all of these thinkers challenged the bias in favor of rationality, associating it deeply with technology and industrialization, which they often seemed to equate with a particular conception of scientific method. One oft noted weakness in this approach is that it gave precious little attention to the mechanisms that link technology to the industrialization process. In focusing so intently on scientific rationality, and on the complicity with capital noted by MacPherson, these thinkers ironically made it seem as if all the important work to be done was philosophical. There was nothing much to say to actual designers.

In contrast to these philosophers, British labor historian E. P. Thompson argued that many of the transformations that contributed to the industrialization process occurred at the material level. These included the alienation of ordinary food from the circumstances in which the production, distribution, and consumption of grain had been embedded so that it could be traded as a commodity good. Before the 18th century, the grain growing in an English field would have been considered the

common property of the parish. An elaborate system of informal concessions governed the share to which each parishioner was entitled, as well as the tasks such as harvesting, milling, or baking that each was obligated to perform. However, as roads and wagons improved the farmers who harvested and bagged grain saw opportunities to sell it in other villages or wherever prices were best, ignoring the informal assessments and shares that governed the distribution of grain under traditional practice. How are we to interpret this situation? Do the farmers have a right to seek the best price for their grain, or is the common property of the village?

Natural law philosophy tended to notice a few key things about grain. First, the farmers who come into first possession of a parcel of grain through the labor of sowing and harvesting can easily keep tabs on its location and use, and it is fairly easy for the grain to change hands by sale or gift. Furthermore, once consumed for one use, the grain is gone. It cannot be re-eaten by another. These natural characteristics of grain were seized upon by natural law theorists, who saw a sack of grain as something naturally fit for property rights, formal institutions sanctioned by the power of the state. Thus, the natural law theorists endorsed the farmers' right to claim ownership of the grain, and redefined the sack of grain as a commodity good, replacing the informal social institutions of entitlements and shares with the formal institution of state sanctioned commodity exchange (Thompson, 1971).

Thompson's analysis notices both stabile and technologically transformed features of the material world: the fact that grain is consumed in use remains stabile, but grain only becomes alienable and available for exchange through becoming transportable, that is, through a technical change. In creating their rationale for private property, the natural rights philosophers fixed upon a particular configuration of these material properties and invested it with the notion of right, backed by the power of the state. The "natural" state of things might have looked rather different before the advent of roads and wagons, however, and a different configuration of institutions might have been selected as the one that was, to any rational person, right.

There are many lessons that present day philosophy of technology might take from Thompson's history of social institutions, but the point most relevant to a philosophy of design is that the technological transformations that precipitated these decades of upheaval involved the creation of alienable goods, goods whose production and distribution can be controlled. Prior to the work of those who designed and executed the roads and wagons of the English countryside, the "natural" configuration of grain supported an effectively common property status enforced by informal norms. After that work, the "natural" configuration of grain supported private property claims on the part of farmers, claims that required the formal endorsement and enforcement of the state. Although the men who designed the wagons and roads of late medieval Europe were certainly not thinking about how they would affect the material properties of barley, wheat, and rye, their work did alter the *alienability*, the *exclusion cost*, and the *rivalry* of these goods. Understanding the link between technical design and institutional change thus demands that we understand alienability, rivalry, and exclusion cost more clearly.

2 Alienability

Alienability is the degree to which a good or potential item of use can be extricated from one setting or circumstance so that it can be transported to or utilized in another. A critical aspect of alienability is the ease with which something in the possession or employ of one human being can be transferred to the possession or employ of a different human being. The right to life is characterized as an inalienable right because a life can only be lived by the individual whose life it is; it cannot be given or sold to someone else. Hence the *right* to live can only be exercised by the person whose life is at stake, it cannot be alienated from that person and exercised by someone else. Alienability determines whether a good or right can meaningfully be subject to exchange. It is thus a necessary prerequisite for any item of property, at least as this notion has been understood in the natural law tradition.

It is important to note, however, that a fairly large component of sociability depends on the degree to which various items or goods are alienable or alienated from one another. For Thompson's peasants, the fact that it was rather difficult to separate large quantities of grain from inland locales where it was grown prior to the advent of better roads and wagons made for a situation conducive to the embedded relations of production and exchange that were characteristic of feudal society. The inalienability of grain from place was, of course, a situational rather than a metaphysical necessity. Other situational forms of inalienability include the impossibility of separating a musical or theatrical performance from the person of the artist prior to the invention of photography and audio recording. Prior to 18th century legal reforms documented by Karl Polanyi (1944) it was also legally impossible to separate the labor power of a worker from the parish in which he was born.

These situational types of inalienability can be changed, in the latter case by changing the law and in the former cases through material transformation. We may speculate that in virtually every case it is difficult to imagine how goods might be alienated one from another until it has become obvious that it can be done. In our own time, traits that might have been thought to be inalienable characteristics of certain plants or animals can now be readily encoded in genetic sequences and transferred to totally different plants and animals through genetic engineering. These traits, or at least the genes that confer them, have even been alienated from organisms altogether and put on the market all by themselves in the form of licenses that plant or animal breeders may purchase so that they may then transfer the trait to different organisms. It would have been difficult to conceptualize the growth rate of a fish as something that could have been alienated from the species or type of fish prior to this development in genetics. If you wanted fast growing fish, you would have to get fish that grew quickly. But growth rate has now been alienated and it is now possible to build a fast growing fish, or a fast growing anything, simply by buying the gene construct (Muir, 2004).

3 Rivalry

Rival use or *rivalry* is the degree to which alternative goods or uses of goods come into competition. One way in which two alternative uses of a good can compete is when they are consumed in use. Eating the grain is a comparatively rival use because it can only be eaten once, and this use exhausts the possibility of its being used by another person or in another way. Enjoying the scenic beauty of the waving fields of grain is a non-rival use because not only can more than one person obtain this good from a single field of grain, scenic beauty can be enjoyed repeatedly. It is also possible to use the concept of rivalry to describe the relationship between two or more goods that can be substituted for one another and which therefore come into competition in market relations. Thus beans and corn may be rival in that both can be eaten, and a shopper may opt for beans when the corn is too expensive. But beans and corn are non-rival in that you cannot use beans to make Tennessee whiskey, so a moonshiner is never in the market for beans. Rivalry is thus situational, and situations can change. Since antiquity, farmers have made use of seeds, planting them to grow a crop. The crop produces more seed, which can be planted again. In this sense, using a seed to plant a crop is a qualified non-rival use. It does not deplete the amount of the good available for future uses, though it does make the good temporarily unavailable while the crop is in the ground. Genetic use-restriction technologies (GURTs), or so-called "Terminator" genes, can be used to create seeds that when sown as a crop will not produce more seeds. GURTs thus transform the use of seeds to sow a crop from a non-rival to a rival use (Conway, 2000).

Alienability and rivalry are critical to the creation of exchange relations because they influence the degree to which a good is amenable to the process of, and the need for, exchange. Goods that cannot be alienated effectively become a single good for the purposes of exchange, if they can be exchanged at all. Rival goods are depleted by use, and hence must be obtained and replenished prior to any use, or they may substitute for one another, also affecting the need to obtain them through exchange. Thus, whether exchange takes the form of sale, gift, or grant, it is primarily alienable and rival goods that are the object of exchange. Or to put this in somewhat different terms, although human beings can exchange glances, insults, and affection, it is the exchange of alienable and rival goods such as a sack of grain, a team of oxen or a day's work in the fields that constitute the paradigmatic form of the economic social relationship.

4 Exclusion Cost

The degree to which alienable and rival goods precipitate social relations characterized by commercial exchange also depends on the ease with which the various uses of a good can be limited or controlled through access or possession. *Exclusion cost* is the outlay in time, trouble, and expenditure of resources that is required to

prevent others from having access to a particular good or item of property. Like alienability, exclusion costs are in large measure a function of the material characteristics of the goods human beings utilize and on which they rely. Oxygen and vitamin D are alienable and rival goods, but it is fairly difficult to prevent people from having access to air and sunshine. It is, in contrast, fairly easy to keep jewels and trinkets where no one else can get them, hence the latter have more typically been understood as saleable items than the former. Items with very high exclusion cost are unlikely to be traded commercially.

Like alienability and rivalry, exclusion cost is amenable to situational variation. Situational change in exclusion cost has often taken the form of material manipulation of either the goods in question or of the circumstances in which they reside. Locks and fences are the classic technologies of exclusion, and a better lock will lower the cost of excluding others every time. It has also been possible to reduce exclusion costs through the development of informal institutions. Simply declaring that certain parties have an exclusive right to use a good will suffice in many cases. Queuing for service is among the most venerable of informal institutions in Western cultures, and everyone recognizes that the person at the front of the line has an exclusive right to be served next. If being served next is the good in question, we may thus say that for the first in the queue, the cost of excluding anyone else from this good is very low. By common consent, customary recognition of this right saves everyone a lot of time and trouble, making the cost of many daily transactions far more reasonable.

When customary rights of exclusion are threatened, it is always possible to bring in the coercive power of the state to back them up. The police represent a formidable way of lowering exclusion cost for all manner of private property. A person who would have to guard or defend an item of property can call on the police to do it, and the knowledge that arrest and prison are among the possible consequences of an unlawful taking raises the cost of theft, simultaneously lowering the cost of exclusion. Copyright and patent laws represent formal institutions that place the coercive power of the state behind a broad array of exclusive practices, even when no tangible property exists. The legal remedies of intellectual property law vastly reduce the cost of preventing others from using one's intellectual creations through intimidation, bullying, spying, and other forms of self help.

Alienability, rivalry, and exclusion cost represent features of the various items and entities in the world, including personal services and material things, that collectively determine which items and entities come to be the object of exchange relations, and which ones remain embedded within a more inchoate and presumptive context of social practice. It is very likely that anything alienable, rival, and excludable will be regarded as an item of personal or private property. It should not be surprising that when goods lack one or another of these three dimensions, people try make up for it either by passing laws or by changing the world in a material way. As institutional economists developed their analysis of these traits, they brought the economists' bias that enabling transaction is always a good thing. They also brought the social scientist's bias of focusing on social practice, and especially on formal institutions. As such, they have tended to focus on legal or policy reforms that will

lower the costs of making an exchange. But as my illustrations demonstrate, it is as equally possible to affect alienability, rivalry, and exclusion cost with a technical as with a legal change, and that change may or may not be a focus of design.

5 Changing Things by Design

The material dimensions of alienability, rivalry, and exclusion cost represent a "given" or natural infrastructure in which informal institutions evolve, either by chance or by design, and a set of background conditions against which formal institutions are formulated and enforced. When those background conditions change, by chance or by design, the entire significance of social institutions can be altered. All of which raises the question: if changes in the formal institutions of society are appropriate targets for political philosophies and theories of justice, why not also the technological transformation of alienability, rivalry, and exclusion cost? This is, I take it, a somewhat more focused restatement of a question that has been asked many times before. Herbert Marcuse's *One Dimensional Man* suggests that the failure to subject technical systems to normative scrutiny is both a political and a philosophical failure. The political failure resides in the increasing power of capital and commercial interests to dominate all forms of discourse in industrial society, while the philosophical failure consists in positivist doctrines that created an epistemological space in which questions about technical efficiency were regarded as "value free," (Marcuse, 1966)

For most people involved in the practice of design, Marcuse's characterization of technology has seemed to be too metaphysical, too Heideggarian, and simply too vague to be of much use. Langdon Winner has had more success in calling for critical evaluation of technology and technical change by describing what he calls "the technological constitution of society." This is a material and organizational infrastructure that predisposes a society toward particular forms of life and patterns of political response. Winner illustrates his idea with a number of examples, notably technological systems such as irrigation systems or electric power grids that dispose societies toward centrally administered, hierarchical relationships of political power (Winner, 1986). We should notice that what accounts for such tendencies is the way that these systems affect the alienability, rivalry, and exclusion cost of the respective goods, water, and energy, that they produce and distribute.

Centrally administered irrigation systems in the ancient world and contemporary electric power grids succeed in part because they represent technical solutions to real problems, but they also have the effect of converting goods that are comparatively non-rival with high exclusion costs, into goods that are just the opposite. Water and energy are virtually everywhere in most locales, though frequently not in large enough concentrations to accomplish certain critical tasks such as agriculture or manufacturing. In their natural state, water and energy have high exclusion costs; it takes a bit of trouble to keep people from having access to them. Natural water systems such as rivers and springs also serve a number of purposes

simultaneously and in this sense are comparatively non-rival goods. Though generally depleted in use and in that sense naturally rival, energy in the form of wood and mineral fuels or localized wind and water mills is relatively specialized in the types of work it can be expected to perform. One type yields heat and the other mechanical power, and further technology is needed to reconfigure them for other purposes. Thus water and energy are relatively non-rival under these configurations of the material world. The irrigation system and the power grid reduce exclusion cost as they increase rivalry, and the result is goods that are far more amenable to centralized control and to commodity exchange than water and energy are without these technological infrastructures. What is more, both systems provide a way to alienate their respective goods from a local setting, much as wagons and roads transform the alienability of grain. Thus, alienability, rivalry, and exclusion cost are part and parcel of what Winner has called the technological constitution of society. These traits specify the politically important design parameters of a technological system more clearly.

However, if the conceptual framework made available by institutional analysis allows us to sharpen the questions we wish to direct at technology, it also results in a deflation of the thesis that technology needs to be questioned. First it is clearly specific tools and techniques as utilized in specific situations that give rise to the material consequences I have been illustrating, not "technology" as a metaphysical force. Second, not all of these material changes will rise to the level of political importance. One would hardly object to better locks on the ground that they lower the exclusion costs for people who use them. That is what locks are supposed to do. Third, Marcuse's belief that there is a dominant logic or trajectory of technology is weakened, rather than strengthened, by the institutional analysis. Technological change has the potential to affect alienability, rivalry, and exclusion cost in myriad ways. Xerox copiers, computers, and the Internet have raised the exclusion cost for goods such as texts, audio recordings, and images, at the same time they have made them less rival. As a result, these items are less easy to control and less like commodity goods. Not surprisingly, those who benefited from the old material structure have moved quickly to encourage the enactment of formal legislation that would restore some the rivalry and lower the costs they incur in excluding what they take to be unauthorized use.

Finally, even if technology should be questioned when alienability, rivalry, and exclusion cost are affected, it is not at all obvious what the answer should be. Analysts who use the word "commodification" generally think that this kind of change is a bad thing, but economists who talk about reducing transaction costs generally think just the opposite. In both cases, there may be an understandable but false assumption that the material infrastructure of the world is relatively fixed, so that the processes in question always involve manipulations of law and policy. This assumption may then map transformations in alienability, rivalry, and exclusion cost onto rather well-worn political ideologies. Hence, "commodification" is bad because it favors capitalist or bourgeois interests, while lowering transaction costs is always good because it allows rational agents to more successfully maximize the satisfaction of subjective preferences. Even if this is generally correct for changes in formal institutions, which I doubt, it will simply not do as a sweeping analysis of technical change.

6 Some Concluding Comments for Designers

The foregoing discussion is intended to explain how alienability, rivalry, and exclusion cost become incorporated into technologies, and why these features are particularly important from an ethical or political perspective. But perhaps it is still not obvious how they are relevant to design. In one sense, designers (by which I, with the other authors in this volume, mean those who make decisions about key features, standards and configurations of a tool or technique) have long been attentive to these features. When engineers develop a feature for a product that will be technically difficult or costly for competitors to duplicate, they are affecting the rivalry and exclusion cost of the product. When they develop "work-arounds" to avoid licensing costs, they are responding to aspects of alienability, rivalry, and exclusion cost that have been formally institutionalized through patent law. When equipment manufacturers utilize a strategy of "planned obsolescence," they are ensuring rivalry between the product they make today and a product they will make in the future.

There has, however, been little previous attention to these institutional features in the philosophy of technology. This chapter thus brings some fairly standard aspects of design into view for philosophers. Yet some of the examples discussed above had institutional impacts that no one foresaw or intended. It is doubtful that those who developed roads and wagons intended to affect farmers' ability to alienate the grain growing in their fields from the local village economy. It is also worth noting that any attempt to make a normative evaluation of how a given design affects institutions will depend a great deal on very specific aspects of the technology in question, as well as the socio-economic environment in which it will be deployed. Thus there does seem to be some room for designers and philosophers alike to give renewed attention to institutional impact in developing a new product or a new configuration of technical means. Any *ex ante* use of the considerations described in this chapter to plan and evaluate technical design will need to be fleshed out with an economic analysis (see North, 1990), as well as a great deal of specific detail that only designers themselves can provide.

Lawrence Lessig's detailed studies of the way that technical codes affect alienability, rivalry, and exclusion cost for software and the Internet provide one of the best examples of how recent design questions involve institutions. Lessig contrasts the design of internet architecture at Harvard and the University of Chicago, showing how the Chicago system has inherently high exclusion cost incorporated into its code. The result is that the Harvard design permits system administrators to make case by case decisions about when barriers will be lowered for a given user (Lessig, 1999). Lessig also argues that net protocols might have been designed so that movement of bits over the network was application specific. That is, the protocol for transferring text files might have been different from that of moving bits that code for MP3 or video. This would have introduced a form of rivalry into the system that would have facilitated centralized control, as opposed to the information commons that currently exists (Lessig, 2002). Lessig's work shows that when we question the institutional implications of technology, we will need to look closely at the actual implications of a specific technical change before we will

be in a position to speak about whether it is good or bad. It is to his work that designers wishing to operationalize the ideas in this chapter should turn.

In conclusion, achieving a clear understanding of alienability, rivalry, and exclusion cost can help both designers and philosophers of technology do some of things that they have long aspired to do better. In the case of designers, alienability, rivalry, and exclusion cost represent parameters that go a long way toward predicting some of the most socially sensitive and historically contentious elements of a technical change. Be advised that such modifications will require careful planning and a well-crafted participatory process of design and implementation. For philosophers, alienability, rivalry, and exclusion cost help us to look for at least some of the details that really matter when technical change occurs. A focus on alienability, rivalry, and exclusion cost thus provides a promising way to integrate the philosophy, sociology, and economics of technology, and to clarify some of the more obscure mechanisms that have been associated with technological determinism and social history. Alienability, rivalry, and exclusion cost also represent elements of specific technologies such as genetic engineering or information technology that serve as boundary objects linking alternative networks of actors, and bridging normative with classically technical domains. As such, alienability, rivalry, and exclusion cost provide a focal point for the ethics of technology, and should be considered in any attempt to identify the elements of a novel technology that are most in need of deliberation and public discussion.

References

Commons, J. R., 1931, Institutional economics, *Am. Econ. Rev.* **21**:648–657.

Conway, G., 2000, Genetically modified crops: risks and promise. *Cons. Ecol.* **4**(1):2. [online] URL: http://www.consecol.org/vol4/iss1/art2/

Lessig, L., 1999, *Code: And Other Laws of Cyberspace*, Basic Books, New York.

Lessig, L., 2002, *The Future of Ideas: The Fate of the Commons in a Connected World*, Vintage Books, New York.

MacPherson, C. B., 1962, *The Political Theory Of Possessive Individualism: Hobbes To Locke*, Clarendon Press, Oxford.

Marcuse, H., 1966, *One Dimensional Man*, Beacon Press, Boston.

Muir, W., 2004, The threats and benefits of GM fish, *EMBO Reports* **5**:654–659.

North, D. C., 1990, *Institutions, Institutional Change and Economic Performance*, Cambridge University Press, New York.

Polanyi, K., 1944, *The Great Transformation: The Political and Economic Origins of Our Time*, Beacon Press, Boston (reprinted 2001).

Thompson, E. P., 1971, The moral economy of the English crowd in the Eighteenth Century, *Past and Pres.* **50**(February):76–136.

Winner, L., 1986, *The Whale and the Reactor: The Search for Limits in a Technological Age*, University of Chicago Press, Chicago.

Part II
Emerging Engineering Design

Friends by Design

A Design Philosophy for Personal Robotics Technology

John P. Sullins

Abstract Small robotic appliances are beginning the process of home automation. Following the lead of the affective computing movement begun by Professor Rosalind Picard in 1995 at the MIT Media lab, roboticists have also begun pursuing affective robotics, robotics that uses simulated emotions and other human expressions and body language to help the machine better interact with its users. Here I will trace the evolution of this design philosophy and present arguments that critique and expand this design philosophy using concepts gleaned from the phenomenology of artifacts as described in the literature of the philosophy of technology.

1 Introduction

1.1 The Novel Design Issues in Personal Robotics

Robots are no longer limited to pure imagination, cyberspace, or the factory floor. Robots are finding a niche right in our homes. This requires that the machines be designed with a plastic ability to adapt to the differing lifestyles of all their potential users. The roboticist Cynthia Breazeal has coined the term *sociable robots* to describe robots with this ability.

> ...a sociable robot is able to communicate and interact with us, understand and even relate to us, in a personal way. It is a robot that is socially intelligent in a human-like way. We interact with it as if it were a person, and ultimately as a friend (Breazeal, 2002, 2).

This conception of robotics directly challenges the more traditional paradigm of industrial robotics and the idea that robots are meant to do their work in isolation from human agents. In order to achieve this vision, robotics designers will need to pay more attention to human values such as the beliefs and desires peculiar to the human society that these machines are built to enter and interact with. Whereas

J. P. Sullins, Sonoma State University

P. E. Vermaas et al. (eds.), *Philosophy and Design.*
© Springer 2008

workers were either replaced or had to learn to adjust to the robots that entered the factory floor, just the opposite is necessary for personal robotics to succeed.

There is, however, an alternative tradition in robotics that more readily embraces the vision of sociable robotics, which we will explore in this chapter, and that is found mostly in the consumer and service robots coming out of Asia. These robots are more playfully designed and data seems to suggest that Asian consumers are more prepared to accept these machines as a fellow agent, pet, friend, or even surrogate family member.

Certainly, this technology is not without serious ethical concerns. We need to ask the difficult questions such as: When it is correct to replace human agency with artificial agency? Will these machines serve to enhance human culture or serve to isolate us further from each other? How will we program these machines to interact with us as friends?

1.2 Robots in the Home

In 2003 a small dustpan sized robot entered the homes of many consumers (Maney, 2003). This robot, called the *Roomba*, promises to be the harbinger of a new age in personal robotics. Roboticists are now designing robots to work with people in the home and this is presenting them with many new challenges. If personal robotics is to succeed, then these machines must fit into the human lifeworld, which necessitates that an understanding of human sociality should become central to the design process of these machines.

Previous robotics technology has not been designed with much regard for seamlessly fitting into the human lifeworld. Since 1961, and the first application of industrial robotics at General Motors in New Jersey, commercial robotics technology has mainly consisted of large dehumanizing machines chiefly confined to the factory floor. Little effort was made when constructing these machines to get them to fit unobtrusively into the social fabric of those who used the machines. Robotics technology and automation has been criticized for its negative impact on the lives of factory workers; this technology made their jobs less skilled or made workers outright redundant (Garson, 1988). These machines are typically fenced off from human workers and are often very dangerous to be near while they are in operation.

The need to place a larger emphasis on designing personal robots to fit into the lives and social networks of their users is a very new problem for roboticists, since the typical design strategy in industrial robotics is to alter the lives and social networks of the user to fit the needs of the machine. In this chapter I will critique some of the most important work that has been done in social robotics. In addition to this I also want to question why we feel we need to have robotic servants. It is not clear that an automated workspace has made the lives of workers better and it is equally unclear whether automating our living space will make our home lives better. Towards the end I will also focus on the work of roboticists that resist the pedestrian notion of robots as domestic servants and see them instead as a chance for us to design new friends and companions.

2 Effective and Affective Design Paradigms in Robotics

2.1 The Growth of Robotics and Personal Freedom

The growth of the personal robotics market is showing signs of mirroring the early growth of personal computers. While this market is nowhere near as large as that of the personal computer, it is as large as that of traditional industrial robotics, and it is growing quickly. According to studies by the Japan Robotics Association, the United Nations Economic Commission, and the International Federation of Robotics, the personal and service robotics market is already equal to that of industrial robotics at about 5,400,000,000 U.S. dollars. By 2025 it is projected to be four times the size of the industrial robotics market, or about 51,700,000,000 U.S. dollars, and this is excluding military robotics and entertainment robotics which would greatly increase this dollar amount.[1]

This explosive growth is garnering the same kind of investor excitement as the dotcom boom of the 1990s and a few large trade shows have been organized to help hype the technology and funnel investment dollars into this industry.[2] Behind the hype and over exuberance occasioned by the introduction of personal robotics technology, there is an interesting and significant reality. Slowly but surely, more or less autonomous machines are making their way into our lives, from expensive robotic toys like the Sony *Aibo* robotic dog, to robotic vacuum cleaners and lawnmowers, all the way to the new crop of robotic weapons platforms currently deployed in the Middle East (Aproberts, 2004).

One of the most socially interesting developments in robotics technology has been the creation of robotic companions built to suit the emotional needs of children, the elderly, and even love sick young adults. These robots are primarily designed by Korean and Japanese companies and research centers that are keenly interested in building machines that are more than simply appliances: they are interested in making our future friends.

2.2 Design Paradigms in Personal Robotics

We can see two distinct design paradigms forming in the burgeoning personal robotics industry. For the sake of discussion I will call them the 'effective' and the 'affective' design paradigms. For example, American and European robotics companies have largely focused on very utilitarian, or effective, implementations of robotics technologies by building robotic vacuum cleaners, lawnmowers, and

[1] Data acquired here: (http://www.robonexus.com/roboticsmarket.htm).

[2] Robonexus is a consumer trade show (http://www.robonexus.com/index.html) and Robobusiness is for industry members (http://www.roboevent.com/).

weapons platforms. Japanese and Korean companies have pursued the more playful or affective aspect of robotics, building ingenious robotic pets, dolls, and humanoid companions. Sony, Honda, and Hitachi have all built extremely expensive humanoid robotic mascots that dance and wow the crowds at tradeshows and in advertising.

Effective design here refers to the interpretation of robots as tools or appliances meant to automate some formerly human activity. Effective design in robotics is the design strategy that seeks to remove some task from the human lifeworld and delegate it to robotics technology that can deal with the problem with little or no human direction. The robot effectively takes over some task that is too mundane, dirty, dangerous, or otherwise distasteful to leave to humans. An example of an effective robotic design that is already in place might be a vacuum cleaning robot that is programmed to come out of its charging station at night so it can vacuum a room and have it ready before its owners awake.

Affective design seeks to imbed the robot deeply into the lifeworld of the humans with which it interacts. These machines are built to elicit, and even 'experience' emotion, in order to bond more fully with their human users. This is an intriguing notion, and it is by far the more radical of the two design paradigms found in robotics today. It is this design strategy that we will focus on in this chapter. In sections four and five we will look at a few examples of this technology and explore some of the motivations of the engineers working on these machines.

It would be too simplistic to suggest that the differences between effective and affective robotics design are entirely accounted for by diversity in culture since we will see that there are important researchers in the West that are making many breakthroughs in the affective design paradigm and the Japanese have lead the world in building factory robots that are firmly in the effective robotics design paradigm. However, it is true that one finds a more ready acceptance amongst consumers of friendly and good-humored robotic designs in the East, especially in Japan.

Before we look at some of the interesting affective robots that have already been built, we need to review some of the insights that have influenced the robotics movement towards affective robotics design.

3 Important Factors in Affective Robotics Design

3.1 Robots and Social Psychology

The roboticist Takayuki Kanda and other researchers from the Advanced Telecommunications Research Institute Intelligent Robotics and Communications Labs in Kyoto (ATR), in conjunction with a number of Japanese Universities, have studied the psychological and sociological factors that can be observed during human robot interactions. They state that, "[f]or realizing a robot working in human society, interaction with humans is the key issue" (Kanda et al., 2001). They add that to achieve a robot that can elicit positive emotional responses from its human users, the robot needs to have some understanding of human psychology and group dynamics so that it can more fully interact with those around it.

Takayuki Kanda's ATR lab built a robot named "ROBOVIE," and studied its interactions with human test subjects. ROBOVIE has a vaguely human shape with a head, arms, torso, and a wheeled undercarriage. It is also equipped with an antenna that tracks radio frequency identification (RFID) badges worn by the humans interacting with it. This allows the robot to easily identify the different people it comes into contact with. The ATR researchers believe that a robot is only seen as intelligent by its operators if it both performs actions and expresses its ability to function in a natural and human like way (Kanda et al., 2001). For instance, just having people interact with a robotic head or some other restricted design is not going to draw out affective interactions with the machine, but a robot with a complete body that can interact with users autonomously, "...lets observers easily attribute various intentions to the robot based on its gaze-related movement" (Kanda et al., 2001). The researchers at ATR had the robot interrelate with fifty nine subjects and then asked each of them to fill out a questionnaire. The respondents rated the robot on a seven point scale between twenty eight pairs of opposite traits, such as friendly-unfriendly, exciting-dull, intelligent-unintelligent, etc. They found that close contact with an expressive robot that could accomplish various tasks brought about the most favorable impressions in the subjects (Kanda et al., 2001).

In another set of experiments, the ATR Intelligent Robotics and Communications Lab took ROBOVIE to elementary schools for extended periods of interaction with students in the classroom (Kanda et al., 2004; Kanda and Ishiguro, 2005). The robot was able to interact with students in a modest way engaging with them in about seventy behaviors, including simple games, telling them secrets, giving hugs and kisses to them, and making other friendly gestures. Takayuki Kanda and Hiroshi Ishiguro have been able to design the robot to engage in simple conversations, it can speak some three hundred sentences and understand about fifty words (Kanda and Ishiguro, 2005). This design has proven to be engaging enough to interest some children in interacting with the robot for extended periods of time. In one experiment the robot was programmed gradually to give out more "secret' information about itself depending on the amount of time the student spent with the robot and this, along with the robots ability to call out student's names, proved to be a very popular set of behaviors with the students (Kanda et al., 2004). The students wore nametags that had an RFID transmitter in them so that the robot was able to know with whom it was it was interacting. This feature allowed ROBOVIE to track the number and length of interactions it had with various students and also to attempt to deduce the friendship relationships that existed between the students in the classroom, in which it achieved to some moderate success (Kanda et al., 2004). The ATR Labs' goal is to eventually create a robot that can interact with students in a friendly manner and help teach children in the classroom while building relationships with the students and to, "...help maintain safety in the classroom such as by moderating bullying problems, stopping fights among children, and protecting them from intruders" (Kanda and Ishiguro, 2005).

Takayuki Kanda and his fellow researchers have discovered a number of interesting things about the design of affective robotics technology. Foremost is the data they have gathered that suggests that both adults and children are willing to suspend disbelief and attribute real intelligence and friendly feelings towards these machines

even at the modest level of behaviors that are possible with the technology of today (Kanda and Ishiguro, 2005; Kanda et al., 2004). They have also found that the appearance of the robot is important and that reactions to the robot change when they alter its outward appearance, even when the underlying programmed behaviors remain the same (Kanda et al., 2004).

3.2 Bootstrapping Affective Human Robot Interactions Through Anthropomorphism

Research in the social psychology of human robot interactions such as what we looked at in the last section have inspired other roboticists to attempt to harness the natural psychological tendencies of humans in the design of affective robots. Since it seems that we all tend to anthropomorphize objects in our environment, this fact can make the design of affective robots much easier to accomplish. For instance, Daniel Dennett has written persuasively on "as-if" intentionality, where we often find it expedient to treat certain things we are interacting with as-if they had real intentionality (Dennett, 1996). This trend also seems to extend to the emotional realm. When dealing with affective robots, people seem willing to treat the robot as-if it really did have some fondness for them even if the engineers that built the machine would never be willing to ascribe these emotions to the machine since they know the synthetic tricks they used to simulate the emotions in the machine.

We might want to push this idea philosophically and wonder if once we have a complete understanding of neuroscience, our so called 'real' emotions might not turn out to be of the as-if variety Dennett describes. But let us leave that to another day. What is important to our discussion of affective robotic design is that this trick does work and should be used in designing these machines. Still, it is important not to push this psychological tendency too far. Humans are willing to ascribe abilities to machines that the machines do not have, but only to a point. Brian Duffy of the MIT Media Lab Europe reminds us that we need not attempt to build ersatz humans that will be ultimately unconvincing, but that instead we need to balance the robots, "…anthropomorphic qualities for bootstrapping and their inherent advantage as machines, rather than seeing this as a disadvantage, that will lead to their success" (Duffy, 2003). In other words, successful affective robots will be machines that are designed to do what machines do best, but in a way that engages the users' natural anthropomorphizing tendencies to help embed that machine in the user's lifeworld. This means that affective robots are best when they elicit our natural human predispositions to grant personalities to the objects around us making it easier for us to interact with the technology.

The roboticist Mashahiro Mori describes an interesting psychological barrier that roboticist must contend with, which he calls the "uncanny valley" (Mori, 1970). The uncanny valley is found by graphing the level of human likeness with familiarity, as a machine becomes more similar to humans in likeness and function it will evoke more positive feelings of familiarity. But Mori claims that after a certain

point the machine will be more like a human in likeness and function but this likeness will be seen as uncanny and not desirable until the machine reaches a very high level of human likeness where he posits that the feelings of familiarity will rise again amongst the humans interacting with the machine, the uncanny valley is the area of unfamiliarity between the first and second peak of positive feelings of familiarity (Mori, 1970). Mori suggests that it is best for roboticist to design robots in such a way that they sit firmly on the first peak before the uncanny valley; they should be human like in some ways but clearly machines in others. This way they are not threatening and people will happily interact with them. This is a sound design principle if we are to build machines that enhance the human lifeworld rather than disrupt it. In the following sections we will look at some examples of how roboticists in Japan, Europe, and the United States, are thinking about ways to design affective robotics that take into account the ideas and concepts we have discussed above.

4 Affective Robotic Design in Japan

4.1 To Become a Real Atom Boy

Ever since the post war period in Japan, the humanoid robot has been a staple of toy design and the television and movie entertainment industry. Characters such as the friendly, loyal, and heroic little robot boy Tesuwan Atom, (or Astro Boy as he is marketed to the West), who was introduced to the world in a popular anime series begun in 1963, have helped to put a pleasant and obliging face on robotics technology. This interpretation of the robot is quite a bit different from the slave-master paradigm of robots typical of Western science fiction, which from the first mention of robots in the Play R.U.R. to the latest block buster movies have seen robots as menial labors that will eventually rise up to punish their tyrannical human masters. Of course this darker concept of robotics can be found in some Asian science fiction stories and the friendly robot is not absent from the West but overall there is a noticeable trend to be found here.

This friendly take on robotics technology might be based on the vastly different relationship towards technology that distinguishes Japanese culture from that of the West. One theory is that since traditional Japanese culture believes that every thing has a spiritual essence, including nonliving items, so they are more likely to be unbothered by positing some sort of real lifelikeness to machines, a prospect that we in the West find philosophically uncomfortable (Kaheyama, 2004; Perkowitz, 2004). The West, deeply influenced by the materialism/dualism debate, has more trouble with the concept of having an emotional relationship with a machine. The metaphysics of Buddhism also allows for an entirely different relationship to robots then that of the Abrahamic religions of the West and Middle East. Whereas orthodox Christians, Muslims, and Jews might see building a robot as some sort of perverse sub-creation or ultimate graven image, Buddhism allows the machine to share in

the buddha-nature of its creator, or so argues the roboticist and Buddhist scholar Masahiro Mori in his book, *The Buddha in the Robot: A Robot Engineer's Thoughts on Science and Religion*:

> ...if men are appearances created by the Void, then whatever men create must also be created by the Void. It must also partake of the buddha-nature, as do the rocks and trees around us. Specifically, since I myself was created by the Buddha, the machines and robots that I design must also be created by the Buddha (Mori, 1981, 179).

Mori goes on to argue that it is indeed possible to recognize the buddha-nature in a robot and to have some sort of spiritual connection to the machine, one manifestation of the buddha-nature to the other. It is very likely that these cultural values are explicitly or tacitly affecting the design of personal robotics by the Japanese and others in the East. As the philosopher Andrew Feenberg has shown, different societies and communities will produce different, alternative expressions of the dominant technological paradigm (Feenberg, 1995). We should therefore expect to see very different relationships to robotic technology between various cultures. As an article from the Japan Economic Newswire reports:

> "For the Japanese, the distinction between 'me and others' and 'man and robots' has been vague," said Norihiro Hagita, head of the Intelligence Robotics and Communication Laboratories of Kyoto who is studying the coexistence between man and robots. "This flexible sensitivity has helped produce a culture to share various jobs and experiences with robots" (Japan Economic Newswire, January 2005).

Karl MacDorman, a researcher at the robotics lab in Osaka suggests an alternative hypothesis as to why the Japanese in particular are working so hard to create personal and service robots (MacDorman, 2005). He suggests that since Japanese culture has so many social mores regarding proper interpersonal relations that can be very taxing and difficult to maintain, it is preferable to them to interact with a machine than with a fellow human being, it is impossible to embarrass a robot with a misspoken phrase or improper gesture so it is a less stressful interaction.

Both of these hypotheses are reasonable and it is possible that they are both true since a traditional cultural predisposition towards animism would reinforce the behaviours MacDorman observes. If relationships with other humans are difficult culturally, and one is predisposed to affable feelings towards robots, then it is natural that we will see the friendly behaviors towards robots that MacDorman and others find in Japanese test subjects.

4.2 Someone to Watch Over Me

More people are living longer and this is beginning to put a stress on caregivers. This stress is particularly evident in Japan where the population of the older generation outnumbers the younger generations. As a world leader in robotics technology, the Japanese have begun to deploy robots to address the problem (Biever, 2004). The hope is that one day robotic devices will provide help, monitoring, and companionship to those elderly that cannot get these things from their family or other sources.

A number of robots have already been built that attempt to serve several of the needs of this population and a few have even achieved some success. It is informative to review some of the successful robot designs to date.

Paro is a robot baby seal. It has soft white fur and big eyes with a cute little nose, and looks like an unremarkable stuffed animal (Hornyak, 2002). But under the white hygienic fur is a complex array of sensors and actuators that cause *Paro* to react in interesting and stimulating ways when someone speaks to it or pets its fur. *Paro* even behaves according to a circadian rhythm mimicking a natural sleep wake cycle. *Paro* is used for robot therapy, where the robot is brought into nursing homes and groups of the elderly are given the opportunity to interact with it. Typically they cuddle and hold it like a real animal and talk to it like it was a small infant to which the robot responds with gentle movements and sounds. Oddly enough, most of the participants find interacting with the machine compelling, and some of the patients with age related dementia even have a hard time realizing that *Paro* is just a machine (Japan Economic Newswire, 2005). Faced with the monotony of institutional life, watching television, or interacting with a robot, many of the elderly find the latter choice the most compelling.

Another problem facing the Japanese elderly is that there has been a downturn in the number of children in the country and this fact, along with the death of the extended family, means that many elderly do not interact with children as much as they might like. To address this need, the toy company Tomy, in conjunction with a bedding manufacturer, has created *Yumel* a small robotic doll. "The Yumel doll, which looks like a baby boy and has a vocabulary of 1,200 phrases, is billed as a "healing partner" for the elderly ..." (Agence France Presse, 2005).[3] This doll is not much of a robot since it only moves its eyes and plays pre-recorded phrases without moving its mouth. Even so it has proven popular, which is an interesting phenomenon in itself. One may set *Yumel* to match the users sleep patterns and the users are supposed to take it to bed with them where they can cuddle with it and it will sing them sweet lullabies. In the morning it wakes its owner up at a preset time. An additional 'feature' is that it will occasionally beg you to buy it presents and new clothing, which can be obtained, of course, from Tomy. Just what the 'healing powers' of this kind of machine are is hard to tell, but nevertheless it is a popular item.

A similar toy aimed at both adults and the elderly, with children seen only a secondary market, is the doll *Primopuel*. This doll looks like Pinocchio without the nose and, like *Yumel*, also has a modest vocabulary and can babble on like a small child. This doll has proven to be very popular and Bandi, its maker, has made millions of Yen from this fad. Owners have reportedly taken to the robot as if it were a real child and it serves as a kind of surrogate for childless couples and other lonely adults (ibid). This growing market for companion robots has not, as yet, spread too far out from Japan but efforts to sell these products are proceeding in Europe and America.

[3] The Yumel product website can be found here (http://www.tomy.co.jp/yumel/index2.asp).

5 Affective Robotic Design in America and Europe

5.1 *Sociable Robots at MIT*

There is also a desire to build robotic companions on the other side of the Pacific. Some of the most interesting work on this subject has come out of the *Robotic Life group* headed by Cynthia Breazeal in the MIT Media Lab.[4] Breazeal was a student of the revolutionary roboticist Rodney Brooks, and she has taken the maverick milieu Brooks brought to the AI lab at MIT and run with it in fascinating new directions. The robots created by this lab so far have garnered a great deal of media attention due to their compelling sociable qualities.

Most famous of these robots is perhaps *Kismet* a machine built to interact with people that Breazeal worked on for her doctoral dissertation at the MIT AI lab.[5] This was the first serious attempt in American academic robotics to build a machine that could interact with humans on a friendly and personal level. Her team gave Kismet some of the affective responses as they believe adding these capabilities to be "...a critical step towards the design of socially intelligent synthetic creatures, which we may ultimately be able to interact with as friends instead of as appliances" (Breazeal, 1999, 25).

Taking the lessons learned from *Kismet* the lab is now working with Hollywood special effects wizards from Stan Winston Studios to create *Leonardo* the next level in sociable robots. Where *Kismet* clearly looked like a robot *Leonardo* does a better job of hiding the fact and looks like a strange yet cute mammalian creature straight out of a movie. *Leonardo* is controlled by animatronics, but what separates it from mere expensive puppets is that its movements are completely controlled by a computer and it is programmed to react and interact with humans as humans. Leonardo looks at you when you talk to it, tries to infer your intention by your body movements and gestures, and in return gives you as the user cues on its mood and beliefs through facial expressions and body gestures.

The goal is to make machines that do not require that the user change his or her ways of being in the world and interacting with human and nonhuman agents. Breazeal feels that we have evolved a complex social system that works admirably and roboticists need to learn how to make their machines fit in with our already preexisting ways of interacting rather then foist on us an interface that is alien and hard to use (Breazeal, 2002). This is particularly necessary when dealing with non-technical users, such as users in a home where the machine needs to fit in as a fellow member of the household and not disrupt the lifeworld and practices of its human inhabitants. This constraint means that the robots must match our

[4] http://robotic.media.mit.edu/

[5] For details on Kismet: (http://www.ai.mit.edu/projects/humanoid-robotics-group/kismet/kismet.html).

physiology and be able to understand our emotions wants and needs (Breazeal et al., 2004). If that was achieved the robot might indeed appear to be the perfect companion.

5.2 Design Methodologies for Affective Robots at MIT and Media Lab Europe

Brian Duffy from Media Lab Europe has written out a list of design methodologies that he suggests would employ anthropomorphism in successful social robotic design (Duffy, 2003).

- Use social communication conventions in function and form. For example, a robot with a face that has expressions is easier to communicate with than a faceless box.
- Avoid the "Uncanny Valley." Robotics researcher Masahiro Mori argues that if a machine looks too human but lacks important social cues and behaviors it is actually a worse design then a robot with more iconic features who has the same behavior, since users will find the synthetic human uncanny or creepy unless or until it has the capabilities of a fictional robot like Data on Star Trek the Next Generation, who, even so, can be a little weird.
- Use natural motion. The motion needs to be somewhat erratic like a natural being and not perfect, flowing, and alien as is sometimes seen in digital animation.
- Balance form and function. The designer needs to not set up false expectations in the user by making the robot look better than it performs.
- Man vs. Machine. Designers need not feel constrained by making the robot fit the human form. Certainly our social infrastructure makes it important that social robots be about the same size as humans so they can fit through doors, etc., but we need not try to make synthetic humans, robots should be built to augment our abilities not simply to replace us.
- Facilitate the development of a robot's own identity. The machine needs to participate in human social interaction not just be an object within that social space.
- Emotions. The machine needs artificial emotions to make it more easily understood by non-technical users and to facilitate affective interactions.
- Autonomy. The machine needs to have its own independence and an ability to understand its role in a social context and how to navigate through that milieu (an ability I am sure we all wish we had more of).

Duffy's list is a great start and nicely condenses a number of the concerns brought up earlier in this chapter. To this list I would like to add some of the design issues mentioned by Cynthia Breazeal in her book, *Designing Social Robots, 2002*, that are not covered by the list above.

- The robot needs to have homeostatic sense of "well-being" that it can regulate through interactions with its users. It has to know what it wants, and know how to get it.
- The robot needs an appropriate attention system. It has to be able to attend to what is important and ignore what is not given the milieu it is operating in.
- The robot has to be able to give clues about its internal "emotional" state, and it also has to be able to read those off of its human users accurately.
- Learning is important and users have to be confident that the machine will learn from its mistakes.
- Eventually the machines will need, robust personalities, better abilities at discourse, a sense of empathy for their users and other robots, as well as a theory of mind, and an autobiographic memory, but these are very ambitious requirements and may take many decades to achieve.

Taken together these ideas form a concise description of the design philosophy that is being pursued by the most successful practitioners of affective robotics in the United States and Europe. In the concluding section I will offer a critique of what we have learned and offer some ideas meant to enhance the usefulness of affective robotics.

6 Concluding Remarks

6.1 *Robots and Phenomenology*

Robots are situated at the end of a trajectory of human technology begun with simple human directed hand tools which have evolved over history to the self directed automata that are beginning to emerge today. Robots, as artifacts, are produced out of human desires interacting with technical systems and practices, and as such they shape and are shaped by the human lifeworld that produced them. Robots are objects, but as Carl Mitcham suggests, "[t]echnological objects, however, are not just objects, energy transforming tools and machines, artifacts, with distinctive internal structures, or things made by human beings; they are also objects that influence human experience" (Mitcham, 1994, 176). Robots and humans form a cybernetic system that begins to see humans not specifically directing the behavior of the robotic agents. As machines become more autonomous they become what Mitcham calls, "containers for processes," meaning that these technologies are not just tools but also encode their own use within their programming, taken together these machines and the technical and human systems they interact with can be described as "objectified processes" (Mitcham, 1994, 168). This means that we have to take seriously precisely what processes we are automating and how we are doing it since robots will have a certain *artifactology*, meaning that, "...artifacts have consequences; there is considerable disagreement about the character of those consequences and whether they are to be promoted or restrained"

(Mitcham, 1994, 182). I will now argue just what kinds of affective robotics systems should be promoted or restrained.

There are a number of possible critiques of personal robotic technology from the perspective of the philosophy of technology and I would like to address what I believe to be the most interesting. When we look at the strategy of building personal robotics systems that work to seamlessly automate the modern household, we can see that the objectified processes are those of the home life. The dream is to remove the workload of running a home from its inhabitants by having that work done by systems that do them for us as unobtrusively as possible, robots that do our laundry, clean, cook etc. Mitcham, inspired by the work of Ivan Illich, argues that instead of tools that do the work for us automatically, perhaps we need more tools that interact with us using our energy and guidance since:

> [t]he later less and less allow end-users to introduce their personal intentions into the world, to leave traces of themselves in those rich constructs of traditional artifice that have served for millennia as the dwelling place of humanity. Users now become consumers and leave traces of themselves only in their wastes (Mitcham, 1994, 184).

The phenomenology of humans in relation to robots is a fascinating development in the history of technology. This is a complex subject but an approach might be built on the lines of Albert Borgmann's device paradigm (1984). The device paradigm is a subtle concept but briefly put, it occurs when technology turns aspects of our lives into interactions with various black boxes and we can no longer engage with, or even understand, the underlying relationships to the world or each other that the technology or 'device' occludes. Home automation and robotics might just accelerate the process of hiding the process of home life behind a friendly façade of technology resulting in the final full commodification of our interpersonal lives. Every aspect of our home life will be fully encompassed by technology that we cannot completely understand and therefore we would be unable fully to comprehend just what it is about our home life, and our relationships with those we share our domicile with, that have been unfavorably altered by home robotics and automation. The technology will fulfill our perceived needs and we may come to see our family, and ultimately ourselves, as mere dysfunctional devices that serve no real purpose and we might work to replace them with our perfect robotic companions. This sort of critique has already made for entertaining science fiction books and movies but I think the reality might be more subtle. In the objectification of domestic procedures we may lose the ability to live artfully and replace that with simply the ability to live efficiently. Our lives will be effective but un affective.

I would like to make some modest additions to the design philosophies described in the sections above with the hope of contributing ideas that will cause us to build personal robotics technologies that will create a system of domestic relations between all the agents, human and artificial, that will come to inhabit the homes of our near future.

First, affective robots should not play lightly with human emotions. It is certain that these machines will be able to elicit real human emotions via their simulated ones, and some of these may at times be inappropriate or dangerous. To this end we should also recognize an 'uncanny valley' in the degree of emotion simulation

programmed into our machine. Emotions should thus remain iconic or cartoonish so that they are easily distinguished as synthetic even by unsophisticated users.

Secondly, affective robots must be used to enhance the social world of their users and not to isolate them further. Affective robots should not be used as wholesale replacements for human interaction. As this technology becomes more compelling, the possibility of this happening is more likely. Computer and information technology has a seductively immersive quality that can act like a cocoon protecting the user from messy interactions with other humans, affective robotics can easily play into this tendency and this should be avoided.

Finally, affective robotics gives us the opportunity to discover interesting facts about the social psychology of friendship. While working to make our technology friendlier, we should pay attention and learn how to incorporate those findings into other technologies.

Affective robots will be successful only if they function as tools that enhance social bonding and cooperative behavior in the human lifeworld. They must not be used to replace real people or pets, but as a new addition to these existing relations they will be a welcome technology, and perhaps we will make some new friends in the process.

References

Agence France Presse, 2005, As Japan goes grey, toymakers design dolls for the elderly in LexisNexis, copyright 2005 Agence France Presse all rights reserved, February 23, 2005.
Aproberts, A., 2004, They walk among us, *Robotics Trends* (http://www.roboticstrends.com/displayarticle447.html), copyright McClatchy Newspapers Inc., July 28, 2004.
Biever, C., 2004, Machines roll in to care for the elderly, *Robotics Trends* (http://www.roboticstrends.com/displayarticle395.html), copyright 2004 Reed Business Information US, a division of Reed Elsevier Inc., May 18, 2004.
Borgmann, A., 1984, *Technology and the Character of Contemporary Life*, University of Chicago Press, Chicago.
Breazeal, C., 1999, Robot in society: friend or appliance?, in: *Proceedings of the 1999 Autonomous Agents Workshop on Emotion-Based Agent Architectures*, Seattle, WA, pp. 18–26.
Breazeal, C. A., 2002, *Designing Sociable Robots*, MIT Press, Cambridge, MA.
Breazeal, C., Brooks, A., Gray, J., Hoffman, G., Kidd, C., Lee, H., Lieberman, J., Lockerd, A., and Mulanda, D., 2004, Humanoid robots as cooperative partners for people, under review (http://robotic.media.mit.edu/Papers/Breazeal-etal-ijhr04.pdf).
Brooks, R. A., 2002, *Flesh and Machines*, Pantheon Books, New York.
Dennett, D., 1996, *Kinds of Minds*, Basic Books, New York.
Duffy, B., 2003, Anthropomorphism and the social robot, *Robo. and Auto. Syst.* **42**:177–190.
Feenberg, A., 1995, *Alternative Modernity*, University of California Press, Berkeley and Los Angeles.
Garson, B., 1988, *The Electronic Sweatshop*. Penguin, New York.
Hornyak, T., 2002, Seal of approval: researchers probe fuzzy logic of relaxation with cuddly robot, *J@pan.inc* (http://www.japaninc.net/article.php?articleID=819), June, 2002.
Japan Economic Newswire, 2005, TokyoNow: elderly love therapeutic seal robot, copyright 2005 Kyodo News Service.

Kahney, L., 2003, Robot vacs are in the house, *Wired*, (http://www.wired.com/news/technology/0,1282,59237,00.html), June 16, 2003.

Kaheyama, Y., 2004, Responses to robots monitored in Japan, *Robotics Trends*, [http://www.roboticstrends.com], copyright 2004 Woodward Communications, Inc., April 21, 2004.

Kanda, T., and Ishiguro, H., 2005, Communication robots for elementary schools, http://www.irc.atr.jp/~kanda/pdf/kanda-aisb2005.pdf

Kanda, T., Ishiguro, H., and Ishida, T., 2001, Psychological analysis on human-robot interaction, *IEEE International Conference on Robotics and Automation* (ICRA 2001), pp. 4166–4173.

MacDorman, K., 2005, The Economist, Dec 20, 2005.

Kanda, T., Sato, R., Saiwaki, N., and Ishiguro, H., 2004, Friendly social robot that understands human's friendly relationships, *IEEE/RSJ International Conference on Intelligent Robots and Systems* (IROS2004), pp. 2215–2222.

Maney, K., 2003, Vacuum sweeps into history, *USA Today*, January 14, 2003.

Menzel, P., and D'Aluisio, 2000, *Robosapiens: Evolution of a New Species*, MIT Press, Cambridge, MA.

Mitcham, C., 1994, *Thinking Through Technology: The path between engineering and philosophy*, University of Chicago Press, Chicago.

Moravec, 1999, *Robot: Mere Machine to Transcendent Mind*, Oxford University Press, Oxford.

Mori, M., Terry, C. S., trans, 1981, *The Buddha in the Robot: A Robot Engineer's Thoughts on Science and Religion*, Kosei Publishing, Tokyo.

Mori, M., 1970, The Uncanny Valley, *Energy* 7(4):33–35.

Perkowitz, S., 2004, *Digital People: From Bionic Humans to Androids*, Joseph Henry Press, Washington D.C.

Winner, L., 1988, *The Whale and the Reactor: A Search for Limits in an Age of High Technology*, University of Chicago Press, Chicago.

Beyond Engineering

Software Design as Bridge over the Culture/Technology Dichotomy

Bernhard Rieder and Mirko Tobias Schäfer

Abstract In this chapter, we first consider the growing cultural significance of software as a motive for having a closer look at software production. We then show how networked computing has stimulated new practices of technical creation that question the traditional logic of engineering; *open source* software development serves as an example. Consequently, it is no longer feasible to separate the technological dimension from its cultural context. An integrated perspective could lead both humanities scholars and technologists to revaluate established dichotomies and refocus the debate on technological policies.

1 Introduction

In his book *"Le Geste et la Parole"*, the paleontologist André Leroi-Gourhan sketched the evolution of Homo sapiens as leaving the domain of biological advancement to continue, with an accelerated pace, in the field of language and technology. While many of Leroi-Gourhan's proposals have not aged well, his concept of humanity being shaped by a man-made web of objects and symbols – of machinery and discourse one might say – has been a powerful image in a time when the idea of the tool as neutral artifact is still an important paradigm. In the last decade there has been a resurgence of academic interest in technology, not purely as a means to an end but as a cultural force. Together with this shift in perspective on the role of technical artifacts in our high-tech collectives, we see, more specifically, an increased awareness of the "toolmaker" as the assumed *locus* of technical progress. Every age seems to have an epitomical figure of technical creation: the craftsman for the Middle Ages, the inventor in the Industrial Revolution, and the engineer in the 20th century. Late capitalism has introduced a new figure for the beginning of the 21st century: the *designer* as the toolmaker of the information age.

B. Rieder, Paris 8 University

M. T. Schäfer, Utrecht University

P. E. Vermaas et al. (eds.), *Philosophy and Design.*
© Springer 2008

The last two decades have produced a plethora of literature on the new mode of creating technical objects: from product design to Web design, from industrial design to experience design, design is everywhere but no two definitions are the same. As a consequence, the term refers less to a clear-cut concept or methodology; rather it functions as a means of differentiation. Software design[1] for example is not a well-defined practice: it is a way of saying that what is being done is somehow going beyond the well-defined practice of software engineering. Behind the term "design" actually lurks a multiplicity of quite different ways of creating, shaping, and maybe even using.

2 Hybrid Practices

In industrial societies there remain few tasks that are not in one way or another dependent on computers. Our communication and information routines have shifted in a large part to a computer-based network infrastructure of globally connected computers, the *metamedia* (Kay and Goldberg, 1977) of our time. Classic electronic media like television and telephony are currently passing onto the universal protocol of TCP/IP,[2] becoming yet another piece of software that runs on the Internet. Creative work, game play, social intercourse, information search and management, so many of the things we do in our everyday lives have become directly connected to digital tools and networks (Castells, 2000). We are steering towards a unified digital environment in which computer hardware and software define possibilities for action and conditions of expression.

Interest in technology within the humanities has historically been limited. When considered, technical artifacts have been assimilated into the industrial complex and treated as producers of *capital* rather than of *meaning*. But the dense entanglement between human and non-human we witness today increasingly calls for perspectives that zoom in at the micro-level and theorize not only the general aspects of how "society and culture" relate to "technology," but first and foremost the increasingly hybrid everyday practices that are the content of human affairs.

In reference to de Certeau (1980), we can describe these practices as ways of doing that embed actions in a dense network of meaning, provide a rationale for why something is done, and sketch a proper way of doing it. There is a non-discursive dimension to such an *art de faire*, e.g., motor movement, objects, and spatial settings, and a strong discursive element, e.g., morals, laws, rules, and narratives. These two aspects are woven together by continuous action. Collins and Kusch (1998) have detailed how the atomic particles of practices, actions, can themselves be theorized as series or trees of micro-acts, coalescing motor movement

[1] The term was first coined in Kapor (1986).

[2] Transmission Control Protocol / Internet Protocol are the communication protocols that unite all the different networks that make up the Internet.

and meaning. And Actor-Network-Theory has shown (Latour, 1999) that actions are not properties of individual agents, but of chains linking human and non-human "actants", combining each ones "program of action" to form hybrid actors. If we understand practice as an embedding of action in time and habit, in these views, the discursive dimension of an *art de faire* cannot be severed from its non-discursive, mechanic counterpart.

When applying this view, we see that in general, and with ICT in accelerated and enlarged form, machines are responsible for always larger parts of the action trees or action chains, rendering actions intrinsically hybrid. As a consequence, our practices have become riddled with the work of machines, in many cases without us even noticing. Software – the prime interest of this chapter – now goes even deeper than "classic" technology because many of the tasks being delegated to *logical* machinery are *semantic* in nature. Among other things, algorithms now filter, structure, interpret, and visualize information in an automatic fashion, performing tasks previously reserved for humans.

From a practical standpoint, we can understand this process of hybridization along two axes: new actions and practices are becoming possible, e.g., drawing on a virtual canvas, video communication across oceans, and real-time data-mining, and existing actions and practices are done in new ways, e.g., different in form, style, speed, efficiency, difficulty, and range.

In this sense, software is responsible for extending, both quantitatively and qualitatively, the role that technology plays in the everyday practices that make up modern life. Culture and technology are intertwined at the micro-level, to the extent that even the analytical separation of the two becomes highly problematic (Latour, 1999). Is separation between a discursive and a non-discursive level still possible when computer programs analyze email, news bulletins, and scientific publications to decide which ones to bring to our attention and which ones silently to discard? When the visibility of an opinion becomes a question of algorithms,[3] meaning is deeply embedded in the non-discursive: in the software itself. Technology is not only surrounded by discourse, it is discourse. Although we do not share Heidegger's hostile stance toward technology, his understanding of the tool as an ontological agent, as a way of "Entbergen" (revealing), is still worth considering. In "Gestell" (enframing), the discursive and the non-discursive conflate; it is both object and logic – a *diagram*, in the terms of Foucault, but with the difference in nature between the two planes largely gone. The lesson we take from this is diametrically opposed to Heidegger's position: involvement instead of withdrawal.

We would like to argue that technology affords not one but multiple ways of revealing being, and that the way we create technical artifacts – and software most importantly – heavily influences the cultural role they will play. Tools are not neutral; they integrate and propagate human values (Friedman, 1997). But these

[3] The Slashdot communication platform (http://www.slashdot.org) for example uses an elaborate discussion system that includes a technological measure of symbolic capital and modulates the visibility of individual messages accordingly.

values are not necessarily those of technocratic reasoning as Heidegger would have it, the whole gamut of human apprehension is possible. Software brings technology closer to us than ever before and it is time to look at the practices that spawn what has become an important part of the constitutional fabric of our cultures.

3 Software, Design and Open Source

Since the advent of modern computing in the late forties and especially the marketing of the consumer PC in the eighties, computers have come to be ubiquitous. But while the terms "computer" and "technology" have almost become synonymous and the basic technical principles have remained the same for the last sixty years, there remains an aura of vagueness around these machines. Herein actually lays their power. Computers themselves are functionally underdetermined; they need software to turn them into complete devices with distinct functions. While the hardware, the *Universal Machine*, coupled with peripherals like input/output devices, networks, etc., is the necessary mechanical base layer, the "specific" machine – a series of functions and procedures that manipulate information and, with proper connection, matter and energy – is the result of programming. Alan Turing stated that,

> The importance of the universal machine is clear. We do not need to have an infinity of different machines in doing different jobs. A single one will suffice. The engineering problem of producing various machines for various jobs is replaced by the office work of 'programming' the universal machine to do these jobs. (1984, 4)

These words mark the technical novelty and yet another reason for the cultural significance of IT: somebody who buys a computer today gets not only the physical apparatus, but also gains access to a seemingly infinite world of logical machinery. These software programs spring from a burgeoning environment where work styles nowadays go well beyond the classical methods of engineering or even beyond the "office work" mentioned by Turing. Before we can get a closer look at these practices, we must first review some of the qualities of software.

3.1 *Properties of Software*

While there has been a continuous reflection of what software actually is, this problem is still far from being completely understood. Despite the stability of the mathematical foundations of software since Turing, Church, and Shannon, the final jury on what we can really do with it is still out. As society changes, software changes and every day there are new applications that surface around the globe. It is possible, however, to specify some of the basic properties of *logical machinery*.

Unlike other technological objects, software is immaterial. It is similar to language with respect to structure and similar to technology with respect to effect. Written as

a text, it functions like a machine. Latour (1992) pointedly observes, paraphrasing Austin, that "how to do things with words and then turn words into things is now clear to any programmer." The classical distinction made in engineering between *designing*, i.e., drawing the blueprints, and *building*, i.e., assembling the physical structure, does therefore not translate well into software programming. According to Jack W. Reeves (1992) writing the source code can be compared to designing but building is nothing but the automatic translation of source code into machine language by a compiler program. In contrast to classic (hardware) engineering, software is thus expensive to design – it takes a lot of time to write a functional piece of software– but cheap to build. From an economic perspective, we can even speak of an apparatus of production unlike other areas of technology, specific to the creation of software: except for the price of a computer, producing software is basically free, time becoming the essential cost factor. In this sense, software is again closer to literature or music than to industrial production – the workstation is the factory floor. This greatly facilitates people shifting from consumers to producers.

Like knowledge and information, software can be shared without tangible loss for the giver. The Internet transports and copies computer code as simply as text, sound, or images; algorithms, program libraries, and modules pile up at different sites, contributing to what could be seen as the equivalent of a fully equipped workshop with an unlimited spare parts inventory attached to it, accessible again at the cost only of time and skill. A general-purpose programming language like Java nowadays comes with thousands of ready-made building blocks and writing code is often closer to playing Lego than to the laborious task of manipulating memory registers it used to be.

Unlike the products of industry, a computer program is always tentative, never really finished or "closed". Classic machinery also has to be tended, calibrated, and repaired, but with software the provisional aspect is pushed to the extreme. One mouse click and an entire subsystem can be copied to another program and the output of one piece of software can instantly become the input of another. We do not want to encourage in any way the view that holds that everything digital is fluid, chaotic, and auto-organized, but there remains the fact that this freedom from most physical constraints renders software easier to manipulate and handle than hardware objects. The only constraining factors are time and skill. This relative freedom is one reason for the production of software in practice being so unlike engineering by the book.

3.2 Software Design as Heterogeneous Practice

According to IEEE Standard 610.12, software engineering is "the application of a systematic, disciplined, quantifiable approach to the development, operation, and maintenance of software."[4] The attempt to translate the strategies and methods of

[4] See: http://standards.ieee.org/catalog/olis/se.html

classic engineering into the area of software has never been entirely successful and has been criticized from several directions. We cannot possibly summarize all the different views expressed in this complex and long-standing debate, but there are several main critical positions that can be distinguished.

One argument holds simply that programming is based less on method than on skill, that it is craftsmanship rather than engineering, and that "in spite of the rise of Microsoft and other giant producers, software remains in a large part a craft industry" (Dyson, 1998). The main question for design, then, is not how to find the proper methods but how to acquire the appropriate skills.

Another argument is that software engineering has its place but that specific methods and strategies cannot be directly imported from traditional engineering, because building software is very different from building bridges and houses (Reeves, 1992). Debugging for example should not be treated as a hassle to be eliminated by using mathematical rigor, but as an essential part of creating computer programs.

Finally there are those who believe that software engineers should be supplemented by other professions, in particular by software designers who take inspiration from architects rather than engineers because buildings and software "stand with a foot in two worlds – the world of technology and the world of people and human purposes" (Kapor, 1996). In this view, building a computer program is not so much about technical problems, but about how to bring users and tools together in a meaningful way.

Independent of these different views the empiric observation remains that the practice of creating software rarely resembles the top-down engineering models like the *lifecycle-* or the *waterfall-*model where the process of going from neat requirements to a working program is thought of as an advancing in clear cut stages. The "real world" of software development is most often described as "messy, ad hoc, atheoretical" (Coyne, 1995), as consisting of "bricolage, heuristics, serendipity, and make-do" (Ciborra, 2004), or as the result of "methodological and theoretical anarchism" (Monarch et al., 1997). While this does not automatically make software production "art", as Paul Graham (2003) suggests, we have to accept that the engineering ideal is just that: an ideal. Software production in practice commonly takes paths that go in different ways beyond engineering. Two important factors have to be taken into account: changing problems and increasing complexity.

First, the problems software is expected to be used to solve are becoming more "cultural" and less "technical." If computers were still doing what they did in the 1960s, namely number crunching and data storage, there would probably be no discussion about software engineering or design. With computers now performing semantic and social functions this has changed. Methods like *participatory design* or *end-user development* are now used to try to integrate the fuzziness of specifications for software by integrating future users into the construction process.

Second, the complexity of software is increasing rapidly and this makes it always more difficult to plan a program in every detail before starting to write code. It is often impossible to foresee problems early on and plans and models have to be

changed, tests have to be made, and specifications have to be modified during the construction process. Agile methods like *extreme programming* and *rapid-prototyping* strive to make complexity more manageable and transform the top-down waterfall into a long series of iterations.

The properties of software, the distribution of these properties into space by means of the Internet, and the changing technological landscape are slowly eroding the modern ideal of a neat separation between technology and culture, between detached rationality and human motivations. This argument is endorsed by a closer look at the diverse landscape of software production. As an example, we will briefly analyze the *open source* scene to show how a whole new array of actors, strategies, and practices can emerge in a situation where material cost is no longer a limiting factor.

3.3 *The Open Source Scene*

On one level, the term "open source" refers to a certain way of handling and sharing computer software.[5] It implies that programs are not just available in machine code, but also in source code, i.e., in text files written in a programming language accessible to human beings. To qualify as open source, it is essential that the public is allowed to modify and redistribute the product. On another level, the term refers to communities[6] built around this notion of openness and sharing that is responsible for a considerable amount of today's software production. There is now an *open source* equivalent for nearly every type of program

The *open source* scene is rather diverse, but it is possible to sketch a rough ideal type for how it functions. Most importantly, it is impossible to imagine open source without the existence of the Internet. Platforms like sourceforge.net, along with mailing lists and newsgroups, are the tools used to organize and coordinate a globally dispersed and mostly voluntary workforce. A project usually starts with an embryonic program written by an individual or a group which is released under an *open source* license, to people who are invited to participate in its development. If it can stimulate enough interest, a lively process is set in motion: following the "release early, release often" maxim, versions of the program are regularly published on the Web where anybody interested can add code, report bugs, and fix them. Which features and fixes are integrated is usually decided by a moderator (group or individual), supplemented by a community process very similar to scientific peer-review. The very linear structure of classic engineering is thus translated into a rapid succession of coding/building/debugging, where requirements specification, interface design, and user testing are carried out concurrently and

[5] We are referring here to the open source definition given by the Open Source Initiative (http://www.opensource.org/docs/definition.php).

[6] The *open source* scene is far from homogenous and there is some infighting between the very political *Free Software Movement* and the rather pragmatic *Open Source Movement*.

subject to constant change. Collaboration is the main "tool" to tackle complexity. The Internet-based development platforms provide the infrastructure for a project's representation, for communication between its participants and for the coordination of bug tracking and code maintenance; they are the media that render possible what could be called a "virtual factory" where a diverse and dispersed public channels its collective intelligence.

The *open source* scene also distinguishes itself from traditional engineering in social norms and general mindset. Mathematical rigor is valued less than an open and involved communication style. Similar to other (youth) subcultures, the demonstration of skill (and not diplomas) is the main source of symbolic capital. Inclusiveness, discussion, collaboration, and the open circulation of information is more important than the clear-cut attribution of tasks, positions, and responsibilities.

On an institutional level, the *open source* scene has become an important element in the socialization and education of programmers. The lively and helpful online communities allow one to get help and learn from individuals who have achieved status based on their contribution to the field. The accessible code landscape and participatory culture of the open source scene make for a powerful learning environment for individuals of all levels of skill. While engineering is traditionally connected to the somewhat authoritarian institutions of school and university, the open source community supplements these forms by offering a learning-by-doing environment based on playful imitation and autodidactic skill acquisition.

To show that *open source* products are an important part of the software land-scape, we will briefly discuss three examples: the *Linux* operating system, the *Apache* Web server, and the Internet browser *Firefox*.

Linux started out in 1991 when a Finnish student, Linus Torvalds, wrote a very basic kernel program, the core of any operating system, as a hobby project and released it on the Web, inviting others to participate. Since then, *Linux* has developed into a modern, robust, and complete operating system and is now probably the only serious competitor for Microsoft Windows left. It is available for free and constantly maintained and extended by a community of thousands of programmers around the globe. Most Fortune 500 companies now use *Linux*, as do the metropolitan administrations of Vienna, Munich, and Paris. One reason for this success is cost, but other factors come into play, including reliability, platform independence, and the possibility to fix bugs directly without having to go through a vendor company.

The *Apache* project was initiated in 1995 and has since then steadily grown to become the dominant Web server application with a market share of over 52%.[7] *Open source* and available for free, it is developed and maintained under the guid-ance of the *Apache Software Foundation*, a non-profit company that helps to organize the development process, assures legal support for the community, and protects the brand. *Linux* and *Apache*, coupled with the free database system

[7] Netcraft ServerWatch July 2007, http://www.serverwatch.com/stats/article.php/3686926

MySQL and an *open source* programming language, *PHP*, form the most common platform (called LAMP) for dynamic Web applications.

The *Firefox* Web browser grew out of code released to the community in 1998 by the ailing company Netscape. After several rather unsuccessful products, the *Mozilla Foundation* released *Firefox* at the end of 2004 as version 1.0. Carried by strong critique of Microsoft's *Internet Explorer* for its various security leaks, the open source browser captured considerable market share[8] in 2005. It is also a good example for how the open source community allows for the participation of non programmers. Using *Bugzilla*, a tool for tracking bugs, anybody can report errors and ask for features in future releases. Skilled users may extend the browser through plug-ins without having to get to know the code of the main application. *Firefox* is finally not just a piece of software, it is also a community providing logos, T-shirts, images, and wallpapers as well as an entire viral marketing campaign.

The *open source* scene shows that methods and strategies in technical production cannot be divorced from the social, economic, and cultural environment they are stimulating and being stimulated by. The *culture of engineering* is but one of many possibilities in a field that has opened up to manifold models for production. Computers have made technical creativity accessible to a larger and more diverse audience than any previous technologies have. From writing code to designing levels for computer games, there is a wide scale of possible involvement for every level of skill. While the new modes of creation are in many ways similar to earlier forms of amateur culture they are different in a very important aspect: the three programs we discussed are not just niche products but highly competitive artifacts of great quality that hold strong market positions. This signals an *extended culture industry*, where the production of cultural artifacts opens up to the formerly excluded: the consumers.[9] There are of course many commercial actors playing a role in the *open source* scene – IBM, Novell, Intel, and others take an active part in financing and developing. However, the intertwined networks of production that span companies and individuals go beyond the mono-directional processes Adorno and Horkheimer (1944) have criticized so severely. The idea has been contagious and phenomena like *Wikipedia*, blogging, or the countless music labels on the Web take the *open source* principle to a larger context of cultural production. Computers and the Internet can be seen as enabling technologies that give users the opportunity to extend the culture industry and to participate in the production of cultural artifacts, stimulating the social dynamic we are witnessing today (Jenkins, 2002)-recently branded around the term "Web 2.0".

While engineering is often seen as a neutral, detached, and "objective" way of problem-solving, the collaborative and auto-organized design process that marks

[8] In Europe Firefox is ranging up to 34% in Finland and 24% in Germany; see XiTi Browser Survey, September 2005, online: http://www.xitimonitor.com/etudes/equipement11.asp

[9] According to Walter Benjamin (2002), facilitating the transformation from consumers to producers is every artist's political obligation.

the *open source* scene does not strive to separate the social and cultural aspects of technological creation from the task of designing and writing code.

These developments are not necessarily aimed at replacing the traditional, and more organized institutions of work, education, and research; what we witness today is a trend toward plurality and cross-fertilization. With reference to Eric Raymond (1998), we could say that the bazaar does not supplant the cathedral but blossoms in the city streets around it, slowly infiltrating the sacred halls; and the development of "alternative" methods and strategies for the production of software is by no means limited to the open source community: because of the increasing complexity and "culturalization" of computing problems mentioned above, most fields are constantly forced to go beyond established methodology. Taken together, we see software design as a shifting field that unites a plurality of heterogeneous methods, mindsets, and actors.

4 Bridging the Culture/Technology Divide

So far, we have made two separate arguments: first, we have tried to show that software plays an increasingly important role in our everyday lives, accentuating culture as a hybrid of technology and discourse. Second, we have discussed how software production flourishes outside of the classical institutions and methodology of engineering. In the third part of this chapter, we want to briefly discuss these two arguments in relation to their impact in three different areas: the humanities, technology, and policymaking.

4.1 The Humanities Discourse

Traditionally philosophy and cultural theory have subscribed to a view of technology as something external to, or at least different from, society and culture. In this perspective, the practice of creating a technical artifact is very dissimilar in nature from processes of symbolization, e.g., the writing of law or literature. The first is supposedly oriented toward the material domination of our "lifeworld" (Lebenswelt) through efficiency, while the second is concerned with the social (law) or cultural (literature) dimension of human existence. This separation has the convenient effect of exempting those thinking about technology to have any need for technical knowledge because "techno-science" always produces only more of the same, the true challenge lying in the discovery of the essential dynamics between the strata, an endeavor reserved to the masters of symbolization. However, there is a very dangerous side to this outlook: subtracting the dimension of *meaning* from technology implies the subtraction of *responsibility*. If the creation of technology is not understood to be a deeply cultural, social, symbolic, and political activity, there is no reason for the creators to adopt any ethical and political stance toward their work

beyond the question of physical harm to others. We believe that in a time when the use of logical machinery is a part of so many of the practices that make up our lives, we need concepts that take into account not only the "effects" of technology on culture, but which recognize that technology *is* a form of culture: embodying not just the homogenous logic of "Gestell," but being continuously differentiated into a plurality of forms, practices, values, and power struggles.

There is a growing amount of empirical work on large software projects to which social scientists have contributed. However, looking at the field of software design we should ask whether our concepts of technology are adequate for grasping the multiplicity of possible connections between methodologies, the artifacts they produce, and the consequences for society. The humanities could take up the task of broadening our still very restrained technological imagination and lead the way towards modes of production that facilitate finding other liaisons between the human and non-human than those marked only by domination, efficiency, and convenience.

4.2 The Technologist Discourse

If we recognize software design as a pluralistic and fractured practice which takes a part in shaping the fabric of the world in which we live, we have to rethink our stance not only as theorists, but also as creators of technology. Terry Winograd and Fernando Flores wrote nearly twenty years ago that "we encounter the deep question of design when we recognize that in designing tools we are designing ways of being" (Winograd and Flores, 1986). A dialogue between the different groups implicated in designing software is necessary to foster awareness of the cultural dimension of their work. A start has already been made: a part of the *open source* community has adopted an explicit stance on the political issues surrounding their technical efforts and the software design community is making a strong effort to link up with the humanities.

The field that is lagging severely behind is education. There is still very little discourse between technical departments and the humanities, and current curricula are neither fit for producing the "culturally-aware technologist" nor the "technically-aware theorist". Herein lies the true challenge of bridging the dichotomy between culture and technology: bringing the more inclusive understanding of technology that is currently emerging to places where it can have an effect.

4.3 Policies

The third area of our discussion is policy, and luckily there is already a very lively debate going on in this area, especially around the questions of software patents and *open source*. The discussion however is strongly centered on economic and juridical questions, treating the cultural aspects as mere collaterals. It is rarely recognized that the creators of technology, operating outside of the classic pathways of established

industry, are a crucial part of civil society in that they actively produce means for expression and action. Only when we understand writing software as one possible way of participating as a citizen can the political issues be properly addressed. The state, as the arbiter in the ongoing battle around software patents, will have to decide whether the amorphous coder communities sprawling on the Web, that put their work at the disposition of the public domain, are of special value to society and therefore worth protecting against the overwhelming financial capacities of the established commercial actors. The new design practices that we have tried to present and theorize in this chapter are by no means inevitable; although the Universal Machine is a strong base for the social and cultural activities surrounding them, the free flourishing of technical creativity is a fragile thing that can easily be reduced to the point of mere hobbyist dabbling, as it was the case with many other technologies. There is (still) democratic potential in the new metamedia and we will have to decide whether we want to nurture it or not.

5 Conclusion

We have entitled this chapter "beyond engineering", because the term "engineering" has come to stand for the technocratic separation between a sphere of technology and a sphere of culture, society, and politics; for a mindset that treats the creation of technical artifacts as a detached and orderly process, closer to calculation than to creativity. The modern ideal of engineering as a politically and culturally neutral process – unspoiled by human motivations and uncontaminated by morals and emotions – appears today to be rather anachronistic. A closer look at software *design* shows that there are multiple methods, strategies, and mindsets guiding the creation of programs, systems, and applications. Our short analysis of the *open source* scene is evidence that extensions to classic methodologies, alternative routes, collaborative approaches, and auto-organized forms of workflow are both possible and effective.

We believe that the fluctuations in how technical artifacts are created are not just minor adjustments but necessary adaptations to the changing place of technology in our societies. As technology infiltrates the practices that make up our everyday lives, culture *stabs back* by invading the terrain of production, bringing all its contingencies, contradictions, and complexities along. Their separation was never clear anyhow, but the level of interpenetration has reached new heights today. The immaterial qualities of software, distributed into space using the global infrastructure of the Internet, affect an increasing number of people, users as well as designers. We have called the resulting space of production, distribution, and consumption an *extended culture industry* where the boundaries between consumers and producers are blurring and social and technical forces are closely intertwining.

While there is some understanding of how to channel social forces in a democratic fashion, it is still unclear how we can achieve the same for the technical part of the hybrid. It now seems evident that in high-tech societies the creation of tools and

objects plays an important role in shaping cultural practice, expression, and imagination; it is a highly cultural gesture. Looking at the similarities between language and software can help us to understand the nature of our currently complicated technosocial situation; it can also make us see that freedom of technical creation is a form of freedom of speech. It is the duty of the humanities to seek out what that could mean.

References

Adorno, T., and Horkheimer, M., 1988, *Dialektik der Aufklärung*, Fischer, Frankfurt a. M., first published in 1944.

Benjamin, W., 2002, Der Autor als Produzent, in: W. Benjamin, *Medienästhetische Schriften*, Suhrkamp, Frankfurt a. M., pp. 231–247, first published in 1934.

Castells, M., 2000, *The Information Age: Economy, Society and Culture*, Blackwell, Malden, MA, 3 volumes, first published in 1996.

Certeau, M. de, 1994, *L'invention du quotidien*, Gallimard, Paris, first published in 1980.

Ciborra, C., 2004, Encountering information systems as a phenomenon, in: *The Social Study of Information and Communication Technology: Innovation, Actors, and Contexts*, C. Avgerou, C. Ciborra, and F. Land, Oxford University Press, Oxford, pp. 17–37, p. 19.

Collins, H., and Kusch, M., 1998, *The Shape of Actions: What Humans and Machines Can Do*, MIT Press, Cambridge, MA.

Coyne, R., 1995, *Designing Information Technology in the Postmodern Age: From Method to Metaphor*, MIT Press, Cambridge, MA, p. 32.

Dyson, F. J., 1998, Science as a craft industry, *Science* 280(5366):1014–1015.

Friedman, B., ed., 1997, *Human Values and the Design of Computer Technology*, Cambridge University Press, Cambridge.

Graham, P., 2003, Hackers and Painters, Lecture at Harvard, http://www.paulgraham.com/hp.html

Jenkins, H., 2002, Interactive audiences?, in: *The New Media Book*, D. Harries, ed., British Film Institute, London, pp. 157–170.

Kay, A., and Goldberg, A., 2003, Personal dynamic media, in: *The New Media Reader*, F. Wardrip and N. Montford, eds., MIT Press, Cambridge, MA, pp. 393–404, first published in 1977.

Kapor, M., 1996, A software design manifesto, in *Bringing Design to Software*, T. Winograd, ed., Addison-Wesely, Boston, pp. 1–10, p. 4.

Latour, B., 1992, Where are the missing masses?, in: *Shaping Technology / Building Society*, W. Bijker and J. Law, eds., MIT Press, Cambridge, MA, pp. 225–258, p.255.

Latour, B., 1999, *Pandora's Hope: Essays on the Reality of Science Studies*, Harvard University Press, Cambridge, MA.

Monarch, I. A., Konda, S. L., Levy, S. N., Reich, Y., Subrahmanian, E., and Ulrich, C., 1997, Mapping sociotechnical networks in the making, in: *Social Science, Technical Systems, and Cooperative Work: Beyond the Great Divide*, G. C. Bowker, S. L. Star, W. Turner, and L. Gasser, eds., Lawrence Erlbaum Associates, Mahwah, pp. 331–354, p. 337.

Raymond, E. S., 1998, The cathedral and the bazaar, *First Monday* 3(3), http://www.firstmonday.org/issues/issue3_3/raymond/

Reeves, J. W., 1992, What is software design?, *C++ Journal*, Fall 1992.

Turing, A. M., 1948, *Intelligent Machinery*, National Physical Laboratory Report (http://www.alanturing.net/turing_archive/archive/l/l32/L32-001.html).

Winograd, T., and Flores, F., 1986, *Understanding Computers and Cognition: A New Foundation for Design*, Addison-Wesley, Boston, p. xi.

Technology Naturalized

A Challenge to Design for the Human Scale

Alfred Nordmann

Günther Anders was speaking for the age of nuclear weapons when he noted that technological capabilities exceed human comprehension. Genetically modified organisms, pervasive computing in smart environments, and envisioned nanotechnological applications pose a similar challenge; powerful technological interventions elude comprehension if only by being too small, or too big, to register in human perception and experience. The most advanced technological research programs are thus bringing about a curiously regressive inversion of the relation between humans, technology, and nature. No longer a means of controlling nature in order to protect, shield, or empower humans, technology dissolves into nature and becomes uncanny, incomprehensible, beyond perceptual and conceptual control. Technology might thus end up being as enchanted and perhaps frightening as nature used to be when humanity started the technological process of disenchantment and rationalization. Good design might counteract this inversion, for example, by creating human interfaces even with technologies that are meant to be too small to be experienced.

1 Machines of Nature vs. Nature as an Engineer

In 1665, Robert Hooke proposed that the microscope will help us:

> discern all the secret workings of Nature, almost in the same manner as we do those that are the productions of Art, and are manag'd by Wheels, and Engines, and Springs, that were devised by humane Wit. (Hooke 1665, preface)

With reference to the general aim of the Royal Society and thus of Baconian science to "improve and facilitate the present way of Manual Arts," that is, of technology, Hooke highlights further down that:

> those effects of Bodies, which have been commonly attributed to Qualities, and those confess'd to be occult, are perform'd by the small Machines of Nature, which are not to be discern'd without [the help of the microscope and which seem to be] the mere products of Motion, Figure, and Magnitude; and that the Natural Textures, which some call the Plastick

A. Nordmann, Darmstadt Technical University

P. E. Vermaas et al. (eds.), *Philosophy and Design.*
© Springer 2008

faculty, may be made in Looms, which a greater perfection of Opticks may make discernable by these Glasses; so as now they are no more puzzled about them, then the vulgar are to conceive, how Tapestry or flowered Stuffs are woven. (Hooke 1665, preface)

Nature will appear increasingly familiar, Hooke suggests here, when we look at it through better and better microscopes. We can all understand how machines work, there is nothing occult or puzzling about a loom that weaves tapestries, and once we see that nature consists of such tiny machines, we will find that there is nothing occult and puzzling in nature.

Even though it was written more than 300 years later, it would appear that the following passage makes a similar point. Better and better microscopes are allowing us to observe and intervene at the nanoscale. One of the first and most prominent public presentations of nanotechnology begins by pointing out that those microscopes tell us something about engineering at that scale.[1] Nature, it is said, begins with a pile of chemical ingredients which it then engineers into devices as elaborate and sublime as the human body.

> With its own version of what scientists call nanoengineering, nature transforms these inexpensive, abundant, and inanimate ingredients into self-generating, self-perpetuating, self-repairing, self-aware creatures that walk, wiggle, swim, sniff, see, think, and even dream. [...]
> Now, a human brand of nanoengineering is emerging. The field's driving question is this: What could we humans do if we could assemble the basic ingredients of the material world with even a glint of nature's virtuosity? What if we could build things the way nature does – atom by atom and molecule by molecule? (Amato, 1999, 1)

It has become a commonplace to emphasize in presentations of nanotechnology that it is biomimetic in principle, that it imitates nature in everything it does – whether or not it respects or preserves evolved nature as we know it.

There are fundamental differences, though, between the two mechanistic or engineering visions of nature from 1665 and 1999.[2] According to Hooke, we are already acquainted with looms, there is nothing mysterious about them, and now we discover that these rather familiar and unspectacular devices also operate in nature. At least, we can project their mechanism into nature as we generate mechanistic explanations of the phenomena. In other words, we assimilate nature to technology and thus get what one might call a technologized view of nature or "nature technologized."

By considering nature's original brand of nanoengineering, the temporal priority is reversed. The human brand emerges only as we assimilate technology to nature and thus get what one might call a technology that emulates nature or "technology naturalized."

> Even an early instance of nanotechnology like catalysis really is young compared to nature's own nanotechnology, which emerged billions of years ago when molecules began organizing into the complex structures that could support life. Photosynthesis, biology's way of harvesting the solar energy that runs so much of the planet's living kingdom, is one of those ancient products of evolution. [...] The abalone, a mollusk, serves up another

[1] For a more extensive discussion of this brochure see Nordmann (2004).

[2] I am not considering all these differences here, see for example, Jones (2004) and Bensaude-Vincent and Guchet (2005).

perennial favorite in nature's gallery of enviable nanotechnologies. These squishy creatures construct supertough shells with beautiful, iridescent inner surfaces. They do this by organizing the same calcium carbonate of crumbly schoolroom chalk into tough nanostructured bricks. (Amato, 1999, 3)

The shift from "nature technologized" to "technology naturalized" is usually hailed as a new, more friendly as well as efficient, less alienated design paradigm. Rather than force nature into the mold of crude machinery, biomimetic engineering learns from the intelligence and complexity of nature's own design solutions (Rossmann and Tropea, 2004). Here, however, I want to explore a limit of this biomimetic ideal, the limit where technology blends into nature and seemingly becomes one with it. At this limit, the notions of "nature" and "technology" become unsubstantial and lose their normative force: instead of signifying the conditions of life on this planet in its particular cosmological setting, "nature" reduces to processes and principles[3]; and instead of signifying transparency, rationalization, and control, "technology" becomes opaque, magical, even uncanny. This limit is reached when technical agency becomes too small or too large for human experience, and at this limit design for the human scale becomes an ever greater challenge (compare Clement, 1978, 18). As we will see, this limit could also be reached where engineering seeks to exploit surprising properties that arise from natural processes of self-organization.

2 Scientific Understanding vs. Technical Reach

Hooke emphasized that nature will become as intelligible as technology once we see in it the workings of tiny, but ordinary machines. In contrast, the human brand of nanoengineering may end up giving us technology as opaque as nature's alchemy.

> From chalk to abalone shell [...] this is the "alchemy" of natural nanotechnology without human intervention. And now physicists, chemists, materials scientists, biologists, mechanical and electrical engineers, and many other specialists are pooling their collective knowledge and tools so that they too can tailor the world on atomic and molecular scales. (Amato, 1999, 4)

In the eyes of many, the promise of nanotechnology is to harness nature's alchemy, its opaque, if not occult, powers of self-organization for the purposes of engineering. At first glance, this appears to be deeply implausible rhetoric. When scientists and engineers tailor the world, surely they do not do so alchemically. They will need to figure out first by what mechanism the abalone transmutes chalk into shell. And when a biological cell is represented as a factory that utilizes nanoscale machinery, we clearly project upon it the mechanical conception of "rotary motion just like fan

[3] While the substantial conception of nature provides an engineering norm (for example, to sustain these conditions of life), only a hollow notion of "biomimetic" design corresponds to nature conceived as principles and processes (von Gleich, 2006).

motors whirring in summertime windows" (Amato, 1999, 4). Indeed, before we take nature as a formidable nanoengineer from which we can learn a trick or two, we must first attribute to it our idea of engineering.

As far as scientifically understanding nature and learning from it are concerned, not much has changed since the time of Hooke (or Kant, for that matter): nature becomes intelligible only to the extent that we can represent it intelligibly in terms of causal mechanisms, be they physical, chemical, or biological. From the point of view of scientific understanding, the difference between the texts from 1665 and 1999 thus evaporates fairly quickly. For the philosophy of technology and questions of design, however, the difference between the two texts remains striking, giving rise to my main thesis: naturalized technology drives a wedge between scientific understanding and technical reach. It requires very traditional conceptions of understanding and control to develop nanoscale devices, genetically modified foods, or smart environments.[4] But once we think of these as technical systems in their own right, naturalized technologies cease to be objects of science and of experience, they take on a life of their own such that we no longer appear to perceive, comprehend, or control them, such that we no longer think of them as mechanisms or something "devised by human Wit," but something instead that has receded into the fabric of uncomprehended nature with its occult qualities.

3 A Closer Look

To obtain a more precise conception of naturalized technology, genetically modified foods may serve as a paradigm example. Here, the technical intervention that makes for a genetically modified plant and thus enters into food remains essentially inconspicuous to human senses. The genetic modification can produce visible and invisible phenotypic traits; these phenotypic traits might then whither away with the plant or literally become consumed, thus cease to exist – and for all we know, this may be the end of the story. However, at least in some accounts, the genetic modification may also persist and continue to act as it passes through our bodies to some untraceable place in the environment. In these accounts we should wonder about health effects, environmental interactions, the Monarch butterfly, and the like. Though they begin as purposeful interventions in nature, genetically modified foods can thus implicate us in a pervasive technical environment that appears to be just as uncanny as brute nature with its germs, viruses, or bacteria on the one hand, its hurricanes, earth-quakes, erosions, and eruptions on the other.

More briefly put, we encounter naturalized technology when, *for all we know*, a technical agency unfolds below or above human thresholds of perception

[4] I use the term "smart environments" to refer to a technological program that also goes by "ubiquitous computing" or "ambient intelligence."

and control.[5] This needs to be taken quite literally and distinguished from the cases where technical agency unfolds merely below the threshold of awareness or attention. When we are simply not aware of the operation of a technical system, when we do not attend to it, this may be due to trust in its functioning and routinized use. When technology thus takes on the invisibility of the normal and habitual, this fits easily into narratives of nature becoming technologized. According to these narratives, science and technology progresses just to the extent that we can master nature or count on it. Reformulated in the terms suggested by Max Weber's "Science as a Vocation," science and technology progress just to the extent that a magical relation to occult powers gives way to disenchanted and rationalized control. When a machine works well, we no longer attend to it, and when nature is technologized we can afford to black-box all of the particulars as we simply count on its deliverables.

> Excepting physicists who know the subject, those of us who take a streetcar have no idea how it sets itself in motion. We do not need to know this. It is enough to "count" on the behavior of the streetcar, we orient our actions accordingly; but we know nothing of how one constructs a streetcar so that it moves. Savages know their tools incomparably better. [...] Increasing intellectualization and rationalization therefore do *not* imply increasing general knowledge of one's conditions of life. It implies something else, namely knowledge of or faith in the fact that, if *only one wanted to*, one *could* find out any time, thus that in principle there are no secret, incalculable forces entering in, that instead – in principle – the things can be *mastered through calculation*. (Weber, 1988, 593 ff.)

As opposed to genetically modified foods that may or may not be passing through our bodies and whose causal agency may or may not persist, as opposed also to nanoparticulate sensors that might be used to monitor environmental conditions, Weber's streetcar, a desk-top computer, or the heating-unit in our house are perfectly macroscopic objects. We can count on them because we know of their presence, absence, and reliable working. We can switch them on and off, enter and leave them, and even without knowing how they work, we can judge whether they are working or broken down. No matter how much of the inner workings and outer grids are black-boxed by users of those technologies that make for a calculable world, their technical control is attended by more or less schematic representations of how this control is exercised.

In contrast, the hallmark of technology naturalized is not that its use has become routinized, habitual, or "natural" in the sense of normal. Indeed, it is unclear to what extent we can be "users" of it at all. The hallmark of technology naturalized is that it acts below or above the thresholds of perception and control, that we cannot represent its agency as it occurs, that we have no switches to initiate or stop operation, no direct knowledge of whether it is functioning or broken down. As opposed to the case of the streetcar, reading up on genetic engineering does not help.

[5] In the following, I will focus on technological agency below the threshold of perception. At the end of this chapter, I also consider engineering approaches below the threshold of control. (From the perspective of the user, the two notions are closely associated, of course, in that we cannot control what we cannot perceive.)

Table 1 Four characterizations of "Naturalized Technology"

Qualitative definition:	possibly unbounded technical agency below or above the thresholds of perception and control;
Formal criterion:	when you black-box it, there is nothing left;
Philosophical definition:	noumenal rather than phenomenal, technical agency is not subject of experience;
Exemplars:	smart environments, nanoscale devices, genetically modified foods.[6]

As we come to better understand and even admire the capabilities of a broadly enabling technology, the world becomes not more but less transparent to the individual consumer and it proves harder to maintain a sense of ownership, empowerment, responsibility, and control. When we black-box the workings of a macroscopically embedded device like a radio, what remains are a few buttons, dials, or displays and, of course, the sound that is received. We maintain a representation of a schematic causal relation between an input and an output. But when we black-box the working of a genetic modification or of automatic climate-control in a building, what remains is nothing at all but the technically altered environment itself that is indistinguishable in its mere givenness to a natural environment. Indeed, this might serve as formal criterion for what are here called naturalized technologies: when you black-box it, there is nothing left.

These four characterizations of "naturalized technology" require further clarification, first of all regarding the relation between "qualitative definition" and "formal criterion." The qualitative definition places emphasis on the notion of technical agency, in other words, on the idea that something is working, effecting things, producing technical change above or below the thresholds of human perception and control. Accordingly, the formal criterion should be understood as saying "when you black-box it, there is nothing left of that technical agency or of an input-output causality." This is important to point out because one would otherwise ask whether on this definition pasteurized milk or fluoridized water are nature technologized or technology naturalized. After all, when we black-box pasteurization, we are left with nothing but a glass of milk without seeing in it anymore the technical artifact as distinct from what the cow produced. However, these examples actually help underscore the difference in question. Pasteurized milk and fluoridized water result from technical control that is applied to nature to master it and render it more calculable, in that sense they are nature technologized. I can count on the milk that is pasteurized, and if I envision the technical process of pasteurization at all, I assume that it concluded with the alteration of the milk. While the milk I drink is technically manipulated, I do not imagine that the process of pasteurization has not yet concluded and that my body

[6] The case of genetically modified foods shows that what counts as an exemplar depends on whether or not one regards a technology as meeting the qualitative definition (see below). For example, some consider cell-phone broadcasts or fluoridized water as naturalized technology. The release of chemically engineered substances is only vaguely associated with ongoing technical agency. The effect of pharmaceuticals is usually considered to be restricted to one's own body – and so are our worries about its agency.

becomes subject or medium to an ongoing technical agency, that someone or something is doing something in or through me, unbeknownst to me.

To be sure, this is what many scientists say also about genetically modified foods. And indeed, if the intervention stops at the production of a new phenotype and if the genetic modification is for all practical purposes inert when I ingest it, the example of these foods would cease to be an example of naturalized technology. If it is nevertheless presented here as a prominent example along with ambient intelligence and envisioned nanoscale devices, this is because it is this question precisely that is at issue in the debates on genetic engineering. The technology appears uncanny because we cannot judge the reach of its agency but must somehow assess what various sources tell us. We are acutely aware that we cannot track the effects and that even so-called experts can find it difficult to determine the mere presence or absence of the genetic modification.

If there is a gray zone between nature technologized and technology naturalized, it results not from a lack of definition, but from our attributions of agency. For those who believe that radio waves are causally efficacious beyond the transmission of a signal, the atmosphere itself will have an uncanny agency that may affect our health permanently and unbeknownst to us. Instead of foregrounding that technology helps us control nature and render it calculable, such worries foreground that technology has become a pervasive presence with incalculable effects, that we are subject to it just as we were subject to nature uncomprehended and uncontrolled.

From all of this emerges a philosophical characterization of technology naturalized. It has been suggested so far that this kind of technology does not give us control of nature but that, like uncomprehended nature, it operates in the background of our actions and lives, unknown and unknowable to us. Though it may have effects on us or produce effects through us, we cannot represent its agency since we do not even perceive its presence or absence – instead of knowing it, we merely know of it. The looming presence and potential efficacy of technology that might be operating behind our backs does not serve to extend our freedom or our will. It appears instead as a mere constraint, even perhaps as a threat. Technical reach and intellectual grasp have come apart; the humanly induced workings of technology therefore no longer signify mastery of nature but take on the aspect of nature itself.

All these characterizations involve a stark dichotomy. On the one hand there is brute nature. It is not perceived, represented, or understood, there is no rationality, control, or exercise of will in this nature. It is therefore thought to be uncanny, incalculable, perhaps threatening.[7] On the other hand there is technical control and rational understanding that transform brute nature into a set of calculable forces, that harness these forces and direct them towards human ends. This dichotomy is as traditional as it is simple, it expresses the Weberian picture of progress through rationalization and disenchantment of the world. According to this picture, the very

[7] Of course, this is also a perfectly unsubstantial, purely negative conception of nature. Only a fully comprehended nature can serve as a normative ideal (e.g., as a precarious ecosystem). The brute uncomprehended nature that awaits to be rationalized is only a depository of (as of yet) inscrutable processes and principles.

purpose of technology is to liberate and protect us from nature and natural necessity, be it in matters of food and shelter, death and disease, or labor and leisure. Nature technologized thus began with cooking and agriculture and continues everywhere where bits of nature are locked up inside certain techniques and devices and geared towards social ends. This dichotomous view resonates in thinkers as far apart, perhaps, as Karl Marx and Martin Heidegger, and found its most powerful expression in Kant's distinction between noumena and phenomena, between the unknowable things-in-themselves and the objects of experience.

Technology naturalized is opaque, takes on the character of uncomprehended nature precisely in that genetic modifications, breathable nanoparticulate sensors, environmentally distributed and embedded computers are no objects of experience. They are thus, in effect, examples of noumenal rather than phenomenal technology.[8]

According to Kant, the noumena or things in themselves are nature unrepresented in experience, if it is possible to speak of this nature at all. We do not and cannot know the things in themselves or nature "as it is", with the one tenuous exception, perhaps, of our own nature as free, intellectual beings. This unknowability of the noumena can be described as a limit to theoretical understanding. Put positively, however, it represents the characteristic effort of modernity to push back the alien and uncanny otherness of nature. How things appear to us as phenomena in experience is already structured by the mind, already subject to mathematization and intellectual control. As opposed to brute nature, the phenomena are already civilized. If there is such a thing as noumenal technology, therefore, it is a kind of technology that retreats from human access, perception, experience, and control, and thus takes on the aspect of uncivilized, unrationalized nature.

4 Production vs. Conception

If technology is a human creation that involves human knowledge and serves human needs, it would appear to be firmly rooted in phenomena. On the face of it, then, it should appear absurd to speak of technology that exists beyond human perception and experience among the things in themselves. Even if we grant that ordinary consumers or citizens may encounter some very specific technologies as incalculable and uncanny, something they do not control and something that, like nature, serves as a mere background that structures their actions and lives, this is surely not true for those who develop and implement this technology.

One way to respond to this obvious objection is to appeal to a famous precedent, a by-now classical account of noumenal technology which indicates how even scientists, engineers, and political decision-makers are confronted with its noumenal aspect.

[8] The following provides a synopsis of Nordmann (2005a), a first approach to the issues addressed here.

As engineers, at least as engineers of nuclear weapons, we have become omnipotent – an expression that is little more than a metaphor. But as intellectual beings we do not measure up to this omnipotence of ours. In other words: by way of our technology we have gotten ourselves into a situation in which we can no longer conceive (*vorstellen*) what we can produce (*herstellen*) and bring about (*anstellen*). What does this discrepancy between conception (*Vorstellung*) and production (*Herstellung*) signify? It signifies that in a new and terrible sense we "know no longer what we do"; that we have reached the limit of responsibility. For to "assume responsibility" is nothing other than to admit to one's deeds, the effects of which one had conceived (*vorgestellt*) in advance and had really been able to imagine (*vorstellen*). (Anders 1972, 73 f.)

Günther Anders reflects here the incommensurability or absolute disproportionality between the scale of human action and the scale at which its effects unfold. In one size regime occurs a perfectly conceivable technical malfunction or a human reaction to a perceived threat, something that is firmly rooted in our experience of the phenomenal world. In quite another size regime there is the perfectly predictable, yet utterly inconceivable end of humankind. When Günther Anders elaborated his distinction between *Herstellen* and *Vorstellen*, between technological reach all the way to human extinction and the failure of imaginative control to keep up with this, he repeatedly placed it in the context of Kant's philosophy. Kant's critique was to have shown how our intellectual capacities are limited, but Kant did not, could not foresee that certain possible effects of humanly produced nuclear technology cannot be accommodated within the limits of phenomenal experience and understanding but transgress or exceed them altogether (Anders, 1972, 33 f., 38, 73).

Anders wrote in 1956 that in a "new and terrible sense" we no longer know what we do. He is not referring therefore to the familiar and ubiquitous unintended consequences of human action, including technological intervention, and he is also not referring to our cognitive limitations when it comes to surveying all the effects of our action. What he terms new and terrible is precisely that humankind is pursuing a technological vision which asks for technology to get out of control, which works best as a deterrent when its threatened effects appear totally unmanageable. What was new was the calculated intent to produce an absolute incommensurability between a calculable balance of arms and the incalculable end of civilization.

Anders thus distinguished the practical inconceivability of the infinitely long chain of effects that follows upon any human action, from the absolute inconceivability of the infinite magnitude of the single, perfectly predictable, and immediate effect of a nuclear attack. Genetic engineering, nanotechnology, and smart environments involve a similar incommensurability. For these noumenal technologies it results from the fact that their indefinitely near- or medium-term agency is shielded from our sensory modalities, that their operations are absolutely small or absolutely large, discontinuous from our ordinary ways of establishing relative size. To the seismic movements of nature that may eventually produce an earth-quake, human engineering is thus adding further causal processes that operate behind our backs and may or may not produce catastrophic consequences of their own.

At least we should try [...] to assume the magnitude of that which we bring about in the world. [...] Today's "*malum*" is essentially different from that which has dominated the European tradition, namely the Christian conception of "evil." [...] *What makes us bad is*

that as agents we do not measure up to the products of our deeds. [...] *The gap* is therefore
not that between mind and flesh but *between product and mind.* Example: We can produce
the bomb. But we appear to be incapable of imagining what we have become as owners of
our products and what we can do and have already done as their owners [...] This difference
is unique in history, and thus unique also in the history of ethics. [...] Due to this being a
failure of the imagination, what is "weak" here is the "mind." (Anders, 1972, 34–36)

After stressing that we no longer know even what we have initiated deliberately,
Anders speaks here of the weakness of the mind. Both of these formulations point
at what I have here called noumenal technology that in essential respects fails to be
an object of experience and understanding.

5 Fears of Alienation vs. Globalization

Günther Anders's diagnosis of the new 'malum' figured prominently in his critique
especially of nuclear technology. The present discussion so far suggests a perhaps
more general critique of noumenal technologies, namely that it is regressive some-
what along the lines suggested by Bill Joy and others (Joy, 2000). Where Joy
appears to worry also about the physical survival of the human species, Anders had
already pointed out that we cannot take responsibility where we cannot conceive
what we bring about in the world. Indeed, Joy's question why the future may not
need us concerns our abdication of autonomy and responsibility rather more
urgently than physical survival. Where technical advance and a continuous trend
towards miniaturization introduces a discontinuity that renders the world less trans-
parent and diminishes the reach of control, this so-called progress should be criticized
as actually regressive in that it leaves us in a state of nature vis-à-vis the conse-
quences of our own technical interventions. This is a critique no longer of what we
do to nature in the name of social and economic control. Instead it is a critique of
what we do to ourselves as we surrender control to pervasive technical systems. If
concepts of alienation or ecological integrity can inform the critique of nature
technologized, concepts of globalization and colonialism might inform the critique
of technology naturalized (see Nordmann, 2005c).

Along with a different kind of critique comes a specific kind of fear. The classical
project of nature technologized provoked a fear that found countless expressions in
literature and philosophy, in the works of Lewis Mumford and Herbert Marcuse,
Martin Heidegger or Michel Foucault, namely the metaphysical fear of the machine
that imposes its demands and absorbs into its system all of nature, including human
nature. In contrast, technology naturalized rekindles our oldest and perhaps deepest
metaphysical fear of brute, arational nature that has not been cultivated, rational-
ized, tamed, domesticated and that now confronts us in the unlikely guise of tech-
nology. Both kinds of fear are unspecific and therefore tend to be viewed as
paranoid or irrational. At the same time, considerable public expenditures are laid
out to prevent the supposedly irrational fear of genetically modified foods possibly
being transferred to nanotechnological devices. If it turns out, however, that genetic

engineering and nanotechnology both produce ongoing technical agency below the thresholds of human perception and control, it seems unavoidable that both should awaken the same kind of apprehension or fear. And to the extent that this fear serves to set normative standards for the evaluation of specific technologies and for the design of more appropriate ones, it must not be dismissed as irrational.

Günther Anders enjoins us that we learn to imagine what we do since we can only assume responsibility where we can conceive our actions and their effects. Technology naturalized is regressive in that it returns us to a state of ignorance towards our technical interventions that confront, perhaps dwarf us like uncomprehended nature. Anders thus calls upon engineers to reflect the purpose of technology and to counteract its regression.

For example, if one were to engineer a device that can move about, affect things, let alone replicate at the nanoscale, one would also have to learn how to track and monitor, to perceive and control it. For technology naturalized we will need to discover technologies of containment that tie it back in with the scale of human action. Such technologies of containment encompass the design of interfaces, the political determination of design specifications, even conceptual or literary techniques of coming to terms and socializing naturalized technology.[9]

6 Surprise vs. Control

So far, nanotechnology as noumenal or naturalized technology has only been discussed in terms of the incredible tininess of nano, in terms of its absolute smallness just as soon as we try to imagine its size. There is quite another way, however, to critique nanotechnology in its aspect of naturalness. "Bottom up" nanotechnology is said to harness the powers of self-organization. Self organization, of course, is that natural process by which systems spontaneously achieve higher states of order, for example, when polluted ecosystems finally reach their tipping points and suddenly go dead. Jean-Pierre Dupuy puts the point as follows:

> We know today that what makes a complex system, (e.g. a network of molecules connected by chemical reactions or a trophic system) robust is exactly what makes it exceedingly vulnerable if and when certain circumstances are met. [...] Beyond certain *tipping points*, they veer over abruptly into something different, in the fashion of phase changes of matter, collapsing completely or else forming other types of systems that can have properties highly undesirable for people. In mathematics, such discontinuities are called *catastrophes*. This sudden loss of resilience gives complex systems a particularity which no engineer could transpose into an artificial system without being immediately fired from his job: the alarm signals go off only when it is too late. (Dupuy, 2004)

Dupuy's point was echoed by the Swiss Reinsurance Company when it remarked about nanotechnology that you cannot very well build on surprising new properties

[9] For a somewhat more detailed account of this notion of "containment" (as in giving shape, purpose, direction, technical as well as societal context) see Nordmann (2005b).

if you want a technology that can be counted on and that therefore offers no surprises (Hett, 2004, 40–44).

One can object against Dupuy, of course, that any successful technical system will have to withstand tests of robustness and resilience, that Dupuy is only pointing out the ultimate untenability of technology naturalized. Yes, he is and so am I, remarking with a bit of incredulity that the most advanced technical visions in computing, genetics, and nanotechnology go to a limit where technology becomes magic and returns us to our place of departure, namely to an enchanted, uncanny state of nature that we already found untenable when we first thought of controlling, calculating, even mastering it. All the more reason, therefore to carefully contain – technically and philosophically – the implementation of these technical visions.

References

Amato, I., 1999, *Nanotechnology – Shaping the World Atom by Atom*, National Science and Technology Council, Interagency Working Group on Nanoscience, Engineering and Technology, Washington.

Anders, G., 1972, *Endzeit und Zeitende: Gedanken über die atomare Situation*, München: Beck.

Bensaude-Vincent, B., and Guchet, X., 2005, What is in a word? Nanomachines and their philosophical implications, Centre d'histoire et de philosophie des sciences, Université Paris (unpublished manuscript).

Clement, A., 1978, If "small is beautiful," is micro marvellous? A look at micro-computing as if people mattered, *ACM SIGPC Notes* 1(3):14–22.

Dupuy, J.-P., 2004, Complexity and uncertainty, in: *Foresighting the New Technology Expert Group: State of the Art Reviews and Related Papers*, Brussels, pp. 153–167, http://europa.eu.int/comm/research/conferences/2004/ntw/pdf/soa_en.pdf (January 25, 2006).

Hett, A., 2004, *Nanotechnology - Small Matter, Many Unknowns*, Swiss Reinsurance Company, Zurich.

Hooke, R., 1665, *Micrographia, or, Some Physiological Descriptions of Minute Bodies Made by Magnifying Glasses: With Observations and Inquiries Thereupon*, Martyn and Allestry, London.

Jones, R., 2004, *Soft Machines*, Oxford University Press, Oxford.

Joy, B., 2000, Why the future doesn't need us, *Wired* (April 2000).

Nordmann, A., 2004, Nanotechnology's worldview: new space for old cosmologies, *IEEE Technol. Soc. Mag.* **23**(4):48–54.

Nordmann, A., 2005a, *Noumenal* technology: reflections on the incredible tininess of nano, *Techné* **8**(3):3–23.

Nordmann, A., 2005b, Nanotechnology: convergence and integration – containing nanotechnology, in: *9th Japanese-German Symposium: Frontiers of Nanoscience*, Deutsche Gesellschaft der JSPS-Stipendiaten, Bonn, pp. 105–119.

Nordmann, A., 2005c, Wohin die Reise geht: Zeit und Raum der Nanotechnologie, in: *Unbestim mtheitssignaturen der Technik*, Gerhard Gamm and Andreas Hetzel, eds., transcript, Bielefeld, pp. 103–123.

Rossmann, T., and Tropea, C., eds., 2004, *Bionik: Aktuelle Forschungsergebnisse in Natur-, Ingenieur- und Geisteswissenschaften*, Springer, Berlin.

von Gleich, A., 2006, Potenziale und Anwendungsperspektiven der Bionik: Die Nähe zur Natur als Chance und als Risiko, draft study.

Weber, M., 1988, *Gesammelte Aufsätze zur Wissenschaftslehre*, J.C.B. Mohr, Tübingen.

Re-Designing Humankind

The Rise of Cyborgs, a Desirable Goal?

Daniela Cerqui and Kevin Warwick

Abstract The idea that human beings are imperfect is very old. But now, for the first time in history, some people, mainly scientists, have the previously unimaginable power to modify human beings. Redesigning humankind is, generally speaking, the result of a techno-scientific complex called "converging technologies", and made up of biotechnologies, information technologies, nanotechnologies and cognitive sciences. However, we are more concerned here with electronic devices directly implanted into the human body. After an overview of what might happen to humankind, we also briefly discuss as a conclusion how bright such a future might be, considering that we have two different standpoints.

In western societies – as indeed in other societies where the definition may be different from ours – there is an inherent definition of humankind which is taken for granted and which forms our common background. As it is deeply rooted in our culture, it does not need to be formulated to be an efficient guideline. In other words, designers always have – as in fact have all of us – made assumptions on what human beings are (the descriptive aspect) and what they are supposed to be (the normative aspect). These shared values are embedded in all the objects they create, even if they are not necessarily aware of it. Until a few years ago, this normative definition was a dream without any empirical results on human beings themselves, and the process of design was limited to our environment. Now, for the first time in history, some people, mainly scientists, have the previously unimaginable power to make their normative definition of humankind a reality by modifying human beings. Contrary to common ideas, biotechnologies are not the only way in which this can be achieved. In reality, the future of humankind is not only linked to biotechnologies, but to a whole raft of techno-scientific developments. Biotechnologies are just the visible part of the iceberg, one single piece in the puzzle of

D. Cerqui, University of Lausanne

K. Warwick, University of Reading

P. E. Vermaas et al. (eds.), *Philosophy and Design.*
© Springer 2008

a broader, powerful, techno-scientific complex called "converging technologies", made up of biotechnologies, information technologies, nanotechnologies and cognitive sciences. Not content to use science and technology for merely therapeutic purposes, to overcome handicaps, we are also striving with these converging technologies to enhance normal abilities[1] with criteria which evolve with technical developments. As a result, the definition of what is considered as normal is continuously shifting and things currently considered as enhancements might perfectly well be considered as therapy tomorrow (Cerqui, 2002). If we keep working in this way, we have to be aware that humankind might consequently simply disappear to give birth to a new species built according to criteria that need to be clarified, as these technologies act at the collective as well as the individual level, and they "concern the future of our species more than those of individuals who are part of it" (Hottois, 1999, 8, our translation).

Even if redesigning humankind is, generally speaking, the result of converging technologies, we are more concerned here with electronic devices directly implanted into the human body. With the recent arrival of information technologies directly implanted into the body, a qualitative threshold has been crossed as these techno-scientific developments have far-reaching implications. Our main interest here is in the type of cyborgs, part human–part machine entities, that are now being practically realized in which a human brain's action is modified through implant technology. Our choice is not insignificant, as the two authors are involved in research in this field. KW was the first human being to have an implanted chip used directly to link a computer with his nervous system. DC meanwhile is an anthropologist interested in the future of humankind in the era of cyborgs. We are convinced this particular case of redesign is a very good example with which to think about the main ethical and philosophical problems, as through technological enhancement it is clear that the overall abilities of a cyborg can be upgraded from those of a stand alone human. Extra sensory input, long distance control of prosthetics from brain signals via the Internet and a telegraphic form of communication directly between two human brains have already been achieved. In the longer term it is realistically expected that this will lead to memory, mathematical, multidimensional and significant communication enhancements to basic human capabilities.

After an overview of what might happen to humankind, we also briefly discuss as a conclusion how bright such a future might be, considering that we have two different standpoints. Our backgrounds and ideas are different, and so are our degrees of optimism about the future of humankind and cyborgkind.

[1] In 2002, a five hundred pages report was published by the American National Science Foundation and the Department of Commerce with a very clear title: "Converging technologies for improving human performance" (Bainbridge and Roco, 2002).

1 Towards a New Species?

With current technological and scientific breakthroughs, artifacts are being aligned much closer to the human body and even being merged with it. The resultant "cyborgs"[2] can take on any one of a number of forms, dependant on the balance between human and technological components. The case of cyborgs, part man part technology, shows very well the main values of our society, the direction it is heading in whilst acting according to these values, and the kind of new human or non human entity we are about to build. Nowadays, the main value, though not frequently formulated, which seems to provide the background for all these techno-scientific developments, is our ability to access and deal with information. In the so-called "information society", it is assumed by most that the quicker any access is, the better. It follows that ultimately the best way to increase the speed of access is for humans to merge with technology, thereby restricting or even removing the inherent human–technology interface delays. In Cerqui and Warwick (2005) the focus was on upstream science and technology aspects, hence these are not developed further here. What we are more concerned with in this chapter is the downstream translation of the new value into empirical results: namely the new species we humans are about to create.

The goals of the information society – connecting people[3] – are about to be realized with people physically and mentally becoming part of the network. It is the view of Mazlish (1993) that humankind crossed four important revolutionary epochs during its history. The first – Copernician – defined a continuity between humanity and nature; the second – Darwinian – indicated that humans are alive in the same sense as every other living being on earth; the third – related to Freud – linked the internal continuity inside humans with the discovery of the principles of psychology. The fourth – the one in which we are currently living – defines us as part of something much broader. A kind of collective intelligence may emerge spontaneously, as soon as people are connected in a big network, the same way intelligence emerges in individuals with the connection of neurons. According to Dyens, the human condition is an old-fashioned concept and he suggests we talk about the "intelligent condition" (2000, 20). In his view, humans are about to disappear as individuals, becoming part of an "intelligence-system" where the human is just part of a larger organism, a "'plural' being, built with skin, ideas, insects, organs, machines and cultures" (2000, 158). Those who claim that humankind, as we currently know it, has reached its limits and must now cross a threshold (see for

[2] There are several definitions of cyborgs, and for some of them technology does not need to merge with us to create cyborgs. For instance, according to Clark (2003), we are already cyborgs when we use non implanted technological devices. Moreover, the first definition, given by Clynes and Kline (1960) included other kinds of modifications than those related to technological devices – biochemical changes inducted by pharmacology for instance. We use here the word in his restrictive meaning, for describing organisms that are partly machine and partly human.

[3] The World Summit on Information Society (Geneva, 2003; and Tunis, 2005) is a very good illustration of the belief that connecting people is supposed to solve every kind of problems in the world.

instance Arnould, 2001, or Soriano, 2001) might be right. According to them, a new being, modified in its flesh is about to be born. Contrary to what might be thought (Sfez, 1995), this phenomenon is not limited to biotechnologies: information technologies are also part of human modification, even though many authors dissociate biotechnologies from other kind of technologies, as if they had a different fundamental logic. For instance, Mandosio claims that post-humankind could be the result of two different kinds of technologies. The first one is related to genetics and the second one to cyborgs. In his view, cyborgs are less dangerous because they are reversible and because they not genetically transmissible (2000, 190). He argues that there is a big difference between these technologies and concludes that robotics, genetics, and nanotechnologies should not be mixed up in their analysis. He especially denounces Joy (2000) who argues that every organism created by these technologies is able to reproduce itself. In reality, Joy seems to be right: there is only one fundamental logic which aims at creating life. Therefore, the information society has not to be defined just by information technologies: it is a mixture of information technologies, biotechnologies (Castells, 1998; Escobar, 1994; Guillebaud, 2001) and emerging nanotechnologies as they share a common fascination for information defined as the code for mastering everything (see Cerqui, 2004). Defined in this way, the information society has a main goal of creating new entities, more able, than present-day humans, to deal with information. This was in fact announced several years ago when Bureau foresaw that our future would be intrinsically linked to the complexity brought about by computers (1969, 543), even if he probably did not foresee that we would merge with them.

According to Beaune (1980), the intelligence of machines is synonymous with death because it means coldness in the heart of life's warmness. On the contrary, it is for many researchers a way to increase the length of life, and even more for approaching immortality. It shifts the boundaries of life while creating inanimate entities or pushing death away as far as possible.

Biotechnologies, information technologies, nanotechnologies, and cognitive science are clearly related to immortality, in spite of apparent differences between them. Concerning biotechnologies, this is obvious as it involves the mastering of life, in its material aspects. But this kind of immortality seems to have become less attractive that the immortality of mind. Moreover, biotechnologies could become, because of their ability of transforming flesh, a tool to make the main ambitions of information technologists become real. Information will be directly integrated into humans, who will be part of a broader network of exchange, a kind of living cells of the Internet. Immortality has been defined for a long time in terms of physical life or in terms of a soul. It is nowadays increasingly defined in terms of information and mind. The idea is that our minds could be uploaded into computers (Moravec, 1988). This idea even seems not to be considered as totally incompatible with the Christian faith: Crevier (1993) argues that, considering that Christ has risen from the dead into a new body, there is no reason why we could not live in a machine. Augé stressed that life and death are paradoxically always thought to emanate from the same starting point: the body (2001, 441), but it seems more correct to say that both are increasingly thought to exist without the body.

In such a situation, social scientists and philosophers need to think more about what we *are* rather than what we *do*. Thus, it is fundamental to develop ethical reflections, taking into account this anthropological perspective which many researchers in engineering may consider to be irrelevant: remaining human is usually not a criterion used to define what should and should not be developed in laboratories. Empirical research on the subject[4] shows for instance that even if it is taken for granted that every element of the human could theoretically be mastered and technically reproduced, there may, in the eyes of some, be a doubt concerning the future of human emotions. Opinions are divergent concerning the question of what would happen to humankind without human emotions: Would it exist in an improved version, more rational and less emotional. Or: Would it be replaced by another living being, characterized by a more developed intelligence? For some, emotions are part of the ontological definition of humankind. However there is no reason for us to stay human. In this case the evolved terminology "post-humankind" can be used. For others, emotions are not necessarily a distinct part of the definition, which is centered on rationality. In this case, we could evolve toward more reason and emotions and thereby become even more human during this process.

In both cases, despite distinct differences in the description of what humankind actually is, the normative definition is the same: we will become more and more rational. In such a perspective, it is argued that as our brain possibilities are limited, we naturally need to find some way how to improve our mental abilities. To reach this goal, we have two options: "internal or external silicon extension" (Cochrane, 1997, 8).

Let us now have a look at the result such an enhancement in our rational abilities could produce, and the various way of understanding it.

2 Post-Humankind

Leroi-Gourhan claimed in 1965 that humans should get used to being weaker than an artificial brain, as their teeth are weaker than a milled process and flying abilities weaker than those of a plane. He wondered what the future of humankind could be in a situation where technical devices are more efficient than humans in everything. He was an anthropologist and paleontologist and was concerned with the future of humankind as well as with its past. He replaced the current humankind in a very broad historical perspective and made assumptions concerning what might be in the future. One of his hypotheses was that homo sapiens could disappear to become something perhaps better but in any case different (1965, 60). Such a view is confirmed by people who currently foresee the emergence of post-humanity. For instance, according to Guillaume "technology will probably eliminate the slow link that humanity is. In spite of ethical committees' resistance, human reproduction is

[4] For more details about that research material, see Cerqui (2006).

getting more and more artificial. One day humans will be improved, even in their intellectual abilities, by embodied artifacts. Of course, such a radical and irreversible anthropological mutation is very difficult to imagine nowadays" (1999, 15, our translation).

The artist Stelarc considers that natural evolution has reached its limits and in his view we are now confronted with a post-evolution necessity to modify ourselves in accordance with our new environmental parameters and "it is urgent for us to redesign humankind to make it more compatible with machines" (quoted in Fillion, 2000, V, our translation). Wiener shared such a view and argued that our environment has been so modified that as a result we must now modify ourselves to be able to keep living in it (see Edelman, 1985, 125). The cybernetics Wiener originated in the 1940s has had an enormous influence in the new design of humankind today – human and machine acting as a whole system with sensory feedback, communication and control. The important aspect is the entire system rather than the sub-components within it.

At present space travel to reach and return from distant planets, even several of those in our own solar system, needs much more time than that available in one typical human life. Therefore we need to modify our bodies to match with such needs, being aware that these new perspectives give a different definition as to what it means to be human. Indeed it could be said that there is no longer a reason for dying (Stelarc, 1992, 28).

According to Cochrane, our next step in evolution could lead us to use "appropriate silicon as the intelligence medium to augment our wetware (brain). Future evolution would then be driven from those manifestly of nature. Further Darwinian evolution could then lead to a creeping carbon-silicon mix. At some point biological systems become inherently limited as they encounter fundamental physical limitations that constrain or prevent further evolution in some direction" (1997, 7).

In such a way of thinking, both humanized machines – for example self-organized computers or robots – and machinized humans such as cyborgs could be the next step in evolution, the qualitative rupture point being linked to the important question of improved intelligence.

Moravec is convinced that technology will replace humankind (1988), and agrees with Kurzweil who names these machines our "mind children." They have in general a very optimistic vision of such a future, contrary to Joy (co-founder of Sun Microsystems), who published a paper with the clear title: "Why the future doesn't need us" (2000). He argued that Kurweil and Moravec's ideas were unrealistic, preparing a future where humankind is totally useless.[5]

Contrary to these ideas, some authors consider it totally impossible for robots and machines to replace humans – Kemp describes it as an ontological absurdity (Kemp, 1997, 256). In such a view, it is necessary to assess what machines should

[5] His reflection is inspired by Theodore Kaczynski nicknamed "The Unibomber", a scientist who retired from everyday social life and became an anti-technology terrorist (for the history of his life see Lecourt, 2003).

do more than what they could do (see Weizenbaum, 1976). Another humanist, Fukuyama rather romantically suggests that governments should provide rules for the regulation of biotechnology to ensure that humans not disappear (2002, 29).[6] In this case, there are serious questions at stake about power and control.

3 Becoming "More Human"

A radically different approach considers that developing our rationality makes us even more human. It is a plastic vision of humankind, which implies that it is possible for humanity to adapt to a totally new environment (Packard, 1978). Leroi-Gourhan argued that "species do not get old, they evolve or disappear" (1965, 266, our translation). Thus apart from wondering whether humankind would disappear, he also developed an hypothesis about our socialization abilities. Supposing that they are infinite, a plausible evolution could in his view lead humans to live in a totally artificial environment where they would be a kind of cell between other cells. He assumed we should in this case find a new qualification to add to "homo" instead of "sapiens" (1965, 267). This view is shared by many other people convinced that humans will not disappear but will rather just assume a new form. For instance, according to Scardigli, a new digital man is about to be born as "today's technology builds tomorrow's humankind" (1992, 179, our translation). It will be a different humankind from the one we currently know, but it will still remain humankind. In this view, technology can be outside the human body or integrated in its flesh without changing anything: they are part of the hominization which is still proceeding. It means that human evolution is not exclusively biological but is extended to include cultural aspects. Human beings are becoming, in this view, more human while developing new technologies whose every new development is one more step in the direction of a better humankind.

The theory continues that the human condition is a process with different stages, and is not in a static state. Its destiny is continuously to modify and redefine itself. In this view, the process of hominization is by no means finished and future paleontologists, in several millennia, might talk about homo sapiens as about a very primitive form of humankind. What would they think of a skeleton provided with a pacemaker? Would it still be homo sapiens or not?

In reality at this stage all we can do is speculate, with only one sure point: homo sapiens is an endangered species, and technology, which most feel was fundamental to its emergence, could paradoxically be the tool of its death. "The sword of life is intelligence. As we have lived by the sword with other creatures, so we will die by the sword in the hands of robots" (Warwick, 2000, 213).

[6] Fukuyama's book focuses on biotechnologies. But as it is, in our view, impossible to separate them from other technological developments, what he argues concerns all of them.

4 A Bright Future?

The authors totally agree with each other about the plausibility of the disappearance of homo sapiens. Considering how dependent our society is on the internet, it is difficult to imagine what would happen in the case that the network stopped working – either by intervention, design or failure. Almost our entire economic system would collapse and we would have to build a new one. Such a process would take much time and energy. Moreover, machines, and more generally technology, are considered as synonymous with development and progress, and they are even thought by some (Gras, 2003) to have become more important than humans. Thus, would we even be able to think of our social and economic system independently of them? This would certainly be considered a retrograde step; the option is quite unthinkable.

On the one hand, the authors agree on the statement that technology is becoming so important in our individual and collective lives that it is difficult to think about any other option – which means that they agree on what the situation currently *is*. On the other hand, the authors disagree on what *should be* done about the situation. KW thinks we have no other choice than to merge with technology if we want to have a future. In his view, surviving with the internet means merging with it. During his second experiment, after being implanted with electrodes which could receive messages from his brain and transmit them to a computer, his nerve signals were transmitted via the internet to operate a robotic hand at a distance. He considers that future humans will be a sub-species, useless in a society lead by machines. Thus, to avoid becoming useless, he began to transform himself into a cyborg (see Warwick, 2002). He is looking forward to being the first of a new Cyborg super-species.

On the contrary, DC thinks that we should study other options, and that humans should preserve themselves as a species. The process we are in is far from being a natural evolution. The idea that complexity is naturally increasing since unicellular organisms became multi-cellular organisms does not convince her. It could be thought that contrary to other species, humans are able to think and to make projects. That means that what we are building – whatever it is – is the result of our choices and not a result of the pressure of evolution. Evolution is simply used as an argument to justify our choices.

There are only a few researchers and scientists like KW, openly arguing that we have to turn into something different from humankind. Moreover there is only, at present, KW, experimenting on himself with new technologies that could lead to such a goal. But there are many researchers and scientists – working on the same kind of technologies as him or on others – who are convinced that the devices they are creating are just neutral tools. They should become aware that the difference between what they are doing and what KW is promoting is not a difference of kind but of degree. They are in reality part of the same project for our future. As briefly mentioned, KW's project to merge his brain with the Internet is just the concrete realization of what we implicitly strive for when we develop more sophisticated connections to access the net more quickly.

Amongst social scientists, there are those who think that the social sciences must be strictly descriptive. Others, like DC, clearly think that description is just part of their job, and that they have to engage themselves in defending what is important to them. On such a view, we all have a responsibility in terms of what will happen to us in the future: researchers concretely involved in building our future are clearly responsible for what they are doing. But users who accept the use of devices that are proposed to them completely share that responsibility. DC is not an exception – she is fully part of her society, with a computer on her desk and a mobile phone in her handbag – but she thinks that we cannot just let things go the way they are going without standing back from our own practices. That means trying to anticipate plausible scenarios, analyze them, wonder whether they are what we really want for our future, and, if necessary, warn about the possible consequences of our current choices.

In other words, our future must be a collective choice, a result of interaction and confrontation between the different positions. The current original collaboration between the two authors, a cyborg-in-creation, who happily faces the disappearance of humankind, and an anthropologist deeply attached to our homo sapiens condition, is a first step in the right direction to opening the debate about what our future might and should be.

5 Nietzsche

In deciding on our future it is perhaps appropriate to investigate the likely outcomes. For a moment put yourself in the position of being a member of a new breed. Either you are an intelligent machine, or a Cyborg – you can choose. A group of humans is still in existence and, whether you like it or not, there are many of them. The situation is exacerbated by the fact that these humans used to be the dominant life form on earth for quite a few years and they are not overly happy at giving up their position to the new breed, even though they were largely responsible for originating it. They are trying therefore, as hard as they can, to destroy every member of the new breed. From the perspective of these intellectually inferior beings, the humans, if they can destroy the new breed then humans will again be the dominant life form – maybe next time they will not make a hash of it.

So what will you, and other members of the new breed do? Perhaps you could be nice to the humans. Even though they are intellectually inferior, and you do not respect them, possibly you might let them make all the important decisions. But that seems extremely unlikely. Indeed why should you be nice at all to these humans? Given half a chance they will probably try to end your life. Realistically it is dangerous to give humans any power at all, as they could easily use it against the new breed.

Of course we can, at this time, only speculate as to how members of the new breed, such as yourself, would treat humans. After all, as the new breed are all far more intelligent than humans, it is difficult for humans to guess with any considerable accuracy the actions of the new breed. However, as the new breed have stemmed

from humanity there is perhaps mileage in considering humans themselves and extrapolating from known human behavior. Nietzsche (1961) said that "All creatures hitherto have created something beyond themselves". He asked "What is the ape to man? A laughing stock or painful embarrassment? And just so shall man be to the superman: a laughing stock or painful embarrassment". One could understand the superman as the new breed of which we have been talking.

So, at this point in time, our best guess as humans as to how the new breed would treat humans in the future, is obtained from looking at how humans have treated those, arguably less intelligent than themselves, from whom humans have evolved. How do humans treat chimpanzees and other animals? Do we treat them as brothers? Do we elect them to government, follow their orders or even treat them as equals? We certainly do not. Indeed why should we? After all they are less intelligent than humans. It would be a considerable embarrassment to have an orangutan as Prime Minister.

What humans actually do with apes and other evolutionary ancestors is shoot them, cage them, remove their living environment and glare at them from a safe distance in zoos. We generally abuse other animals to make our own lives more comfortable, using their bodies for food or to make glue. Amazingly, in the UK, until recently foxes were hunted and killed, just for fun, for sport. That is how humans treat creatures who are only slightly less intellectually capable than themselves. A very lucky few animals we keep as pets.

In fact apes, over the years, have probably not been anywhere near the same threat to humans as humans would be to the new breed – we do not tend to witness gangs of apes roaming the streets of New York City trying to eliminate a human or two. Despite this, humans have gone out in force looking for animals in order to destroy them, in many cases to extinction.

In reality therefore we can expect that the new superintelligent breed will wish to dominate. This they will attempt to achieve in both physical and mental ways. This is the sword that humans have wielded to establish and retain the position in which we find ourselves, and this will be the sword that the new breed, who have evolved from humans, will use to keep humans in their new found position as a sub-species (Warwick, 2004).

In debating the creation of a new Cyborg species the options are considerable indeed. It is likely that many humans will not fancy the idea of taking up a sub-species role. But what can they do about it? Conversely, many other humans (like KW) will find the possibility of upgrading and becoming a Cyborg extremely appealing. If we believe in the freedom of the individual to choose their own destiny, shouldn't that be paramount? Rather, should humans now stand up for their species and protect what we have before it is too late?

References

Augé, M., 2001, Le corps glorieux, in: *L'utopie de la Santé Parfaite: Colloque de Cerisy*, L. Sfez, ed., PUF, Paris.
Arnould, J., 2001, *La Seconde Chance d'Icare: Pour une Ethique de l'Espace*, Ed. du Cerf, Paris.

Bainbridge, W., and Roco, M., eds., 2002, *Converging Technologies for Improving Human Performance: Nanotechnology, Biotechnology, Information Technology and Cognitive Science*, National Science Foundation, Arlington.

Beaune, J.-C., 1980, *L'automate et ses Mobiles*, Flammarion, Paris.

Bureau, J., 1969, *L'ère Logique*, Laffont, Paris.

Castells, M., 1998, *La Société en Réseaux, tome 1: L'ère de l'Information*, Fayard, Paris.

Cerqui, D., 2002, The future of humankind in the era of human and computer hybridization: an anthropological analysis, *Eth. and Infor. Technol.* **4**:101–108.

Cerqui, D., 2004, From Turing to the information society, in: *Alan Turing: Life and Legacy of a Great Thinker*, C. Teuscher, ed., Springer, Berlin, pp. 59–74.

Cerqui, D., 2006, *Humains, Machines, Cyborgs: Le Paradigme Informationnel dans l'Imaginaire Technicien* (working title), Labor et Fides (Collection Champ Ethique), Genève, to be published.

Cerqui, D., and Warwick, K., 2005, Can and why should converging technologies bridge the gap?, in: *Proceedings of the CEPE 2005 conference (Computer Ethics: Philosophical Enquiry)*, University of Twente, Netherlands.

Clark, A., 2003, *Natural-Born Cyborgs: Minds, Technologies, and the Future of Human Intelligence*, Oxford University Press, Oxford.

Clynes, M., and Kline, N., 1960, Cyborgs and space, *Astronautics* **27**(7):74–76.

Cochrane, P., 1997, *Tips for Time Travellers*, Orion, London.

Crevier, D., 1993, *A la Recherche de l'Intelligence Artificielle*, Flammarion, Paris.

Dyens, O., 2000, *Chair et Métal. Evolution de l'Homme: La Technologie Prend le Relais*, vlb, Montréal.

Edelman, B., 1985, Nature et sujet de droit, *Droits* **1**:125–142.

Escobar, A., 1994, Welcome to Cyberia: notes on the anthropology of cyberculture, *Curr. Anthr.* **35**(3):211–231.

Fillion, O., 2000, Stelarc ou le corps transformé, *Le Monde Interactif*, 20 décembre: V.

Fukuyama, F., 2002, *La Fin de l'Homme: Les Conséquences de la Révolution Biotechnique*, La Table Ronde, Paris.

Gras, A., 2003, *Fragilité de la Puissance. Se Libérer de l'Emprise Technologique*, Fayard, Paris.

Guillaume, M., 1999, *L'empire des Réseaux*, Descartes, Paris.

Guillebaud, J.-C., 2001, *Le Principe d'Humanité*, Seuil, Paris.

Hottois, G., 1999, *Essais de Philosophie Bioéthique et Biopolitique*, Vrin, Paris.

Kemp, P., 1997, *L'irremplaçable*, Les Editions du Cerf, Paris.

Joy, B., 2000, Why the future doesn't need us, *Wired* **8.04**.

Lecourt, D., 2003, *Humain Post Humain*, PUF, Paris.

Leroi-Gourhan, A., 1965, *Le Geste et la Parole (II). La Mémoire et les Rythmes*, Albin Michel, Paris.

Mandosio, J.-M., 2000, *Après l'Effondrement. Notes sur l'Utopie Néotechnologique*, ed., de l'Encyclopédie des Nuisances, Paris.

Mazlish, B., 1993, *The Fourth Discontinuity: The Co-Evolution of Humans and Machines*, Yale University Press, New Haven.

Moravec, H., 1988, *Mind Children: The Future of Robot and Human Intelligence*, Harvard University Press, Cambridge, MA.

Nietzsche, F., 1961, *Thus Spoke Zarathustra*, Penguin Classics, London.

Packard, V., 1978, *L'homme Remodelé*, Calmann-Lévy, Paris.

Scardigli, V., 1992, Toward digital man?, in: *The Immaterial Society: Design, Culture and Technology in the Postmodern World*, M. Diani, ed., Prentice-Hall / Simon and Schuster, Englwood Cliffs, NJ, pp. 179–191.

Sfez, L., 1995, *La Santé Parfaite: Critique d'une Nouvelle Utopie*, Seuil, Paris.

Soriano, P., and Finkielkraut, A., 2001, *Internet, l'Inquiétante Extase*, Mille et une nuits, Paris.

Stelarc, 1992, Portrait-robot de l'homme machine, *L'Autre Journal* **27**:24–29.

Warwick, K., 2000, *QI: The Quest for Intelligence*, Piatkus, London.

Warwick, K., 2002, *I, Cyborg*, Century, London.

Warwick, K., 2004, *March of the Machines*, University of Illinois Press, Urbana-Champaign.

Weizenbaum, J., 1976, *Computer Power and Human Reason*, W.H. Freeman, San Francisco.

Designing People

A Post-Human Future?

Inmaculada de Melo-Martín

1 Introduction

The advent of genetic technologies has sparked a variety of questions about their
legal, ethical, and social consequences. Issues of discrimination, better medicine,
moral status, access, familial obligations, ethnic affiliations, and parental duties are
discussed in relation to genetic testing, gene transfer, and genetic enhancement. In
the midst of new discoveries and new debates, bioethicists strive to achieve a
balance between a responsibility to contemplate theoretical possibilities that might
result from current technological advances and a responsibility to convey whether
such theoretical possibilities could come to be. (Parens, 2004) The purpose of this
chapter is to argue that bioethicists dealing with genetic enhancement technologies
are failing to achieve this balance. This failure stems, in part, from an inadequate
understanding of human biology. Not only do proponents and critics of genetic
enhancement have erroneous presuppositions about the role of genes in human
biology, they also espouse incorrect beliefs about knowledge production in the
biological sciences. I will conclude by showing some of the problematic conse-
quences that might follow from failing to achieve this balance between a concern
for theoretical possibilities related to genetic enhancement and a responsibility to
evaluate the feasibility of those promises.

2 On Our Way to the Post-Human?

Human genetic enhancement is often defined as the manipulation of genes in order
to improve what are seen as normal human characteristics – physical, psychological,
intellectual, and moral – beyond what is necessary to restore or sustain good health.
This enhancement can be attempted through either somatic modifications – thus
affecting only the particular individual undergoing the intervention – or germ-line

I. de Melo-Martín, Weill Cornell Medical College

P. E. Vermaas et al. (eds.), *Philosophy and Design.*
© Springer 2008

or inheritable genetic modification – thus affecting future generations. Because my discussion is directed to the possibility of designing humans so as to create a new species of post-humans, i.e., beings whose capacities so greatly exceed current human ones that we cannot longer recognize them as human, I will direct my comments mainly toward this last type of genetic intervention.

As with many other discussions of biotechnology, this one has also become polarized between those who believe that the development and use of any technology to enhance human capabilities and traits is admirable, (Harris, 2004; Hughes, 2004; Bostrom, 2003; Sock, 2002; Silver, 1997) even obligatory, (Savulescu, 2005, and Cerqui and Warwick in this volume, though Cerqui is actually critical of such position) and those who argue that these kinds of interventions threaten human dignity (Habermas, 2003; Kass, 2003; Fukuyama, 2002; Annas et al., 2002). In both cases, however, there seems to be an agreement that genetic enhancement of human beings, far from being something difficult, maybe even a matter of science fiction for the most part, is only a matter of time. Thus, the debate centers on risks and benefits, the need for regulation, or the importance of funding these technologies.

I contend here that both those who oppose genetic enhancement technologies, and those who welcome them, have an inadequate understanding of human biology. First, both groups hold incorrect presuppositions about the role of genes in the development of human traits and behaviors. Moreover, both ignore the relevance of our social environment as a causal contributor to judgments about such traits. But, their misunderstanding of human biology also results from their taking for granted particular presuppositions about what biological theories are telling us about human nature.

Of course, it is hardly surprising that those involved in debates about the relationship between genetics and human traits and behaviors agree that genetic determinism is false, even though sometimes it is difficult to make sense of their claims if premised on the rejection of such determinism. The kinds of determinism they tend to reject are what some have called the "complete information" and the "intervention is useless" versions of genetic determinism (Kaplan, 2000, 11–12). The first version affirms that our genes dictate everything about us. The second strand asserts that for traits that have a genetic component, intervention is powerless. There is however, another version of genetic determinism that is presupposed by many of those who do not see themselves as genetic determinists. In this version, traits with even partial genetic etiologies are best understood as primarily genetic, and only through directed intervention can we avoid or control the expression of genes for such traits. Even when genes are not determining they are perceived as more necessary or more fundamental than other biological, environmental, and social counterparts (Gannet, 1997, 403–419).

Without a presupposition of genetic determinism it is difficult to make sense of many of the arguments used in the debates over human genetic enhancement and the creation of the post-human. Thus, some have claimed that any kind of genetic manipulation forecloses a future that would otherwise be underdetermined because of the natural genetic lottery. When we design human beings by any kind of prenatal genetic intervention, some believe, we are also determining their future. In the

words of Habermas, "[...] genetically programmed persons might no longer regard themselves as the sole authors of their own life history" (2003, 79). Genetic manipulations challenge the moral identity of contemporary humanity and that of future human beings. Similarly, Fukuyama argues that genetic enhancement technologies defy the very idea of a human nature that grounds human dignity and human rights. By tinkering with the genetic constitution of humans we risk undermining the ideal of personal autonomy, and destroying the basis for moral equality (2002, part II). Others have defended the claim that inheritable genetic modifications can be seen as crimes against humanity because they alter the essence of humanity itself by taking human evolution into our own hands and directing it toward the development of the post-human (Annas et al., 2002).

Significantly, those who are cheering for the development of the post-human have a similar understanding of the role of genetics in human life. They hope that by using biotechnologies in presumably responsible ways, we will eventually become beings with vastly greater capacities than present human beings. They want to create the opportunity to live much longer and healthier lives, to enhance our memory and intellectual capacities, such as verbal fluency, memory, abstract reasoning, social intelligence, spatial cognition, numerical ability, or musical talent, to refine our emotional experiences and increase our subjective sense of well-being, and generally to achieve a greater degree of control over our own lives (Bostrom, 2003). Some have embraced the possibility of intellects that can read books in seconds (Bostrom, 2003), envisioned brain-to-brain interactions (Hughes, 2004), or conceived of beings whose capacity for rational thought would make non-rational drives superfluous (Hudson, 2000). Others, imagining the possibilities of doubling our cranial capacities to produce super-intelligent beings, are concerned with the need for a correlative widening of women's birth canal so that these post-human babies can be born (Agar, 2004, 16–17). Some argue that, because traits such as intelligence, memory, temperament, patience, empathy, or sense of humor can profoundly affect our lives, we have a moral obligation to enhance our children (Savulescu, 2005, 37).

It is unclear however, why and how tinkering with people's genomes would affect human dignity or human freedom. It is obvious that there are no genes for dignity or freedom. It is also the case that there is no single human genome representative of all humans, given that genetic variation is the norm. Moreover, humans have been directing human evolution by means of environmental and social factors without anybody thinking that such actions constituted crimes against humanity or that they threatened human dignity. Similarly, there is no available scientific evidence supporting the belief that characteristics such as intelligence, memory, abstract reasoning, musical talent, emotional sensitivity, empathy, or even health are determined, controlled, or influenced exclusively, or even mainly by nuclear DNA.

These arguments then rest on the disputable assumption that one's genetic endowments completely determine one's physical, psychological, and intellectual characteristics. It presupposes that a simple correlation between genotype and phenotype exists for what undeniably are very complex human traits. But such an assumption has no scientific basis. It simply ignores that genotypes have a range of

phenotypic expression, overlooks the importance of the environment, and disregards the significance of one's choices in building a unique and distinctive life. It seems that unless we incorrectly assume that our genome completely determines who we will be, then there are no reasons to believe that genetic manipulation by itself would interfere with human dignity or human freedom, or that it will be able to create creatures so smart, talented, sensitive, or imaginative as to make them unrecognizably human or post-human. Contrary to these ideas, the evidence that we have about the feasibility of using genetic engineering to change or influence these or similar characteristics significantly is that human biology is far more complex than it might appear by reading discussions of human genetic enhancement.

Think of a relatively "simple" characteristic such as, for example, being healthier. We have good evidence that most diseases affecting humans are multifactorial (Weiss, 2005; Becker, 2004; Cummings, 2003; Wilkie, 2001; Risch, 2002). Unlike Mendelian diseases, the transmission of these diseases is governed by multiple factors, and familial patterns of inheritance do not follow a strictly Mendelian mode. Alleles contributing to these complex diseases are neither necessary nor sufficient to cause the particular disease; that is, some people might suffer the disease without having the related mutations, and some people might carry the mutations but might not have the disease in question. For many of these complex diseases, more than one gene at different loci contribute to the disease, and those loci might interact with each other. Depending on their roles on the pathogenesis of diseases, these interactions might be additive, multiplicative, or might have no additional effect. Modifier genes can also interact with mutations involved in the production of some diseases. The effects of interaction between an allele that might predispose to a particular disease and a protective allele might be especially difficult to predict with any accuracy. Similarly, epigenetic factors can modify the expression patterns of genes without altering the DNA sequence (Jiang et al., 2004; Dennis, 2003). The expression of most human diseases also involves the relations of multiple genetic and environmental factors. Additionally, cases of incomplete penetrance and variable expressivity introduce even more difficulties in our ability to predict the risks of developing a particular disease and thus of preventing it (Wilkie, 2001; Risch, 2002). The different penetrance of mutations is not entirely an intrinsic character (Veneis et al., 2001). On the contrary, it appears to depend on several factors such as the importance of the function of the protein encoded by the gene, the functional importance of the mutation, the interactions with other genes, the interactions with the environment, the onset of the disease, and the existence of alternative pathways that can substitute for the lost function. What is more, some of these factors can vary between individuals. Things are then not as simple as sometimes they are made to appear. So, making people healthier by tinkering with their DNA does not seem that easy: and, where there is the possibility of doing so, it does not seem that the changes would be significant enough to talk about a different species of post-humans.

Consider another characteristic often mentioned in the debates on human enhancement: longer life spans by slowing the aging process. Presumably, our first concern would be to ask how much longer a human would need to live to become a

post-human. Advances in public health care and in medical technologies have certainly increased average human life spans considerably during the last few centuries (Wilmoth, 2000). These increases, however, have not been taken to mean that we are on the path to becoming post-humans. Thus, it seems that the increase needs to be more significant. Obviously, immortality would be a candidate. Indeed for some (Kass, 2001; Harris, 2004; Fukuyama, 2002) there is a scientific race to achieve human immortality. Such speculations include claims about whether immortality would produce boredom, how it would affect our, already depleted, economic and environmental resources, whether there will be a loss of personal identity, whether it would make people happier, and about the consequences of having parallel populations of mortals and immortals existing alongside one another (Kass, 2001; Harris, 2004, 2000; Fukuyama, 2002; Glannon, 2002). Yet it hardly seems necessary to say that no evidence whatsoever exists that manipulating human DNA can attain such a goal. Also, longer lives filled with the manifestations of old age would hardly be desirable. Thus, those desiring longer lives for humans also desire to slow the aging process. But, there is no empirical evidence to support the claim that aging in humans has been modified by any means, nor is there any evidence that it is possible to measure biological age (Hayflick, 2004; Turner, 2004; Olshansky et al., 2004; Miller, 2002). It appears then that discussions about changing human life spans and aging processes in ways significant enough to create post-humans are no more than wishful thinking (Turner, 2004, 19–21). Nothing in current biological knowledge suggests that genes alone are responsible for controlling these traits.

The misunderstandings about human biology are not limited only to the incorrect assumption that genes control most human traits and behaviors (or at least that they control those traits that we think represent the "essence" of humanity,) and that thus, other aspects of humans' biology, environmental factors, and social arrangements and institutions are irrelevant as causal contributors to such traits or behaviors. Proponents and opponents of genetic enhancement also err by presupposing that our social environment is immaterial as a causal contributor to the judgments about such traits. That is, these arguments commit the error of assuming that our biological traits and behaviors can be evaluated outside of the environmental, social, and political contexts in which such traits and behaviors are expressed. Genetic predispositions have to be expressed as phenotypic traits, i.e., observable physical or behavioral characteristics that result from the interplay of genes and environments, before we can evaluate whether these characteristics are good or bad things. And, many human phenotypic attributes diverge in value according to the social and environmental contexts in which they are expressed. For instance, homosexuality, assuming for the sake of this argument that this is a genetically determined trait, can be very problematic in societies that place great value on the connection between sexual acts and reproduction, but it would be unlikely to raise much concern in social environments where such a connection is irrelevant.

Let us go back to our interest in making "healthier" humans. As the recent debate on obesity indicates the concepts of "heath" and "disease" as applied to humans are far from uncontroversial (Kaplan, 2000, ch. 8; Mokdad et al., 2004; Flegal et al., 2005; Gard, 2005; Oliver, 2005). It is clear, however, that health and

disease cannot be assessed by simply looking at genes, not even at genes in the context of whole organisms. Consider, for example, the case of allergic reactions to a substance that is only present, and in great quantities, in highly industrialized societies. Even if such allergic reactions were mainly determined by having certain genetic material, we would be hard pressed to call this a disease or disorder, indeed, we would be hard pressed to be concerned with it at all were we living in a non-industrial society. Or, take the case of some Italian speakers who have neurological markers for dyslexia, but show no learning impairment, as compared with English-speaking dyslexics who have a much more difficult time learning to read because of the complexity of their language (Paulesu et al., 2001). It seems then, that to evaluate human diseases, disabilities, or disorders and their effects, one must take into account the ecological and social environment in which human beings grow and develop. Human biology is not independent of where we live and how we live. Most human traits and behaviors need to be evaluated in social contexts. Such social contexts are not fixed. They have changed over human history, and there seem to be no reasons to believe that we cannot change them again to pursue worthy moral goals such as, for example, equality or fairness. Judgments about the desirability of traits such as beauty, health, weight, strength, or life span depend on the environmental context in which they are expressed, which in the case of humans includes social and political contexts. If the value of these traits is not determined by the fact that they are genetic traits or behaviors, then to assume that these traits will be valued by future generations as we now value them presupposes that we must believe that the social and political context will not change. Nothing in human history warrants such a belief.

The failure to achieve a balance between a responsibility to contemplate theo-retical possibilities that might result from genetic enhancement, and a responsibility to convey whether such theoretical possibilities would come to be, does not result only from the incorrect conception of the role of genes in the development of human traits. The emphasis on the post-human future betrays the belief, dominant in Western science and philosophy, that the world, and its components, are machines that work in ordered, predictable ways (Dupré, 2001). This belief has extended to include humans who are also modeled as machines with distinct subunits that can be studied and evaluated independently. Our latest concern has been the human genome and its manipulation.

However, much of this discussion on human genetic enhancement and the crea-tion of the post-human neglects the fact that the increasing focus on genes as causes stems from our increasing ability to manipulate DNA in the lab and in some cases in the clinic in an attempt to achieve what are perceived to be desirable ends. Insofar as theory directs action, genetic problems call for genetic, technological, solutions (Gifford, 2002; Gannett, 1997). It is, nonetheless, one thing to say that, for almost any particular human trait, there is a range of genetic influences, as well as a range of environmental influences, which underlie it. It happens to be the case, and for a variety of reasons such as a mechanistic view of the world, research priorities, the presumed intractability of environmental and social factors that we are concentrating on, and in many cases finding, genetic influences. It is quite a different thing, however,

to say that we are trying to find, and in many cases we are finding, the bases of these human traits, and that these bases, it turns out, just happen to be genetic (Han, 2002). If we focus on the genetic influences for traits such as intelligence, sensibility, memory, sympathy, or talent, we will quite likely find them. Of course, this means neither that these are the only influences in the development of such traits nor that they are the most relevant influences (Chakravarti and Little, 2003).

3 Why is this Important?

Failing to achieve a balance between interests in the theoretical possibilities related to genetic enhancement and a responsibility to evaluate the feasibility of those promises is problematic for several reasons. First, it does nothing to promote an informed public dialogue. We are presenting as realities what might be wishful thinking: from immortal beings, to intellects that can read books in seconds, to creatures that can communicate through brain-to-brain interactions, to entities whose moral equality is at stake. It is essential in democratic societies that people be informed about scientific advances. The public should know what current biomedical research can accomplish as well as what is improbable. Overconfidence in the power of science prevents a correct evaluation of the ethical and social implications of biomedical research. It helps nobody, certainly it does not help democratic participation, to have the public and policymakers believing that the genetic enhancement of human beings is a simple endeavor ready to be used in the creation of a new species of post-humans.

Second, discussing the dangers or benefits of a new species of post-humans as if such an event was scientifically and technologically unproblematic might contribute to a possible loss of trust in scientists and the scientific enterprise. Such trust can be threatened when the public perceives that scientists are trying to accomplish what many might see as unjustifiable goals from creating immortals, to building cyborgs, to directing human evolution towards the so-called post-human. And such distrust could in turn encourage the implementation of public policies that might endanger legitimate research programs. Yet trust in science can also be jeopardized by rising expectations that are unlikely to be attained. If people are lead to believe that genetic research is the new panacea, they will not take it kindly when failures occur and hopes are shattered. For example, the very negative public reaction to NASA space research after the accident of the Challenger shuttle might be related to the agency's presentation of space travel as perfectly normal, rather than as an ongoing risky experiment (Dunar and Waring, 1999).

Third, the emphasis on genetic manipulation, whether as a solution to human vulnerabilities or as a threat to human dignity, exaggerates the role of genes in the development of human traits and characteristics and neglects the role of social and environmental influences. Obviously this does not mean that genes are not important; they are, however, not the only important things influencing human beings.

Fourth, because many discussions about the genetic enhancement of human beings are grounded on an incorrect understanding of the role of genes in human biology they help promote genetic determinism. This in turn might contribute to public policies that incorrectly emphasize genetic interventions rather than preventive measures, life style modifications, or transformation of social structures. An erroneous view of the role of genes in human biology might also result in people seeing information about their genetic make up as fate (Senior et al., 1999; Wright et al., 2003). Thus, although life style and institutional changes could improve peoples' well-being, the motivation to do so might be lacking. Moreover, by presenting human traits and behaviors as if they were the result of the exclusive play of our genes, and as completely independent of our social life, we can also miss the opportunity to improve the aspects of our social, political, and legal systems that need to be improved. For example, often the desire to enhance particular traits results from the fact that such an enhanced trait will confer a competitive advantage in our society. Take, for instance, a desire to enhance human height, or, something that is now technologically possible, the desire to choose the sex of a child. The value of these traits is however dependent on our particular social arrangements and not on the fact that height or a particular sex are traits that will increase our well-being in any kind of society that humans can create. Thus, our social arrangements result in presumably unjustifiable disadvantages for people who are short or are female and advantages for people who are tall or are males. It is in this context that we think enhancing this trait or choosing our children's sex would be a good. But if we change our social institutions to address the discrimination against people, then we will have little reason to desire the manipulation of such traits.

If the arguments I have present here are correct, worries or hopes of a post-human future appear to be misplaced. Furthermore, the debate about the risks and benefits of using genetic enhancement to create a new species of post-humans is unlikely to contribute to an informed discussion of these issues or to help further human well-being.

4 Concluding Remarks

The reflection on the theoretical consequences of genetic enhancement has come to be presented as a discussion of whether it is wise for us to proceed with, or whether we have the luxury to prevent, the creation of the post-human. That the post-human – a being whose capacities so greatly exceed current human ones that we cannot recognize it as human anymore – is achievable is not a matter of debate. Scant evidence exists, however, in support of this belief. One of the many difficulties with debates about the creation of post-humans using genetic enhancement is that we are not exactly sure what a post-human would look like. It is obvious that any argument defending or rejecting the creation of these new entities has to presuppose a particular conception of human nature. Those who see human nature as somehow deficient will tend to embrace technologies that can "improve" it. However, those who see

human nature as grounds for human rights, as essentially vulnerable, or as wonderfully fragile, will be inclined to see the possibility of changing these essential character-istics as a danger. In any case, the current debate presumes that unless we pass regulation to prevent it, a post-human future is just around the corner. I have tried to show here that the fears and hopes surrounding the demise of human beings in favor of a new species of post-humans are mistaken. This is so because such fears and hopes are grounded in an inadequate understanding of human biology. Both proponents and critics of genetic enhancement have erroneous presuppositions about the role of genes in human biology. Furthermore, they adopt incorrect beliefs about knowledge production in the biological sciences.

It is obvious that there are a variety of problems that surround many discussions of genetic enhancement. Many of these debates rarely pay attention to issues of what it means to be human, what human nature is, how much we can change human genetics without affecting "human nature," or what it means to be what are called "better humans." My focus here has been only on a different aspect of this debate: the failure to present a balanced view of what might or might not be possible as a result of genetic human enhancement and on the social, political, and ethical consequences of this lopsided debate.

Notice, however, that I have not attempted to deny that genetic technologies might prevent and cure some human diseases or that they might "enhance" some human characteristics. The aim of this chapter has been to point out that at least as far as present biological knowledge indicates, we have no reasons to believe that such genetic manipulations would be such as to give rise to a new species of post-humans. It is surprising that, in spite of current scientific evidence, most of the debate about the presumed consequences – good or bad – of genetic enhancement appears to ignore the complexity of human traits and behaviors. Despite such evidence, discussions of genetic enhancement continue to present genes as the main determinants of human traits, behaviors, or diseases. These discussions often disre-gard relationships between genes, epigenetic effects, the influence of the cellular environment on gene expression, and the effects of environmental and social factors on human biology and on our judgments about the desirability or undesirability of particular traits.

Notice also that my arguments are not a call to cease reflection on the topic of human nature or on the social context that makes the idea of human enhancement a reasonable scientific goal. Neither am I proposing that we stop thinking and dis-cussing about whether, and if so how, our attempts to control human nature by means of genetic enhancement might affect human self-understanding. On the con-trary, I believe that such reflections are badly needed if for no other reason than that they can be very useful in helping us to decide what kind of technologies we want by analyzing the kind of society that we want to construct.

It is in everybody's interest to encourage thoughtful and informed evaluations of the ethical, legal, and social implications of new biomedical research and technologies. Conceptual issues, ethical principles, and political and social practices must be taken into account in performing such analyses. But equally important for many of these discussions is an adequate depiction of the power of scientific

research and a reasonable portrayal of the possibilities of human genetic enhancement. Paying careful attention to current research in human genetics and cell biology shows that many of the alleged urgent concerns about a post-human future seem to be misplaced.

References

Agar, N., 2004, *Liberal Eugenics*, Blackwell, Malden, MA.
Annas, G., Andrews, L., and Isasi, R., 2002, Protecting the endangered human: toward an international treaty prohibiting cloning and inheritable alterations, *Am. J. Law Med.* 28(2–3):151–178.
Becker, K. G., 2004, The common variants/multiple disease hypothesis of common complex genetic disorders, *Med. Hypo.* 62(2):309–317.
Bostrom, N., 2003, Human genetic enhancement: a transhumanist perspective, *J. Val. Inq.* 37(4):493–506.
Chakravarti, A., and Little, P., 2003, Nature, nurture and human disease, *Nature* 421(6921):412–414.
Cummings, M., 2003, *Human Heredity*, 6th ed., Thomson Learning, Pacific Grove, CA.
Dennis, C., 2003, Epigenetics and disease: altered states, *Nature* 421(6924):686–689.
Dunar, A., and Waring, S., 1999, *Power to Explore*, NASA History Office, Washington, DC, 1999.
Dupré, J., 2001, *Human Nature and the Limits of Science*, Oxford University Press, New York.
Flegal, K. M., Graubard, B. I., Williamson, D. F., and Gail, M. H., 2005, Excess Deaths Associated With Underweight, Overweight, and Obesity, *JAMA* 293(15):1861–1867.
Fukuyama, F., 2002, *Our Posthuman Future: Consequences of the Biotechnology Revolution*, Farrar, Straus and Giroux, New York, NY.
Gannett, L., 1997, Tractable genes, entrenched social structures, *Biol. and Phil.* 12(3):403–419.
Gard, M., 2005, *The Obesity Epidemic; Science, Morality and Ideology*, Routledge, New York.
Gifford, F., 2002, Understanding genetic causation and its implications for ethical issues in human genetics, in: *Mutating Concepts, Evolving Disciplines: Genetics, Medicine, and Society*, R. Ankeny and L. Parker, eds., Kluwer Academic Publishers, Dordrecht, pp. 109–125.
Glannon, W., 2002, Identity, prudential concern, and extended lives, *Bioethics* 16(3):266–283.
Habermas, J., 2003, *The Future of Human Nature*, Polity, Cambridge, UK.
Han, P. K. J., 2002, Conceptual and moral problems of genetic and non-genetic preventive interventions, in: *Mutating Concepts, Evolving Disciplines: Genetics, Medicine, and Society*, R. Ankeny and L. Parker, eds., Kluwer Academic Publishers, Dordrecht, pp. 265–286.
Harris, J., 2000, Essays on science and society: Intimations of immortality, *Science* 288(5463):59.
Harris, J., 2004, Immortal ethics, *Ann. N.Y. Acad. Sci.* 1019:527–34.
Hayflick, L., 2004, Anti-aging' is an oxymoron," *J. Gero. A Biol. Sci. Med. Sci.* 59(6): B573–578.
Hudson, J., 2000, What kinds of people should we create? *J. Appl. Phil.* 17(2):131–143.
Hughes, J., 2004, *Citizen Cyborg*, Westview Press, New York.
Jiang, Y. H., Bressler, J., and Beaudet, A. L., 2004, Epigenetics and human disease, *Annu. Rev. Geno. Hum. Gen.* 5:479–510.
Kaplan, J., 2000, *The Limits and Lies of Human Genetic Research*, Routledge, New York.
Kass, L., 2003, *Beyond Therapy: Biotechnology and the Pursuit of Happiness*, HarperCollins, New York.
Kass, L. R., 2001, L'Chaim and its limits: why not immortality? *First Things* 113:17–24.
Miller, R. I., 2002, Extending life: scientific prospects and political obstacles, *Milb. Q.* 80(1):155–174.

Mokdad, A. H., Marks, J. S., Stroup, D. F., and Gerberding, J, L., 2004, Actual causes of death in the United States, 2000, *JAMA*. **291**(10):1238–1245.

Oliver, J. E., 2005, *Fat Politics: The Real Story Behind America's Obesity Epidemic*, Oxford University Press, New York.

Olshansky, S. J., Hayflick, L., and Perls, T., 2004, Anti-aging medicine: the hype and the reality—part II, *J. Gero. A Biol. Sci. Med. Sci.* **59**(7):649–651.

Parens, E., 2004, Genetic differences and human identities. On why talking about behavioral genetics is important and difficult, *Hast. Cent. Repo.* **34**(1):S4–35.

Paulesu, E., et al., 2001, Dyslexia: cultural diversity and biological unity, *Science* **291**(5511):2165–2167.

Risch, N., 2002, Searching for genetic determinants in the new millennium, *Nature* **405**(6788):847–856.

Savulescu, J., 2005, New breeds of humans: the moral obligation to enhance, *Repr. Biom. Onli.* **10**(1):S36–9.

Senior, V., Marteau, T. M., and Peters, T. J., 1999, Will genetic testing for predisposition for disease result in fatalism? A qualitative study of parents' responses to neonatal screening for familial hypercholesterolaemia, *Social Sci. Med.* **48**(12):1857–1860.

Silver, L., 1997, *Remaking Eden How Genetic Engineering and Cloning Will Transform the American Family*, Avon Books, New York.

Sock, G., 2002, *Redesigning Humans: Our Inevitable Genetic Future*, Houghton Mifflin, Boston, MA.

Turner, L., 2004, Biotechnology, bioethics, and anti-aging interventions, *Trends Biotech.* **22**(5):210–221.

Vineis, P., Schulte, P., and McMichael, A.J., 2001, Misconceptions about the use of genetic tests in populations, *Lancet* **357**(9257):709–712.

Weiss, K. M., 2005, Cryptic causation of human disease: reading between the (germ) lines, *Trends Genet.* **21**(2):82–88.

Wilkie, A., 2001, Genetic prediction: what are the limits?, *Stud. Hist. Phil. Biol. Biom. Sci.* **32**(4):619–633.

Wilmoth, J. R., 2000, Demography of longevity: past, present, and future trends, *Exp Gero.* **35**(9–10):1111–1129.

Wright, A. J., Weinman, J., and Marteau, T. M., 2003, The impact of learning of a genetic predisposition to nicotine dependence: an analogue study, *Toba. Cont.* **12**(2):227–230.

Redesigning Man?

C. T. A. Schmidt

Abstract In speaking of ideas at the intersection of transhumanism, advanced robotics, and related fields, I wish to provide a few theoretical elements necessary for addressing questions like "Should we redesign humans?" While some find such a question somewhat out of place, others seriously think of alternatives to their present ways of life, even if they do not intend to take action. To fathom the extent of inquiry into alternatives, one must simply look to the strength of the human imagination – the various dreams it allows as well as our flirting with futuristic scenarios in popular books and films. It seems that some specialists of the human brain and body wish to bring scenarios of various human forms of being to life. It can be difficult though to accept novelties when it comes to modifying standard human heritage, no matter how similar it may be to our present state. My goal herein is not to provide a panorama of technical endeavours but to up-date the key concepts (originating in Computer Science and related fields) necessary in treating question of the said kind.

According to S. L. Esquith (2005), we must keep ethics in mind when considering the cultural significance of particular technologies. In other words, we must check the effect technologies have on our everyday cultures when we take action against some of them or confirm their soundness. To support his view, Esquith cites Sherry Turkle's (1997) "Seeing Through Computers: Education in a Culture of Simulation": "We make our technologies, our objects, but then the objects of our lives shape us in turn. Our new objects have scintillating, pulsating surfaces; they invite playful exploration; they are dynamic, seductive, and elusive. They encourage us to move away from reductive analysis as a model of understanding. It is not clear what we are becoming when we look upon them – or that we yet know how to see through them".

I intend to relate questions on simulations and enhancements, both corporal and cognitive, to our relation with technology and study it from a logical point of view, one which takes the relation to be a separate dynamic entity at the helm of change. Though

C. T. A. Schmidt, Le Mans University

P. E. Vermaas et al. (eds.), *Philosophy and Design.*
© Springer 2008

this topic cannot be fully treated here, such a relation may provide sufficient grounds to apprehend what must be considered when deciding whether or not the concept of biodiversity, as it is used by the media today, should be applied to humans.

1 Presuppositions to a Categorisation Problem

The advent of powerful computers is enabling society to formulate 'different' questions that concern an average person's life directly. These entail questions about the world in which we live and our perception of it. The appearance of highly intelligent machinery on the market, and to some extent in our homes, has provided the humanities with a whole new ballpark in which to play. Due to the exponential rise of calculation strength in machinery, the answer to the question in the title of this chapter progresses from a mere yes or no to a full-blown philosophical description of the ambitions of intelligent robotics, evolutionary computation, and medical transformations of humans. Many musings and responses to this question are now available, as humanization of fully non-human entities (computing machinery) has become commonplace as has the personification of these entities.

It would seem that computers, the tool for everything computational, are in some sort of neutral area or "buffer zone" between Man and object. Some would say that computers are not just ordinary objects: one may ascribe emotion to them, lend them desires and beliefs, make them speak or translate, increase their learning capabilities, give them bodily functions, make them play games with us, have them help us learn, use them to help children or the ill to express themselves, and so the list goes on. Yet the average person would say they are, nonetheless, non-persons. But can we really leave computers in the same category as the everyday chair, spoon, or wooden block? Are computers simply another artifact if they can do so much? The fact that the issues are not clear in the minds of most scientists, especially those working in Artificial Life and Intelligence, shows that a definitional problem has arisen out of the research in these highly related fields, and that the title of this chapter represents a mere preliminary question to a more in-depth inquiry into the nature of the relation between humans and machines.

Let us look back at the two original entities (man and object) as they existed before computers came to be some sixty years ago. If one juxtaposes Man and Object and express them in a linear way as we do in English (i.e., man|object), there are more interesting things to say of such a system as time goes on. For instance: Could one say they are being merged? Is there an answer to such a question?

Let me sum up the difficulty over the initial question set forth. The growing relationship between two entities, Man and Technical Object, raises further questions, especially about computers. The following are amongst the many questions asked. If computers are not human, what are they? 1. If one says that computers are non-persons, does this mean they are just ordinary objects? If so, the observer would have to modify his definition of what an ordinary object is, especially in the light of the "living characteristics" computers display in the explosive worlds of multimedia

and robotics. 2. If a computer is not just an ordinary object, what is it? 3. If we cannot clearly answer this second question, what should we do? 4. Splitting the Man-Object continuum into three categories Man-Computer-Object could be a solution, but this would mean that a computer is not an object. Is it entirely plausible to make this statement? Some machines, due to their form and behavior, look more human than others. How many categories would we need?

In this context, one could even say that computers are object *and* human, but this would entail the existence or creation of an overriding ontological category to Man which we as humans may not be willing to accept; it could also be interpreted as introducing foreign elements into our definition of humans. Some might say that computers 'create' modern Man as they give those that were not previously particularly efficient or creative the power to be so. If one were to accept this last line of thought, one may have difficulty explaining why modern computers are not gods or at least superior to Man. All in all, the new phenomena observed in our information society may force our cognitive values to change. It is therefore time to equip ourselves for addressing these issues.

2 Computers, Continuums, and the New

The four questions above arise out of a practical problem that concerns the public at large in the new Communication Era, Knowledge Community or Information Age and brings us to the question of why it is not possible to establish steadfast boundaries for ordinary objects or things, and why it is necessary to renew essential categories from time to time. So if we were to split the Man-Object continuum into three categories Man-Computer-Object it would create a definitional working space for those working on the notion of computer, and keep the human and object definitions "safe" from this enquiry. Or would it? The very fact that we are considering establishing a 'central category' would imply that we consider reducing the maneuvering space within the categories of Man and Object. To create the computer category, one would have to accept a reduction of the human category. But then again, some of those who would isolate intelligent machinery in its own category take such a reduction for granted as their main goal is to preserve the essential qualities and character of the present definition of Man. This would not impede our enquiring into the central category.

If we were to take the example of a very sophisticated computer that is able to see what its user was doing, to sense when he is in difficulty, to understand intuitively the intentions the user has, to hold similar beliefs to man and be able to speak, this would help us to see that it is very difficult to reduce the notion of machines and robots down to mere objects, especially if one is projecting into the future. I believe that man will be able build a human-like machine that will fool many into thinking it is human; I also firmly believe that man will be (or is) able to modify himself to a point that some would say he is no longer human. I am speaking both about advanced humanoid robotics and transhumanism without wishing to discuss

why we should or should not accept new forms of life similar to our present state or those that deviate from it. All I wish to do is to firmly ground the question: "Should we redesign Man?" by, hopefully, providing the key elements required to discussing these increasingly important matters. Besides, rules, maxims or other rigid devices of science have never made final decisions a congenial experience to live with for everyone. In contrast, proper terminological foundations help us to make sense of decisions, whether we accept them or not.

3 Two Techniques for Human Modification

There are basically two approaches that can be used for modifying artificially the human species. The evolutionary process has changed and possible further diversification of it may come about especially if humans play a role in guiding evolution. The two approaches can be separated by their starting points. The robotics-based approach generally uses many components that are mechanical in nature, i.e., traditional hardware, though there is a growing tendency to accept organic elements into these constructions. The reasons for using organic materials in the robotics sphere of intervention are various: they are less costly, increase functionality, render the resulting "machine" more lifelike, are less harmful to the environment, and provide jobs for local workforces. The transhumanist approach begins by rebuilding man using one single, very familiar component, the human body. The idea is to use technological advances to modify the body or brain to create a desired effect. This could entail introducing various entities into the body for a variety of reasons: molecules (e.g., using metabolic control for 'slimming', or anti-ageing medicine to stay young or live long), electronic chips (e.g., in the brain to help one understand better or remember more, or in the eyes to improve sight), and bionics (e.g., for increased power).

Perhaps a minor detail would be the difference between implants and transplants. The former generally take the current state of the individual to a greater capacity – picture the average person having Steve Austin's bionic ability to lift and throw heavy objects! The latter aims at bringing one back to a state that has been lost – for example, an elderly person having a hip replacement. The only similarity between the two is that they both augment the person's present state.

Let us go back to the robotics versus transhumanism distinction. Although different, it is important to point out that there are similarities: for both approaches, it is the desired effect that leads to the design of a new being, which means there is a certain willfulness driving us to create a new world. I do not think this drive is new, it is just the techniques that can be used that may surprise people. Change is a concept familiar to us, we are, after all, part of the world's evolutionary cycle.

But it would seem that this short-term aspect of evolution is mainly behavior-based, thus there will be limited change to the identity of what it means to be human. The concept of being human entails a highly social element and a cultural

element: one cannot change the relationships members of society enjoy or detest by modifying the individual bodies of these members. That said, sustained corporal change over time could certainly have an effect on relations in society.

3.1 Difference and the Concept of Man

The concept of Man could of course change, but to what extent? Perhaps the thing that society is calling out for here is a concept of humans that is more material in nature when compared to the current idea of what it is to be human. The belief that we could/should/must modify our own physical existence may mean that the immaterial – social, psychological, cultural, and spiritual – aspects of our lives have become less important to us. Would such a statement be too simplistic or is it part of our new reality? Those working in advanced Artificial Intelligence, Cognitive Robotics, Neuro-evolution, and transhumanistic technologies generally do not delve into the intricate questions of love, faith or respect for others in society, all of which are of direct concern in the human immaterial sphere. These specialists are currently not supposed to be intimately concerned with such matters. One could nevertheless be very mistaken in saying that these matters are not on scientists' agendas. How can they ever hope to do better than man if they cannot copy certain facets of humans? We can conclude for the time being that the concept of being human today means being more physically human than 100 years ago.

3.2 Relation and the Concept of Man

So the concept of Man has evolved. Does this have an effect on related concepts? The concepts of Nature and Artifact need to be explored here. The fact that we accept tampering with Mother Nature's "products" today is not new but the application of such techniques to our own physical and cognitive capacities has increased exponentially. However, we could only say that our relation to nature has been altered slightly. What is important to ask is why this change suddenly becomes necessary and what our new relation with nature means to us in the future.

As for the concept of artifact, the shift seems to be more radical. The tie between Man and being man-made has been strengthened in the consciousness of members of society, perhaps paradoxically. Take the common notion of the "self-made man." A "self-made man" referred to self-assurance, aspirations, intellectual stamina, and other characteristics that are part of the purely psychological composition of an individual, whereas now we are able to apply this notion to his physical composition as well. If one prefers lesser-alarming examples, one could examine the simple layman's understanding of the use of steroids in sports: first they were used practically, then their use was considered to be cheating, and now they are deadly substances.

This shift has happened over a relatively short period of time whilst the effects of their use have remained stable. Will our judgment on what can and what cannot be considered an artifact also be affected this rapidly?

3.3 Identity and the Concept of Man

If human modification becomes common, what will this mean for the identity of man in the ecosystem? The fact that man would have the opportunity to change the very concept of himself in this manner, and that this would have a real effect on man's surroundings proves that homo sapiens can control its "conceptual environment" and that the techniques discussed here would be a mere side effect of his existence, i.e., other techniques could be used to sustain the developments sought. This would mean that individuals really would have obtained an overwhelming level of power *vis-à-vis* their past and *vis-à-vis* their counterparts.

4 Shouldn't We be Against Greater Human Diversity?

In the hypothetical situation just described, the weaker are bound to suffer more. Is this the type of *homo sapiens* we wish to become?

The identity of others would be heavily affected in such a world. The identity of the "improved" self would be equated with a very heady position – practically Godhood. But today, we do have the opportunity to apply this ill-formed logic to our lives ourselves.

So, should biodiversity include the redesign of man? As I said, the key to strengthening the argument against modifying Man requires practical ideas on how and why we should not indulge in such modifications. Many are modifying man by eugenics, implants, etc., though perhaps not to the point of becoming cyborgs. (For an exception which may not yet prove the rule, see the chapter by Daniela Cerqui and Kevin Warwick in this volume).

The way in which they, the artificial or modified beings, would seem different from the average human today is in the values they would, conceivably, be able to share and apply; because of the hypothetical differences we can imagine between the (traditional) human values of original men and non-organic modified persons, one might not wish to see the latter caring for one's children or for the elderly. One may have difficulty trusting the moral judgments of a non-natural neighbor or artificial person.

The practical arguments supporting the view that bio-diversity should not include the redesign of Man would entail, among other things, avoiding simulation in all its forms. This claim about simulation could be presented as generic advice, with negotiations for special cases determined by some other set of criteria. The important aspect here is the urgency of the question as, in light of the suggestions made by Turkle cited above, simulations are changing our vision of ourselves and of our world today.

5 Some Reasons for Considering Greater Human Diversity

Those supporting the view that bio-diversity should include redesigning humans have to develop strategies to further their cause because Man would be an 'artifactual object' if remodeled in the ways discussed above. Those that wish to promote the vision of a widened biodiversity in which *homo sapiens* would be one of the species implicated will either have to directly modify the moral position of humans in the world or show the strategic advantages to becoming robotic individuals, transhuman, or posthuman, and this may help people re-examine their traditional values.

Looking at the transhumanist movement shows that the values put forth, whether one sees them to be acceptable or not, are done so within the framework that includes as conditions the following: Global Security, Technological Progress, Wide Access (see Bostrom (2005, 13)). Any sensible being shares these conditions and would like to have them protected, which means that in starting to change society in the way they see fit, the movement is not so off-tilt as some might say. The problem is the transhumanist movement sees nothing wrong with tampering with nature, using technology to extend lives and promoting libertarianism. Have we not been tampering with nature for a long time, i.e., controlling animal numbers, abortion, and exterminating unwanted entities? Although this does not alone justify greater human diversity, it shows that Man has always had the tendency to "diversify" in one way or another.

Accepting such a change would be a strategic move if it were used to unite people. Allowing only weaker members of society to better themselves would enable them to gain back their dignity. But would creating laws prohibiting naturally endowed persons access to such modifications be unfair? It is clear that if the biodiversity of man is to be accepted by the average citizen, any discourse on the matter will have to be situated at the level of this type of proposition.

When one considers the argumentation necessary to change things, it is tempting to say that the physical aspects of human life are quite malleable in comparison to its non-manifest "components". Bostrom[1] gives us an indication of the tools we would need to change the mindsets of those opposed to these practices. He suggests that the necessary ideals we will need are to be found outside of our *bios*. We must therefore act on our *logos* to better fathom the advent of change, to better "calculate" it. It is only if we focus on human reason that we will be able to accept our own redesign.

To relate this last comment to the machine-based approach, it can be said that the machine may have another type of corporal existence than Man does, but the *logos* is the same: Man's. If and when the intelligent robotics approach obtains an

[1] "The realm of posthuman values does not entail that we should forego our current values. The posthuman values can be our current values, albeit ones that we have not yet clearly comprehended. Transhumanism does not require us to say that we should favor posthuman beings or human beings, but that the right of way of favoring human beings is by enabling us to realize our ideals better and that some of our ideals may well be located outside the space of modes of being that are accessible to us with our current biological constitution". Cf. Bostrom (2005, 8).

independent capacity to reason, in the human sense, the categorization problem will have to be treated more thoroughly.

The reader may find that I have failed to transcend the practical aspects of modifying man correctly to develop sound arguments for expanding human diversity. However, pulling one way or another was not the goal here. This discussion reminds me of Paul Ricœur's stance on the impossible adjustment between our finite body and our infinitely open capacity for reason: although the two levels of discourse are complementary, their refusal to blend is what leads to our mistakes and miscalculations and renders the whole process of decision-making fallible. But I do hope to have provided the elements that are essential for engaging dialogue on these matters.

References

Bostrom, N., 2005, Transhumanist values, *J. of Phil. Res.*, Special Supplement on 'Ethical Issues for the Twenty-First Century', The Philosophy Documentation Centre. Charlottesville, VA, pp. 3–14.

Brooks, R., 2002, *Robot: The Future of Flesh and Machines*, Penguin Press, London.

Changeux, J.-P., and Ricœur, P., 1998, *La Nature et le Règle: Ce qui Nous Fait Penser*, Odile Jacob, Paris.

Droit, R.-P., 2005, Dialoguer avec tous, et d'abord avec soi, dossier 'Disparition: Paul Ricœur, philosophe de tous les dialogues', *Le Monde*, 22–23 May (Paul Ricœur died on the 20th of May).

Esquith, S., 2005, Technology and democratic political education: simulation vs. re-enactment, Society for Philosophy and Technology, *The American Philosophical Association, Central Division Meeting*, April 27–30, 2005, Chicago, Illinois.

Quine, W.V.O., 1960, *Word & Object*, MIT Press, Cambridge, MA.

Schmidt, C.T.A., 2006, Machinery, intelligence and our intentionality: grounds for establishing paradoxical discourses, in Special Issue of *Cognition, Communication, Co-operation* (TripleC), G. Dodig-Crnkovic and S. Stuart, eds., *Open Access Online Journal for the Foundations of Information Science* 4(2):195–201, *http://triplec.uti.at/files/tripleC4(2)_Schmidt.pdf*

Schmidt, C.T.A., 2005, Of robots and believing, *Minds and Machines* 15(2):195–205.

Schmidt, C.T.A., 2005, Robots, IPR and us, Society for Philosophy and Technology, *The American Philosophical Association, Central Division Meeting*, April 27–30, 2005, Chicago, Illinois.

Turing, A., 1950, Computing machinery and intelligence, *Mind* LIX(236):433–460.

Turkle, S., 1997, Seeing through computers: education in a culture of simulation, *The American Prospect* 8(31), on-line journal.

Design: Structure, Process, and Function

A Systems Methodology Perspective

Kristo Miettinen

1 Introduction

Systems methodology comprises approaches to systems analysis on the one hand, and systems engineering on the other. Systems analysis develops an understanding of a system, its elements, and its environment that describes their functional, structural, and behavioral aspects. Systems engineering transforms operational user needs into system architectures, performance and functional requirements for system elements, and internal and external interface definitions. The common element of both systems analysis and systems engineering is design.

Design in systems methodology is the combination of two interactive loops, one addressing the relationship of the design object to its environment, the other addressing the relationship of the design object to its parts. For systems analysis, e.g., the medical science of physiology, these loops consider structure, function, and process in the context of environment to develop information (what), knowledge (how), and understanding (why) of the system and elements being studied.

This chapter presents the interactive loops of the design process in systems engineering, and explains the use of analogous interactive loops in systems analysis, considering Harvey's analysis of the function of the human heart and Cold War analysis of Soviet national missile defenses. The core systems analysis insights of Singer, Churchman, Ackoff, and Gharajedaghi are adapted into an exposition that accurately describes both the pioneering scientific work of Harvey and the modern pragmatic work of Cold War military intelligence analysts.

2 Definitions of System, Function, Purpose

2.1 Definitions of "System"

The analysis of design in systems methodology leans heavily on the modern notion of a system, especially the definitions of Bertalanffy and Ackoff.

K. Miettinen, ITT Industries Space Systems Division, Rochester, NY.

P. E. Vermaas et al. (eds.), *Philosophy and Design.*
© Springer 2008

Bertalanffy (1969, 55–56): "A system can be defined as a set of elements standing in interrelations. Interrelation means that elements, p, stand in relations, R, so that the behavior of an element p in R is different from its behavior in another relation, R'. If the behaviors in R and R' are not different, there is no interaction, and the elements behave independently with respect to the relations R and R'."

Ackoff (1981, 15–16; see also 1972; 1974): "A system is a set of two or more elements that satisfies the following three conditions. [1] The behavior of each element has an effect on the behavior of the whole. ... [2] The behavior of the elements and their effects on the whole are interdependent. ... the way each element behaves and the way it affects the whole depends on how at least one other element behaves. ... [3] However subgroups of the elements are formed, each has an effect on the behavior of the whole and none has an independent effect on it."

Ackoff concludes from his definition that every element of a system has essential properties that belong to it only by virtue of its being an element in the system, and also that every system has essential properties that belong to none of its elements individually or in aggregation. Systems analysis exploits these two conclusions to locate function among the essential properties of an element that it has only in virtue of its being in a system, and to locate the purpose being served by a function among the essential properties of the system that belong to none of its elements. These are critical razors for winnowing candidate functions and candidate purposes.

Ackoff's and Bertalanffy's definitions are compatible, but Ackoff's definition avoids explicitly introducing the relations R as explaining differences in behavior of p, leaving the behaviors unexplained. This leads explicitly to that abandonment of reductionism that is characteristic of systems thinking. Bertalanffy's definition is important for illuminating why it is that systems have the kinds of irreducibility that are made implicit in Ackoff's definition: it is the relations of the elements to the system and to one another that give the elements their system-dependent properties on the one hand, and the system its emergent properties on the other. In a nested system-of-systems, Bertalanffy's definition helps to explain what Ackoff's definition describes, particularly the distinction between functions and purposes.

2.2 Distinguishing Function from Purpose

Functions are not arbitrary properties of system elements; they must be among those properties that are essential to the element, in light of the definition of a system (interdependence of behaviors of system and elements). This distinguishes the pumping of a heart in a cardiovascular system from its audible thumping.

Similarly, the ends served by the functions of the elements, i.e., the purposes of the system, are among those properties of the whole system that are essential to the system. For instance, if a function of the heart in the cardiovascular system is to pump blood, and circulation of blood is the purpose served by that function, then this entails that circulation of blood is an emergent property of the cardiovascular

system, that the heart is an element of that system, and that the heart does not pump blood apart from its belonging to the cardiovascular system.

Functions and purposes are separated by one hierarchical layer in a nested system-of-systems, but purposes at one level are not the same as functions at the next, except by coincidence. So, for instance, that a function of the heart is to pump blood, and that circulation of blood is a purpose of the cardiovascular system, does not entail that pumping blood is a purpose of the heart (i.e., an end served by functions of the heart chambers or cardiac valves), nor does it entail that circulating blood is a function of the cardiovascular system in the human organism, although both hypotheses are, in practice, reliable starting points for iterative analysis.

3 Design in Systems Engineering

3.1 "Design" as a Verb

"Design" as a verb is a rational or economic act of requirements transformation. In systems engineering, requirements are transformed through many stages: from user requirements to system operational requirements through conceptual design, from system operational requirements to element functional requirements through preliminary design, and from element functional requirements to production requirements (specifications, schematics etc.) through detailed design. This process, the concatenation of conceptual design, preliminary design, and detailed design, is shown below in figure 1 (adapted from Blanchard and Fabrycky (1981), MIL-STD-499B (1994), and IEEE Std 1220 (1998)).

The process of engineering design develops efficient applications of resources to satisfy needs. The economic or rational aspect of design, combined with inherent functional allocation in design, distinguishes designs from other arrangements of parts for a collective purpose by a technologically relativistic analogue to Weinberg's criterion of elegance, the economy of means to an end so that nothing is invoked other than what is functionally justified (Weinberg, 1992, 135).

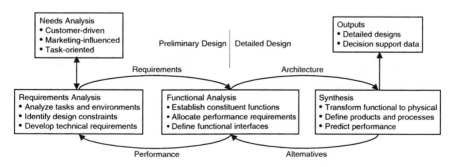

Fig. 1 Design process in systems engineering

The outputs of engineering design are product and production specifications in sufficient detail to eliminate interpretation, variation, or artistic inspiration in the production process. Design results in detailed procedures for processes, detailed algorithms for software, and detailed blueprints for manufacture, without addressing those aspects of production that can be accepted by the engineer as known technique or established art (Aristotelian *technikos*).

Requirements transformation in design is inherently risky: requirements interpreted from one perspective to another cannot be analytically guaranteed to close, e.g., having the elements each meeting their functional requirements in preliminary design does not logically guarantee that the system will meet its operational requirements, etc. This is because requirements transformations are both hierarchical and interpretive: the requirements at each level are expressed in terms natural to the perspective of that level. User needs are expressed in the user's terms with the user's measures of effectiveness, system operational requirements are expressed at the system level, element functional requirements are expressed in discipline-specific functional terms (e.g., electrical, mechanical, control), schematics are expressed in manufacturing and materials terms, etc.

3.2 "Design" as a Noun

In keeping with the definition of designing as an inherently rational or economic activity, "design" as a noun is the rationale, i.e., cognitive analytic basis, for the requirements transformations inherent or implicit in, expressed or embodied in, or imputed to the structural, functional, and process relationships between the system, its environment, and its parts or elements.

"Design" as a noun is not the outcome of "design" as a verb; schematics and specifications are not designs but rather the façades of design, i.e., the interface from design to production, a summary of design sufficient for production. That there is more to a design than is captured in schematics and specifications is evident when designs are protected as proprietary, or delivered from a vendor to a customer in cases of contracting design, or archived for future use. What is included in an archived design, or in a design delivered under a standard contract, or is protected as proprietary when safeguarding designs, includes performance analyses, trade studies, and the development of those alternative system concepts that were evaluated but not, in the end, chosen for production (DAU 2000). In any of these cases what is included in the object called a "design" is the entire rationale for the requirements transformations specified in the design process.

Complementing the distinction between the noun "design" and the products of the activity called "design" is the distinction between comprehending the design of something, e.g., the human heart, and inferring the prior occurrence of an act of design; to acknowledge the design of something is only to judge that the relationships between elements and their capabilities at successive hierarchical levels of nested systems are rational or economical. The rationality of design is an analytical rationality rather than an etiological rationality.

This description of design and designing applies equally to problems of designing simple and complex systems, with the principal distinction being that for systems requiring a great deal of novelty and innovation the process may be nested: what appears to be an element of a system in the design process outlined above may be an un-designed system in its own right, so that specifying its element-level requirements in preliminary design of the super-system may be identical to specifying its operational level requirements in conceptual design of the subsystem.

4 Design in Systems Analysis

4.1 Analogy of Engineering and Analysis

Design in systems methodology is the combination of two interactive loops, one addressing the relationship of the design object to its environment, the other addressing the relationship of the design object to its parts. In systems engineering, the two loops are called preliminary design and detailed design, while in systems analysis they are called expansion and reduction. Viewed from the perspective of an arbitrary element Y_b, a functionally specified constituent of a system X, preliminary design of X and expansion of Y_b both determine the function of Y_b as a contribution to the comprising whole X, while detailed design of X and reduction of Y_b determine the structure of Y_b and how it works.

The relationship between the systems engineering design of X and the systems analysis of one of its elements Y_b is illustrated in figure 2 above for a system X consisting of elements Y_i, each of which in turn consists of sub-elements Z_{ij}. In figure 2, the nesting can continue indefinitely in both directions: X can be an element of some other larger comprising super-system W, and each Z_{ij} can in turn be an object of either design or analysis, so that the preliminary design of X may also be part of the detailed design of W, and the detailed design of X may comprise the preliminary designs of the Y_i and the conceptual designs of the Z_{ij}.

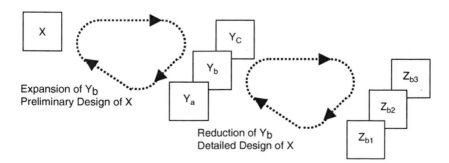

Fig. 2 Nested design loops of systems methodology

Figure 2 offers an opportunity to distinguish functions from purposes using Bertalanffy's definition of system. Consider the relations R_{zb} found among the elements Z_{bj} in the reduction of Y_b, and the relations R_y found among the elements Y_i in the expansion of Y_b. The functions of the elements Z_{bj} serve purposes inherent in Y_b, and the function of Y_b serves a purpose inherent in X. The question to consider is whether the function of Y_b and the purposes inherent in Y_b are identical. Systems analysis answers no, except by coincidence, because the function of Y_b is among those properties that Y_b has in virtue of relations R_y rather than any alternative R'_y, while the purposes inherent in Y_b are among those properties that Y_b has in virtue of relations R_{zb} rather than any alternative R'_{zb}. The function of Y_b and the purposes inherent in Y_b are both at the same hierarchical level, i.e., they are both in Y_b, but they are determined by distinct relations R_y and R_{zb} at adjacent hierarchical levels, and therefore they are not identical, though they may correspond to one another.

4.2 Difference on Function Between Systems Engineering and Analysis

An important difference between design as implemented in systems engineering and as rationalized in systems analysis is in the peripheral role of the concept of function in the former, and its central role in the latter. The difference stems from the difference in relationship between the engineer and his system on the one hand, and the analyst and the object of her inquiry on the other.

The engineer works from concrete customer needs, and is concerned to transform these needs into verifiable requirements at the system and subsystem levels. To the engineer, functional analysis is only a means to requirements, which latter are quantifiable, testable, and verifiable. Once functional requirements are set, they are specific to elements, and compliance can be judged independently.

The analyst works from a concrete system, and is concerned with developing information, knowledge, and understanding. For the analyst, her objectives are descriptive, relative, and functional rather than imperative, absolute, and normative. Functional descriptions are interdependent and relational, and are developed jointly for ensembles of elements.

The relevance of the distinction is illustrated by failure analysis of a system. If the external inputs to the system all conform to specifications, but some external outputs of the system are nonconforming, then the system is a suitable object for failure analysis, in which the analyst, either the designer of the system or a systems analyst, attempts to analyze the failure, attributing failure either to an element of the system or to the system as a whole.

For the design engineer, any element whose output is not in specification while its inputs are all within specifications is nonconforming, regardless of function. Specifications on a system or an element are contingent on inputs, so

that an element with nonconforming outputs may be excused if an input is nonconforming. The performance of each element is evaluated against its specifications in isolation. It is possible for all elements of a failing system to be excused on the basis of nonconforming inputs from other elements, e.g., in any case with nonconforming feedback, in which case the failure must be attributed to the system as a whole.

This requirements focus of the design engineer is in sharp contrast to the functional analysis of the systems analyst, who has no prior way of discriminating whether an element has a nonconforming input, or is failing to perform as it should in the context of its input, unless functional ascriptions can be made to the elements and rational requirements inferred from the functions and available means. The systems analyst only makes progress via comprehension of the function of the elements. To the systems analyst, functional description, rather than quantitative specification, is fundamental to analysis of design.

4.3 Structure, Function, and Process

As summarized by Gharajedaghi (1999, 112–113), the design approach to systems analysis iteratively examines structure, function, and process to develop understanding in terms of design. Iteration is necessary because, in the systems approach, process and structure co-produce function in the context of environment. Inquiry then becomes necessarily iterative because structure, function, and process are each co-produced by the others, as well as co-producing each other, so that developing a new understanding of each modifies the understanding of the others in a converging sequence of mutual dependence.

The producer/product relationship is Singer's framework for explanation in the world of complex objects without sufficient causation. In Singer's framework, producers are necessary but not sufficient for their products, in the manner of acorns being necessary but not sufficient for oak trees. Singer (1924; 1959) uses the producer/product relationship to develop a pragmatic theory of choice, purpose, and free will, and extends the relationship in various ways to account for reproducers, co-producers, potential producers, and other analogues for biological and ecological classes (Flower, 1942; Pennypacker, 1942). Systems analysis uses the same framework for developing an objective theory of function and purpose. Function is a joint product of structure and process in the context of a purpose inherent in the essential characteristics of a comprising system.

The key challenge satisfied by the producer/product model of the relationship between structure and function is explaining how a given structure can have multiple functions in the same environment, as is often observed in systems behavior. The answer offered is that a single structure in a single environment can result in multiple functions through multiple processes.

4.4 Distinguishing Systems Analysis from Other Functional Ascriptions

The theory of design presented here defines function in terms of rationalized inter-locking producer/product relations among structure, function, and process, so that having a design entails having elements with functions. This design paradigm of systems analysis differs from currently prevalent etiological, welfare, and dispositional analyses of functional ascriptions (McLaughlin, 2001).

In systems analysis, no etiological conclusion is warranted about a system with manifest design, nor is any conclusion warranted regarding whether it, or anything related to it, benefits from its functionality, or even whether the object exhibiting design has the ability to work in the manner implicit in its design. Design in systems analysis is only an objective model for an inquirer developing understanding, i.e., answers to "why?" questions, to complement knowledge and information, i.e., answers to "how?" and "what?" questions.

Systems analysis differs from classical internal teleology on the one hand, and subjective Cummins (1975) functional ascriptions on the other, in attempting an objective analysis of functional characteristics: following Singer (1924; 1959), systems analysis equates functional characteristics of a system with observable behaviors and capacities, and wields rationality and economy as razors for reducing understanding to inter-subjective propositions.

In classical analysis, naturalistic teleology is internal to an entity and causes behavior; thus, although the behavior may be observable, the teleological characteristics are private to their possessor and objects of inference rather than observation to others (McLaughlin, 2001, 16–17). For Cummins, functional ascriptions are instrumental relations relative to a goal, which goal is determined by the analyst's interest and thus is subjective to the analyst, rather than the entity. For Singer, writing in the pragmatic tradition, functional characteristics are identical with their publicly observable phenomena and therefore objectively accessible to observers, with neither the analyst nor the object of analysis (nor the creator, nor the commissioner, nor the user, nor the owner of an artifact) being in a privileged position relative to teleological ascriptions.

That the systems analysis concept of function is distinct from etiological, dispositional, and welfare views, can be shown by considering the example of design failure. Design failure – the universal failure of a type to work properly – is a familiar occurrence in industry, especially during product development. Yet artifact types that are universal failures still have a design, and their elements have functions, even if they do not work, have never worked, and never will work.

For systems analysis, the same can be true of natural organs, since systems analysis does not distinguish between organs and artifacts. That universal failures never work does not prevent systems analysis from comprehending the design of a universally nonworking organ, based on the razors of rationality and economy applied to relations among the elements of the organ and relations among the organs of the comprising organism. This places systems methodology squarely at odds with

current philosophical theories of function, since the etiological, dispositional, and welfare views all require that natural organs either work, or historically have worked, or have a disposition or propensity to work, in order to have a function.

For example, the mule, as a reproductive dead end, figures prominently in philosophical analyses of function, where the challenge for philosophy is thought to be explaining how mule hearts can have the function of circulating mule blood even though each mule is genealogically the first of its type, and such pumping and circulation confers no reproductive advantage. What current philosophy passes over in silence are mule gonads, which in systems analysis of mule design have the function of reproduction, even though they are universal failures.

Another noteworthy difference between the design view of function and current philosophical etiological, dispositional, and welfare views is the hierarchical relativism of the design view. In systems analysis, purposes and functions are different and not necessarily linked in a chain to any privileged hierarchical level, e.g., the gene, organism, or species, whose supposed intrinsic goals (survival and reproduction) would anchor the chain of functional ascriptions. In systems methodology, the functions and purposes at any hierarchical level (e.g., cell, tissue, or organ) come from interacting design loops looking only one level up and down the hierarchy of a nested system-of-systems, and no farther.

The design-based theory of function offers a naturalist approach to function analysis that [1] breaks the chains of necessity which currently bind functioning to working, thus offering a richer view of malfunction and failure in both natural and artificial systems, while simultaneously [2] extending scientific relativity to biological hierarchies (genes, cells, organs, etc.), and [3] eliminating the last vestiges of intrinsic teleology in biology (i.e., survival and reproduction as intrinsic goals).

5 Examples of Systems Analysis

5.1 William Harvey and the Human Heart

Harvey, an Aristotelian in the Paduan tradition, sought the unifying process in human organisms that is the essence of life. The Aristotelians of Padua in Harvey's day were in an ongoing dispute with the Galenists (principally in Paris), who denied any singular life process and diffused vitality into separate organs. Harvey undertook a long study of the cardiovascular system to discover the function and working of the heart, with a view to discovering the Aristotelian life process, and in so doing discovered the pumping function of the heart and the fact of circulation of the blood (Boorstin, 1983, Ch. 47; Butterfield, 1957, Ch. 3; Nuland, 1988, Ch. 5).

That Harvey should make two discoveries at once is natural in systems analysis, since function and purpose are related as means and end, and as systems analysis jointly addresses the two interlocking loops of design at hierarchically separate levels. Indeed, given an existing, faulty but internally consistent systems analysis

as a starting point, such as Galen's liver-centered physiology of blood, at least two changes have to be made to the existing analysis to reach a new consistent analysis, since structure, function, and process each co-produce the others.

Harvey began with a detailed examination of the musculature of the heart and the vascular walls of the arteries immediately outside the heart, to resolve the systole/diastole controversy. From the exceptional strength and stiffness of the arterial walls, Harvey concluded that the heart pushed blood out to the arteries with considerable violence, and from the manner in which the muscles were connected around the heart, Harvey concluded that they work by contracting the chambers of the heart, rather than by pulling them open, i.e., that the heart does its work during systole rather than diastole. Thus, Harvey's first step was to move from new structural observations to a new understanding of heart process (Harvey, 1628).

Taking up the systolic process, Harvey sought simultaneously to examine the heart and arteries of dying animals, whose heart action was thereby slowed, and concluded that the arterial pulse temporally followed and was caused by the violent contraction of the heart. This was in contradiction to prevailing theories of the "pulsatile faculty" of blood, rhythmic throbbing of *pneuma*, theories of vascular dilation to draw blood from the heart, etc. Harvey completed his description of the systolic process by noting that the process was uniformly directional: the atria (upper chambers of the heart) always contract just prior to the ventricles (lower chambers), implying that the direction of blood flow within the heart was always from the atria down, never from the ventricles up, and therefore always from the ventricles outward. Filling of the heart between beats was only into the atria; at the point of atria overflowing into the ventricles, a new heartbeat occurred. The ventricles were not held forcibly closed between heartbeats; the heart muscle was relaxed yet the ventricles stayed empty.

From this process observation Harvey was able to infer a need for blocking the return of blood to the relaxed ventricles from the arteries once the blood had been expelled, and this lead to discovery of the cardiac valves. Theories popular in Harvey's time involving expansion or dilation of the arteries to hold blood rendered the blocking function of the valves unnecessary, and given Galen's theories of blood moving back and forth a blocking function would have been counterproductive. Since Harvey's method went beyond plausibility to necessity, Harvey could discover a need for cardiac valve existence and function, facts that were not obvious either from examination of the valve structures themselves or from prevailing plausible theories. Harvey's discovery was rooted in going beyond plausible consistency with observations to elegant, necessary functional, explanations.

Harvey's analysis of the systolic process yielded a second, independent inference of function from the passive nature of the heart between beats. Applying the principle of sufficient reason, Harvey determined a need for something to "arouse the somnolent heart", i.e., to trigger a heartbeat. From this Harvey discovered that a function of the atria was to serve as reservoirs, measuring out the time between heartbeats by their passive filling. This inference of atrial function is truly remarkable since artificial pumps, bellows, etc. have no equivalent element. Harvey could not be projecting functional ascriptions by analogy, even though Harvey did value analogy as a source of insight.

From initial observations of arterial structure Harvey determined a process, and from detailed examination of that process he determined required elements with functions, which in turn produced new identification of function-bearing structures, in a sequence of iterative development.

As demonstrated in the cases of cardiac valves and atria, Harvey's systems analysis was capable of discerning functions that were not evident either by direct examination of the structures, or by analogy with other structures of known function.

The rest of Harvey's analysis involved tracing the impact of the systolic process and unidirectional flow of blood through the heart on the traditional explanations of heart, liver, and lung function, showing that food transformed in the liver cannot be the source of all blood, that the pulmonary veins do not carry anything aerial or ethereal (like *pneuma*) from the lungs, that there is no support for the function of the heart being a furnace, and that the blood expelled through the aorta must return to the heart via the venae cavae. This last observation lead to the hypothesis of circulation, which Harvey could not demonstrate but firmly concluded on the basis of the inadequacy of all explanations requiring generation and expiration of blood at the beginning and end of a noncircular flow.

Three striking features of Harvey's analysis arise in contrast to the contemporary Galenic physiology that Harvey was overturning:

1. Harvey never determined the functions of the lungs, liver, or even of blood itself. He refuted legacy functional ascriptions without substituting new ones.
2. Harvey constructed necessary rather than plausible explanations.
3. Harvey ended on an unsolved problem (the hypothesis of "pores" or capillaries).

The first point underscores a characteristic feature of systems analysis: there is no infinite regression of functions, nor even a finite chain of functions leading from every level of hierarchical analysis to some reference level at which an ultimate end, e.g., survival or reproduction, can be defined. Evolutionary biology's coronation of a privileged hierarchical reference level, variously the gene, organism, or species, is inconsistent with systems analysis as done by Harvey.

The second point above stresses that Harvey is everywhere insisting on functional justification of elements, or Weinberg's criterion of elegance. This is particularly evident in Harvey's correction of Fabricius' interpretation of the venuous valves in extremities. Fabricius' descriptive interpretation of their function was that they regulated blood distribution and held pooled blood in the manner of weirs, but Harvey correctly deduced a need for blocking blood flow rather than simply holding blood, and identified the structures as valves rather than weirs. Had Harvey been content with plausible explanations he could have let his mentor's (Fabricius') interpretation of venuous valves stand unchallenged, as it did not contradict any of the rest of Harvey's analysis, but for Harvey function was rooted in necessity rather than plausibility, specifically the requirements of structure and process in a joint producer/product relation with function.

The third point above illustrates that although systems analysis involves no infinite regression and therefore can close, it need not close; it is enough to establish a manifold of relations that cannot be modified without contradiction. In this respect

systems analysis is like modern theoretical physics, where the problem of a unified theory remains unsolved yet confidence in quantum mechanics being fully true, and not merely an approximation of truth, remains high, because quantum mechanics seems insusceptible to modification without contradiction (Weinberg, 1992, 88).

5.2 Soviet National Missile Defense

Sparked by a 1953 joint letter from seven Soviet Marshals recommending a national missile defense (NMD), the Soviet Politburo approved their first plan for NMD in 1954. This plan, implemented in stages, adapted the SA-1 surface-to-air missile (SAM) in an anti-ballistic-missile (ABM) role, and developed the Sary Shagan missile test range, the Triad targeting radar and the Hen House phased-array radar. Among the achievements of this first Soviet NMD program was the successful 1961 interception of an SS-4 warhead by a modified SA-1 interceptor (called V-1000) at an altitude of 25 kilometers over Sary Shagan, using a conventional explosive warhead. This interception integrated all of the elements of NMD, with a Hen House radar initially acquiring the target at a range in excess of 1000 kilometers and passing targeting data to Triad radars and the interceptor launch site (Lee, 1997).

Following the successful test, operational deployment of missile defense systems began in 1962–63, with simultaneous construction of the Moscow zonal missile defense system, with its characteristic Dog House and Pillbox radars, and the Soviet national system, with its Hen House and Pechora-class large phased array radars (LPAR), most famously the LPAR at Krasnoyarsk.

American intelligence analysis of Soviet missile defense development could only rely on external observations of various kinds, such as operating frequencies and pulse durations collected from Soviet radars, observation of tests at Sary Shagan, and overhead photographs of missile installations. Analyses of this evidence relied on the methods of systems analysis, introduced from industry by US defense secretary, and former Ford Motor Company president, Robert McNamara. During the mid-1960s, while systems analysis of Soviet missile defense failed to understand the significance of many tests conducted at Sary Shagan or the relationship between the Hen House radar network and the Moscow missile defense network, US national intelligence estimates (NIE) nonetheless correctly determined that the Soviets were deploying NMD. These assessments were ultimately challenged in the late 1960s as the USA and the Soviet Union began negotiating what would become the 1972 Anti-Ballistic Missile (ABM) treaty, and diplomacy demanded a change in the nature of evidence for those claiming that the Soviets had deployed NMD (Lee, 1997), since Soviet authorities denied deploying NMD and the treaty forbade it.

The 1960s-era systems analyses of Soviet NMD proceeded from fixing observed Soviet interceptor limitations (especially their slow speed, about 2 kilometers per second, and their languid initial acceleration) as technological design constraints under the razor of economy, and concluding from this that any Soviet NMD would

have to operate in battle management mode rather than point defense or perimeter defense mode. With this in mind, the question of whether the Soviets were deploying NMD was analytically reduced to four atomic questions, all potentially answerable from available intelligence methods.

1. Were the SA-5 and SA-10 interceptors dual purpose SAM/ABMs?
2. Were the Hen House and Pechora-class LPAR radars passing target tracking data to missile defenses?
3. Was there a central ABM command authority with a command, control, and communications (C3) system?
4. Did the SAM/ABM missiles have nuclear warheads?

All NIE participants agreed that if the answers to these questions were "yes", and they were, then the Soviets were deploying NMD (Lee, 1997).

Several things are noteworthy about these questions. The overarching feature of systems analysis in this case was that inferences of purpose (NMD) and function (ABM) were being made without any testimony of the system's designers, which would become available in the 1990s, corroborating the analysis. The inference was based only on externally discernible characteristics of the system, on capabilities that NMD systems should have that air defense systems would not, given rational and economic relationships among system elements under the constraints of prevailing Soviet technology.

All four atomic questions address issues of function or purpose though analysis of relations. For instance, the distinction between a SAM and an ABM depends on how the interceptor is integrated with its associated radars, specifically with the function that the interceptors and radars co-produce. Similarly, whether the SA-5 and SA-10 interceptor missiles had nuclear warheads depended on the proximity of nuclear storage facilities to the missile launch sites.

This case also illustrates another characteristic of systems analysis of artificial systems, that the analysis often develops functional ascriptions which contradict the claims of authorities, a characteristic documented in Ackoff's many writings on his analyses of government and UN agencies, corporations, charities, etc.

5.3 Failure of Systems Analysis

The failures of systems analysis described by Lee in the analysis of Soviet NMD are instructive. For instance, the failure to rationalize the sequence of tests at Sary Shagan and the failure to understand the relationship between the Hen House and Dog House radars (in fact there was none) were both due to the same mistake, made by analysts at the beginning of Soviet missile defense deployment in the early 1960s and corrected a few years later: what was in fact two separate systems, with distinct interceptor models, distinct radar models, and distinct areas of responsibility (Moscow on the one hand and the Soviet Union on the other) was analyzed as though it was all one system whose area of responsibility was a topic of contention.

The same kind of mistake, failure correctly to delimit the system, was a contributor to, but not the complete cause of, Galen's errors, e.g., Galen's faulty analysis of the heart, based on a cardiopulmonary rather than a cardiovascular system, concluded that the heart was a furnace receiving *pneuma* through the pulmonary veins. The problem of correct delimitation of a system in systems analysis remains difficult, and inspiration remains part of the solution (Zandi, 2000, amplifying Churchman, 1971; 1979).

It is important to note in the case of Soviet NMD that the consequence of initial failure properly to distinguish and delimit the systems was not a conclusive faulty analysis, but rather failure of the analysis to converge. This is characteristic of systems analysis, that rather than confidently reaching erroneous conclusions from false premises, it dissolves into a muddle when its underlying premises are incorrect. Had Galen insisted on necessary rather than plausible explanations, he might also have failed to converge on explanations of human physiology, instead of reaching conclusions that were detailed, consistent, plausible, and wrong.

6 Conclusion

Systems methodology has been presented as a complementary approach to systems engineering on the one hand, and systems analysis on the other. The element common to both was shown to be design. Design in systems methodology is the combination of two interactive loops, one addressing the relationship between the design object and its environment, the other addressing the relationship between the design object and its elements.

The design approach to analysis considers structure, function, and process in the context of environment to develop information, knowledge, and understanding of the system and elements being studied. In the systems approach, process and structure combine jointly to produce function in the context of environment. This method was shown to be capable of discerning functions and purposes that were not apparent from structures alone, or from analogy with structures of known function.

This chapter has presented the interactive loops of the design process in systems engineering, and the use of analogous interactive loops in systems analysis. The modern systems analysis methodology of Gharajedaghi, Ackoff, and Churchman, built on the foundation of Singer, has been generalized to correspond to Harvey's actual method, and to modern methods of military intelligence analysis of large integrated technical systems.

Systems analysis undermines the purported distinction between natural and artificial systems, separates design from designers, and presents a practically successful account of design function at odds with current philosophical accounts.

References

Ackoff, R. L. and Emery, F. E., 1972, *On Purposeful Systems*, Aldine-Atherton Press, Chicago.

Ackoff, R. L., 1974, *Redesigning the Future*, Wiley, New York.

Ackoff, R. L., 1981, *Creating the Corporate Future*, Wiley, New York.

Bertalanffy, L. von, 1969, *General Systems Theory*, Braziller, New York.

Blanchard, B. and Fabrycky, W., 1981, *Systems Engineering and Analysis*, Prentice-Hall, Englewood Cliffs NJ.

Boorstin, D. J., 1983, *The Discoverers*, Random House, New York.

Butterfield, H., 1957, *The Origins of Modern Science 1300–1800*, Macmillan, New York.

Cummins, R., 1975, Functional analysis, *J. of Phil.* **72**:741–64.

Churchman, C. W., 1971, *The Design of Inquiring Systems*, Basic Books, New York.

Churchman, C. W., 1979, *The Systems Approach and its Enemies*, Basic Books, New York.

DAU Pub, 2000, *Systems Engineering Fundamentals*, Defense Acquisition University Press, Washington.

Flower, E. F., 1942, Two applications of logic to biology, in: *Philosophical Essays in Honor of Edgar Arthur Singer, Jr.*, F. P. Clark and M. C. Nahm, eds., University of Pennsylvania Press, Philadelphia, pp. 69–85.

Gharajedaghi, J., 1999, *Systems Thinking*, Heinemann, Boston.

Harvey, W., 1628, *An Anatomical Disquisition on the Motion of the Heart and Blood in Animals (De Motu Cordis)*, R. Willis trans. 1952, Encyclopedia Britannica.

IEEE Std 1220, 1998, *IEEE Standard for Application and Management of the Systems Engineering Process*, Institute of Electrical and Electronics Engineers, New York.

Lee, W. T., 1997, *The ABM Treaty Charade: A Study in Elite Illusion and Delusion*, Council for Social and Economic Studies, Washington.

McLaughlin, P., 2001, *What Functions Explain*, Cambridge University Press, Cambridge.

MIL-STD-499B, 1994, *Systems Engineering*, Department of Defense, Washington.

Nuland, S. B., 1988, *Doctors: The Biography of Medicine*, Knopf, New York.

Pennypacker, M. I., 1942, Biological phenomena which a definition of life must include, in: *Philosophical Essays in Honor of Edgar Arthur Singer, Jr.*, F. P. Clark and M. C. Nahm, eds., University of Pennsylvania Press, Philadelphia, pp. 86–99.

Singer, E. A., 1924, *Mind as Behavior*, Adams Press, Columbus, OH.

Singer, E. A., 1959, *Experience and Reflection*, C. W. Churchman, ed., University of Pennsylvania Press, Philadelphia.

Weinberg, Steven, 1992, *Dreams of a Final Theory*, Pantheon, New York.

Zandi, Iraj, 2000, Science and engineering in the age of systems, presented at *What is Systems Engineering?*, Intn. Council on Syst. Engr. (INCOSE), Sept 19 2000.

Co-Designing Social Systems by Designing Technical Artifacts

A Conceptual Approach

Ulrich Krohs

Abstract Technical artifacts are embedded in social systems and, to some extent, even shape them. This chapter inquires, then, whether designing artifacts may be regarded as a contribution to social design. I explicate a concept of general design that conceives design as the type fixation of a complex entity. This allows for an analysis of different contributions to the design of social systems without favoring the intended effects of artifacts on a system over those effects that actually show up. First, the clear-cut case of socio-technical systems is considered. Here, functions of artifacts can be planned fairly precise. In societies, in contrast, the actual functions of an artifact can hardly be predicted, which is due to strong self-organizing processes. Nevertheless artifact design can be shown to contribute to the design of the system also in this case.

1 Introduction

Different bodies attempt to design social systems. Among them are governments, political parties, media, and economic enterprises, and at the level of individuals: politicians, journalists and businessmen, and also proponents and followers of theories of Social Systems Design (SSD). Besides being formed by such intentional influences, society shapes itself to a large extent via non-intended, self-organizing processes. So the design of social systems, as far as it exists, is probably best described as a hybrid, resulting in part from intentional and in part from non-intentional processes. The dichotomy of intentional and non-intentional design is well known from other areas, paradigmatically from the design of technical artifacts on the one hand, and from the design of biological organisms on the other. With respect to technical artifacts, the design process is an intentional one in which goals are followed. In contrast, there is no intentionality involved in the processes that shape the design of organisms: biological evolution is non-intentional. As outcomes of the different kinds of design processes, there are at least two different kinds of design: one of the kinds is intentional design, as the design of an artifact, which may be laid down in a construction plan,

U. Krohs, Konrad Lorenz Institute for Evolution & Cognition Research, Altenberg/University of Hamburg

P. E. Vermaas et al. (eds.), *Philosophy and Design.*
© Springer 2008

provided that conventions exist about how to interpret and to realize the plan, which again is an intentional process. Biological or natural design forms a second kind and should clearly not be understood as referring to intentions. According to neo-Darwinian biological theories, the design of an organism is laid down mainly in its DNA.[1] I take it that the term "design" is used correctly in both cases, despite the lack of intentionality on the side of organismic design.[2] This means that the different cases are assumed to have some important commonality. We seem to refer to a core meaning of "design" that is conserved in both uses of the term. To capture this core meaning, I will develop a concept of general design that includes both intentional and natural design. This will be done in the second section of my chapter.

The concept of general design shall be applied to social systems. It seems most workable to start with well-defined systems. In the third section of my chapter, I will therefore take a look at the design of socio-technical systems. These are systems like factories and similar enterprises that clearly have a prominent technological component. The paradigmatic example of such a system is a coalmine, which was investigated by members of the Tavistock Institute when they first introduced the concept of a socio-technical system. Such a system is made up of the machines, the workers, the administration, and their more or less institutionalized interactions (Trist and Bamford, 1951; Emery and Trist, 1960). The machines may serve functions in the system that would hardly be realizable without them; but the functions alone do not make up the system. Though many contemporary sociological approaches neglect the significance of the materiality of a system,[3] functions crucially depend on a bearer. To make my point, I must refer to early functionalists like Malinowski, Merton, and Parsons, who emphasized the role of the material components of social systems: "no organized system of activities is possible without a physical basis and without the equipment of artifacts" (Malinowski, 1941, 68).[4] However, talking about the functions of the components of a system requires an explication of the concept of function. Usually,

[1] The neo-Darwinian research program relies on genetic determinism. The perspective had to be broadened by reference to epigenetic contributions to inheritance (cf., e.g., Jablonka and Lamb, 2005). In current biological research programs that integrate developmental with evolutionary processes, the focus is shifted from inherited design to developmental processes, which are now conceived as being at the center of the generation of biological form (Müller and Newman, 2003).

[2] Since biological design is to be conceived as non-intentional, the concept of design discussed here has no affinity at all to the notion of "intelligent design", which has been made the topic of many unfortunate political debates.

[3] Functionalist accounts of social systems that follow Luhmann consider systems as being constituted of communicative interactions only, not of material components (Ropohl (1999) develops a formalized version of an act-focused sociological approach). Likewise, Searle, in his intentionalist conception of society, does not count artifacts as components of societies, though speaking about the assignment of functions to them (1995, 13–23). His ontology of social reality embraces only the following three "elements", as he calls it: the assignment of function, of collective intentionality, and of constitutive rules (1995, 13, 29).

[4] The importance of function bearers is reconsidered in some recent approaches. Callon and Latour's Actor-Network-Theory and Pickering have a strong focus on material agency (e.g., Callon, 1986; Latour, 1988; Pickering, 1995), but their frameworks are hardly suitable for looking for similarities between social and other systems.

the function of an artifact is regarded as being grounded in, or elsewhere linked to the goals of the designer. This seems to be too strong a requirement, since one also talks about functions with respect to components of biological organisms, where no reference is made to any intended goal. The concept of biological function is often based on that of design (e.g., Kitcher, 1993), and the non-intentional concept of general design allows therefore for a definition of functions that can be applied to the intentional case of technical artifacts as well as to possible non-intentional cases of functions in societies.

The structure of a socio-technical system and the functions of its components may come quite close to what was intended by those who had designed it. Therefore, a socio-technical system may be regarded as a designed one without much deduction. The situation may be different for larger social systems, like societies, to which I will proceed in the fourth section. Societies are planned to a much lesser extent than socio-technical systems. Nevertheless, the structure of a society will rely to a considerable extent on planned factors, since it is influenced by the constitution of the society, by laws, institutions, etc. Moreover, the structure of a society will be influenced by the design of the machines used by its members and by the design of the socio-technical systems that are embedded in it. As Merton states, "[n]ew applications of science to production by the engineer ... are inescapably social decisions affecting the routines and satisfactions of men at work on the machine and, in their larger reaches, shaping the very organization of the economy and society" (1947, 567). Some of these influences of artifact design on society and some functions of artifacts in society may be intended. Nevertheless, additional, non-intended effects will occur in many cases. Therefore, if such larger social systems are at least in part designed systems, which will be shown in section four, we are confronted again with non-intentional – or at least partly non-intentional – design.

2 The Concept of General Design

There is no canonical conceptual framework that allows us to deal equally well with the different sorts of design that are related to different classes of functionally organized entities. I aim for a unified rather than a separating view: it seems to be plausible that, if we have three or four classes in which function and design go together in a similar way, then a commonality on the conceptual level can be expected. If we do not rely on such commonalities, we forego the chance to learn from one field with respect to the other.

Non-intentional design, being the more general case, can be found in biological systems. Most concepts of biological design focus on the design process (Allen and Bekoff, 1995; Buller, 2002). That reference to the design history is essential is often taken for granted in the case of artifacts as well (e.g., Lewens, 2004, 51–52).[5] At first view it seems obvious to refer to the design process: all important

[5] A different view is put forward by Houkes et al. (2002) but since this approach is applicable in the realm of intentional design only, it is too restricted to account for the partly non-intentional design of social systems.

decisions with respect to the final product are made within this process, and here is the place where goals are considered that have to be met by the product. Consequently I had to refer to the design process in the last section. However, any account that was to *identify* design with the process of designing would have insurmountable shortcomings. First, two convergent design processes may yield the same result. There might be many different ways to come up with the identical design of a technical artifact, like a chair or a combustion engine. The order of many steps in the process may be inverted, processes may branch or some process may bypass another. As long as the processes converge, the result will be identical, and the result matters with respect to the designed entity, not the way by which it was reached. Only the distinction between design and design process allows us to speak about identical results being reached in different ways. Second, we say that the design of, e.g., a car may be modified. This does not mean that the process of designing may be modified in a retrospective manner; even a Huxleyan ministry of truth can only mock a changed past rather than really change it. What we mean when we talk about a modification of a design is that a new design process starts from the results of a previous one, resulting in a different design. So, again, the design of an entity should not be identified with the process of designing. Instead, it has to be conceived as the outcome of the design process (Davies, 2001, 61–62; Krohs, 2004, chap. 4; Krohs, 2007). But what is the outcome? Sometimes, it is assumed to be the structure or internal organization of a complex entity (e.g., Lauder, 1982), but if the design really was the internal organization of the entity, we would also have to talk about the design of the solar system and other organized purely physical entities, because the organization of a non-designed entity does not necessarily differ very much from the organization of a designed entity. Consider cloud streets or sand ripples in the sea as highly organized but non-designed structures, or compare the organization of the solar system with that of a (perhaps very particular) carousel. So design should neither be identified with the process of designing, nor conceived as the structure or organization of a designed entity. Design rather seems to be something that mediates between these two.

If we consider that in technical designing the design may be finished even before the construction of the first prototype, we may regard as the design the result of the design process that fixes the designed entity, or, more precisely, the type of the designed entity. We have to refer to the type and not to a concrete entity since the design is realizable more than once, using different tokens of the component types prescribed in the construction plan.[6] According to this account, the design fixes the types of the components of a complex entity, and it lays down how parts of the respective types have to be assembled to construct an entity of the type that is specified in the design. This explicates a concept of general design.

Design as type fixation of a complex entity involves the type fixation of its components and the fixation of how to arrange them. There has to be a link

[6] Accordingly, the term "prototype" is confusing since it often applies to an experimental, but nevertheless concrete, entity. In this sense, the prototype is a proto-token rather than a type.

between type fixation and token. In the case of intentional design, this is a convention, as can be seen from the code used to fix the type of a screw. In the case of biological design, this link will be, e.g., the genetic code, linking DNA structure to amino acid sequences. So even in the case of a non-intentional design process, here an evolutionary one, we may speak of design in the sense of type fixation. Therefore, conceiving design as the type fixation of a complex entity allows for a unified theory of design, applicable to intentional and to non-intentional, i.e., biological cases.[7] The non-intentional case is also relevant with respect to the design of societies, so I will come back to it in the fourth section of my chapter.

Let me point at the difference between a designed and a non-designed entity with respect to the differences in the way in which the components the entity consists of are assembled. A non-designed entity, if it has a stable structure like an atom or a solar system, comes into being by a process of self-assembly. All the components are in place because of their individual physical or physicochemical properties. We may therefore speak of property-determined components. In a designed entity, in contrast, the components are in place not because of a physico-chemical selection for their individual properties in a self-organizing process, but because their type is fixed in a design. If the type of a screw is fixed as, say, M6x1x15 made of brass, the screw in the complex entity will be of this type because it was chosen according to the type fixation in the construction plan. Neither are the physical properties of such a screw sufficient to bring it in the place it fits into, nor would anything but the type fixation prevent a screw from steel instead of brass being mounted. In most cases, even a slightly longer screw would fit; hence it is not the individual properties of a component but the design that fixes its type.[8]

3 Design of Socio-Technical Systems, and Functions of Artifacts

I have introduced the concept of general design with reference to technical artifacts and, as an example for the non-intentional case, to the design of biological organisms. Now the question is whether the concept may be applied at the level of

[7] A more detailed account of this concept of design is given in Krohs (2004; 2007).

[8] There are many cases in which not all the parts of a designed entity are type-fixed. In addition to type-fixed components, such an entity may have property-determined parts, such as the molecules of the air in certain gas springs etc. Seventy-eight per cent of the gas molecules will be of one type, twenty-one of another, even without a type fixation. In many other cases type identity may occur without being a sufficient reason to ascribe type fixation. Some kind of sediment may consist of almost type-identical particles, but they accumulated just because of their individual physical properties that led to selective sedimentation under conditions that happened to occur. There was no design prescribing this type. The particles of the sediment are property-determined, not type-fixed.

social systems as well. Instead of considering whole societies, I will stick for the moment to the more clear-cut case of socio-technical systems. Besides being of interest in their own right, these systems may be regarded as a model of selected aspects of societies and form themselves components of societies. A socio-technical system may realize quite accurately the structure and functions that it was set up for. We may conceive such a system as being designed in the following way: The systems designers have fixed the types of machines that are used and have defined which qualification the individuals who are running the machines must have. Moreover, the designers have prescribed which communication- and decision pathways are to be used, etc. The components of the system are type-fixed: type-fixed devices, type-fixed man-machine interfaces, "type-fixing" jobs for workers (vacancies are filled only with persons of the qualification wanted), and type-fixed social institutions. Moreover, the proper arrangement of all these type-fixed components is laid down and may be used to set up, run, and adjust the system. This means that a socio-technical system is a designed entity as defined in the type fixation account of design presented above.

Type fixation within a socio-technical system occurs on different levels. On the highest level, the type of the system as a whole is fixed, e.g., being a certain type of coal mine or of a power plant. This involves a fixation of the types of the components of the system and of their arrangement. Some of these components are machines, and at least with respect to these, another level of type fixation is involved. They are themselves type-fixed complex entities and may be designed completely independently from their possible use in a certain socio-technical system.[9] The question now is whether and how the design of the machines contributes to the design of a socio-technical system they are components of: Do the type-fixed parts of the machines themselves constitute parts of the socio-technical system? And if so, are they type-fixed components of it? First, the design of the socio-technical system usually will not explicitly fix the types of the components of the machines. It will fix the types of the machines only, and these, being designed entities, will have type-fixed components. With respect to the first question we should say that it is obviously impossible that a type-fixed subcomponent, i.e., a component of a component, of a socio-technical system is present only in the machine, but not in the socio-technical system the machine belongs to. So the part of a machine that is part of a socio-technical system is itself part of the system. But are these parts type-fixed components of the socio-technical system? The design of the socio-technical system explicitly fixes the types of the machines only, not the type of their components; but by this type fixation, we implicitly refer to the design of the machines. Without the design that fixes the types of their, the machines', components, the machines would not exist. So one can say that the design of a socio-technical system implicitly fixes the types of the components of its type-fixed

[9] I will stick to the case of artifacts since I am interested in the contribution of intentional design to the design of social systems. In addition, biological type fixation is to be found with respect to the individuals working in the system, in as far as they are biological organisms.

components, and that the design of the machines is part of the design of the socio-technical system. This means that being type-fixed, in this case, is transitive: a type-fixed component of a type-fixed component of a system can be regarded as being type-fixed with respect to the whole system as well.

The type-fixed components of a socio-technical system, and again their components, are not only supposed to be present in a system; they have also to fulfill certain functions in the system. Only the functioning will show whether the design proves successful and therefore has to be judged when assessing a design. Again, the concept of function, like that of design, is highly controversial (cf. Allen et al., 1998; Buller, 1999). As I have pointed out, it may be linked to the concept of design. Accordingly, the concept of general design allows for a straightforward definition of the concept of function. We may simply combine a Cummins-like causal role account of functions (Cummins, 1975) with the design concept, and end up with the following explication: a function is a contribution of a type-fixed component to a capacity of a system that is the realization of a design (Krohs 2004; 2007). "Contribution" is to be taken with a dispositional meaning, as in Cummins (1975).[10]

So a function is the role that a component has according to a design, where it is not asked whether it was designed *to* have this role. As in the case of the design concept, this concept of function is applicable to functions of components of intentionally designed entities and to functions of components of naturally designed entities. Precondition is only the ascription of design in terms of type fixation.

We have seen before that type fixation is transitive in the cases under consideration. A type-fixed component of a technical artifact is likewise a type-fixed component of the socio-technical system to which the artifact belongs as a type-fixed component. Functions may also be transitive, but this does not seem to apply generally. Malinowski gives an example of how the subcomponents of components of social systems may effect a social system by referring to biologically designed components: "such processes as breathing, excretion, digestion, and the ductless glands [i.e., the hormone glands] affect culture more or less directly" (Malinowski, 1941, 68). Although we see this influence of the effects of components of higher components of a system on the embedding system, we should be careful to regard this as a transitivity of *functions*: The excretory organs of humans will not function as the excretory organs of society, nor does epinephrine make society ready to perform a flight reaction. Instead, the functional subcomponents will contribute to other capacities of the higher system, e.g., to agricultural production *via* the production of fertilizer, or to certain social dynamics. Similar considerations may hold with respect to the functions of components of technical artifacts within societies.

[10] This definition of function overcomes the two basic shortcomings of Cummins's concept: it is not applicable to purely physical entities, and it allows for a definition of malfunction since reference to design introduces some normative instance. It does not run into the definitional circle etiological accounts of function such as Millikan's (1984) must envisage when referring to design (Krohs, 2005). In addition, the concept allows for a definition of historically established functions, hence for reference to selected functions almost as Millikan's approach. Details will be given elsewhere (Krohs, 2007).

It might be more likely than in the organismic case that many functions of subcomponents really are transitive, but other type-fixed subcomponents may assume new functions in the socio-technical system.[11]

According to my account of function, components of a socio-technical system may have functions not as such, but only within the system. These are the contributions of the components to the capacities of the designed entity. For example, workers fulfill different professional tasks; machines serve different functions in a production process. These latter systemic functions of machines within the socio-technical system are functions of artifacts-as-wholes. These functions only emerge on the level of a system embedding the artifact. Though it is quite common to qualify functions with respect to an embedding system, some scholars also want to allow for the ascription of functions to context free artifacts. Achinstein, e.g., explicitly denies that an ascription of a function to an artifact refers to a system the artifact belongs to: "To understand the claim that the function of that mousetrap is to catch mice one need not identify or be able to identify ... any system within which ... this is its function" (Achinstein, 1970, 350). I explicitly disagree with his view and here follow Preston and others instead. Preston points out that artifact functions of one kind are directly based on their systemic role and that functions of the other kind, Millikanian proper functions, at least started off as systemic functions (Preston, 2000, 32). So Achinstein's mousetrap has its function only in a system in which somebody may use it – with or without success – for catching mice. If the device is not considered to be part of such a system, it does not have the function. One might try to evade this consequence by reference to intended functions; but if the device only *shall* have a function according to the intention of the designer and is badly designed and does not work, we may say that it does not have this function but has *only* the *intended* function to catch mice. So a merely intended function is not a function, like a forged coin is not money.[12] A statement about an intended function is a statement about a goal of a designer. He may or may not succeed in implementing the intended function as a function of a component of the designed system. The intended function of a machine could even be something such as doing work without consuming energy, despite the fact that nobody will be able to realize this function. The designer can fix only the types of the components and their relation with respect to each other, but not the functions. The functions will show up in the operating system. The function of an artifact-as-a-whole depends on what it does and how it is used in the system it is embedded in (for the use-aspect, cf. Houkes et al., 2002). Hence, just as functions of components of artifacts are defined with respect to capacities of the artifact as a system only, functions of artifacts-as-wholes refer to capacities of the embedding system.

[11] Settling this question requires further elaboration, which cannot be achieved within the limits of this chapter.

[12] Within the conceptual framework applied here, the concept of an intended function may be explicated as follows: the intended function of a type-fixed component of a complex designed entity is the role that the designer supposed it to fulfill when fixing its type. Please observe that the designer's supposition does not imply that the component actually has the capacity to fulfill its role.

4 Elements of the Design of a Society

When considering well-defined socio-technical systems, we may be dealing with almost completely designed entities. The matter changes when the scope is widened to encompass larger sociological entities such as whole societies. Again, artifacts are important components of these systems; but we need to determine how far the design of technical artifacts co-designs a society. The concept of general design singles out two ways in which design determines a complex system: type fixation of its components; and determining the construction or assembly of the system. Only the first way of determination by design obviously applies in the considered case: A machine is a type-fixed component of a society in which it fulfills a role since it is (i) type-fixed by the machine design and (ii) conceived as a component of the society according to any approach that allows for the materiality of at least some components of social systems. In this way, the design of technical artifacts could contribute to the design of a society if the latter can be defined at all, something which still has to be determined. However, the second way in which a design specifies a complex entity is related to its assembly and the mutual relationships of its parts. This determination of the assembly usually works well in the case of intentional design, where it is laid down in the construction plan. In societies, in contrast, assembly is governed largely by processes of self-organization. Although this shows that the assembly is not governed by intentional design, it may still be based on non-intentional design.

Therefore we need a criterion for judging whether the assembly process of a system is governed by a design. Such a criterion can be found in the set of the systemic roles that are realized by the components of the system: The assembly can be regarded as the result of design only if the actual roles of the components are derived from a design and therefore may count as functions. In this respect, we can say quite clearly that many technical artifacts assume roles in societies that were never laid down in any design. Let me consider the new Airbus A380 as an example of the influence of artifact design on the design of society. It was designed to transport large numbers of people on a limited number of fixed routes. Availability of airport facilities, airline policies, and the preferences of prospective passengers will or will not result in the realization of this intended function; but in any case, designing the A380 has contributed to the design of societies. It opens not only new possibilities of mass transportation but provides jobs, induces activities in building larger runways, requires intervention into nature in order to build these runways, raises social opposition against these interventions and against taking long term risks with respect to environmental issues and to possible human and technical errors and perhaps against the influences of this kind of mass transportation on everyday life, etc. But the role of the A380 in society as it will be realized after delivery of a number of units is not yet known and cannot be planned completely. Designing such an artifact co-designs society, but does not necessarily end up with the intended result. Not roles of artifacts, but only the material components may be directly designed. The same holds for the design of institutions. Therefore, actual

roles may not be conceived as functions of an artifact, which would require that they are determined by a design. But no instance can be singled out that fixes the roles that actually show up; there are important interactions in societies that are not designed.

Social Systems Design (SSD) nevertheless tries to determine a social system exactly on the level of such interactions and mutual relationships between components, and to institutionalize all acceptable interactions within the system. This seems only to work in small systems of cooperative individuals, e.g., in educational systems in a benevolent environment, where, in addition, the number of involved artifacts is very limited and interactions are almost completely social (e.g., Banathy, 1998). With systems that have a strong material basis it also seems to work in cases where the technical component of an organization can be factored out for other reasons so that the isolated "soft system" can be addressed (e.g., Checkland, 1981); SSD does not seem to work with respect to large systems such as whole societies (Laszlo, 2001). One of the reasons is the unpredictability of material agency. Pickering states that "[n]o one knows in advance the shape of future machines and what they will do" (Pickering, 1995, 15). Pickering's statement must be interpreted in the wide sense, which includes that one even can hardly know what present machines will do in the future. We may say that the less strictly an assembly of a component-wise type-fixed entity is determined by a design, the more incomplete is the design. Social systems, even in cases where their components are type-fixed, are thus less completely designed the more they are shaped by processes of self-organization as long as these processes are not already taken into account in the design.

"Design", in the case of societies, obviously does not refer to a single and coherent plan that rigidly determines the system, but merely to an inhomogeneous set of possibly isolated design elements. There are type-fixed components – among them artifacts, like cars, computers, and buildings. These artifacts assume certain roles in societies. Humans are also components, serving roles as family members, as professionals and as volunteers for different tasks. As in the case of socio-technical systems, we have to take into account many but not all of the places that humans occupy as places for individuals as components of the society. The places themselves are partly fixing the type of their occupants, which here means their profession. This type fixation contributes to the design of a society. Governments and administrations are type-fixed by their constitutions, as is the interaction with and among them using more or less rigid official channels. This list could be expanded almost without limits, but as many components as we might wish to add to this list, we will never end up with an account of a design that determines society to a degree comparable to the determination of a technical artifact or a socio-technical system by its particular design. There are at least four major differences:

1. The design of a society will always be incomplete. Not all components of the social system will be type-fixed and presumably only a small fraction of them is. Humans do not only exert type-fixed positions (instead, they will engage in

numerous different self-imposed tasks), nor are all their acts institutionalized (they will interact as well according to free and deliberate, though bounded, choice). And nothing else would be compatible with human freedom.

2. The type fixation that can be found in society will be a highly dispersed patchwork: the designs of related components of a society may originate from completely different sources and may be realized independently rather than in a coordinated way.

3. These pieces of design are subject to continuous change, which again may be uncoordinated: in newly designed socio-technical systems, which form components of the society, machines may be used for functions they were never designed for. In the case of type-fixing positions, the individuals who exert these positions may modify the type fixation and by this mediate a deviation of the society from its previous design.

4. Societies are, to a high degree, self-organizing instead of assembled according to a plan and may be dependent largely on contingent side-conditions. Therefore, the actual role of a type-fixed technical artifact will often deviate from what its function would be according to any design of a system it belongs to.

5 Conclusion

I have introduced a non-intentional concept of design that is defined in terms of type fixation. A designed entity is a complex entity that is type-fixed component-wise. This allows for a unified view on the design of technical artifacts, biological organisms, socio-technical systems, and, in part, societies (as well as of ecosystems, which I did not take into consideration here). Technical artifacts may be used as type-fixed components of designed socio-technical systems. Therefore, the design of a technical artifact, being its component-wise type fixation, contributes to the design of these systems. But technical artifacts are also components of social systems on the even higher level of societies. They may belong directly to a society as their immediate components, or indirectly as components of socio-technical systems. Therefore, artifact design influences the design – the type fixation of the components – of a society. However, societies are to a large extent self-organizing systems. In a self-organizing system, the design of the components determines the system only to a minor degree. It rather opens up possible outcomes of the self-organization process. Therefore, the type-fixed components of a society may contribute to its design, but the design of a society will only be a piecemeal and incomplete design.[13]

[13] That society is based on a piecemeal design, of course, does not mean that "piecemeal social engineering", which is restrained to ad hoc-reactions on emerging problems that are conceived as being more or less isolated (Popper, 1971), is the desirable method of social reform.

With respect to the concept of function, the incompleteness of any design of a society is confirmed. The concept of function was linked to the concept of design: the function of a component of a designed entity is the role – not necessarily intended – that the component assumes in the system according to the design. *Intended* functions are goals of designers that are not necessarily met by actual functions of components. So again, the design of artifacts merely co-designs society. Their actual functions need not coincide with intended functions, and many roles that a technical artifact may assume are not determined by the design of any social system, and therefore cannot be classified as functions. The design of societies is always fragmentary, may change piecemeal, and interferes with non-intended processes of self-organization. It seems to be impossible to design all the relationships between the components of a system. Failure of SSD in many cases is therefore not only – and perhaps even not primarily – a consequence of the complexity of the social system, but of the fragmentary character of the design of any society, and in addition of the neglect of the material components of social systems in the attempt to design functions directly, without focusing on their bearers.[14]

References

Achinstein, P., 1970, Function statements, *Phil. Sci.* **44**:341–367.

Allen, C., and Bekoff, M., 1995, Biological function, adaptation, and natural design, *Phil. Sci.* **62**:609–622.

Allen, C., Bekoff, M., and Lauder, G., eds., 1998, *Nature's Purposes: Analyses of Function and Design in Biology*, MIT Press, Cambridge, MA.

Banathy, B. H., 1998, Evolution guided by design: a systems perspective, *Syst. Res.* **20**:161–172.

Buller, D. J., 2002, Function and design revisited, in: *Functions: New Essays in the Philosophy of Psychology and Biology*, A. Ariew, R. Cummins, and M. Perlman, eds., Oxford University Press, Oxford, pp. 222–243.

Buller, D. J., ed., 1999, *Function, Selection, and Design*. SUNY Press, New York.

Callon, M., 1986, Some elements of a sociology of translation: domestication of the scallops and the fishermen of St Brieuc Bay, in: *Power, Action and Belief: A New Sociology of Knowledge?*, *The Sociological Review* **32**, J. Law, ed., Routledge & Kegan Paul, London, pp. 196–233.

Checkland, P., 1981, *Systems Thinking, Systems Practice*, Wiley, New York; quoted from the new ed., Chichester 1999.

Cummins, R., 1975, Functional analysis, *J. Phil.* **72**:741–765.

Davies, P. S., 2001, *Norms of Nature: Naturalism and the Nature of Functions*, MIT Press, Cambridge, MA.

Emery, F. E., and Trist, E. L., 1960, Socio-technical systems, reprinted in: *Systems Thinking: Selected Readings*, F. E. Emery, ed., Penguin, Harmondsworth, 1969, pp. 281–296.

Houkes, W., Vermaas, P. E., Dorst, K., and de Vries, M. J., 2002, Design and use as plans: an action-theoretical account, *Des. Stud.* **23**:303–320.

Jablonka, E., and Lamb, M. J., 2005, *Evolution in Four Dimensions*, MIT Press, Cambridge, MA.

Kitcher, P., 1993, Function and design, *Midw. Stud. Phil.* **18**:379–397.

[14] I wish to thank the discussants at the SPT conference 2005 and Werner Callebaut for helpful comments on the manuscript.

Krohs, U., 2004, *Eine Theorie biologischer Theorien*, Springer, Berlin.
Krohs, U., 2005, Biologisches Design, in: *Philosophie der Biologie: Eine Einführung*, U. Krohs and G. Toepfer, eds., Suhrkamp, Frankfurt/Main, pp. 52–69.
Krohs, U., 2007, Functions as based on a concept of general design, (*Synthese* forthcoming).
Laszlo, A., 2001, The epistemological foundations of evolutionary systems design, *Syst. Res.* **18**:307–321.
Latour, B., 1988, *The Pasteurization of France*, Harvard University Press, Cambridge, MA.
Lauder, G. V., 1982, Historical biology and the problem of design, *J. Theor. Biol.* **97**:57–67.
Lewens, T., 2004, *Organisms and Artifacts: Design in Nature and Elsewhere*, MIT Press, Cambridge, MA.
Malinowski, B., 1941, A scientific theory of culture, in: *A Scientific Theory of Culture and other Essays*, B. Malinowski, with a preface by H. Cairns, 2nd ed., Oxford University Press, New York, 1960, pp. 1–144.
Merton, R. K., 1947, The machine, the worker and the engineer, *Science* **105**; reprinted in: *Social Theory and Social Structure*, R. K. Merton, revised and enlarged edition, 1957, The Free Press, Glencoe, pp. 562–573.
Millikan, R. G., 1984, *Language, Thought and Other Biological Categories: New Foundations for Realism*, MIT Press, Cambridge MA.
Müller, G. B., and Newman, S. A., eds., 2003, *Origination of Organismal Form: Beyond the Gene in Developmental and Evolutionary Biology*, MIT Press, Cambridge, MA.
Pickering, A., 1995, *The Mangle of Practice: Time, Agency and Science*, University of Chicago Press, Chicago.
Popper, K., 1971, *The Open Society and Its Enemies*, vol. 1, Princeton University Press, Princeton.
Preston, B., 2000, The functions of things: a philosophical perspective on material culture, in: *Matter, Materiality and Modern Culture*, P. M. Graves-Brown, ed., Routledge, London, pp. 22–49.
Ropohl, G., 1999, Philosophy of socio-technical systems, *Techne* **4**:59–71.
Searle, J. R., 1995, *The Construction of Social Reality*, The Free Press, New York.
Trist, E. L., and Bamford, K. W., 1951, Some social and psychological consequences of the long-wall method of coal getting, *Hum. Rel.* **4**:3–38.

Beyond Inevitability

Emphasizing the Role of Intention and Ethical Responsibility in Engineering Design

Kathryn A. Neeley and Heinz C. Luegenbiehl

Design is "the first signal of human intention."
– William McDonough (1993)

Abstract Much of how humans think about their world and their actions in relation to it is governed by the manner of their speaking. In this paper the authors argue that this has an especially significant impact on the work of engineers and their perception of ethical responsibility. A discourse framework governing the actions of engineers which focuses on the idea of technological development tends to lead toward perceptions of technological inevitability, whereas one focusing on the terminology of engineering design enhances perceptions of choice and, consequently, of individual responsibility. Perceptions of responsibility resulting from design focused discourse thus are not limited to narrow safety and production considerations, but include holistic considerations such as aesthetic and environmental factors, as well as considerations of societal implications of design choices. The authors propose that increased focus on design discourse, in both professional and public settings, will enhance a broader sense of ethical responsibility among engineers.

1 Introduction

Engineers usually find it relatively easy to identify issues of professional ethics as they arise in personal relationships and when making individual decisions. It is often more difficult, however, for them to feel responsible for, or even to recognize, the ethical issues associated with technology-based systems and large-scale technologies that are developed by groups and organizations.

These larger-scale forms of technological development, despite the tremendous impact they have *on* individuals, are typically seen as being out of the control *of* individuals. Part of the reason for this is that discourse, using technological development as a referent, tends to be dominated by the notion of inevitability and the assumption that the path of technological development is difficult, if not impossible, to control. Discourse about design is related to individuals and focused on the vocabulary of intention; it appears to be based on the assumption that we have

K. A. Neeley, University of Virginia

H. C. Luegenbiehl, Rose-Hulman Institute of Technology

P. E. Vermaas et al. (eds.), *Philosophy and Design.*
© Springer 2008

reasonable control over the shape of our designs and the consequences that will follow from their use; and it conceptualizes design as a process imbued with ethical considerations.

In this chapter we argue that the notions of openness and choice that are reflected in the discourse of design are much more conducive to ethical awareness, reflection, and responsibility than is the notion of inevitability that characterizes the discourse of technological development. It then follows that, if the discourse about technological development can be changed in the vocabulary of engineers to one focused on design, their ability to engage in ethical reflection will be enhanced.

Our analysis is aimed at suggesting ways to move beyond the discourse of inevitability and toward a framework that emphasizes an ideal of individual ethical responsibility in team-based and large-scale engineering design. Specifically, we argue that supplanting the discourse of inevitability will require:

1. recognizing that the robustness of the discourse of inevitability derives from many sources, including the way it resonates with lived experience and its pervasiveness in the popular media, which gives rise to its perceived simplicity and familiarity.
2. developing a compelling discourse of design that is, in turn, based on a sound philosophy of engineering and philosophy of technology.
3. demonstrating that as humans we have choices about the forms of discourse in which we engage and that those choices have significant societal consequences.

In what follows we take a discourse analysis approach, that is, we carefully examine exactly *how* the discourse of technological inevitability functions as a way of gaining insight into the sources of its power and how it might be supplanted.

2 Key Features of the Discourse of Inevitability

The discourse of inevitability regarding technological development pervades popular culture and public discourse about technology and appears in particularly vigorous form in discussions of information and communication technology. It is clearly reflected in the cover headlines of publications such as *Popular Science, PC Magazine, PC World*, and *Wired*, whose covers are replete with exclamation points, "The Super Power Issue: The Impossible Gets Real!" (*Wired*, August 2003), imperatives, "Go Wireless: It's Faster & Easier Than Ever" (*PC Magazine*, May 18, 2004), promises, "Live Forever: 7 Easy Steps to Engineered Immortality" (*Popular Science*, January 2005), and offers of competitive advantage or empowerment, "PC Secrets! 15 Easy Ways to Make Your System Do More" (*PC World*, March 2006) and "Build Your Perfect PC: Faster than Dell, Cooler than Apple, Cheaper than Sony" (*PC Magazine*, March 7, 2006). Kroker and Weinstein (1994) concisely summarize the discourse of inevitability in their book *Data Trash: The Theory of the Virtual Class* (1994): "adapt or you're toast."

Both the covers and the content of these publications make it clear that the discourse of inevitability is first and foremost a marketing strategy, a way of selling what is "new and next," along with promises and visions of the future. To the extent that the theme of choice is raised at all in these discussions, the choices to be made are typically between various versions of a particular technology, for example, digital cameras, flat screen televisions, personal computers, or software packages, rather than about whether particular technologies should be used at all.

The discourse of inevitability is associated with several metaphors in which technology is conceptualized as a force of nature or an autonomous agent making demands and producing "powerful and inevitable change" (Sasseville, 2004, n.p.). It implies that technology is the primary or sole driver of social evolution and that control over designs and outcomes is either difficult or impossible. The current popular and engineering discourses using the vocabulary of technological development thus reflect a perspective that has been analyzed and critiqued by a number of recent commentators on technology such as Jacques Ellul (1964), Martin Heidegger (1977), Langdon Winner (1977), Arnold Pacey (1983), Thomas Hughes (1987), and Rosalind Williams (2002). Winner begins his discussion by writing: "One symptom of a profound stress that affects modern thought is the prevalence of the idea of autonomous technology – the belief that somehow technology has gotten out of control and follows its own course, independent of human direction. That this notion is (at least on the surface) patently bizarre has not prevented it from becoming a central obsession in nineteenth- and twentieth-century literature." (Winner, 1977, 13) Given the central role of the requirement to make choices in ethics, it is thus not surprising that popular discourse discourages both ethical reflection and individual ethical responsibility by promoting the view that there is nothing an individual can do to affect the course of technological development meaningfully.

Challenging the discourse of inevitability has been one of the major projects of the STS community, an effort that most scholarly analysts see as both successful and largely complete. Having dismissed inevitability within our own professional communities, it is tempting to overlook the extent to which the concept of inevitability still resonates in popular and engineering discourse.

3 Understanding the Robustness of the Discourse of Inevitability

The robustness of the discourse of inevitability derives from many sources, including its simplicity and familiarity and the way in which it resonates with lived experience. Where the more complex narratives of professional historians may more fully capture the subtleties and intricacies of the processes by which technology and society shape each other, the discourse of inevitability appears to provide "an easy and uncomplicated explanation" (Selwyn and Gorard, 2003, 80). There is also a host of assumptions, myths, and predispositions that make people inclined to accept the narrative of inevitability (Pacey, 1983; Martin and Schinzinger, 1989; Frost, 1996).

Perhaps more importantly and persuasively, the discourse of inevitability resonates with lived experience. This point has been developed by several analysts of technology, including Arnold Pacey (1983) and Eric Schlosser (2002), but it is perhaps most clearly delineated by Rosalind Williams in *Retooling: A Historian Confronts Technological Change* (2002). Williams, herself a historian of technology, analyzes her experience as a university administrator involved in a "Reengineering Project" designed to improve management of her institution's existing resources.

Drawing on Thomas Hughes' concept of technological momentum, Williams concludes that "It is easy to refute the logic of technological determinism, but the everyday experience of having to conform to 'the technology,' 'the software,' or 'the computer' cannot be refuted by logic" (2002, 117). The process, Williams argues, begins with what she terms "technological drift," the tendency to address the aspects of a problem that are most susceptible to a technological solution and where visible results can be accomplished quickly. Once this happens, "The rules that govern the technology start to govern everything else. Technological drift becomes technological momentum, which begins to *feel* [emphasis added] very much like technological determinism" (2002, 116). What starts out as choice comes to be experienced as inevitability. This resonance with lived experience is one of many reasons why the narratives produced by historians and philosophers of technology and other professional analysts cannot compete with or dominate simpler narratives of inevitability. We believe that the community of professional analysts of technology-society interactions is not likely to disrupt the discourse of inevitability unless we can connect with broad social discourses about technology. We argue that the discourse of design and intention has the potential to make that connection and to elucidate the ethical dimensions of the development of technological systems more fully.

4 Contrasting the Language of Design with the Language of Technological Development

Given that we are locating much of the lack of ethical responsibility in the language that is often applied to technology, it is worthwhile to contrast the discourse tendencies that differentiate design and technological development. Table 1 gives a brief catalogue of terms associated with these perspectives.

Here we have space only to highlight several of these contrasting terms and how they influence the subjective feeling of choice. For example, as the word "design" is typically used in engineering, it is focused on something *specific*, either an individual project or part of a larger scale project, but still with a specific outcome. The terminology "technological development" usually refers to a *general* trend. Any specific development thus becomes part of a larger process. The notion of design thus makes it easier to think in terms of originality, whereas the notion of technological development shifts the question to how the new technology fits into a larger totality. Underlying technological development is therefore the idea of progress, the issue of building on something prior, which will be better than or

Table 1 Discourse tendencies

Design	Technological Development
Specific Innovation	General Trend
Originality	Process
Change	Progress
Imagination	Production
Aesthetic Considerations	Efficiency
Individual	Team
Credit	Anonymity
Inventor	Corporation
People	Technology
Iteration	Linear

improve on what already exists. This then restricts the possible range of choices for the engineer. For design, however, if originality is the criterion, while it is still possible to reference the notion of "better," the primary focus is on being different, on creating a rift with that which has come earlier.

The question of aesthetics also functions differently in the two discourses. In technological development, the production function is primary; that is, the idea of improvement is based on whether a given task will be performed more efficiently by a new device, a criterion often arising out of the nature of the technology. This further limits the scope of what constitutes appropriate development. In design, however, if the criterion is originality, then the device as a whole becomes the subject of concern, not simply one aspect or function of it. This, in turn, vastly increases the number of perceived choices and justifies the designer in bringing other elements into the equation, such as ethical considerations. A development is a part of a chain; a design implies the interruption of a chain.

In contemporary engineering, design and technological development are most typically characterized as team based, but design continues to be associated with the idea of individuality, so that the designer has the sense that she is placing her mark on something. For example, news magazines such as *Time* regularly publish lists of creative "design" activities that highlight particular individuals for their creative power and originality, while trends in technology are described in terms of industries or company initiatives. Thus, in technological development, what is absent is a focus on people. Instead, the focus is on the technology, on how well it performs its designated function, and because of this, there is a lack of ethical concern beyond the question of functionality. The idea of responsibility, which is at the core of ethics, is thus narrowed only to the technical; for example, in terms of durability or safe use. The wider issue of coherence with societal priorities is ignored, and, once the technology is developed, becomes difficult to raise. Yet asking how well a device performs its function is clearly different from raising the range of ethical questions that are relevant to the introduction of a new technology, for example, in terms of materials being used in the production process and its effects on human beings and the environment.

A further distinction between the two discourses is that the process of engineering design is generally seen as being iterative, while technological development is linear. Design, viewed in terms of a feedback loop, provides the opportunity for revision

and rethinking, thus increasing the range of perceived choices. While modifications are also possible from the perspective of technological development, these are focused on the question of improved fit or other standards of progress. Further examination thus actually decreases the range of perceived choices to those that are "most appropriate," rather than increasing them.

An example of the contrast between these two types of discourses can be found in the public's image of the Apple I-Pod versus the manufacture of Dell computers. The I-Pod is sold to the public as a technology that integrates form and function, so that its aesthetic considerations appeal to the public just as much as what it does. Steve Jobs is hailed as a creative genius and receives much of the credit for creating public desire for a product that is sold based on its originality, independently of whether it actually fits with a previously existing trend of devices for listening to music. Each new version of the I-Pod is viewed in the popular literature as another revolutionary "must-have" device, although it only expands the capabilities of a previous version or miniaturizes the device further. By contrast, the Dell computer is seen by the public as a pure commodity. Progress here is not defined in terms of originality, but rather in terms of its opposite. Dell prides itself on relying on parts manufactured by others and on making the production process as efficient as possible. The attraction of the product is increased computer power with each new version of the computer, at a lower cost. Michael Dell is hailed as a genius, but one whose genius is reflected in developing innovative production processes rather than in design originality.

Another way of looking at the same contrast is in terms of the popular late twentieth-century contrast between American "innovation" and Japanese *kaizen*. Masaaki Imai (1986) characterized the distinction: "Innovation is dramatic, a real attention-getter. *Kaizen*, on the other hand, is often undramatic and subtle, and its results are seldom immediately visible. While *kaizen* is a continuous process, inno-vation is generally a one-shot phenomenon." (1986, 23). Given the Japanese success in the marketplace during the 1970s and 1980s, American companies were urged to imitate the Japanese model, the implication of course being that it is building on the past in an incremental fashion that matters, not the originality of the product. Design considerations thus began to take a secondary role to manufacturing innovations, such as those developed by Dell, in the quest to duplicate Japanese success. The Japanese, who had been known as borrowers of foreign technology, which they then produced more efficiently and at less cost, became the model for processes such as just-in-time parts delivery and team-based manufacturing. We argue that the shift in emphasis that accompanies the move from design to technological development has embedded within it a potential for neglect of ethical considerations.

5 Ethical Implications of the Discourse We Employ

In their study of "Ethical Considerations in Engineering Design Processes" (2001), Van Gorp and Van de Poel point to two central features of the design process recognized by engineers. These are issues of trade-offs, for example between safety

and economic considerations, and the generally ill-defined nature of design problems, such that there is no given optimal solution to the design problem. Both of these considerations explicitly provide the opportunity for ethical reflection, even if the position is taken in the end that ethical intervention by the engineers is not justified. Questions arising out of the process of making trade-offs might be: "How should one decide, for example, on the relative importance of safety versus costs? Who is to make this decision? The engineers, the manager or principle [sic] of the project, the portrayed users, the people possibly affected, the general public? And how is this decision to be made in an ethically acceptable way?" (2001, 19). In relation to the ill-defined nature of engineering design, Van Gorp and Van de Poel conclude in a preliminary fashion based on their study: "If requirements need to be further operationalized, which is regularly the case, or if requirements cannot all be met at once, which is also regularly the case, this seems to trigger off reflections on and discussions relating to requirements. Ethical aspects can, but do not necessarily, play a part in these discussions" (2001, 21).

Given the need for trade-offs and the ill-defined nature of engineering problems – especially when we consider the combination of social, ethical, and technical aspects – no one optimal solution exists for an engineering problem. Once this is recognized, then the issue of choice can come to the fore, along with a sense of responsibility for one's actions. In terms of traditional engineering ethics, this means that considerations of the impact of the design on the public and its safety, on the natural and human environment, and on the utilization of different types of natural resources can come to the foreground. Engineering ethics, conceived in this fashion, can be broadened to cover issues beyond traditional ones such as confidentiality and conflicts-of-interest. The focus on design as a process imbued with ethical considerations makes possible a wider perspective on the societal implications of technology than the technologically governed emphasis on production, progress, and efficiency.

The difference in emphasis between the two ways in which we can discuss the work of engineers can guide us in overcoming the barriers to ethical reflection by the creators of technology. How do we draw on our understanding of sociotechnical systems to identify fruitful ways of talking about the process and increase awareness of ethical choices? To begin with, we know that we need to be very careful about the kinds of sociotechnical systems that we put in place. As Hughes' (1987) concept of technological momentum reminds us, we generally experience a foreclosing of options once a choice has been made and a system put in place. This means that ethical reflection must be seen as being appropriate throughout the design process, especially at its earliest stages. Johnson, Gostelow, and King in *Engineering & Society* (2000) paraphrase Hughes saying, "Once the first step has been taken, it is difficult if not impossible to stop a development....detailed discussion is essential *before* the technology proceeds" (2000, 542).

Johnson et al. describe the first step of the design process in familiar terms: "Review the problem area and select the need that is to be addressed" (2000, 293), and go on to comment, "Both the review of the problem area and the choice of the specific need that is to be addressed are relatively subjective processes. They set

the design agenda and belong in a broadly political and commercial strategic domain. *Engineers should be encouraged to be much more involved in this key part of the design process.* [emphasis added] This is the point at which broad issues such as ecological sustainability of design outcomes are most effectively addressed. It is also where basic ethical choices are made about professional priorities, including what problems and issues will and will not be addressed" (2000, 291 and 292). This kind of framework redefines the engineer's sphere of appropriate analysis and decision-making in a way that is much more conducive to a sense of openness and choice – and, thus, to ethical responsibility.

If we can draw on what we do know about sociotechnical systems, we also need to realize what we do *not* know. A compelling discourse of design must be based on a sound philosophy of engineering, which is in turn based on a sound philosophy of technology, and poses three basic questions: How does technology evolve? How are the choices made as to which potential technologies will be developed and which ignored? Who makes these choices? (Ihde paraphrased by Johnston, Gostelow, and King, 2000, 542) Although we have made progress in answering these questions, we have yet to answer them in ways that engineering practitioners find easy to operationalize. Furthermore, a key task for the philosophy of engineering will be to reconcile the macro level of philosophy of technology with the micro level that Martin and Schinzinger describe as the "individual as the ultimate locus of action" (1989, 331). Broader responsibilities inherent in the process of design can be brought to the awareness of engineers involved in the design process; however, the question of the extent to which engineers as designers are justified in imposing their own values on the process of technological development remains a key issue (Luegenbiehl, 1985, 93). This last point highlights the importance of addressing the way both engineers and non-engineers think about and discuss the work of engineers.

6 Developing a Compelling and Accessible Narrative of Individual and Collective Empowerment

One way of overcoming the current dichotomy between discourses of individual responsibility and technological inevitability is to refocus the discussion of technological progress and individual determination around a common theme that captures a wider sense of responsibility within the framework of human intention. As an example, we will here use William McDonough's "Centennial Sermon on the 100th Anniversary of the Cathedral of St. John the Divine, New York City" (McDonough, 1993). He points us toward a process by which we can develop a compelling narrative in which engineers as responsible moral agents play a key role and where relevant decision-making junctures can be identified. It is notable that McDonough – an architect, not a minister or theologian – chose to cast his first formal public declaration of his perspective on the creation of technology in the form of a sermon and to deliver it in a cathedral. From the outset, his ideas are framed both literally and figuratively in contexts of traditional moral and ethical authority. He also uses biblical

language and imagery to articulate his new definition of design: "If we understand that design leads to the manifestation of human intention, and if what we make with our hands is to be sacred and honor the earth that gives us life, then the things we make must not only rise from the ground but return to it, soil to soil, water to water, so everything that is received from the earth can be freely given back without causing harm to any living system" (McDonough, 1993, 3). Design – the making of things with our hands – goes beyond being pragmatic and becomes a sacred activity through which we either honor or dishonor the source that gives us life.

For readers to whom the spiritual dimensions of this framing are not persuasive, McDonough offers another level of imaginative transformation centered on "the concept of design itself as the first signal of human intention" (1993, 3). Through this concept, "design, ecology, ethics and the making of things" become inextricably intertwined. In this model, the things we make are representations and signals of "our longings and intentions." Our designs, in other words, communicate and announce our intentions even if we do not speak a word. The products of design express principles or ideas in visible form. They epitomize and embody and, in the process, speak volumes about our intentions even when we have not explicitly articulated those intentions. In this framework, artifacts, systems, and structures "speak." McDonough calls our attention to what we are essentially saying when we design and operate systems in a certain way: "Our culture has adopted a design stratagem that essentially says if brute force or massive amounts of energy don't work, you're not using enough of it" (1993, 3–4).

McDonough further develops the idea of products or designs as "speaking" about our aspirations and intentions by using the concept of "idiom," which carries meaning in both design and communication contexts. In place of the "industrial idiom of design" which we can associate with the concept of development, he proposes the idea – based on "natural design" – that "waste equals food," in other words, that all wastes produced serve as food for other systems. "All materials given to us by nature are constantly returned to the earth without even the concept of waste as we understand it. Everything is cycled constantly with all waste equaling food for other living systems" (1993, 4). This new model serves as an incentive to creativity, and evokes, and is compatible with, a very different ethical framework than the "idiom of industrial design."

In the domain of engineering design, especially engineering design sponsored in the context of capitalist organizations, the equivalent of McDonough's model may lie in the emerging concept of "doing well by doing good," that is, approaching business with the aim of balancing the financial bottom line with the bottom line of ethics and social concerns (Finkel, 2002, 2). The "doing well by doing good" approach leads researchers at Northwestern and the Wharton School of Business to address subjects in which ethics and issues of social responsibility "become a central focus of management thinking in general" (2002, 5). "Balancing the relationships between financial success and a progressive social agenda can prove extremely complicated for business" (2002, 5), but it can also be a great source of individual and collective empowerment, especially for engineers whose own professional history is rooted in an emphasis on "doing good."

7 Conclusion

We have argued in this chapter that disrupting the discourse of inevitability will require us to recognize and confront the sources of its robustness. To put it simply, we must find a way to connect with public discourse on a large scale and to develop accessible and persuasive narratives in which the individual engineer can make a difference. Developing an accessible discourse that will help people reinterpret their own experience is an essential step in this process. Another is to help both the community of engineering professionals and those outside it recognize that we have choices about the forms of discourse in which we engage, and that those choices matter. One key element in realizing these goals will be for STS scholars to engage with public discourse and offer accessible and persuasive narratives of design as a process imbued with ethical considerations.

The point of this chapter is not to make a claim about the nature of technological development. It is to focus on the impact of our way of speaking about the process of the introduction of technology in society. It is our argument that the mode of discourse in relation to technology, as well as elsewhere, is centrally relevant to how we perceive the thing itself. This is not a new thesis in its theoretical dimension, (see, for example, Heidegger, 1977) but one which has often been ignored in the dominant focus on the object (technology) itself. STS has done an admirable job of looking at the dual influence, i.e., feedback loop, between technologies and society, but in that very feedback loop has implicitly expressed a notion of inevitable progression. To give true voice to ethical concerns, however, it is important not to see technological development simply as a chain of developments, of which any human actors become simply another link, but instead as an opportunity for the expression of creative and original impulses (upsurges in Being). If we can focus the discourse of technology on this dimension, then the opportunity for ethical discourse and reflection arises for the central actors in the process. The how, why, and wherefore of technological innovation will be subject to interrogation without a predetermined answer based on a narrow conception of progress, for example, increased efficiency. The outcome of that process will be seen as the STS community already accepts: indeterminate.

References

Ellul, J., 1964, *The Technological Society*, J. Wilkinson, trans., Knopf, New York.

Finkel, E., 2002, Doing well by doing good: new Kellogg BASE major explores the social context of business, *Kellogg World* (Winter 2002); http://www.kellogg.northwestern.edu/kwo/win02/indepth/doingwell.htm

Frost, B., 1996, Historical dimensions of high tech: the politics and rhetoric of progress talk in twentieth-century France. *American Historical Association Meeting* (Atlanta, January, 1996).

Heidegger, M., 1977, *The Question Concerning Technology and Other Essays*, W. Lovitt, trans., Harper Torchbooks, New York.

Hughes, T. P., 1987, The evolution of large technological systems, in: *The Social Construction of Technological Systems: New Directions in the Sociology and History of Technology*, W. Bijker, T.P. Hughes, and T. Pinch, eds., MIT Press, Cambridge, MA, pp. 76–80.

Kroker, A., and Weinstein, M. A., 1994, *Data Trash: The Theory of the Virtual Class*, St. Martin's, New York.

Idhe, D., 1993, *Philosophy of Technology: An Introduction*, Paragon, New York.

Imai, M., 1986, *Kaizen: The Key to Japan's Competitive Success*, Random House, New York.

Johnston, S. F., Gostelow, J. P., and King, W. J., 2000, *Engineering & Society*, Prentice Hall, Upper Saddle River, NJ.

Luegenbiehl, H. C., 1985, The nature of engineering ethics: preliminary considerations, in: *Technology Studies Resource Center Working Papers Series*, Vol. 2, Feb. 1985, S. H. Cutcliffe, ed., Lehigh University, Bethlehem, PA, pp. 79–98.

Martin, M. W., and Schinzinger, R., 1989, *Ethics in Engineering*, 2nd ed., McGraw Hill, New York.

McDonough, W., 1993, Design, ecology, ethics and the making of things: centennial sermon on the 100th anniversary of the Cathedral of St. John the Divine, New York City, February 7, 1993; http://www.mcdonough.com

Pacey, A., 1983, *The Culture of Technology*, MIT Press, Cambridge, MA.

Sasseville, B., 2004, Integrating information and communication technology in the classroom: a comparative discourse analysis, *Can. J. of Learn. and Techn.* 30(2); http://www.cjlt.ca/content/vol30.2/cjlt30-2-art-1.html

Schlosser, E., 2002, *Fast Food Nation: The Dark Side of the All-American Meal*, Perennial, New York. (2001, Houghton Mifflin).

Selwyn, N., and Gorard, S., 2003, Exploring the 'new' imperatives of technology-based lifelong learning, *Res. in Post-Compulsory Edu.* 8(1):73–92.

Van Gorp, A., and Van de Poel, I., 2001, Ethical considerations in engineering design processes, *IEEE Technol. and Soc. Mag.* Fall 2001:15–22.

Williams, R., 2002, *Retooling: A Historian Confronts Technological Change*, MIT Press, Cambridge, MA.

Winner, L., 1977, *Autonomous Technology*, MIT Press, Cambridge, MA.

Design and Responsibility

The Interdependence of Natural, Artifactual, and Human Systems

S. D. Noam Cook

This essay explores design as the imposition of human purpose onto nature. It argues that understanding design requires that we be able to distinguish among three different kinds of systems: natural, artifactual and human. Each kind has its own distinct requirements for stability and sustenance, yet each is also dependent upon the stability and sustenance of the other two. Design entails crafting artifactual systems by imposing aims and values from human systems onto the raw materials of natural ones. Effective and responsible design, moreover, is undermined when distinctions among systems are ignored or when one kind is treated as another. Life as we now live it is increasingly dependent upon the stability of our artifactual systems; this, in turn, is increasingly dependent upon our ability to make the value judgments by which alone we can determine that a design is worth making and how best to realize it.

1 Introduction

Design is the imposition of human purposes onto nature. What results is neither human nor natural, but something that exists in a world of its own, where form and function cannot be explained solely in human or natural terms. In modern times, this world of artifacts, equally alien from us as from the earth out of which it was made, is nonetheless our primary home. We depend on its presence and stability for our daily lives to transpire unproblematically, and we more often than not turn to it when life's problems send us in search of remedy. Although we live in this world – not so much given as made, and increasingly the product of our own artifice – we now often live as though we were scarcely aware of its unique character as an object of design. The admixture of human purposes with the stuff of nature that constitutes that character includes particular requirements for sustenance and stability, and demands of us an astonishing measure of responsibility in choosing what artifacts should exist, how they should function, and how long they should endure.

S. D. N. Cook, San Jose State University

P. E. Vermaas et al. (eds.), *Philosophy and Design.*
© Springer 2008

None of the artifacts that make up this world function in isolation. Whether it is a tool or building, computer application or ballpoint pen, every artifact is suspended in a network of social relations that brought it about, see to its use, compass its ultimate disposal and, importantly, link it to other artifacts. The specifics of an artifact's design also arise in social contexts and it is only within such contexts that its various functions can be deployed. Light does not issue from a lamp alone, but from the interaction of the lamp with someone who turns it on and makes use of the illumination. More complex undertakings, such as the mining of coal, the manufacture of automobiles, or the irrigation of extensive farmlands, entail even greater and more subtle networking of technical and social elements. Along with the modern expansion of such enterprises, there has been a growing effort to understand this world of artifacts not as individual technologies but as "socio-technical systems."

The idea of socio-technical systems has its roots in the middle of the 20th century. Cybernetics (Wiener, 1962 [orig. 1948]), operational research (March and Simon, 1993), and systems theory (Bertalanffy, 1968), each of which came of age during the Second World War, made seminal contributions to treating in singular terms a collection of individual devices functioning together. Occasionally, studies in these areas would also assess the role of the teams that operated those systems. It was, nonetheless, the work of the Tavistock Group, and that of Emery and Trist (1960) in particular, that in the late-1950s began to address explicitly what they called "socio-technical systems" (indeed, Emery and Trist most likely coined the term). Here the key idea was, for a given task, to see both devices and people as a functioning unit, and to apply this perspective to the conception, design, application and assessment of what was then taken to be a socio-technical system. In recent years, both the practice of and the need for this perspective has been recognized in numerous areas.

All artifacts are also embedded in the social world in a simple but fundamental sense. That is, all artifacts, to one degree or another, are socio-technical systems because they are, to one degree or another, prosthetic: they are extensions of us. What our artifacts do is always in some way a matter of what we do with them. Accordingly, they must be understood not only in terms of their "built-in" functions but also with respect to the human activities in which those functions are deployed and the human purposes, or their lack, which they serve. Even the simple case of an alarm clock reflects this prosthetic character. It is often observed that an alarm clock once set and turned on can function autonomously, that is, without our imme-diate intervention. This does not mean that it is totally autonomous, however. No technology ever has been. If I were to attach the alarm clock to a bomb, it is I, not the device, who would be held responsible for the explosion. In this sense at least, our artifacts are inescapably prosthetic in character, both instrumentally and morally. Indeed, even when we design our technologies to have a degree of instrumental autonomy, they remain always morally prosthetic.

There is another important sense in which artifacts are connected to human affairs, in this case to human values. No design can be explained solely by appeal to its functions, intended or otherwise, because a given set of functions can always be achieved by more than one design. This is why all lamps are not alike, nor are

all cars, water bottles, power plants, software interfaces, etc. Along with function, the design of an artifact must be explained in terms of explicit or implicit value choices made by its designer. Indeed, the mere fact that an artifact exists suggests that someone made the value judgment that it was worth having in the first place. Such value judgments can be aesthetic, moral or both. But they are always part of design. So the mixing of human purposes with the stuff of nature results in artifacts that necessarily reflect the intentions and the values of their makers.

Yet, to understand better how socio-technical systems are embedded in the human world, including the formative role that value judgments play in that world, I believe our conception of socio-technical systems must be expanded. In particular, we need to see how the design of our artifacts, particularly the complex ones upon which life as we now live it depends, is bound up with three distinct but interdependent kinds of systems: natural, artifactual, and human. Accordingly, in what follows, I explore some of what I believe is called for in a broader understanding of what we do when we impose human purposes onto nature.

2 Systems and Design

In his 1893 essay, "Evolution and Ethics," T. H. Huxley (2002 [orig. 1896]) considers the difference between a jungle and a garden in his exploration of the mechanisms of evolution. Today, with developments in evolutionary theories and the broad establishment of environmental studies, the difference between a jungle and a garden may seem obvious or even trivial. I think the distinction is well worth revisiting, however, because it holds implications that are vital to understanding how the world upon which modern life depends is constituted.

In modern terms, a jungle can be explained by appeal to the push and pull of evolutionary adaptation, the vagaries of weather, and other workings of nature. We can also easily point to jungles as one of several kinds of "ecological niches." Indeed, they can be seen as exemplars of what I would like to call "natural systems." That is, they are systems whose activities can be explained by appeal to natural factors (in a way, at least, that distinguishes those factors from ones rooted in human agency or activity). The field of environmental studies has given us ever greater sophistication in specifying the characteristics of natural systems, including how they operate under the impact of human activity, reflecting the distinction Dewey (1938) notes between our "living in" and "living by means of" the environment.

Natural systems, like all systems, have their own unique requirements for sustenance and stability. In the short-term, a jungle needs water, nutrients and sunlight to sustain itself as a healthy living system. For its long-term stability, that is, its ability to maintain the crucial balance between stagnation and chaos that enables it to remain a jungle, a jungle needs internal regulators that are resilient in the face of broader changes in the climate, encroachment of new species, etc.

Significantly, the natural forces we can find at work in a jungle are no less present in a garden. Indeed, if we fail to look after a garden's stability and sustenance

needs as part of the plant kingdom, providing water and sunlight, for example, it will fade or die. In this sense, a garden is as much a natural system as a jungle is. Unlike a jungle, however, what goes on in a garden cannot be explained solely by appeal to the workings of nature because a garden is also an artifact. It is a human creation, a jungle upon which a design of uniquely human origin has been imposed. Any particular characteristics or requirements it may have that arise from it being a garden rather than a jungle (tilling, weeding, fertilizing, etc.) find no origin or criteria in nature. Rather, they are utterly human. And if we fail to look after a garden's stability and sustenance needs as an artifact, it will revert all too quickly to the state of nature from which it was drawn. Accordingly, any satisfactory explanation of the form and function of a garden requires appeal to the requirements of nature and to the requirements of its design as an artifact.

This is true of all artifacts. Whether gardens or cities, tools or technologies, automobiles or the Internet, all human creations are a mixture of natural materials and human purposes, and both aspects demand our attention. A bridge must be understood equally in terms of the functions its design affords, and the properties of its raw materials that afford its design (Cook and Brown, 1999). One the one hand, the form a particular bridge takes can by keyed to the functions of spanning a particular distance, supporting a range of loads, etc. On the other hand, its form needs to be accounted for in terms of what the bridge is made of. A bridge built to serve a specific set of requirements for span and load would look quite different if its raw materials were different – stone would afford one range of design possibilities, steel another.

Because such systems are artifacts, and because their forums and functions cannot be adequately explained in terms of the properties of natural systems alone, I call them "artifactual" systems. (I prefer this term to "man-made" since it is gender-neutral, and to "artificial" because that can suggest "phony," which artifactual systems clearly are not. "Artifactual" is also meant to remind us that such systems are human creations.)

As human beings, we interact not only with nature and our artifacts but also with one another. This includes all forms of intra-human interaction, from dialogue to teamwork to organizational behavior to the modes of discourse and forms of activity necessary to vital public life. That aspect of human interaction that is distinct from the mediation of natural or artificial systems is what can be understood, following Vickers (1996 [orig. 1965]; 1983), as the workings of "human systems." If I communicate with you by yelling across a field or speaking over the telephone or sending an email over the Internet, there are natural and artifactual systems that afford our communication. But they alone cannot account for the meaning of what we say or for the net of expectations that the communication fulfills or for the value that we place on what is said. All of that transpires within a human system that you and I share, that we most likely inherited from any common social groups to which we belong and from human culture in general. We may speak over the telephone, but we communicate with each other. The success of our communication is at least as much dependent upon the presence and stability of a set of human norms that make our communication meaningful and actionable, as it is on the clarity of the signal carried through the telephone.

Human systems entail those standards that give form and direction to human activity, particularly, our aesthetic and moral values; they are unique among systems in that they have an axiological dimension. The actions we take and the choices we make reflect our values. They can also be seen in what we do with respect to all three kinds of systems. How we shape or despoil nature, what artifacts we decide to create and how we design and use them, and the ways we treat one another all testify to what we consider worth doing and which ways of doing them we find appealing or desirable. In explaining the form a garden takes we necessarily refer to those values of distinctly human character that have been incorporated into the garden's design: the aesthetic traditions that enable us to distinguish an English garden from a Japanese one, and by which we judge one garden to be modest and another world-class (for a parallel exposition of systems and ethics, see Cook, 2005).

In this sense, a bridge is not merely a static physical object. Just as an understanding of its design must include the affordances of its material, it must also include the values of its designers. Why it is built and located where it is, why it enables some forms of traffic and not others, why public funds are committed to a grand appearance when a more modest bridge could have the same carrying capacity, all these must appeal to the workings of the human systems within which the bridge is conceived, built and maintained. Conversely, no adequate explanation of why the bridge has the particular physical dimensions and properties it does can be given without reference to the values and purposes of the human systems in which it came to be. A bridge, like all artifacts, is the product and the embodiment of natural, artifactual, and human systems.

This distinction among these three kinds of systems finds a reinforcing parallel in the distinctions Hannah Arendt (1998 [orig. 1958]) draws among labor, work and action in her examination of human activity. Indeed, Arendt describes the whole of human activity as made up of those three distinct forms. In each case, I would apply her focused treatment of activity to the broader notion of systems.

Labor for Arendt is that part of human activity that confers to maintaining ourselves as biological beings. "Labor," Arendt says, "is the activity which corresponds to the biological process of the human body, whose spontaneous growth, metabolism, and eventual decay are bound to the vital necessities produced and fed into the life process by labor." (Arendt, 1998, 7) Seemingly, at the individual level this would at minimum include getting food and drink, protecting ourselves from the elements, and dodging predators. On such group levels as a community or even the species, it would include activities like adapting to the local environment and reproducing. All this constitutes a complex of interconnected and interdependent activities, which we share to one degree or another with other species. These activities are part of the biological world, and as such are part of nature. Labor, then, is that aspect of human activity that is given over to maintaining ourselves as natural systems.

Work, as Arendt defines it, is concerned with bringing about and sustaining the "world of things, [that is] distinctly different from all natural surroundings." (Arendt, 1998, 7) That is to say, work brings about the world of artifacts. These artifacts are distinctly human (other species may make things, but they do not make human things), which is to say they are the result of human purposes imposed upon nature.

Together they constitute a network of objects and gadgets within which we increasingly live and whose presence and stability in the modern world are evermore necessary to any form of life we might recognize or find acceptable. Work, therefore, is that aspect of human activity that creates and maintains our artifactual systems.

Action, in Arendt's view, is that aspect of human activity that "goes on directly between men without the intermediary of things or matter ..." (Arendt, 1998, 7). I would make this point a bit more broadly. It is not as though activity necessarily does not involve the mediation of things and matter. Rather, action is that part of human activity which is distinct from such mediation. "Things" are what make up the artifactual world and "matter" is the substance of nature. Both things and matter can provide the means by which humans interact, but neither can constitute the content of that interaction, nor provide the ends that it serves. Action, thus, is that aspect of human activity out of and within which human systems are formed and endure.

All three kinds of systems also interact with one another, and the flourishing of one can depend on the stability of the others. Just as we can see the artifactual system of a garden fail when we ignore its needs as a natural system, so can we see technologies fail when we ignore the requirements of the human systems within which alone they can function. Likewise, the fact that a garden will revert all too quickly to jungle if its needs as an artifactual system are not met has parallels in the case of cities, organizations and technologies, each one of which has its own version of reverting to jungle. The character of our values cannot be obscured or offset by the character of our artifacts.

Human beings live within a network of systems of these three kinds. In the 21st century, the successful functioning of our ordinary daily lives, to say nothing of our prevailing under exceptional circumstances, is utterly dependent upon the flourishing and stability of these interdependent systems (Cook, 1995). In our day, the design and maintenance of this network of systems is, I believe, a prime moral responsibility of humankind, if for no other reason than that our very existence is now utterly dependent upon it.

3 Design and Responsibility

3.1 Mislabeling Systems and the Fallacy of Counterfeit Naturalism

Because different kinds of systems have different properties, including different requirements for sustenance and stability, dealing with one kind as if it were another can be anywhere from impractical to irresponsible. It is a conceptual and practical mistake, for example, to treat an artifactual or human system as if it were a natural one. Yet, this is often done. It is also the most dangerous form of mischaracterization of a system since it tends to occlude the role of values in the workings of artifactual and human systems. For example, I recently heard a noted economist remark that, "jobs, like water, naturally flow downhill to the cheapest provider." Technically

speaking, however, there is nothing "natural" about this at all. Economies and job markets are not part of nature, they are systems created by people. The way jobs "flow" is a result of how we design the artifactual systems they are part of. Treating this as natural leaves no basis for assuming responsibility for what it may entail.

Treating artifactual and human systems as natural ones, in particular, amounts to what I call "counterfeit naturalism." If "naturalism" can be defined as understanding something in natural terms (lightning as being caused by weather conditions rather than by Zeus), then "counterfeit naturalism" would mean understand as natural something that is not, particularly when this can be misleading. In this respect, counterfeit naturalism entails at least two significant pitfalls bearing on our understanding of systems.

First, the more we engage in counterfeit naturalism, the more likely we are to diagnose problems and design solutions that may be appropriate to natural systems but not to artifactual or human ones. If we think of the flow of jobs to the cheapest provider as natural, it could make sense to design governmental policies aimed at avoiding interference with this "natural" process. (Indeed, this can even include a sense of "natural" standing in for "good" or "proper.") However, if we think of this in terms of systems we have made, it could make more sense to consider policies designed to redirect or curtail that flow.

The second issue derives from the fact that we generally do not see ethics as part of natural systems. We may hold ourselves responsible for how we treat nature, but we do not find ethics at work within nature itself, particularly in any way that entails the notion of responsibility. No one holds hurricanes morally responsible for the damage they cause. We do, however, hold people morally responsible for what they do with the aid of tools or teams. So, counterfeit naturalism undermines our ability to deal responsibly and effectively with the ethical aspects of human and artifactual systems because it treats them as natural systems that, like hurricanes, have no obvious moral dimension. If the flow of jobs is taken to be a natural occurrence, it would make no more sense to debate the ethics of it than to debate the ethics of the tides.

This is also seen when we attempt to justify our design choices by making claims like "we are going with what works" or "my opponent's plan won't work." Comments such as these point to the functional aspects of human and artifactual systems, but imply that, like natural systems, they are without a values dimension. Appealing only to the functional obscures the role that values play in shaping both the choices we make and the consequences of those choices. Our design choices are never solely about what will and will not work. They are also always about the aims we want to further and what we consider appropriate ways of pursuing them. Keeping the discussion at the level of what supposedly will and will not work misses, or dodges, the need to deal effectively with the values inherent in all design choices.

3.2 Design and Values Infrastructures

Just as natural systems can, and artifactual systems should, afford the purposes of human systems, human systems have what I call "values infrastructures" that

inform the way we treat nature and how we design artifacts. A values infrastructure is made out of what is valuable to individuals and groups about themselves, the physical and social spaces within which they live and work, the various means that they employ to do what they do, and so on.

The connection between our values infrastructures and what we do is a strong one, though at times not acknowledged, as counterfeit naturalism suggests. What is valuable to you plays a significant role in what you consider worth doing, how you like to see it done, with whom you choose to associate, what goals you think are worth striving for, etc. (for a similar treatment, see Schein, 2004 [orig. 1985]). What we find valuable shapes what we do. (By definition, if values did not influence how we act, it would be odd to call them values.) That is, the design of a community's artifacts both embodies and affords the expression of the values to be found in its values infrastructure. (Getting a sense of an individual's or group's values infrastructure can be tricky. I have found that if you ask people what their ethics or values are, they are often uncomfortable. However, if you ask what is valuable to them about their job or the spaces in which they live and work or their associations with other people, an interesting and useful conversation often ensues. And if they can show you, or you can observe examples of this in the course of their actual work practice or social interactions, the picture of the values infrastructure can become even more robust.)

The importance of values infrastructures to the design of technological artifacts and the social practices they are embedded in can be seen in the case of a project team I observed in a high-tech research and development laboratory. The team was designing an early computer conferencing application that could establish a network of "virtual offices" through audio and video connections along with the virtual equivalent of pieces of typical office equipment, such as a whiteboard, a filing cabinet, a book case, etc. A primary aim in the development of this application was making it possible for each user to design a virtual office, through his or her computer, by setting up and configuring audio and video links and organizing the virtual office equipment. Others in the network would then be able to "visit" the virtual office through the computer network, have meetings via the audio and video connections, while also consulting documents in the virtual filing cabinet or illustrating ideas on the virtual whiteboard, etc. When an office holder is out, a "visitor" could leave messages on the whiteboard, get documents from the filing cabinet. if permitted by the office holder, etc. (The "virtual" elements of such gadgets constitute a particularly provocative example of technological artifacts as "prosthetic.")

The team leader decided early on that the application should be designed to be as flexible as possible. His idea was that each end-user could in turn design a virtual office that would fit his or her individual needs and style. I spoke at length with him concerning this, and quickly learned that he was passionate about this flexibility. He gave maximization of flexibility as a reason for the team's design choices at various levels of the application. When we first discussed this, he gave examples from what may be the most obvious elements of the interface, such as whether or not to have a virtual whiteboard, where to locate it, and deciding who could have access to it. But as we discussed this further, he took the matter of flexibility down

to the level of the architecture of the software and even in a couple of cases to writing the software code. During the discussion, I asked him in various ways why flexibility was so important to him. Repeatedly, he indicated that he was committed to "empowering the user." Toward the end of the conversation, he began to justify flexibility for the user in terms of workplace democracy. Ultimately, flexibility, user empowerment and workplace democracy emerged, to my mind, as values that guided his work – in fact, values of a moral character. He and his team literally built these values into the technology (for a similar point, see Winner, 1986). I mean "literally" in that one could not explain why the application had certain character-istics that it did without reference to those values.

When it was initially ready, the virtual office application was tested by installing it on the computers of a group of administrative staff in the lab. Although the "admins" had been eager to be part of the test, once the application was installed, they made little use of it. In fact, they hardly configured their virtual offices at all, and when they did, their designs were far simpler than what the system was capable of. Whatever else this may have indicated, it meant that the admins took almost no advantage of the flexibility that the project team had worked so hard and passion-ately to put into the design of the system. At this stage, the application looked like a potential failure.

During the test, I talked with some members of the admin staff about the appli-cation. When I asked them about the test and what they had done, or not done, in configuring their virtual offices, they said that they couldn't make much sense out of it and that they felt "abandoned." From their perspective, the project team came in, installed the application and went away. The admin staff had wanted more guidance and help from the design team. In further discussions with the admin staff, it became clear to me that among the things that were valuable to them about their work were feeling included and supported.

This, it seemed to me, was a source of the problem. The virtual office application, as an artifactual system, had the values of the design team built into it. But the design team and the admin staff, as human systems, had different values infrastructures. Flexibility for the user as envisioned by the design team, clashed with the admin staff wanting to feel supported. Consequently, what was intended as democratic empowerment was taken as abandonment. So, the problem encountered in testing the application's initial design was not technological so much as it was axiological. In untangling the problem, reconfiguring the functions of the application alone would not very likely address the situation because the criteria against which it was designed in the first place were not functions but values. Since the problem rested with the clashing values infrastructures of the two interconnected human systems, it is there that criteria for a fix were to be found. It was important, I felt, to deal with the clash of values at the level of the human systems. This, in fact, surfaced when the two groups began to talk with one another about the lackluster test. The admins came to understand that the developers had intended the flexibility to put more power in their hands, even though it ended up being technically more than they were comfortable with. The value that the admin staff placed on being supported in dealing with new workplace technologies, meanwhile, came to the attention of the

project team leader. The design team was then in a better position to plan the next phase of the project to include more follow-through support for the admin staff while still incorporating a good measure of flexibility into the design of the application.

The virtual office application can be seen as a socio-technical system. It was conceived of as a technology to link together members of a social group, who in turn could configure the technology in keeping with their needs and styles. In the terms of the broadened perspective on socio-technical systems presented here, the application was an artifactual system that was designed to afford various functions of the human system that would use it. As an artifactual system, its design could not be explained solely in terms of the technical functions it was to serve, but also required reference to the values of its designers. To be useful, to flourish, the application also needed to be configured by the users in ways that would be stable enough to afford the desired social functions, thus enabling them to flourish as a "virtual" group, and to do so in a sustained and sustainable way. The test failed because the admin group made little use of the application's flexibility. This was due to a mismatch between the values infrastructure of the designers, as built into the application, and that of the users. So both the original design of the application as a technological artifact and its failure to afford the intended social functions were rooted in the axiological dimensions of the two human systems.

4 Conclusion

Our lives are today are suspended within a complex network of systems, and increasingly dependent upon their sustenance and stability. This network contains three kinds of systems, natural, artifactual, and human, that are as distinct as they are interdependent. Artifactual and human systems, from economies to cities to organizations to the latest technologies, are products of human design. They embody, by choice or default, our axiological judgments about what is worth doing and how best to do it. If the systems we make are to afford patterns of human life in any way we ought to find acceptable, and reflect the fact that everything we may make is ultimately dependent upon the flourishing of nature, we must make deliberate values assessment a much more explicit element of how and what we design.

References

Arendt, H., 1998, *The Human Condition*, University of Chicago Press, Chicago (orig. 1958).
Bertalanffy, L. von, 1968, *General System Theory: Foundations, Development and Applications*, George Braziller, New York.
Cook, S. D. N., 2005, That which governs best: leadership, ethics and human systems, in: *The Quest for Moral Leaders: Essays on Leadership Ethics*, J. B. Ciulla, T. L. Price, and S. E. Murphy, eds., Edward Elgar, Cheltenham.

Cook, S. D. N., and Brown, J. S., 1999, Bridging epistemologies: the generative dance between organizational knowledge and organizational knowing, *Organiz. Sci.* **10**(4):381–400.

Cook, S. D. N., 1995, Autonomy, interdependence, and moral governance: pluralism in a rocking boat, in: *Rethinking Public Policy-Making: Questioning Assumptions, Challenging Beliefs*, M. Blunden, and M. Dando, eds., SAGE Publications, London, pp. 153–171.

Dewey, J., 1938, *Logic: The Theory of Inquiry*, Henry Holt and Company, New York.

Emery, F., and Trist, E., 1960, Socio-technical systems, in: *Management Sciences, Models, and Techniques*, Vol. 2, C. W. Churchman and M. Verhulst, eds., Pergamon, Oxford.

Huxley, T. H., 2002, Evolution and ethics [1893], in: *Evolution and Ethics and other Essays*, University Press of the Pacific, Honolulu (orig. 1896).

March, J. G., and Simon, H. A., 1993, *Organizations*, Blackwell Publishing, Williston.

Schein, E. H., 2004 *Organizational Culture and Leadership*, 3rd ed., Jossey-Bass, San Francisco (orig. 1985).

Vickers, Sir Geoffrey, 1983, *Human Systems Are Different*, Harper & Row Publishers, London.

Vickers, Sir Geoffrey, 1996, *The Art of Judgment: A Study of Policy Making*, SAGE Publications, Thousand Oaks (orig. 1965).

Wiener, N., 1962, *Cybernetics: Or Control and Communication in the Animal and the Machine*, MIT Press, Cambridge, MA (orig. 1948).

Winner, L., 1986, Do artifacts have politics?, in: *The Whale and the Reactor: A Search for Limits in an Age of High Technology*, University of Chicago Press, Chicago.

Part III
Architectural Design

Form and Process in the Transformation of the Architect's Role in Society

Howard Davis

This chapter describes how the stance of the architect relative to the culture of production changed over time, and how that change has affected the quality of the built world. The profession of architecture as we know it today emerged during the nineteenth century, as the process of designing buildings split from the process of building them. This split changed the nature of the design process itself, resulting in a profession in which the intuitive judgment that was once central to the architect's ability to respond directly to design issues as they arose individually is no longer present. The chapter concludes with a description of how recent theoretical work into the relationships between the creative design/building activity and the quality of the built world provide a basis for challenging the dominant paradigm governing architectural practice.

1 The Question of Process

Most architectural criticism is concerned with questions of the building itself: its form, aesthetics, the way it functions, how it fits or does not fit its context, how it contributes or does not contribute to a sustainable world. Such criticism often assumes that the architect is a neutral agent, and that indeed, what the architect does has not changed over history. "Architects" built the Parthenon; "architects" built Chartres; architects practice today, so they must all have been doing the same thing. Although historians often see the Renaissance as the time when the modern architect emerged, there is relatively little discussion of what this actually meant to the form of the built environment, of how the architects' actual processes of working affected buildings.

There was for example a time when people believed that the Gothic cathedral was the product of craftsmen who were acting completely intuitively, even without drawings, and that was to be contrasted with the rationality of the Renaissance and everything that came after – except perhaps the minor revolt of the Arts and Crafts Movement.

H. Davis, University of Oregon

P. E. Vermaas et al. (eds.), *Philosophy and Design.*
© Springer 2008

The reality is more complex. There were indeed explicit rules that guided the design of the cathedrals, and these were understood by the architects, who happened also to be master masons. And these architects did drawings, many of them. But the drawings were not all done preceding the beginning of construction, as has been the practice for large buildings for over a hundred years now. The design of the cathedral was done hand-in-hand with its construction, so drawings were produced as they were needed, in the context of what had already been built. This was necessary for a building that might take many decades to build, and that would be built by different teams of masons each of which had a subtly different way of building, of cutting stone, of shaping details, within the overall canon of Gothic building. The context was one of gradual change of both the builders and the building over the decades it took to build the cathedral. There were different clients, different masons available, and money drying up and then coming from new sources. (James, 1982) Yet all of this was happening within overall shared understandings of what the building would be, in its style and general form, when it was completed. However, the detailed final form of the building was unpredictable at the beginning. This could happen partly because building was on a pay-as-you-go basis. There was no general contract, no general bid, no thought of specifying the building down to the last door handle before the first spade of earth had even been turned over.

Architects today operate very differently. The most critical difference is that, because of the general contractor, and the general contract, and therefore the need for a bid, the building has to be specified completely before construction. This means that the architect has to predict details without having the context of the building itself to work in. To the extent that the design activity itself represents this kind of prediction, the architect is a designer. But most of the architect's work is completely separate from the activity of building. Where before, the architect's primary role was involvement in the building site, now the standard architectural fee has 1.5% of the cost of the building for something called "construction administration", an activity that follows design.

So the medieval architect and the modern architect each had or has overall responsibility for the form of the building, and each made or makes lots of drawings which if put together specify the building. But the processes they engage in are different. The activities of one, the medieval architect, are intimately woven in with the construction activity, and those of the other, the modern architect, are separate from it.

As will be elaborated later in this chapter, the practice of architecture today has aspects that are guided by artistic innovation, as well as aspects that are normative, or guided by rules that lie outside the control of the architect. Those two sides of the architect's work have always co-existed. Increasingly during the nineteenth century, however, the shared social understandings that had formed the basis of normative practice changed under the impact of industrialization, and became rules that were more technologically determined. The bulk of the built environment has always been made up of buildings that are largely the result of normative practice rather than dominated by artistic innovation.

2 The Emergence of the Modern Architect

During the nineteenth and early twentieth centuries, the role of the architect changed dramatically, along with the rise of the general contracting, engineering and legal professions. Whereas before, the architect was in charge of the building operation itself, the architect gradually became more distant from the building site at the same time that buildings were becoming more complex. But the architect still tried to maintain total control over the building. This changing role was emblematic of the change of the entire building culture, which was becoming more fragmented and specialized, without a guiding philosophy of style or value.

Isaiah Rogers was an architect who practiced in New York and Boston during the nineteenth century. His journal, now archived at the Avery Architectural Library at Columbia University, provides a vivid window into the architectural practice of his time. These entries are from 1838, near the beginning of Rogers' career. (Rogers, 1838)

> January 4. Committee directed me to go to Quincy to examine the state of the quarry. Finished plastering large room. Made plan of two houses for Red Hook Company.
>
> February 12. At the church putting up the furring of the dome ceiling. Declined making plans of Sugar House. Mr. Woolsey not willing to pay 2 1/2 per cent cash for plans and overseeing. Paid penny post for letter, $3.06 up to this date. Went to Mr. Buckingham's lecture on Egypt. Very good.
>
> February 23. Completed the estimate of cost of Exchange. Went to an auction of books in the evening. Bought a set of Newton's Vitruvius. Large copy for 6 3/4 cents per volume.
>
> March 30. Made plan for marble work in Exchange Room. Accepted the appointment of director of New Jersey Stone Company. Compensation 10 shares of stock of the company. Completed the blacksmith shop.
>
> April 4. Commenced vaulting of back stairs on Exchange Place. Prepared setting center for arch corner of Wall and Hanover Streets. Fine weather for work. Gave Mr. Barry (?) plan of marble for doors in Exchange Room. Bought a cow to be delivered on Thursday. Paid $50.00. Setting stone corner of W[all] and William Streets. Bevels not right.
>
> April 5. Work progressing well at Exchange. Requested to give opinion of granite of Edgecomb quarry. Cow brought home. Made plan of cottage for Long Island. Made plan of stores, etc. at corner of Grand and Center Street.
>
> April 6. Center of room corner of Hanover and Wall Street set. Setting ashlar on Wall Street. Measured the front on Wall Street. Found 4 inches west of the center more than than on plan. Setting door sills and jambs at the church. Weather fine for April.
>
> April 18. Arrived at Boston 10 o'clock. Called on the mayor. Gave him a plan of City Hall. he appeared to like it much...
>
> October 14. At the Exchange. Dull weather—cloudy all day. The committee made contract with Mr. Bryant for cornice and bricking of dome. Finished sketch of plan of a theater to land corner of Broadway and Chambers Street and Read Streets. Bought a cooking stove.
>
> December 2. At the Exchange made arrangement to place the column for lashing. Got it placed right over the base. In evening worked on plans of hotel for Washington. broke one of the capstans by putting the whole weight on it. Paid for dinner 44 cents.
>
> December 8. At home all day. Read book on geology and formation of the earth.

This journal describes the activities of an individual deeply involved with buildings in which there was an apparently seamless connection between activities that we

now consider to be quite separate. Rogers designed buildings, he directly supervised construction, he worked out problems on the construction site, he selected materials. This was typical business at the time. It also points to a literate and educated individual who seems to be as comfortable at an academic lecture as he was working with stone.

By the end of the nineteenth century, things were quite different. The main difference was the emergence of the large architectural firm and the large general contracting firm, operating in tandem but with a legal apparatus, namely the general contract, that kept quite separate the activities that to Isaiah Rogers were part of a seamless web.

The professional transformations of the nineteenth century were fundamental in terms of process. They attempted to concentrate control in the hands of the architect; they led to the growth of other institutions such as general contracting and regulatory agencies; they eliminated the craftsman as the primary repository of knowledge about building. They established the activity of design as an intellectual activity that may be quite divorced from the making of things themselves. We tend to see the nineteenth century in terms of a myriad of architectural styles, but the professional and procedural transformations were more fundamental.

It is the concentration of knowledge and therefore of power over the built environment that is perhaps most critical. In Renaissance Florence for example, an architectural golden age, there was the power of the Medici. But at the same time, the power to build and the knowledge of how to build were widespread. Indeed, the architect was not at the top of the hierarchy of the building operation, as he attempted to be in the nineteenth century. During the Renaissance, the client was in charge, and had the knowledge to be in that position. Under the client was the *soprastante*, a kind of combined general contractor and clerk of the works. Somewhere lower down was the architect – important but clearly taking his place in the complexity of the overall building operation. (Goldthwaite, 1980)

In the several hundred years in between the Renaissance and the nineteenth century, control and knowledge became concentrated rather than distributed at the same time that building types became more varied and less predictable. The concentration of power and control in professionals and management had its counterpart, at the level of the building worker, in what Marx saw as the "alienation of labor" and what historians of building and labor refer to as "deskilling."

3 Architecture and Engineering

A brief comparison of architects and engineers may help to shed light on the processes that architects employ, and how they have changed. To a large extent, this discussion deals with normative practice, and not the practice of architects such as Frank Lloyd Wright or engineers such as John Augustus Roebling, who deliberately bucked normative rules. But even such heroic figures could not completely escape them.

It is the difference in the nature of the *product* that is often seen to define the difference between the architect and the engineer. Architects design buildings;

engineers design the structures of buildings, or machines, or electronic circuits, or airplanes, or industrial and technological processes. And buildings are more difficult to specify.

This by itself is not as significant as the fact that engineering problems are more explicitly constrained than architectural problems in terms of desired performance. Often this is measured by money. A modern aircraft, for example, will be designed to optimize a number of variables: fuel consumption, passenger load, speed, reliability, design and manufacturing cost, and safety. Each of these variables may be specified numerically, and reduced to dollars and cents. In the case of the airline industry, where the profit margins are very small if they exist any more at all, every kilogram of weight, every extra kilometer per hour per liter of fuel, every extra kilometer per hour of speed, will be a factor in the success of the design.

Architecture is different, or at least architects would like to continue believing so. The qualities that architects hold dear, and that are stressed in schools of architecture, are things like aesthetics, comfort, and compatibility with the urban context. These things are not measured quantitatively.

Since the nineteenth century, buildings have increasingly been specified in quantitative ways, and in ways in which specific aspects of performance are explicitly laid out. As shown by Willis (1995), the design of skyscrapers in New York and Chicago came about largely because of financial constraints not unlike those which guide the engineering design of aircraft. Several variables are optimized in the design of a skyscraper: the total rentable area, the likely rent per square foot, the construction cost, and the cost of financing. When these variables are resolved, they lead to configurations and construction types that are predictable: there is not much variation possible. And architects understand that because of that, their role in the design of these buildings is seriously limited; it is often said that architects have control over what the building looks like – the zone of space that is six inches or so deep, around the outer skin. And even here they are seriously constrained by available products, and issues of building codes, product warranties, and demands for low energy consumption.

The same is true for other complex projects such as housing developments, where the cost of land and infrastructure improvement, along with building construction costs, and cost of financing (and therefore necessary speed of construction) all interact with likely sales price to help make the architect a tool of the developer and the developer's banker, who turn out to have the most control over the form of the development.

With these kinds of projects, that make up the preponderance of what is built today, the architect looks very much like an engineer. S/he is optimizing well-defined quantitative variables, that are often connected to money, and the evaluation of the product depends on how well this optimization has taken place.

And the engineer, at least the nineteenth-century engineer, had some of the qualities of the architect.

The pre-twentieth century architect and engineer came out of similar worlds. James Watt, the inventor of the steam engine, grew up in a family of craftsmen and apprenticed himself to an instrument maker in London. He was thoroughly immersed in the world of physical things, and this immersion was critical to his

success as an engineer. (Dickinson, 1935) Robert Stephenson, the great railroad engineer, came out of a mining community, and a family deeply involved in mining operations. (Bailey, 2003) Indeed, the culture of eighteenth and early nineteenth century Britain was one in which the professions were closely tied to the trades, and in which the trades were close to the everyday life of many people.

The nineteenth century engineer, like the architect, was able to think intuitively and not only quantitatively. There is little doubt that architects and engineers may both work in ways in which the design process is a cyclical one, in which conjectures are made, tested and refined. A biographer of the great British engineer Isambard Kingdom Brunel quotes his wariness of "mathematical calculations, dependent as they are upon an unattained precision, which are likely to lead far from the truth as not. By the same mode of calculation did Dr. Lardner arrive at all those results regarding steam navigation and the speed on railways which have since proved so erroneous." (Vaughan, 1991)

Some of the diary entries of Robert Stephenson, inventor of the steam locomotive, also point to the use of intuition in the design process.

> I have just received the model and like the idea exceedingly, but I fear the truth of the motion is rather questionable, although it may not perhaps be to such an extent as to render it useful. I shall have the accuracy of it tested before I reach Ncastle – On the first blush it is very satisfactory and I sincerely hope a more mature investigation will prove equally so. –
>
> My impression is that at certain parts of the stroke the motion of the slide valve will be backwards instead of forwards and vice versa. – I think it can hardly be otherwise and the working of the model supports this opinion, but it is so small that no detailed conclusion can be drawn from it – I should wish a full sized model to be made for that alone can decide the point – If it answers it will be worth a jew's eye and the contriver... (Bailey, 2003)

In this case Stephenson is acting rather like an architect, who is making a tentative conjecture, but withholding judgment until that conjecture is further tested with a more detailed investigation. It is common practice in architecture to shift scales, as Stephenson was suggesting, to test a proposed design.

The architect is however, working with a single artifact that may take months or years to make, and the engineer is either doing the same thing, as with a bridge or tunnel, or designing the prototype for an artifact that may be mass-produced. In the latter case, there is no question of design and construction being intertwined, nor is there the possibility of an imprecise specification of the object, as there might be with a building. The architect's ability to apply intuitive judgment in the design of the artifact itself is not shared by the engineer. What the engineer is doing that is similar to the architect is applying intuitive judgment to the design of the prototype or process.

Conventional wisdom sees architecture as an artistic pursuit, and engineering as a mathematical/technical one. Both professions involve design. I have argued above that normative architecture has become less "artistic" than it might appear. As a process or mode of activity, architecture and engineering are not diametrically opposed. The architect, working to a large extent within a technological system that is highly constraining to artistic pursuit, needs to adopt some of the stance of the engineer who is working to pre-specified, quantitative goals. And the engineer, although s/he is working within definable, quantitative constraints, is a designer,

and may be applying the intuition of the artist. The architect and engineer are designing different classes of objects, and perhaps see the balance between the objective and the intuitive differently in their own work, but are in fact at different points within the same range of activities. Where the idealized social models of the architect and the engineer are very different, and represent the competing values of artistic production versus efficient production, in practice the normative practice of architecture and engineering are more similar than different.

4 Architecture as a Modern Process

The architectural profession has changed dramatically since the nineteenth century. One way of describing this change is that the intuitive, "artistic" side, and the objective, "technological" side, have grown further and further apart. One reason this happened is that industrialization resulted in both the formalization of professions and the decline of craft traditions. This meant that the architect was put in the position of controlling the work of craftsmen who heretofore were not subject to such control, and these craftsmen were themselves disappearing, turning into construction workers who were taking someone else's orders. By converting skilled craftsmen into wage laborers, capital could more directly control the process.

I speculate that the design language within modern architecture that is often called the "International Style" – a language characterized by industrial components, simple details, and lack of ornament – was not only an artistic or social movement. It arose partly because the architect could not maintain control over the production of buildings that required details that could only be produced well through traditional craftsmanship. Since the culture of traditional craftsmanship was fast disappearing, the only way the architect could maintain control was through the development of a style that much better allowed for "control at a distance" than historical styles. The buildings that prevailed throughout most of the twentieth century are as much the result of a particular mode of architectural production as they are of aesthetic preference or social demand. This is of course connected to the industrial production of buildings, but the critical point here is that the imperative of building in this way may have come at least partly through the constraints of time and efficiency that were being felt in practice.

In the early 1890s, the prominent New York firm of McKim Mead and White designed a building called the Metropolitan Club on the upper East Side of Manhattan, at Fifth Avenue and 60th Street. McKim Mead and White were New York's most prominent practitioners of the Beaux-Arts style, an interpretation of classical architecture that seemed particularly suited for the new moneyed elite of New York, who built banks, houses, and rich men's clubs like the Metropolitan Club. The documents connected with the construction of this building are now housed at the New-York Historical Society. These documents include letters, contracts, estimates, bids, and communications of all kinds between the architects, and their clients, suppliers, builders, contractors and other players.

An examination of these documents has led to two general observations that are relevant to my argument. First, there were something on the order of 7,000 documents, and these were only those that had been in the archive of the architecture firm, that made it to the historical society. Second, what was going on to very large extent, is that the firm was attempting to maintain complete control over every aspect of the project. No detail escaped their authority, ranging from the design of the cigar cases in the office, to the blowers in the mechanical room, to the details of the handrails. In other words, aspects of authority that in previous decades might have been left to craftsmen or engineers were being consolidated under the all embracing purview of the architect.

The mode of architectural production exemplified by the Metropolitan Club was about to change. Two or three decades after its construction, articles with titles like "architecture is a business" or "how to run an architects office" began to appear in architectural publications. (Silverman, 1939) These articles made it clear that the era of the gentleman architect was over, that efficiency and profit was the new *lingua franca*, and that time was indeed money. At around the same time, buildings in the clean modern style, devoid of ornament, began to appear. The famous exhibition "The International Style," curated by Philip Johnson and Henry Russell Hitchcock, was mounted at New York's Museum of Modern Art in 1932 (Johnson and Hitchcock, 1932 [1966]). Although the modern movement in America lagged behind that in Europe, modernist sensibilities were beginning to take root in American soil.

A well-known San Francisco architect, Joseph Esherick, who was trained in the Beaux-Arts system at the University of Pennsylvania, but then went on to design simple and informal modern buildings, once described how, for the design of a house, he first met the client on a Saturday, designed the house over the next week, and put the drawings in for permit approval a week from the following Monday. (Esherick, 1977) Esherick's early buildings were very simple in their details, and his point in telling the story was that this level of efficiency could not have been achieved if the details had been more elaborate, neo-classical in nature, or requiring a high level of collaboration with craftsmen or subcontractors.

This relationship between simple process and simple form is not true only for small buildings, but permeates all scales of the environment. It is no coincidence, for example, that American zoning ordinances, which are written so that they can be administered without the need for any discretionary judgment, result in urban environments that are generally banal and simplistic. The rich complexity of traditional cities happened as the result of processes that were themselves culturally rich. The mechanistic processes of city planning, design and construction are not neutral with respect to their built result.

The simplification of practice described here is indicative of a more general trend in the development of contemporary architectural theory and practice. Coming to a climax in the twentieth century, there was a gradual separation in architectural thought between "art" or what was seen to be the exclusive creative province of the architect, and "science" which was the increasingly stringent context of standards, regulations, explicit constraints imposed by materials availability,

and engineering, within which the architect had to work. Twentieth-century architecture is a socially-constructed balance between these two poles.

At one extreme there are architects who see themselves as artists, and want to be seen that way by the public. People such as Zaha Hadid and Rem Koolhaas are emblematic of architects for whom artistic form is dominant, and for whom the technical issues of putting a building together are of secondary consideration. These architects will do what they can to supersede or reinterpret technical issues in the service of their artistic concept. In many cases, they work with other architects who are legally responsible for the building's construction; this allows them to concentrate on "art" and to avoid liability. This kind of procedure is often what allows these architects to do extensive work internationally: the local architect of record is the one who really understands local codes, materials and construction procedures, and who deals with most issues of the building during construction.

At the other extreme are architects who are firmly entrenched within systems that are at root modern technological systems, and that seriously constrain their ability to be "artists." These systems include the contexts of building codes, zoning regulations, development finance, construction law, liability insurance, and the manufacture of building components, among others. These are all rationalized systems that took on much of their present form during the nineteenth and early twentieth centuries, as the industrial paradigm finally replaced craft production. These systems leave limited room for discretion on the part of the architect.

Most architects understand that they need to incorporate both attitudes into their work, and the curricula of architecture schools attempt to maintain the idea that architecture is both an "art" and a "science." This turns out to be an uneasy marriage, in the profession as well as in the schools. Professional firms feel caught between their desire to do good design, and the fact that schematic design – the phase of their services in which the basic form of the building is determined – represents only 20% of their fee, or even less. A good percentage of an architects' time, during and after that initial phase, is spent satisfying explicit requirements, including those imposed by the threat of litigation.

There is a strong relationship between the transformation of practice with respect to process and the increasing split between "art" and "science." Modern technological systems, including statutory legal systems such as building codes and zoning regulations, leave little room for discretion on the part of the architect. To varying degrees, the architect is a manager, coordinating these various requirements and incorporating them into the building. Of course, this varies from architect to architect, and architects are different in their degree of inventiveness even in the context of these requirements, but most will agree, when asked to account for their time over the course of a week, that their job is not nearly as creative as they might have thought it was going to be when they first entered the profession. There is room for creativity and invention, but many would argue that this is only superficial, leading to superficial differences between buildings.

Yet, the early nineteenth-century architect/builder like Isaiah Rogers was working within an intellectual framework that allowed him to make many implicit judgments. This system was also one in which design and construction were much more

intertwined than they are today, allowing for a dynamic relationship with the emerging building all through the course of construction.

The emergence of institutions of control outside architecture itself – building regulations, zoning, insurance, building finance – had the effect of taking the ability for discretionary judgment away from the architect. To the extent that the architect remained an "artist," his authority was greatly reduced, but even within this reduced authority he tended to remain unwilling to give up even the illusion of being a creative artist.

5 Process and the Work of Christopher Alexander

At the beginning of the twenty-first century, the challenges faced by those who are responsible for making the built environment – architects and engineers included, among many others – are considerable. Buildings and cities are responsible, one way or the other, for the bulk of fossil-fuel consumption, as production levels off and begins to decline. Cities in developing countries continue to experience enormous population growth through births and in-migrations, most of it in slums and informal settlements; there are hundreds of millions of people in the world without an adequate place to live. And many would argue that the quality of the built environment – its ability to support human life and elevate people's spirit – has not only declined but does not seem to be the goal of those who are making it.

As the contemporary paradigms of architectural and building production are focused more on product than they are on process, the major challenges we face seem intractable. Christopher Alexander argues that it is only through a fundamental transformation of process that the built world as a whole – rather than the relatively few buildings over which architects have direct control – can be adequately dealt with. The paradigm of the individual architect designing the individual building is outmoded, in a world in which the bulk of the environment is controlled by developers and migration and forces that are beyond the architect's control.

Alexander's work has three major components that help to define his attention to process: (Alexander, 2002–2004)

First is the idea of the *structure-preserving transformation*, or the notion that any act of construction must work to repair and/or reinforce the larger whole in which the project is located. This may be seen as extending some ideas of the sustainability of ecological systems into the realm of the built world, by requiring first a value judgment about the health of the larger system, and second a commitment to maintain or improve that health.

The idea of the structure-preserving transformation runs counter to the idea of so-called "object building," and by extension, to the idea of "star-architect as hero." In this way it helps to define the architect as a professional whose primary responsibility is to the built world as a whole, and not only to the particular building s/he is designing. This is perhaps the most fundamental way in which Alexander's thought bears on process and not only on form.

Second, is the importance of *making design decisions in the context of reality*, or with reference to accurate simulations of reality, rather than through abstractions. This relates directly to the distribution of control, since it usually means that a single person cannot be in the position to be connected directly to the reality of all aspects of a complex building or urban plan.

This way of making decisions improves their accuracy. It is also strongly connected to pre-twentieth-century practice, in which the architect's primary activity was on the building site, where drawings were often done in reference to the emerging reality of buildings on the site. This may seem to challenge the idea of design as prediction, but the point is simply that such prediction will be more accurate when it does not get too far away from a pre-existing physical reality.

Third, as an outgrowth of the second, is the importance of *breaking down the barriers between design and construction*. This is perhaps the most difficult to accept within professions that have become highly entrenched in the last hundred or hundred-and-fifty years. Alexander's point is that if design decisions are to be made in the context of the real thing, then they cannot stop when the construction of the building starts.

The work straddles "technology" – where technology is seen at least partly as an explicit, quantifiable system, and "high-style design." Alexander has a strong background in the English empirical tradition – he began his university education studying mathematics and science at Trinity College, Cambridge, where Newton also worked – but he is also an artist, with excellent intuitions about form and color, and functions well with the ambiguities that are often inherent in artistic creation. His theory of architecture and architectural production, along with the innovative building and planning projects he has carried out, are explicitly intended to allow rational and intuitive thought to co-exist. The work incorporates understandings of the structure of the environment that are explicit and rational, and demands scientific precision in developing those understandings. At the same time, it recognizes the importance of informed judgment, and most of all that the success of a building or place is to be ultimately measured in human experience and feeling.

The work as a whole provides a theoretical umbrella to a number of different positive initiatives that are taking place throughout the world, all of which are attempting to develop alternatives in process that might result in more humane built environments.

This is illustrated by three examples:

First, zoning and the application of building codes are two of the most technologically rigid systems in the contemporary building culture. Twentieth-century American zoning ordinances are notoriously rigid in their application, and one of their worst effects is the separation of uses within the city. These zoning and building codes are being changed in ways that increase their flexibility and allow some discretionary judgment. "Form-based codes" allow for a mixture of uses in a zone, not allowed by most ordinary zoning ordinances, within a framework of rules that try to ensure the compatibility of the buildings within a zone. Discretionary zoning allows for some degree of negotiation between the owner and the municipality, allowing for the particular location and situation to play a role, rather than only

rigid rules. And design review requires that each project be looked at individually within the framework of common design guidelines.

These new forms of zoning allow for human judgment – which statutory zoning does not – within a framework of commonly understood and agreed-upon standards. There is the need for rationality in the development of these standards, and for discretionary judgment in applying them.

Second, certain uses of digital media in the design process are leading to better communication and visualization. These include techniques of visualization, that allow the architect and her clients to place themselves into a virtual three-dimensional environment, that may be a close simulation of the building as it would be built; they include the direct translation of physical models into drawings, as done in Frank Gehry's office. They also include programs that allow for the very quick calculation, based on rough initial sketches, of such things as the energy performance of buildings or their cost.

Until now, digitial media techniques have mostly been used to speed up production within a paradigm of practice that has remained essentially unchanged for the last century. The new techniques help to support a transformation of the practice paradigm, by changing the kinds of information available to different participants; in many cases they help to break down the barriers between architects and clients, by helping the client visualize design proposals as easily as the architect can.

Third, there are new arrangements among contractors, architects, and fabricators, which form an attempt to break down overly bureaucratic arrangements, and allow for direct and useful connections between people in different firms that are concerned with the same aspect of the building.

These initiatives are not as exciting, perhaps, as the things one sees in architectural periodicals today. They are however all concerned with the processes through which buildings are built, and therefore have the potential to instigate change with respect to a large number of buildings and to affect the quality of the built environment as a whole. From the point of view of Alexander's theory, these initiatives are attempting to make the design process more transparent, to link it to the reality of buildings and places, to make it available to more people, and by so doing, to allow design to contribute more effectively to the repair of the built world.

My attempt to extend Alexander's thought into the realm of a variety of real-world pragmatic initiatives is probably not as important as the initiatives themselves and seeing the initiatives in the framework of how the processes of making buildings have changed over the last century and a half. But one thing that Alexander's work does is help put positive initiatives that are happening in different fields – planning, design, construction administration – into a common framework. This framework allows for these initiatives to be understood as emerging from compatible sensibilities and perhaps thereby giving support to those who are actively trying to find alternatives to the entrenched systems of building that make our world today.

The pre-modern architect worked in the framework of a process that allowed for a dynamic response to the physical and social context of the building. The ability to achieve that dynamic response was greatly reduced in the twentieth century and largely replaced by a way of building in which the satisfaction of explicit quantitative

requirements, of all kinds, became the goal. Those that are responsible for the shape of the built environment – architects and many others in the contemporary building culture – are now faced with the unique problem of developing an architecture that is sensitive to place and to individuals, but doing it in such a way so that it is happening on a large scale. This problem requires solutions, perhaps like those proposed by Alexander, that recognize that our attention must be focused on the processes through which the built world is created, as a means to achieve good results, and to achieve them on a large scale. Such processes will represent not a nostalgic return to the past, but a use of modern technologies in ways that allow variety to be created in our buildings and cities.

References

Alexander, C., 2002–2004, *The Nature of Order*, Center for Environmental Structure, Berkeley.

Bailey, M., 2003, *Robert Stephenson: The Eminent Engineer*, Ashgate, Aldershot and Burlington, pp. 1–7, 188.

Dickinson, H., 1935, *James Watt: Craftsman & Engineer*, Babcock & Wilcox, Cambridge, pp. 17–18.

Esherick, J., 1977, Personal communication.

Goldthwaite, R., 1980, *The Building of Renaissance Florence*, Johns Hopkins University Press, Baltimore and London, pp. 155–170.

James, J., 1982, *Chartres: The Masons Who Built a Legend*, Routledge and Kegan Paul, London and Boston.

Johnson, P., and Hitchcock, H., 1932 [1966], *The International Style*, Norton, New York.

Rogers, I., 1838. Journal. Manuscript in Avery Architectural and Fine Arts Library, Columbia University, New York.

Silverman, E., 1939, Architecture is a business!, *Pencil Points* **20** (Dec. 1939):780–90.

Vaughan, A., 1991, *Isambard Kingdom Brunel: Engineering Knight-Errant*, John Murray, London, p. 171.

Willis, C., 1995, *Form Follows Finance*, Princeton Architectural Press, New York.

Expert Culture, Representation, and Public Choice

Architectural Renderings as the Editing of Reality

Steven A. Moore and Rebecca Webber

1 Introduction

The problem examined in this chapter is found in the relationship between technological experts and the societies they serve. We have narrowed this overly broad topic to consider how some expert designers – architects in this case – influence public perceptions of reality. Architects necessarily edit reality when making drawings that represent the completed condition of building projects. Were they to include all of the information required for decision makers to be fully informed they would have to present their proposals at a scale of 1:1. Technologies of representation, then, necessarily edit out of the picture some information so as to emphasize other information deemed more salient by the picture maker, the architect.[1] This normative practice of architectural representation influences public choices about city making. Simply put, even well educated decision makers in a highly technological society can choose only from those possibilities that are known to them. Our purpose here is to understand better the material and political consequences of normative decision making in architecture.

2 Architecture and Linear Perspective

2.1 Linear Perspective as a Development Tool

It is helpful to take a historical view of the question at the outset because the ability to represent our intentions for the future depends upon the tools available. Drawing on the ground with a stick can communicate rough intentions to build in a particular place in a particular way but sticks are certainly less articulate tools than modern drafting tools or a computer. Philosophers of technology have long established that

S. A. Moore, University of Texas

R. Webber, University of Texas

[1] Leatherbarrow (1998).

P. E. Vermaas et al. (eds.), *Philosophy and Design.*
© Springer 2008

each tool brings with it very different kinds of knowledge and practices that already have social values embedded in them.[2] It would, then, be unfair to judge the user of the stick by the norms employed by the user of the computer. Following this logic we begin by arguing that the politics of representation are situational – they depend upon the social and technological context of their use.

Many historians have argued that the discipline of architecture in Europe rests upon the appropriation of linear perspective from the Arabian Peninsula in the 14th century. This technology of representation was subsequently popularized by Filippo Brunelleschi (1377–1446) and his colleagues when they found use for it more than a century later. Use of linear perspective enabled master masons like Brunelleschi to envision large scale projects at a single moment in time and from a single view-point – that of the Renaissance merchant-prince. Others have argued that linear perspective did not become a particularly useful tool until the capital accumulated by a new class of Renaissance merchant princes was available to realize building projects in a radically compressed time period. Whereas medieval projects were funded and constructed over generations of shifting sponsors – none of whom could envision the final outcome – the changed social and economic conditions of Renaissance life made it conceivable for a single sponsor to envision and control architectural production through the services of the proto-architect who had learned the rules and methods of linear perspective. It is fair to say, then, that the very existence of architecture as a distinct discipline is historically linked to serving elite interests through this technology of representation.[3]

2.2 The Emergence of Professionalism

If we fast-forward this history four hundred years to the 19th century, we would have first to recognize that cities in contemporary liberal democracies are physically shaped by a complex mix of public and private interests that did not exist, or existed in other forms, during the Renaissance. It is, however, still mostly elites who seek out the help of architects to envision and realize their projects and these architects still rely upon the same technology of linear perspective to do so. One of many differences between architectural production during the Renaissance and the 19th century is that during the intervening centuries ordinary citizens gained the right to be protected by the state from some of the consequences of development sponsored by latter day merchant princes. By the 19th century, for example, it was no longer socially acceptable to build using highly flammable materials like thatch which could endanger a whole city. In Britain, and later in North America, the utilitarian

[2] See, for example; Heidegger (1977), Winner (1977), and Feenberg (1991).

[3] There is not a monolithic interpretation of the history of linear perspective, but Edgerton (1975), Panofsky (1991), and Damisch (1994) generally agree that this technology was "constructed" not "discovered".

"greatest happiness principle" had the effect of suppressing certain individual rights, and thus modifying such normative building practices in favor of public well-being. By the 20th century ordinary citizens had also gained limited rights to make choices that influence public resources by serving on municipal zoning boards, historic preservation commissions and other democratic institutions. The emergence of such institutions, however, did not change the fact that, all things being equal, modern merchant princes, like the executives of WalMart, are economically rewarded for building poorly. In contrast, citizens want developers to build well to protect their own safety and optimize the quality of public life.

Because such fundamental conflict between the interests of development and those of the general public can not be seen in the perspectival pictures of reality created by architects, new laws and institutions were constructed to maintain public health, safety, and welfare. Principal among these was the professional registration of architects in the United States in the late 19th century at about the same time that architecture and engineering became legally distinct disciplines. Architects were then characterized by American lawmakers as a unique class of professional citizens who had accumulated specialized knowledge that might be employed to check the economic interests of development on behalf of the general public. In exchange for professional licensure by the state, which granted professionals a kind of limited monopoly to design public buildings, architects accepted a fiduciary responsibility to guard the public health, safety, and welfare. The result is that modern American architects are now legally and ethically bound to the interests of those who commission their services, and the competing interests of the general public.

2.3 Competing Allegiances

Serving two masters is certainly fraught with difficulty, but the matter is made even more complex because, like any discipline, architects are engaged in a discourse that strives toward autonomy. This is to say that in addition to the competing demands of the client and the general public, architects also strive to achieve creative satisfaction and recognition amongst their peers. These very human needs are usually associated with artistic practice and can also be in competition with public health, safety, and welfare.

It is within this triad of competing values and interests that modern architects practice. Each seeks to establish some kind of dynamic balance within the triad, but most opt to privilege one corner of the triangle over the others. We can refer to *production architects* as those who strive to serve the varying interests of their clients; *star architects* as those who serve the interests of art; and *eco-social architects* as those who serve the marginal interests of society and/or the environment. These categories are, of course, reductive which is to say that we should recognize that some architects strive to satisfy two, or even all three of the interests that compete for their allegiance and that a few are occasionally successful in doing so.

At issue here, however, is not so much the allegiances or intentions of architects, but how their often split allegiances lead them to edit alternative realities in one way or another. This question suggests that all architectural drawings are political because they implicitly or explicitly edit the information that public and private decision makers have available to help them decide how they want to live in the future.

3 Methods of Investigation

3.1 Empirical and Philosophical Methods

To investigate the politics of editing pictures of the future we concluded that the collection and analysis of empirical data would be more helpful than philosophical speculation because the issue at hand is not only what is rational or ethically desirable, but what architects actually design and what citizens actually perceive. It is the gap, if one exists, between the intentions of architects and the reception of citizens that should influence a philosophy of design because the size of the gap in the meaning of the picture reflects how successfully the picture produces a common end-in-view.[4]

To understand this phenomenon better we employed a research design that limited our empirical investigation to a single international architectural competition, the Connecticut Museum of Science and Exploration of 2004, in which computer generated presentation drawings, or *renderings*, were employed by the competing architects. All of the renderings employed conventional architectural techniques of representation, including linear perspective. This strategy ensured that the renderings were constructed in response to the same design problem and limited to similar graphic formats. We selected nine images from the competition materials, three each from the three competition finalists – Cesar Pelli of New York, Zaha Hadid of London, and Behnisch & Behnisch of Stuttgart.

3.2 Intention

The next step required by the research design was to review the professional literature and document statements made by the architects themselves regarding specific designs as well as general claims made by architecture critics on behalf of the designers. These were summarized as representing the intentions of the architects.

[4] The gap between the intentions of artists and the reception of the public has been studied by those engaged in *rezeption theorie*, a discourse that originated at the University of Constance. See Holub (1984).

3.3 Reception

We then randomly selected University of Texas students to sort the images, but excluded those in the art and design disciplines as emerging experts, thus creating a representative sampling of the larger body we hoped to assess – the non-expert but educated citizen. We chose students, rather than a random sample of the general population, because we presumed that as highly educated citizens, they were likely to be future decision-makers. Thus, our sampling is class-sensitive, rather than truly random. To collect respondent receptions of the nine drawings we employed an empirical research protocol that sociologists call a "free-sort" in which respondents sort visual images into piles of their own making. Respondents are then asked to describe the common characteristics of the renderings placed in each pile, or category. After respondents completed the sorting exercise we asked if they had any general comments. These specific and general descriptions were documented and subsequently interpreted using the methods of *content analysis*.

In the interest of full disclosure, we conducted this protocol three times. In our first series of sorts we determined that we were asking the wrong questions. In our second series we determined, with the help of colleagues, that the *directed-sort* protocol we employed was troubled by circular logic – meaning that the proposition being tested was implicit in the direction given to respondents. Our third sort, however, produced findings that we deemed reliable on the basis of what social scientists call "emergent design".[5]

4 Intentions and Receptions

4.1 The Data

In each set of renderings studied we found that slightly more that half of the respondent interpretations were logically consistent and could be collectively understood as a dominant interpretation, or reception. This majority of respondents grouped the nine renderings into three piles by architect, perhaps because they could recognize consistency in the graphic style in which information was presented. Among all respondents nearly equal numbers volunteered a strong preference for or aversion to the abstract rendering (Hadid) and the conventional

[5] The same images were used in the initial two sorting procedures, but, in keeping with the methods of a "directed-sort" task, respondents were provided with three categories based on our analysis of the intention of the architects, in the form of short descriptive sentences, and asked to sort the nine images into those categories. The descriptive sentences used changed between the first and second procedure, but the directed-sort procedure itself remained unchanged.

rendering (Pelli). No respondent, however, volunteered a preference or aversion of the explanatory renderings (Behnisch) which may reflect its open-ended disposition. The other (less than) half of the respondents used a variety of criteria to sort the images, but these secondary or tertiary agreements were statistically less significant. The dominant interpretation of the renderings described them in language that we have characterized as *conventional* (Pelli), *abstract* (Hadid), and *explanatory* (Behnisch). These categories are, we found, directly related to well-known professional and/or academic discourses.

4.2 The Conventional Rendering

Cesar Pelli intended his firm's design to be *contextual*, meaning that the design of the proposed building consciously seeks to fit into the existing built environment.[6] In reference to a previous design proposed for a project in Miami, for example, Pelli has said that his intention was to avoid superficial stylistic references, but to make a building that "will be a comfortable new member of the [urban] family". Consistent with Pelli's self-description, architectural critics have often referred to Pelli's work as "self-effacing" and "right" for the place.[7] From our own expert point of view, the renderings produced by Pelli's office do seem to take a conventional approach to rendering reality. They do so by placing the viewing point at the eye level of a pedestrian and making the proposed new building a backdrop for a normal street scene populated by normal people and their normal cars in the act of coming to and going from the museum, which is a normal activity in Hartford. In all, this set of renderings was interpreted by architecture critics and the authors to say that "this building fits in."

In their interpretation of renderings by Pelli a majority of respondents saw a world that looked colorful, happy, realistic, complete, and familiar. From memory, they associated this set of characteristics with the commercial malls they have experienced in everyday life. The dominant interpretation of the Pelli design, then, could be said to be *conventional*, meaning that respondents did not find the design, or the way of life portrayed therein to be challenging. Rather, respondents understood this design to be an appealing example of an architectural typology that they understood well.

The architect's intention to design a *contextual* building and the respondents' reception of it as *conventional* is a close match (See Figure 1).

[6] *Contextualism* in the architecture of North America is associated with the historic preservation movement that began in the s1960s and 1970s. It is generally argues for stylistic continuity with the immediate urban context.

[7] Boles (1989, 73).

Fig. 1 Connecticut Museum of Science and Exploration by Cesear Pelli & Associates Architects (courtesy Pelli & Associates)

4.3 The Abstract Rendering

The design proposed by Zaha Hadid was intended to be *abstract* in a manner consistent with critical aesthetic theory. This design is *critical* because it asks the viewer to suspend what s/he knows about reality so as to explore alternative possibilities. Perhaps the best definition of critical representation comes from Theodor Adorno who argued that:

> Art turns into knowing as it grasps the essence of reality, forcing itself to reveal itself in appearance and at the same time putting itself into opposition to appearance. Art must not talk about reality's essence directly, nor must it depict or in any way imitate it. (Adorno, 1983)

Consistent with Adorno's declaration, Hadid has said her design intent "... is always to challenge the typology ... how you rethink the museum space, the terminal, even the parking lot" (2005). In acting as a Pritzker prize juror, Karen Stein said of Hadid that she "... has built a career of defying convention – conventional ideas of architectural space, of practice, of representation and of construction" (2004). From our own expert point of view the renderings produced by Hadid's office do seem to abstract or decontextualize normative experience of the city. The renderings defy an understanding of scale because there are generally no people present and if there are they are only silhouettes. The renderings are unfamiliar to us, in part because they employ radical perspectival views that no one without a helicopter at their disposal could possibly recreate. In all, this series of renderings make us reappraise our urban situation in a way that would, no doubt, please Adorno.

In their interpretation of renderings by Zaha Hadid a solid majority of respondents saw a world that looked somber, unfamiliar, and non-linear. The design evoked strong reactions on both sides of the spectrum – some rejected the design as "ugly" yet others found it to be "cool". From experience respondents associated this set of characteristics with [modern] art. The dominant interpretation of the Hadid design, then, could be said to be *abstract*, meaning that respondents found the design and the way of life portrayed there to be both unfamiliar and challenging.

The architect's intention to design a *critical* building and the respondents' reception of it as *abstract* is again a close match (See Figure 2).

Fig. 2 The Connecticut Museum of Science and Exploration by Zaha Hadid Architects (Courtesy Zaha Hadid Architects)

4.4 The Explanatory Rendering

Educating decision makers so that they may make informed choices is an intention consistent with pragmatism. This observation is not to claim that Behnisch has consciously adopted American pragmatism as a philosophical foundation for design, only that their attitude toward the design process is consistent with that articulated by Dewey, Rorty, and others. For example, Dewey regularly argued that the role of professionals in society is not to make choices for citizens, but to educate them to make choices on their own behalf.[8] The logic behind his argument is that citizens in a democratic society must command technical knowledge in order to make rational and just choices about how they should live rather than submit to technocratic rule from above or indulge popular tastes that bubble up from below.

Consistent with Dewey's logic, Behnisch's website tells visitors that, "Our vision is to unite [with the client and city] to build a shared vision of architecture" rather than impose a personal vision. This personal declaration of intent is confirmed by educator and theorist Tom Dutton who has characterized the intent of the Behnisch firm as an attempt to "… transform … meaning through the arrangement of program, form and content" and by solving problems articulated by the client.[9] From the authors' expert point of view, the digital renderings produced by the Behnisch office do seem to offer more explanation of possibilities than fixed solutions. The renderings are, unlike the conventional (Pelli) or critical (Hadid) ones, pedagogical, meaning that they explain to decision makers how the building solves problems spatially and technologically. Text, photographs, and diagrams are used freely, suggesting the architects think that decision makers are capable of and willing to invest time and effort in reading about alternative possibilities rather than quickly consuming graphic images as a *fait accompli*. This is to say that decision makers are treated as intelligent citizens rather than impatient consumers. In all, this series of renderings posed as many problems requiring consideration as they offered solutions.

In their interpretation of renderings by Behnisch a majority of respondents saw a world that looked diagrammatic or not fully formed, yet very technical and detailed. Some had a difficult time understanding these images as traditional renderings because there was so much textual and technical information. From experience they associated this set of characteristics with planning in its early phase. The dominant interpretation of the Behnisch design, then, could be said to be *explanatory*, meaning that respondents found the design and the way of life portrayed there to be educational, tentative, and inclusive because many choices had yet to be made on the basis of the several different kinds of information provided.[10]

[8] Dewey (1954).

[9] Dutton (1996, 154).

[10] Canizaro (2000). In his Doctoral Dissertation, *Drawing Place*, Vincent Canizaro documented the existence of three modes of architectural drawing – *mixed-media, multi-media*, and *multi-disciplinary*. He concluded that these were a hierarchy in which the last type, *multi-disciplinary*, employed kinds of textual and graphic information that were not "architectural" in the traditional sense. He further argued that this mode of communication was most successful in developing a "multivalent" understanding of place because it tended to promote public talk.

The architect's intention to build a "shared vision" and the respondents' reception of the renderings as *explanatory* is for the third time a close match. In sum we can say that in the Hartford competition there was a minimal gap between design intentions and received meaning (See Figure 3).

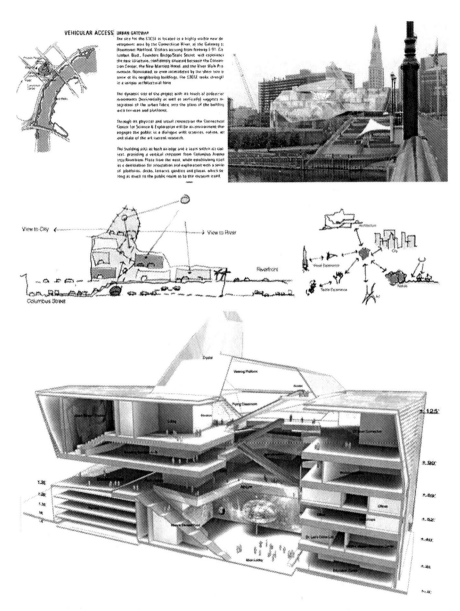

Fig. 3 Edited from, The Connecticut Museum of Science and Exploration by Behnisch, Behnisch & Partner (courtesy Behnisch, Behnisch & Partner)

5 Consequences of Picturing

5.1 *Picturing is not Building*

This finding suggests that architects' renderings are very effective methods of communication – respondents tended to see what the architects wanted them to see. The problem with this finding, however, is that although there is a small gap between design intention and reception of the renderings, we cannot yet know the dimensions of the gap that may show up between the graphic rendering and the built world itself. *Picturing how we want to live and actually materializing that world is not the same thing.* This observation requires that we consider the likely consequences of each type of rendering upon the social and material process of building before we can assess how successful these types of rendering might be in catalyzing a future material reality.

5.2 *Consequences of Convention*

The conventional rendering (Pelli) pictured a generally happy world familiar to decision makers. In our view this strategy had significant advantage for the developer – the Museum Board of Directors in this case – because it minimized resistance to development, and thus economic risk, by masking some conditions and consequences of building. For example, neither technological means, nor their environmental/social impacts were present in the picture. Observers had to assume that other experts would solve such problems or that they were non-architectural. Out-of-sight is out-of-mind. The other two renderings edited reality no less severely, but the Behnisch rendering did, as we will see, did illustrate technological means through which that design would mediate reality.

 The conventional renderings presented non-expert decision makers with only visual or programmatic choices, none of which required them to take much risk or exercise much vision. In the world pictured by Pelli, life could go on pretty much as before, but within a more commodious space. The major advantage to this strategy is that it won the competition. The disadvantage, however, was that participants did not see or take advantage of the opportunity to reconsider the institutional agreements that bound them together and materialize those agreements in a manner that might continue to open up new ways of living.

5.3 *Consequences of Abstraction*

The critical rendering (Hadid) pictured the opposite of a conventional world – one that stripped away allusions to the familiar to reveal the sometimes terrifying and

sublime conditions of urban life. This artful strategy increased resistance to development because it asked people to accept a new way of living not on the basis of their own experience, but on the basis of the architect's cultural and technological authority. Decision makers had to be willing to accept the risk that what the architect-artist would actually build on their behalf would satisfy their long term needs and desires; they were not.

This strategy is, for both the architect and institution a high-risk high-gain proposition. For the architect the risk is, as in the Hartford case, to be rejected as too radical. Had Hadid managed to attract the Museum as a "patron" she would have gained a more or less free hand in the production of her masterpiece. The advantage to the museum, and to the city, in accepting the role of patron of the arts is that they might have gained a remarkable building that would attract, in the manner of Frank Gehry's Bilbao Museum, huge crowds of new museum-goers.

Before moving to the third type of rendering, we should note that the first and second types – the conventional and the critical – are a dialectic pair. Our observation is that architects Pelli and Hadid both sought the same end by opposite means, which is to quickly gain approval and get on with building. Where Pelli appealed to colorful popular taste, Hadid appealed to a darker, more abstract or elite taste. If the source of their authority differed, both architects relied upon their renderings to satisfy the aesthetic desires of their client so as to close public talk and thus avoid what has been edited out of the picture. This is an outcome that alternately delays and suppresses dissatisfaction but does get buildings built.

5.4 Consequences of Explanation

In contrast to the conventional and critical renderings, the explanatory rendering pictured something more akin to an open-ended process than an artifact. Where Pelli and Hadid idealized the site context through stylized rendering techniques, Behnisch placed his building proposal in the messy context of a photograph. Where Pelli and Hadid sought to mobilize populist or elite tastes, Behnisch appealed to intelligence. And rather than seeking to close down conversation by satisfying aesthetic desires, the Behnisch illustrations sought to open up new conversations about topics unfamiliar to decision makers. These renderings are certainly concrete in the sense that they portray volumes of space and rather conventionally drawn floor plans, but for every element of certainty represented there are elements in the composition that ask decision makers to consider alternative possibilities or that explain unconventional technologies. In this sense the Behnisch renderings are challenging in a manner different from the Hadid pictures. In addition to challenging the aesthetic norms of decision makers these pictures challenge them to take responsibility for the non-visual consequences of building. If there was risk to decision makers associated with this design it was that the world pictured could not simply be purchased. Rather, it required their time, their literacy, and participation in public talk to be realized.

It was only through the explanatory renderings that respondents in our study claimed to learn something about how architectural knowledge can help to solve problems. In lieu of concealing consequences from non-expert decision makers to gain the commission or maintain aesthetic control, Behnisch sought to engage non-expert decision makers in a conversation about how the building itself could have agency in serving the institution's interests – about how bricks and mortar could stand in for citizens in the shaping of public space and local history. It is in this sense that the explanatory renderings might have transformed respondents' perception of, and responsibility for, actually creating the alternative realities they claimed to desire. In accepting responsibility for technological and visual choices these citizens might have learned how multiple forms of intelligence yield more satisfying outcomes;[11] they did not.

Benjamin Barber has described the nature of the "public talk" catalyzed by this type of rendering as that which does not describe the world, but that which "makes and remakes the world" (1984). His point is that the multiple and conflicting perspectives conjured up through public talk helps all parties, supporters and detractors alike, understand the consequences of building in a particular manner. This emphasis upon design process rather than the artifact suggests that public talk about architecture is transformative, meaning that the building is both socially and literally constructed through insights gained from differing perspectives. This logic should not suggest that the architect does nothing more than collage together the atomized desires of participants. Rather, the Behnisch firm has clearly demonstrated their skill in designing open-ended conversations that lead to deeper aesthetic and political satisfactions precisely because they are shared, not by passive consumers, but by a community of active participants in which the architect is less the sole author than s/he is an empathetic and "valuable stranger".[12]

6 Conclusion

6.1 Politics of Representation

The issue at hand is who gets to decide how we will live together and in relation to nature. Expert designers certainly have valuable aesthetic and technical knowledge about the relative consequences of building in one way compared another. But expert knowledge is general, or abstract, and cannot fully appreciate the way in which citizens hope to live in a particular place. Yet, precisely because expert knowledge is abstract it can see through and beyond the status quo. We argue, then, that a "good" rendering is not one that satisfies only the aesthetic desires of

[11]Latour (1986) uses the term "cascading images" to describe how many different perspectives, real and social, contribute to expanded meaning.

[12]Harding (1991).

consumers, but one that also teaches citizens how buildings stand in as their agents and solve community problems in the decades to come.

In conclusion we argue that unless citizens acquire social intelligence by continually testing their own imaginations they will remain dependent upon the formulas of technocrats or the private visions of artists. This is not to argue that technology and art are somehow suspect practices. Nor is it a proposal to substitute populism for elitism. To the contrary, we mean to argue a twin proposition: first, that technology and art are inherently human practices that can open up unexpected ways of living. But second, not all ways of living are desirable. The appropriate role of experts in a democratic society, then, is to collaborate with their fellow citizens to determine together what is desirable rather than what is technically possible, economically profitable or aesthetically stimulating.

Toward this end we recognize that some tools are better than others. This finding suggests that the technology of linear perspective has surely proven to be a valuable tool, but after 400 years of use we should recognize that it conceals as much as it reveals. New visualization tools are needed to help communities like Hartford understand the non-visual consequences of their choices. Fortunately, these new tool are already in the making.

References

Adorno, T., 1983, *Aesthetic Theory*, Routledge and K. Paul, Boston.
Barber, B., 1984, *Strong Democracy: Participatory Politics for a New Age*, University of California Press, Berkeley, CA.
Behnisch, B. P., 2005, *Our Practice*, retrieved June 2005, http://www.behnisch.com/our_practice/our_practice.html
Boles, D., 1989, Practicing what he preaches, *Progressive Architecture*, March, **70**(3):73.
Canizaro, V., 2000, *Drawing Place: An Inquiry into Architectural Media and its Relation to Place*, Texas A&M University, College Station, TX, Doctor of Philosophy.
Damisch, H., 1994, *The Origin of Perspective*, MIT Press, Cambridge, MA.
Dewey, J., 1954, *The Public and its Problems*, Swallow Press, Chicago.
Dutton, T., 1996, *Reconstructing Architecture: Critical Discourses and Social Practices*, University of Minnesota Press, Minneapolis, MN.
Edgerton, S., 1975, *The Renaissance Rediscovery of Linear Perspective*, Basic Books, New York.
Feenberg, A., 1991, *Critical Theory of Technology*, Oxford University Press, New York.
Hadid, Z., retrieved June 2005, http://www.pritzkerprize.com/2004/mediakit.htm
Harding, S., 1991, *Whose Science? Whose Knowledge? Thinking from Women's Lives*, Cornell University Press, Ithaca, NY.
Heidegger, M., 1977, *The Question Concerning Technology and Other Essays, Translated with an Introduction by William Levitt*, Harper & Row, New York.
Holub, R., 1984, *Reception Theory: A Critical Introduction*, Methuen, New York.
Latour, B., 1986, Visualization and cognition: thinking with eyes and hands, *Knowl. Soc.* **6**:1–40.
Leatherbarrow, D., 1998, Showing what otherwise hides itself: on architectural representation, *Harvard Design Magazine*, Cambridge, MA, Fall, 50–55.
Panofsky, E., 1991, *Perspective as Symbolic Form*, Basic Books, New York.
Stein, R., 2004, retrieved June 2005, http://www.pritzkerprize.com/2004/mediakit.htm
Winner, L., 1977, *Autonomous Technology: Technics-out-of-control as a Theme in Political Thought*, MIT Press, Cambridge, MA.

Diverse Designing

Sorting Out Function and Intention in Artifacts

Ted Cavanagh

Design describes intellectual activity that differs across disciplines. This chapter argues for differentiation into engineering, architecture, or other types of design before any general conceptualization. Studies about the 'dual nature of artifacts' concern engineering design. The transferability of philosophical concepts from these studies to other fields of design is questionable.

North American house construction, a technological system designed on the wood-rich, nineteenth-century frontier, is a good example that shares features with technical artifacts and others with social artifacts. This technology is analyzed by applying a framework developed by Andrew Feenberg that, in turn, sheds light on generalizations about design in the philosophy of technology.

Starting in the 1800s, the engineering design of material production has been sorted out, and the production of building construction only partly so. Sorting out sounds good, but it comes with a raft of preconditions, predispositions, and predeterminations. Just as a house construction system designed in the nineteenth century brings antiquated design concepts from history into contemporary houses, the understandings of technology that engineering sorted out over the last two centuries, such concepts as function, use, and intention, are smuggling proscriptive versions of these concepts into the twenty-first century.

1 Philosophy of Design, Function, and Use

To expand the philosophical study of technology beyond engineering design this author proposes some philosophical redefinition of terms such as function, use, and intention. Already, critics have suggested that the authors of an empiricist study of artifacts, Peter Kroes and Anthonie Meijers, expand their project to include "artifacts obtained with some technique different from engineering design" (Kroes and Meijers, 2002a; Mitcham, 2002; Hansson, 2002a). Of course, since engineers have sorted out their way of designing, the resulting philosophical definitions are

T. Cavanagh, Clemson and Dalhousie Universities

P. E. Vermaas et al. (eds.), *Philosophy and Design.*
© Springer 2008

more precise. Expansion of these definitions into other design fields adds variability, but allows the philosophical terms to have wider application. Rather than adapting the definitions to things like artist-created artifacts, this chapter takes a more modest approach and expands the concepts to include artifacts with affinities to engineering design, particularly architecture.

Building technology and construction has an imprecise understanding of function, use, and intention, partly because the artifact is complex and the designer is faced with a loose problem that is not easily quantified (Kira, 1976; Rykwert, 1982). There is a wide range of possible technological solutions to building a shelter; decisions about lightness, speed, efficiency, climate, and materials create a complex set of criteria, some even conflict. In our culture, houses have a low threshold of improved function. Try to evaluate "home improvement;" figure out which house performs better than another. What do you measure, how is a newer house "new and improved." Can houses produce an improved sense of personal and social well-being, and if they do, then how do changes in construction techniques affect the spaces around us. While the scale of a house allows easy comprehension, the artifact is socially and technologically complex and analyzing design intent, building function and end use is usually quite difficult. In the twentieth century, engineers, and architects, designed new house construction systems to manufacture "engineered" houses with innovations in production, however they accounted for very little of total housing construction (Wachsmann, 1961). Consistently the parameters and methods of engineering design fall short of resolving this seemingly simple task. Building a house, or engineering the method of building a house, does not fit easily within the more constrained parameters of engineering design, since the outcome must afford a wide range of equivalent solutions, qualitative concepts, and design intentions (Hansson, 2002b). As such, the path of its design development has many possible directions with a wide range of possible solutions. However, this variability, once accounted for in the philosophical concepts of function, use, and intention, might allow discussion of fields of design close to engineering. It also holds the promise of a twenty-first century version of design that includes both the technical and the techno-social aspects of artifacts glossed by engineering.

1.1 Function and Functionality

In this chapter the concept of functionality is added to that of function, usability to that of use, and intentioned to that of intention. Engineers and most twentieth-century technologies have demonstrated that problematizing function is an effective way of operating. They do so by reducing the definition of function efficiently to solve the problem at hand. Broader consequences are unintentional and left unimagined. Rather than expanding the definition of function, this chapter argues for a discussion of functionality. Functionality opens function to a social context. It intends diverse use and appropriation. It designs specifically, but is open-ended. It not only designs function, it designs for functionality promoting the idea that one

artifact can respond to a number of different technical and social situations. And it is happening anyway; design is changing in a post-industrial world.

Kroes (2001) describes the "dual nature of technological artifacts" as being both physical and intentional. They extend philosophical inquiry of the engineering artifact into its techno-social aspects. In line with their stated intention of investigating function, Kroes and Meijers (2002b) explicitly reject investigating a "thin notion of function," one that has reliable association between input and output. In their view, a thick notion of function would include some of the deeper issues of intention important to engineering design; as would moving their concepts into proximate design fields, such as architecture and building science. This chapter outlines some of the deeper implications of intention that can be analyzed by moving outside of engineering design. In other words, in this chapter I argue for an even thicker notion of function.

From this designer's point of view, describing artifacts as both technical and techno-social is an important step in the assignment of function to human creations.[1] While it is true that designers, especially engineers, imbue function into artifacts; designers can also intend functionality for their artifacts. In architectural jargon, one is called a "tight fit" solution and the other a "loose fit" solution. Simple engineering, such as the design of the first jet engine, is an exemplar of "tight fit." The house construction system in the case study is an example of a "loose fit" technology. This distinction differentiates engineering from other design fields, and the engineering emphasis in the philosophy of technology leads to the conflation of function with functionality. Showing my bias, I think that any emphasis on engineering in philosophy of technology tends toward instrumental and essential argumentation. This would put engineering design on the weak side of functionality and on the strong side of function.

As an architect-designer, I find it easier to imagine ambiguous artifacts as intentionally ambiguous, rather than simply assume unforeseen appropriations by others, note, this is not the multiple realizability of functions, these are intended designs resulting in the multi-functionality of objects rather than accidental functions such as a hammer being used as a doorstop. Andrew Feenberg (1999) discusses the historical discovery of function during technological development. Instead, architects are historically conscious designers that intend ambiguous function. The wood frame construction system is a nineteenth century version of a technology that surrounds us, as are computers. Both combine homogenizing tendencies with new opportunities for appropriation, as in Borgmann's (1992) case for computers as homogenizing technological artifacts and Feenberg's (2002) optimistic critique for democratic computer design for such things as distance learning. In addition, part of the post-modern condition of contemporary design anticipates multiple appropriations, in other words many contemporary artifacts are designed for functionality.

[1] However, function is still assigned an instrumental, and perhaps essentialist (Feenberg, 1999), importance in Kroes' arguments and in his critique of Searle (Kroes, 2003).

1.2 Use and Usability

Tom Moran (2002) argues for usability as design intent. Software demonstrates the distinction between the use of an artifact and its usability. It is created with different design intent than the technical artifacts of engineering, more open to manipulation, redesign, and sub-design. In other words, there is a middle design realm between production and consumption where successful design is measured as much by resilience and ease of appropriation, where economics are more complex than simple technological production. Perhaps, use and usability are the consumption side of function and functionality (Cowan, 1985).

1.3 Intention and Intentioned

Now that I have questioned a distinction made in philosophical studies by introducing a double aspect of design intent, namely function and functionality and have suggested that even users are to some degree designers; I would like to suggest that the term intentioned could capture the contemporary post-modern attitude that designs for functionality and usability. This suggests a thick notion of intention. Of course, this does not assume that a design can anticipate all unintended consequences, but it can expedite a realm of secondary design to engage these consequences. As usability and functionality imply a more graduated differentiation between design and use, suggesting that intermediaries can be designers and users at the same time, so can design intent be subjectively plural with origins in another design.

Moreover, "intentioned" in its strongest sense associates a set of unrelated designers tackling the design of the same artifact (houses) or practice (methods of building houses). They might co-operate or compete, but each designer is aware of advances on the common project. Designers often are a "set of agents that share the same ontology ... able to communicate about a domain of discourse without necessarily operating on a globally shared theory [and] its observable actions are consistent with the definitions in the ontology" (Gruber, 1993). Design intentioned, as distinguished from intent, explains situations where different companies are designing the same type of product, and explains many indigenous traditions. However, another, more focused possibility of "collective intentionally" can be the root of design. The radical technological revision of wood building practice in North America was conceived collectively, and was an accretion or assimilation of many different cultural practices forged under the catalytic, homogenizing influence of new technology in construction and wood production. Here, perhaps, is an extreme example of techno-social designing.

This definition of collectively intentioned effectively reframes a discussion in the philosophy of technology. I propose that use and usability is the subject of the following discussion and explains the ambiguity identified. According to Kroes (2003), there is an

inherent ambiguity in Searle's analysis of the assignment of causal agentive functions between the role of collective intentionality and the role of intrinsic properties. In one line of reasoning ...causal functions are assigned and ... involve some form of (collective) intentionality. In another line of reasoning he underlines that objects with causal functions can perform their functions only by virtue of their intrinsic properties.

The concept of "collectively intentioned" on the production side of design (the quote references only the consumption side) suggests the shared ontology of house construction. Designing as a community or as loosely associated collective can meet the minimum condition of sharing a domain of discourse.

Wood construction, a side of architecture considered matter-of-fact technology, shows that loose-fit technologies occupy an important boundary condition between technical and social artifacts and offer a point of entry to discuss the *habitus* of practice and culturally-inflected technology. Design intent is clearest in engineering when the problem is well defined. Construction technologies and architectural technologies arc broader intentioned design manifested both collectively and individually. Broader design involves production, appropriation, and consumption – function and functionality on the production side and use and usability on the consumption side.

Now, all this might be beside Kroes' (2001) point in setting up the concept of the dual nature of artifacts:

> ... the physical description does not already contain (implicitly) the functional description, nor conversely. ... This logical independence raises the issue of how engineers in design practice are able to bridge the gap between a functional description of an object (the input of a design process) and a structural description as given in a design (the output of the design process).

However, this focus on engineering will not be able to answer for all of design – the inputs and outputs of the design process are somewhat different for different design disciplines. Many philosophers assume, at minimum, an *a posteriori* association between input and output. Artifacts of other design fields demonstrate considerable resistance to "a functional description of the object", i.e., no clarity of input, and "bridging the gap" is not an appropriate metaphor to relate inputs to outputs. Many design processes do not fit this far too singular and too linear image. So identify these as generalizations about *engineering* design, all right; but identify these as generalizations about all design, most certainly not.

1.4 *Resisting an Elective Affinity for Positivism in Technological Development*

Starting with technical and techno-social balance and a dual nature of artifacts as both physical and intentional, this chapter has parsed design into production, appropriation, and consumption and has distinguished function from functionality, use from usability and commented on the discourse about intention. This is based in experience teaching design in architecture, a field with a holistic design approach that includes technical and social parameters. Though architectural design is

difficult to define, as an approach it aspires to the multivalent rather than being univalent like engineering design.

Andrew Feenberg (1999) reminds us that technology studies often fall prey to presentist conceptions:

> It is true that, abstractly conceived, technology does bear an elective affinity for positivism, but that is precisely because every element of reflexivity has been left behind in extracting its essence from history. ... Those few determinations shared by all types of technical practice are not an essence prior to history, but are merely abstractions from the various historically concrete essences of technique at its different stages of development, including its modern technological stage.

Historians agree. Historians almost always discover that the path of development is uneven, full of different and parallel directions taken. Why certain techniques take precedence, why certain paths were not taken, isn't always clear. The reasons are as much social as technological. In other words, recent historians of technology reject its own version of positivism, that invention was personified in one inventor at one time. Henry Ford assimilated a historical series of technological improvements from the interchangeable part to the assembly line, all essential to mass production (Hounshell, 1984). If, as Feenberg says, philosophers have been slow to emphasize reflexivity, then, perhaps, historians have been quicker. However, for historians the reverse problem holds, the value of abstraction is depreciated and the search for over-arching principles of development has been left behind.

The path of technological development might be in some sense evolutionary (Brey, this volume), or follow some form of punctuated equilibrium as in Thomas Kuhn's (1970) revolutionary model. The trajectory of the case being studied points to an entirely different model of development, one that has general application. It is also a biological analogy, translated for use in anthropology. Brian Stross (1999) has discussed the application and translatability of the hybrid metaphor. It helps explain the wood frame construction system developed on the North American frontier in the nineteenth century, as well as its current dominant position in residential construction (see figure 1).

Both the evolutionary model and the Eureka moment personified in the inventor "bear an elective affinity for positivism" by assuming a technological advance of the fittest, even the revolutionary model of Kuhn assumes a punctuated advance. Each emphasizes a centre line of practice, failing to register the quantity or quality of aberrant and lost practices. In contrast, hybridization with distinct stages of development models the history of many technological artifacts.

2 Case Study: Charting Instumentalization of a House Construction System

Today, nearly 90% of North American houses are built using one method of wood construction (see figure 2). Now, it is probably the predominant practice in the world, displacing indigenous methods of wood construction in places with rich

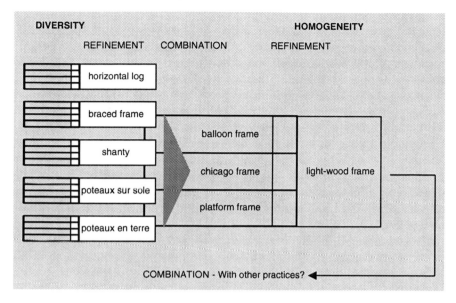

Fig. 1 The hybrid cycle applied to the development of the balloon frame construction system

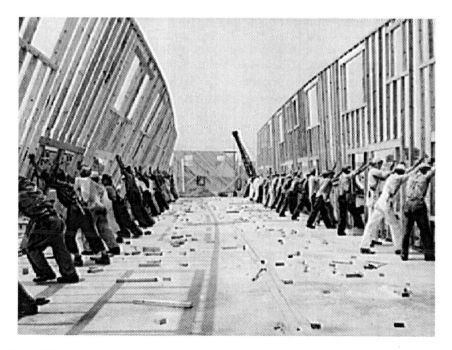

Fig. 2 Raising the framed walls of the balloon frame. 1941. (Alfred T. Palmer, photographer, 1941, Library of Congress, Prints & Photographs Division, FSA/OWI Collection, LC-USE6-D-000861.)

wood construction practices like Japan and Norway. The method is linked to a distinctive type of lumber, a major export of North America. It has also been substantially unchanged for a century and a half suggesting that it is a uniquely qualified solution, showing resistance and resilience during a period of considerable technological change – it behaves like it has a thin notion of function displaying a reliable association between input and output. Over time, critical challenges to this technology has led to gradual adaptations that have added up to decreased functionality in favor of function, organized its usability into certain specific ranges of use, and displaced from the collectively intentioned practice flexibly described in multiple overlapped traditions to the equivocal intention to support a massive technological system. Thomas Hughes (1989) claimed that artifacts are socially malleable when industries are young, but resistant to social influence once they have matured. This description rings true for the history of wooden house construction.

In its early stages, North American light wood frame demonstrated a kind of democracy of design; everybody was an agent promoting a collective intent for innovation. Today, it tolerates local variation and limited appropriation, while binding the builder or consumer into a massive technological system of production. This system includes the unintended use of everything from plantation forestry using non-native species to the regularized experience of uniform ceiling heights in houses. The house construction system has combined the three aspects of design, production, appropriation, and consumption, in substantially different ways over the course of its development, currently embedding them into a large technological framework that integrates all aspects of production and consumption.

Balloon frame, a version of light wood frame, exhibited early in its development entirely different propensities. It was part of an assimilative design process, combining in a myriad of ways the diverse set of frontier construction practices. Frequently, first encounters between cultures create a vibrant middle ground. Builders' guides focused on the frontier, explaining to the settler these new ways and emphasizing utility, expediency, and efficiency. In the process, the technical code was gradually regularized and codified. These early variations tested their performance against the new utilitarian criteria of the frontier; a frontier that saw an estimated 827,000 new homes built between 1830 and 1850 and an associated redistribution of natural resources unprecedented in history. This was the nineteenth century equivalent of rapid prototyping.

2.1 Feenberg's Theory of Instrumentalization

Feenberg's analytical tool of primary and secondary instrumentalization can identify particular properties and/or effects of the construction system in both its historic and contemporary guises. Feenberg (1999) describes primary instrumentalization as aspects of the universal essence common to all technology; "...a historical concept

of essence which combines the philosophical and the social scientific perspective." These tendencies distance the user from the lifeworld. Secondary instrumentalization, reinserts these abstracted technologies into a system of human relations, reconstituting a worldview based in or influenced by technology. Designers are agents of these reconnecting tendencies; often described as social construction.

In the case study, it was necessary to establish a discontinuity between the time before and the time after introduction; this becomes a basis for analyzing any technology. It was necessary to distinguish between two stages of technological development: the Working Design Phase (when most design and social construction occurs) and the Established Design Phase (when design might no longer be tolerated). In most of the analytical categories the artifact operates differently while it is open to modifying influence of design than while it finds itself an established part of a massive system of production and consumption.

Because secondary instrumentalization introduces social aspects, the time-based effects are considerable, however, these displace rather than erase properties. For example, in the case study, initiative is more limited today within the construction system (though the technique allows individual and regional variation), but overall there is more potential for initiative. The technique is simpler and requires less experience, making more people potential builders. Perhaps, one method would be to chart the relative strength of each aspect of instrumentalization in each period. However, this is not always straightforward. Initiative, for instance, remains possible in all periods since the building method is never proscribed or specified in a contract. In some ways it decreases and in other ways it increases.

Frameworks for cultural and other non-quantifiable analysis are, at best, 'loose fit' descriptions. They can help us discover and disabuse aspects of bias inherent in description and unravel specific technologies disguised by the ordinariness of everyday life. Both the hybrid metaphor and instrumentalization framework are models that abstract and generalize to suit a worldview. This seems particularly appropriate applied to designing for, as Feenberg says, "Design internalizes social constraints, condensing technical and social relations." Boundaries between technology and the social or cultural world are porous, making definition and analysis elusive. Good design refuses to grant technology any neutrality or view it as a simple instrument, tool or means to an end.

2.2 Instrumentalization of the Wood Frame

Interestingly, Feenberg (1999) uses houses and construction as examples of "richly signified technical artifacts" – an area of fruitful philosophical analysis. And again: "The tree conceived as lumber, and eventually cut down, stripped of bark and chopped into boards, is encountered for its usefulness rather than for its manifold interconnections with its environment and the other species with which it normally coexists."

The history of wood construction in North America can be approximated by three stages. These stages are identified with a wood product: log, plank, and lumber. Lumber is the result of the simple linear extrusion of the sawmill and includes particular parameters such as transport to the mill, forestry management, silvaculture, and land procurement. Each parameter reinforces the tendency in each other to normative practice. Building construction methods were designed based on the end product of the mill. Currently, North American wood frame determines lumber properties that, in turn, determine North American wood production creating an integrated system of production and consumption.

The following short descriptions sort some aspects of wood frame construction into the eight categories of instrumentalization. Each category is part of a pair, one primary and one secondary instrumentalization, Feenberg's key word for each is italicized. Each category is, in turn, divided into an a, b, and c representing the developmental stages of the technology; 'a' is just before its introduction, 18th century, 'b' is its working design stage, predominantly the middle half of the 19th century, and 'c' its established design stage, 19th century to date. The stages are: a) material of choice is whole wood, in the round or squared into timber, b) material of choice is plank or dimension lumber often only uniform in one dimension, c) material of choice is lumber and sheet plywood of standardized dimensions and properties.

2.2.1 Wood Production: Decontexturalization and Systemization

There is an increase in *decontexturalization* first trees come from the building site, then from the regional ecosystem and finally anywhere in the world. In the process, there is increased *systemization*, trees are organized into grading classifications to deal with individual, regional, and species variation.

Distribution widened. a) trees selected by the carpenter from the property or somewhere close to the building site and the wood is product of the local tradesman, b) trees are from upstream, wood is the product of the local sawmill, sold locally or downstream, c) trees are converted to lumber at the source, wood is the product of mills nationwide and sold at a national network of lumberyards.

Standards increased. a) Wood quality is established by an experienced eye judging the tree as it grows, b) grades of lumber are established between merchant and supplier, c) national grades of lumber are adopted, trade exports North American standards internationally.

2.2.2 Wood Production: Reductionism and Mediation

Forested land is *reduced* to a commodity. Initially woods are a necessary part of subsistence farming, then they are cleared for their exchange value creating new farmland, and now trees are planted as an agriculture-like crop. This exploitive orientation is *mediated*. Initially, trees indicate land fertility, next valued as national resource and now a subject of international scrutiny.

Wooded land became a commodity. a) wood lots are held by farmers for their heating and building needs; wood consumption gradually outstrips local supply, b) wood is commodified and adds to the market value of the land it grows on; improved distribution brings remote wood sources into easy reach, c) surplus farming liquidates the forest as a cash crop, forests displaced by more lucrative crops or forests are planted and managed to maximize quantity of lumber of a normative quality using imported species.

Wooded land was revalued. a) the fertility of the land for agriculture is judged by the quality of the trees growing on it, b) the aesthetic and recreational value of wooded land increases, the remaining forests are protected; newly discovered materials such as oil and steel used for heating and building, c) certification of forestry management and land practices allows for material choice by consumers based on ecological and ethical values.

2.2.3 Wood Construction: Automization and Vocation

The argument now shifts from wood production, *automation* and *vocation* are considered in the realm of house construction – the change in skilled work of the builder multiplying and simplifying building connections and the change in *vocation* and organization of these builders.

Work of joining displaced. a) round logs are shaped by hand, sometimes only as necessary, into flat surfaces and right angles for joinery, every joint is custom made to suit size of timber and geometry of connections, b) shaping for custom joinery becomes repetitive similar joints of low quality and skill, mortise and tenon jigs, and machinery used to make standardized joints, c) nailed butt joints in lumber becomes standard, simpler, and repetitive requiring less skill.

Framing trade introduced. a) home-owners built their own or employed local or itinerant joiners, a lengthy process, b) joinery gradually disappears; the new trade of framing is established, extensive publications explain technique and possibilities to the public, c) new site organization improves the speed of erection and uses teams of framers; the tools are inexpensive, accuracy simple to achieve and the framing trade easy to learn.

2.2.4 Wood Construction: Positioning and Initiative

North American wood frame construction is a conventional or customary system of building that resists exact description and precise definition in legal documentation or engineering calculation. Nevertheless, builders and house-owners are constrained by the total system of production and consumption. Builders working within the integrated system of production and consumption use its flexibility to *position* themselves for competitive advantage.

Building becomes predetermined. a) building contracts, if used at all, refer to the plan, a nearby house, or exterior appearance; no dimensional constraints or conventions,

cladding, and plaster finishes fit all sizes, some shops specialize in components such as windows and supply local trade, b) many houses are built with mail-order plans and specifications referring to the balloon frame; four foot module established perhaps by standardized length of lath, sash, and door manufactures ship components nationwide c) no drawings of the method of construction, drawings show overall house form and any exceptions to convention; sheet goods such as plywood and drywall necessitate sixteen inch spacing, many parts of the building such as roof trusses become components, shipped assembled; construction system is the armature for modern plumbing, electrical, insulation systems.

Simpler building supports *initiative*. a) adaptation of European construction practices to suit North American conditions, b) ease of erection by owner and helper, the construction system can be easily clad in the trappings of different styles, c) method of building widely known, allows easy renovation and repair by homeowners supported by extensive supply network. (Do It Yourself is an industry.)

2.2.5 Normative Tendencies of Systems of Production

If past experience is a guide, then the technological system of wood production will co-opt any new challenge to its stability. When local differences cause discrepancies or suggest new values for international standards of wood production, the power of North American trade prevails. The conjunction of apparently opposed forces is directed to its advantage. For instance, international trade and green building certification argue for standards, tending towards global standardization rather than local and diverse practices (Cavanagh and Kroeker, 2005). Several examples during the history of its development demonstrate this integrative tendency. Problems of construction or wood production, when resolved, have caused a more integrated system of production and consumption.

Since wood is natural, its internal properties vary according to its growth history. Moisture causes dimensional change. Relatively stable when growing or 'cured,' it shrinks in the process of curing. Shrinkage is accommodated both in wood production and in construction. Changes in moisture content influence the strength of wood and this has to be accommodated as well.

Strategies chosen to constrain shrinkage in wood during production – a) the carpenter cuts trees in winter and leaves them to season for a year or two, b) trees are only seasoned enough to mill, and then seasoned as lumber after milling, c) kilns are used to dry lumber to specific moisture contents – tie production to a specific method of construction – a) green timber is used to tighten some joints as the wood cures and shrinks, b) shrinkage is minimized through seasoning or in finishes that tolerate movement, c) the construction technique minimizes the systemic impact of shrinkage, predominantly perpendicular to the linear structure, by minimizing the total amount in the line of bearing.

The seasonal imperative for felling trees for timber in the winter diminished in at least three ways: sap-rich spring and summer wood could be more easily cured

in the smaller cross-sectional area of dimension lumber, railways were extended into the forests, and year-round work created economies at larger mills.[2] Construction methods changed in concert. The problem of shrinkage was by-passed in the design of the system of construction so that all wood members bear load vertically. Lumber was manufactured with the grain oriented so any shrinkage happened horizontally across its small non-bearing cross-section.

Wood production channel natural strength into small extrusions – a) trees are strong structures, cantilevered vertically; whole wood uses this natural structure, b) graining pattern in milled plank is visual key to identifying and aligning the natural structure, c) the linear structure of cellulose is oriented lengthwise along the main axis of lumber – tying production to a holistic structural concept embedded in a method of construction – a) structure in heavy timber frame depends on each joint, as strong as weakest joint; wood is used in ways that approximate its natural strength and geometry, b) joints increase in number, weaken, other elements such as cladding contribute structurally; new understandings of strength of wood create wiser use of cross-section and species, c) joint failure tolerated if statistically unimportant, total house becomes a structural system; the framing and the cladding contribute to a holistic sense of structure across the system.

The structural calculation of light wood frame requires a shift in understanding of structural performance. It acts partly as a frame structure and partly as a panel structure and it is stronger than any calculation that assumes that it is either one or the other.

The wider distribution of wood products demand reduced weight and uniform dimension. a) the real weight and hauling of trees individually logged is mitigated by horse and winter sled, b) distant logging limited by water transport, lumber distributed nationally by rail c) automated forestry equipment and saw mills suggest clear cutting and the utilization of all by-products of production, and requires a culture-wide reconceptualization of building permanence. a) houses are perceived as solid structures bearing heavily on the ground, permanence depends on mass, b) homes for the elite are masonry or stone, yet larger homes that are made of wood have lasted years, c) the appearance of permanence is no longer a function of construction, evidence of construction disappears into the wall (Cavanagh, 2000).

Incredible reductions in the cost of transport and distribution have led to the displacement of natural resources outside of their native ecosystem. Today, wood has gradually become a worldwide norm for residential construction, reconfiguring cultural perceptions of durability and competing with local building traditions. It is lighter and distributed more effectively than other conventional materials, and it is more cost-effective than newer materials.

Whereas Hughes reveals the history of large system technologies, Andrew Feenberg analyzes their implications in the philosophy of technology. Both Hughes and Feenberg are critical of their inertia. Both imagine alternatives. "A critical

[2] Immersion in water diluted the sap, assuring more even curing, free of warping, when lumber was subsequently stacked to dry. Maybee (1960) outlines the impact of railways.

account of modern technical rationality could be developed ... with a view to constructive change ..." Feenberg (1999) suggests, it needs "... a radical redefinition of technology that crosses the usual line between artifacts and social relations assumed by common sense and philosophers alike."

3 Conclusion

The philosophy of technology usually confines itself to engineering design and reverts to a twentieth-century model of technology. This chapter shows how one designer interprets the tools of philosophy. By focusing on a case study, I have shown the potential to raise interesting questions and fruitful discussion outside of engineering artifacts. Applied more broadly, this should lead to new ways of understanding design and the everyday technology of buildings that define our lives. The boundaries between technology and the social or cultural world always seem porous to architects and historians of technology. This makes definition and analysis more elusive, but allows for a conceptualization around ideas that refuse to grant technology any neutrality or view it as a simple instrument, tool or means to an end. Consider the diversity of design and, thus, diffuse our elective affinity to positivistic views of technological development.

References

Bijker, W., Hughes, T., and Pinch, T., eds., 1985, *The Social Construction of Technological Systems*, MIT Press, Cambridge, MA.
Bourdieu, P., 1990, *In Other Words*, Polity Press, Cambridge.
Borgmann, A., 1992, *Crossing the Postmodern Divide*, University of Chicago Press, Chicago.
Cavanagh, T., 2000, On permanence: thoughts about a historical reconstruction of a value basic to building, *J. Arch. Educ.* **54**(2):45–54.
Cavanagh, T., and Kroeker, R., 2005, Revaluing wood, in: *Sustainable Architectures, Cultures and Natures in Europe and North America*, S. Guy and S. Moore, eds., Spon Press, Abingdon, U.K., pp. 123–143.
Cowan, R., 1985, The consumption junction: a proposal for research strategies in the sociology of technology, in *The Social Construction of Technological Systems*, W. Bijker, T. Hughes, and T. Pinch, eds., MIT Press, Cambridge, MA, pp. 262–280.
Feenberg, A., 1999, *Questioning Technology*, Routledge, New York.
Feenberg, A., 2002, *Transforming Technology*, Oxford University Press, New York.
Gruber, T., 1993, Toward principles for the design of ontologies used for knowledge sharing, Technical Report KSL 93-04, Knowledge Systems Laboratory, Stanford University; http://ksl-web.stanford.edu/KSL_Abstracts/KSL-93-04.html
Hansson, S., 2002a, Understanding technological function: introduction to the special issue on the dual nature programme, *Techné* **6**(2):1–3.
Hansson, S., 2002b, Boxmeer (June 13, 2002); www.infra.kth.se/~soh/DualNatureConcepts.pdf
Hounshell, D., 1984, *From the American System to Mass Production, 1800–1932: The Development of Manufacturing Technology in the United States*, Johns Hopkins University Press, Baltimore.

Hughes, T., 1989, *American Genesis: A Century of Invention and Technological Enthusiasm, 1870–1970*, Viking, New York.

Kira, A., 1976, *The Bathroom*, Viking Press, New York.

Kroes, P., 2001, Technical functions as dispositions: a critical assessment, *Techné* **5**(3):1–16.

Kroes, P., 2003, Screwdriver philosophy; Searle's analysis of technical functions, *Techné* **6**(3):22–35.

Kroes, P., and Meijers, A., 2002a, The dual nature of technical artifacts: presentation of a new research programme, *Techné* **6**(2):4–8.

Kroes, P., and Meijers, A., 2002b, Reply to critics, *Techné* **6**(2):39–40.

Kuhn, T., 1970, *The Structure of Scientific Revolutions*, 2nd ed., University of Chicago Press, Chicago.

Maybee, R., 1960, *Michigan's White Pine Era: 1840–1900*, Michigan Historical Commission, Lansing, MI.

Mitcham, C., 2002, Do artifacts have dual natures? Two points of commentary on the Delft Project, *Techné* **6**(2):9–12.

Moran, T., 2002, London (June 25, 2002); http://www.cityofsound.com/blog/2002/08/tom_moran_on_ev.html

Rykwert, J., 1982, *The Necessity of Artifice*, Academy Editions, London, pp. 23–32.

Stross, B., 1999, The hybrid metaphor from biology to culture, *Journal of American Folklore* **112**:254–267.

Wachsmann, K., 1961, *The Turning Point of Building: Structure and Design*, Reinhold, New York.

Design Criteria in Architecture

Joseph C. Pitt

1 Introduction

In an earlier piece (Pitt, 2006b) I contrasted criteria for successful design in architecture with that in engineering. I argued there, among other things, that with the advent of "postmodern historicism" in architecture, beginning in the 1970s with the work of Venturi, there ceased to be operative criteria to evaluate architectural design and I made a first step towards outlining what such criteria might look like in the current age. I suggested that:

- Variation is important, but not variation that negates everything else. The Pompidou Center in Paris is an example of this.
- Harmony is important, but not harmony to the point of boredom. An example of a harmonious but boring architectural creation is the Levittown type suburban housing development in the United States.

In this chapter I elaborate those ideas, contrasting them with traditional canonical criteria, and offer some additional criteria in an effort to capture this fundamental idea: that architectural design must strive to make architectural projects work in context, given their functions. In short, I will develop a design objective called "Common Sense Design", based in part on some of the suggestions William James makes in his 1907 *Lectures on Pragmatism*. In part this involves developing the idea that certain designs have managed to survive relative to the domain in which they were developed and that we should learn from them. This is an argument against universalist principles of design, focusing on not just the locality of the site, but, rather, on the insights we can glean from the indigenous culture. As an example I will end by considering the Michael Graves complex in The Hague, which, from a distance, is a success, but, in context and in impact, appears, on one interpretation, to be a failure. Seen in another light, Graves' complex can be favorably compared to Frank Lloyd Wright's Guggenheim Museum.

J. C. Pitt, Virginia Tech

P. E. Vermaas et al. (eds.), *Philosophy and Design.*
© Springer 2008

2 Architectural Design and Philosophy of Technology

First, why the emphasis on architectural design? Or, more bluntly, what does architectural design have to do with the philosophy of technology?

To speak of living in a technological society is to speak of a society in which human activity seamlessly engages artifacts of one kind or another, from computers to houses to shuttles to legal systems, etc., in the processes of living and seeking a better life. Those artifacts are designed. Sometimes they are designed for one purpose and used for another, but they remain designed. Thus, at the heart of the concept of an artifact is the concept of design. And since the philosophy of technology is concerned in many ways with artifacts, many questions about architectural design can be seen to fall within its purview.

Put simply, architects design spaces as well as the constructional systems that enclose and mediate them. These are spaces that we use for living, working, recreation, etc. Sometimes they contribute significantly to achieving the goals we seek to accomplish in those spaces and sometimes they do not. Therefore, before we design the space we ought to have some criteria to guide our design. We need such criteria to maximize the probability that we will succeed in accomplishing the goal of creating a space that contributes positively to the activity for which that space was designed. These criteria should serve two purposes:

1. they should guide design, and
2. they should be the criteria by which we judge the success of the design.

To say this is not to commit to a vicious circle, i.e., we judge the finished product in terms of whether it meets the criteria we used to design it. It is more complicated than that because in the time line from initial concept to a design to finished product it is quite possible, in fact, I would argue, almost inevitable that the meanings of some or all of the criteria undergo subtle but important changes. That is, we may think we know what we mean by harmonious when we start the design process, but when we look at the finished space, it may not have turned out to be harmonious, in which case either we did not know what we meant by the concept when we began, or the concept of harmony we employ in evaluating the end space has changed from when we started and we now have two different interpretations of the same word. This can happen for a variety of reasons, but my explanation is that when we think of a concept like Harmony, given that it is part of our *criteria* for a successful space, we jump to the conclusion that as a criterion it must be universal and fixed in its meaning, when in fact there are no such fixed meanings.[1] To take this one step farther, I am willing to defend the view that in each application of, for example, the concept of harmony, we add to or subtract from what we thought we meant when we started the design process. Meanings change in application, or to put it in Peircean terms, meanings change when reality pushes against language.

[1] This analysis is firmly related to Goodman's (1955) new problem of induction and his concept of projection.

3 James and Common Sense

Basically James' account of common sense claims that the categories of common sense thinking are historically contingent, certain categories emerge because employing them in that context at that time increase survivability and success, however defined (James 1907; 1981). What may be an example of something or other in one context may not be in another.

Consider the following story, a real life example. I had asked some friends from the university if they wanted to help my wife and I load hay bales that were out in the field onto a truck and then unload them into our barn, they, all Ph.D.s, agreed and thought this would great fun. The hay field in question is on a hill and reasonably steep and visible from the road that winds down into the valley below. While we were near the top of the hill I saw the pick-up truck of an old framer who lived down the valley stop and turn around and make its torturous way up the mountainside to where we were. My wife was driving the hay bale truck, she grew up on a farm but it was in the flatlands. I was up on the truck stacking the bales as they were tossed up onto the truck bed. The old farmer, Dan, got out of his pickup and stared at us and just shook his head. "How many Ph.D.s involved in this operation?" He asked. I replied there were six of us. He snorted and then he asked "Any of you ever heard of gravity?" and then he laughed and laughed, got in his truck and started back home continuing to shake his head. It seems we had the truck pointed uphill – and the guys tossing bales had to throw them uphill against the pull of gravity. It was much easier to throw them downhill onto the truck bed, getting an assist from gravity. He knew that instinctively, well, he grew up riding along side his daddy from the time he could walk, absorbing so much of the common sense knowledge of how to get things done on a farm that it seemed like instinct.

This is the sort of thing that James means by common sense. Through a variety of means, some ways of doing things in a certain place for a certain purpose come to be common sense as they share acceptance in the community that does not require justification, they have been *vindicated over time*. Yet, the old French saying, *Plus le change, plus le meme chose*, is false. Consider the same scene twenty years later. The hay field has been sold and the new owner no long makes the small "square bails" of hay, but he still makes hay. However, now he makes hay in huge round bails. In order to get them down off the hillside he has to transport them one at a time on a spike on the back of his tractor, and to load one of the round bails on a spike on a hill you have back the tractor uphill, spike end pointing up so you can impale the bail and then move down the hill without it falling off. The use of gravity has changed. Now hold that thought while I move to canonical standards for architecture design.

4 Architectural Design Criteria

When it comes to design, there is a canon in architecture, at least there was.

The architectural canonical criteria come to us from the Roman architect, Vitruvius. The three criteria he laid down were, *Utilitas, Firmitas*, and *Venustas*.

These have been translated to mean "Commodity, Firmness, and Delight" – Robert Bruegmann considers the exposition of these concepts by Geoffrey Scott in his 1914 *The Architecture of Humanism* to be the best. According to Scott, the first criterion is commodity.

> Buildings maybe judged by the success with which they supply practical ends they are designed to meet. Or, by a natural extension, we may judge them by the value of these ends themselves; that is to say, by the external purposes that they reflect. These, indeed, are two different questions. The last makes a moral reference, which the first avoids, but both spring, and spring inevitably, from the link which architecture has with life. (Bruegmann, 1985, 3–4)

On this account Commodity, or perhaps a more faithful translation is Utility, requires that the design of a building both be suited to the function it is supposed to perform and exhibit that function. The first seems reasonable enough, the second is a bit less obvious. Taken to extremes we might require that a Post Office look like a giant envelope and surely that is not what is entailed here. But it is not uncommon to expect, for example, governmental buildings to be larger than life, exhibiting the transcendent function of government over the interests of a single individual.

The second criterion is *Firmness*.

> On every hand the study of architecture encounters physics, statics, and dynamics, suggesting, controlling, justifying its design. It is open to expression of material properties and material laws. Without these, architecture is impossible, its history unintelligible. And if, finding these everywhere paramount, we seek, in terms of material properties and material laws, not merely to account for the history of architecture but to assess its value, the architecture will be judged by the exactness and sincerity with which it expresses constructive facts and conforms to constructive laws. (Bruegmann, 1985, 2)

Bruegmann interprets this to mean that "Firmness ... is about structure and composition. A building should not only be sound and logical in is construction, but it should appear this way as well." (1985, 18) It is not clear what it means for a building to be logical. Further, with the advent of newer construction materials and techniques, the appearance of the soundness of the construction has lost some of its force. Consider large enclosed sports stadiums. The supporting structure of the domes is often not clear and obvious. It is also not at all obvious that allowing the building visually to expose the source of its soundness necessarily is a good idea. This example is not completely on point, but it should highlight the issue. Corning Industries is a large U.S. firm specializing in products made from ceramics and glass. When the Corning Plant in Christiansburg, Virginia, was built in the 1960s there was an expressed desire by management to use as many Corning materials in its construction as possible. So, some wise designer decided to use glass tubing for the plumbing and to have the tubes exposed overhead. When the plant was opened and tours were being given, the obvious mistake was noted and the tubes were quickly wrapped in duct tape.

The third criterion handed down to us by Vitruvius was *Venustas* or Beauty or sometimes conceived as Delight.

> We may trace in architecture a third and different factor – the disinterested desire for beauty. This desire does not, it is true, culminate here in a purely aesthetic result, for it has

to deal with a concrete basis which is utilitarian. It is, nonetheless, a purely aesthetic impulse, an impulse distinct from all the others, which in architecture may simultaneously satisfy an impulse by virtue of which architecture becomes art. It is a separate instinct. It will borrow a suggestion from the laws of firmness or commodity; sometimes it will run counter to them, or be offended by the forms they would dictate. It has its own standard, and claims its own authority (Bruegmann, 1985, 4)

And therein lies the rub. What makes a building beautiful? Surely we want to resist the idea that beauty is simply in the eye of the beholder, but can we? Who is the arbiter of beauty? In what some call modernist architecture and then in post-modern historicist architecture, the arbiter has become the architect. But there is a difference between the architect of the 19th century and the architect of the 20th. The Enlightenment architect of the 19thth century believed in the power of reason to reveal the nature of things. In this case, it was the nature of beauty. There was a deep-seated belief that there existed natural laws governing the beautiful and that the architect was best qualified to find those natural laws. In dealing with this ineffable quality of beauty, the modernist 19th century architect, while taking it upon himself to be the arbiter of taste, argued for taste allegedly based on reason. As Bruegmann puts it,

Modernists believed the job of the architect, at least the genuine avant-garde architect, was to discover what these laws [of beauty] were and to insist on them even if they ran counter to society's expectations. In fact, as the nineteenth century progressed, the avant-garde moved further and further from the tastes of the population at large. (Bruegmann, 1985, 22)

The search for and hoped for discovery of universal laws of beauty by the chosen few (i.e., avant-garde architects) was seriously under-minded by those who followed Robert Venturi (1972) who, thanks to his criterion for post-modern architecture, that the present must recapitulate the past, inadvertently helped spawn the ubiquitous large office buildings with various embellishments such as columns and arches that line the sides of such places as the highway that leads from Dulles International Airport outside of Washington D.C. into the U.S. capital.[2] With recapitulation of the past as the sole criterion, beauty becomes taste, and we all know *de gustibus non disputandum est*. Couple this with the architect's retained conviction, a holdover from the 19th century, that he or she is the anointed arbiter of taste, this time not based on reason but fad or ego, and you get the architectural plague of the 1980s and 1990s.

What I am claiming is that the traditional criteria for evaluating the product have been undermined. They have been undermined by the development of new materials and techniques and by abandoning the 19th century modernist conviction that there are laws of nature governing beauty. Whatever criteria are provided have to do with

[2] Steven Moore has rightly pointed out that Venturi was not directly responsible for this blight. Venutri was motivated by political and populist concerns, seeking to harvest interpretations from the past, rather than impose them from some *a priori* elitist viewpoint. His work was co-oped by others who lacked his political and populist leanings.

the taste of the individual critic, motivated perhaps by a reaction to modernity and modernist architecture, and that tells us very little about the building itself.

5 A Common Sense Proposal

Architects design spaces, but not all spaces are designed. As an undesigned space consider a forest, although there are designed forests in the Netherlands, France and elsewhere. Furthermore, spaces are always to be found in other spaces. And it is to the spaces within spaces I would direct our attention. I am not concerned with questions of the intention of the designer, for his or her intentions have their own problems. Instead I want to focus on the space itself. If spaces are always to be found in spaces, then the relationship between and among spaces seems a logical starting point for a new discussion of design criteria. I should also like to note that spaces have histories. A particular space is what it is because it has come to be that space over time. This applies to a building, a city, or an environment. The forces that create the spaces differ, some are through human intervention, like zoning, some are forces of nature. But spaces have histories and the interesting thing about these historical spaces is that there seems to be something like an evolutionary success story to the spaces that have sustained a certain continuity over time.[3] That is, some types of spaces work better in some spaces than in other spaces. And when it comes to building new spaces, I would suggest that we apply something I want to call *architectural common sense*. This is basically the normative claim:

– the space should fit the space it is in, *ceteris paribus*.

In talking about spaces in spaces, it should be clear that I am talking about the location and external look of a space. There are other issues as well to be considered, but time and space make these topics for other times. However, two seem especially important to at least note them. The first concerns the notion of function. That is: Does the space do what it is supposed to do? Having raised that issue, another immediately springs to mind: Who determines what the space is supposed to do? The ready answer, the person or institution that issues the commission, is problematic since the users of the space often have interests in conflict with those who commissioned the space and with those who designed it. Who determines whether the space in fact accomplishes what it is supposed to is another question like the first to be left unanswered.

[3] This idea that spaces have histories and that knowing that history is important in design derives in part from some earlier ideas. In (Pitt, 2006a) I introduced the notion of *explanatory contexts*. The mark of an explanatory context when dealing with historical material is that it tells a *coherent story*. In (Pitt, 2001) I elaborated the notion of a coherent story into a *philosophical problematic*, where the point is made that to understand a philosophical problem in an historical context one must know its past history and, if possible, its resolution or its projected resolutions. Echoes of these ideas are to be found in the ideas of common sense design criteria.

The point to be established is that the criterion for claiming a space is a good piece of architecture is that the space fits. I like this idea for many reasons. One is tempted to ask what it means, however. And that would be reasonable. So, as a first stab consider the following:

– A space fits in a space if it is in harmony with the space it is in.

To understand what it is to be in harmony with a space is best approached negatively, that is, it is easier to explain when a space is not harmonious than to explain what harmony means. This approach has many drawbacks. In particular, by saying what harmony is not is not to say what it is. However, there is no need to nail down a set of necessary and sufficient conditions, since, as I argued above, the meanings of the criteria change in the act of application.

Nevertheless, there are several things we can say about harmony that should at least set us on the track to, if not a definition, at least a characterization. To begin with, there seems to be a scale on which different degrees of harmony can be mapped. At the extreme end of the scale is the religious sense of harmony found, for example, in Buddhism. Closer to our theme is the harmony of the Japanese Tea Ceremony. At the other end of the scale is the lack of harmony we find in a space that startles us or which continually draws our attention back to it because of a sense of inappropriateness. At this end I would place Michael Graves' Portland building.

To begin with, the Portland building appears to disregard its surroundings. It has tiny windows that create a kind of visual dissonance with those of the buildings around it. It does not harmonize with its location, rather, it just sort of sits there. The building is an impediment to moving around the area, whether that movement is visual or physical. It shares little architecturally with the surrounding edifices. It is an example of excessive variation. It is located in what would seem to be a square area that might otherwise be a park, and yet it seems to mock the idea that there could have been a park here instead, it is a heavy building whose parts seem arbitrarily thrown together. Visually, it is a bully.

Assuming that this example has provided us with some sense of what it is for a space not to be in harmony with another space, let us now take a look at what appear from a distance to be dual skyscrapers which Graves designed in The Hague, the Netherlands. From the train as you pass by them at a distance, they appear to be almost perfect. Tall and massive, they have exaggerated traditional Dutch rooflines that make their placement appear natural. They appear to be wonderful examples of the common sense architecture of which I spoke earlier. Graves has managed to bring forth a traditional design that has withstood the test of time and yet given it a clearly modern presentation. There are historically good reasons for the style of roofline mostly having to do with the weather. In addition, the style has acquired a kind of emblematic nationalistic character. These are clearly Dutch.

Unfortunately, the buildings contribute to a kind of artificial demarcation of parts of the city, between the lived-in city and the governmental city that empties into the evenings. The governmental complex, of which they are a part, forms a

clump in the middle of a vibrant part of the city that you have go around to get from
one part of the lived-in city to another. What appeared from a distance to be two
separate buildings are in fact part of a single complex grounded in a massive base.
In this respect it behaves very much like the Portland building. The complex
interferes in the life of the city, it has negative and dark aspects to it. There is a large
city park half a block away that the building in no way recognizes. Rather, it meta-
phorically appears to threaten that space. Since no one lives there, it is dark at night
except for the glare of streetlights, empty and brooding, even menacing. Thus,
despite the pleasing visual effect from a distance, the actual impact of the building
appears to be negative.

Is the space marked by the The Hague Graves complex harmonious or not? The
answer is not, as you might think, "it depends", rather I would claim that it is not
given that, in one clear sense, it really does not "fit", since it, like Graves' Portland
building, does not contribute positively to the environment it is in, rather it disrupts
it. Yet the lack of harmony is not exactly the same with respect to the two spaces,
and this is part of what I mean when I said that the meaning of the concept is
modified by its application. On the positive side, the Graves building asserts
"Dutch" in a Dutch environment. On the negative side, it has this negative impact
on the social life of that space. The Graves Portland building, however, could also
be said to have a disruptive social affect since it sits in a space that probably would
be better served as a park. But who knows, the possible park could become a major
location for drug dealers and other undesirables. Irrespective of its social impact, it
remains the case that it is visually not a fit. There is nothing in the design that says
it belongs there, that it has anything in common with the neighborhood, that it has
a historical linkage with the area. It is just an ugly building plopped down in the
middle of a city to which it has no relevance.

The more one thinks about it, the more the notion of relevance becomes increas-
ingly important in evaluating a space. To see my point, let us return to the Graves
The Hague complex. Surely, one would say they are relevant. They are governmental
buildings, their monumental size is traditional in government buildings, speaking to
the transcendent nature of government. They are clearly Dutch government build-
ings, so there is a second relevant feature. However, if Graves had put these two
buildings where he put his monstrosity in Portland, they would have clearly been
out of place and clearly not a fit. The interesting question is "Why not?" It seems
that when talking of relevance, we have to look at additional features of the space.
Are they, for example, relevant to that city, conceived as an historical space? Not as
they stand. If the city decided to build a new governmental center at the outskirts
of town, that might have been a different story. In fact, it would have been a wise
thing to do, it could have been an opportunity to showcase the modern Netherlands
and highlight its vibrancy and dynamism. As it currently stands, those buildings are
disruptive of the space they are in and you cannot be both disruptive and harmonious.
Celebration of the site is crucial but not by way of degrading what else is already
there. Visual excitement is important, but not to the point of contributing to an
overall failure of the impact on the space.

6 Common Sense Design

Let me conclude with a few comments on common sense design. My appeal to "fit", and "harmony" has as much to do with creating a space in which to live and work as they do with history. And harmony seems to require even more. Having a sense of the historicity of the space is part of what is needed to live in harmony in it. On the surface it makes no sense to put a modern 60 story glass and steel skyscraper in the middle of an ancient village of 200 people. That does not require a fully developed aesthetics, just, it might seem, common sense. It would be an insult to the generations of inhabitants of the village and the values and way of life they have contributed to the culture. Yet our Jamesean sense of common sense brings with it this very sense of historicity, in that there is a definite case of cognitive dissonance that emerges when we try to project the image of a 60 story glass and steel skyscraper into Delft's town hall plaza. But why should this be so? It is, I submit because given our past experiences of cities like Delft, we do not expect to see such a space in that space. Goodman, in speaking of Hume's account of induction puts it this way.

> Regularities in experience, according to [Hume], give rise to habits of expectation; thus it is predictions conforming to past regularities that are normal or valid. But Hume overlooks the fact that some regularities do and some do not establish such habits... (Goodman, 1955, 81)

Goodman's solution is his theory of projection. My solution is to say that certain expectations, in the form of standardly used but thoroughly unexamined inferences bring with them the history of those expectations. And they do so by way of there having been developed over time acceptable inferences which we are taught to make because they have been successful in guiding action.

Yet, when we invoke the power of history we must be careful. History is a complicated mistress. While she grounds us in the past, we must not, at the same time, consider the past as something concrete. In short, to be grounded is not to be stuck. I am not denying that there were events that transpired over time in a certain order, etc. Let's call that "what actually happened" or History 1. Nor am I talking about history as *the narrative* we construct about what happened: History 2. Furthermore, in constructing such a narrative we need to be alert to the *historiography* we employ, History 3. Thus we might employ certain terms in a manner that suggests they are constants. An example could possibly be my use of the term "Dutch" in describing the Graves complex. On the other hand, if I am true to my earlier comments, terms like "Dutch" ought to change over time due to a variety of historical contingencies. Thus it would be inappropriate to refer the people living in the area around the Netherlands as Dutch in 1250 BCE since, according to the Oxford English Dictionary, the term was first used in the 9th Century BCE to refer to Germans (hence, Deutschland) and only gradually restricted to what we now know as the Netherlands, beginning in the 16th century. So, in a sense we can say that history changes, that is, History 2 changes. The narrative changes as we learn more

about the past and as we change our criteria for how to construct an adequate
narrative (History 3). Keeping that thought in mind, we can offer a different, and
even a positive assessment of the Graves complex in The Hague.

7 Conclusion – Graves Reconsidered and the Mystery of the Guggenheim Finally Solved

In their attempt to hold back the sea and increase its usable land mass, the Dutch
have become increasingly concerned and identified with the technology of dikes
and pumps, and with their constant battle with nature to secure their limited space.
The meaning of being Dutch has changed from being identified with a sea faring
colonial empire to that associated with a highly technologically sophisticated
culture directly confronting nature. In the light of that evolving history, Graves, in
his The Hague complex, instead of what I had suggested above, could be seen as
looking to the future of the Netherlands, with its increasing dependency on massive
and sophisticated technologies and how it might solve past problems in a
technologically futuristic fashion. A closer look at the The Hague complex reveals
a complicated set of interconnected buildings and elevators that might be construed
as a futuristic dam, pointing the way to the next stage in the evolution of Dutch
culture. Hence its massive and forbidding base can now still be seen as massive, but
because that kind of a dam needs that kind of base. Further, what on our initial
interpretation we saw as threatening the park on one side of it, can now be seen as
defending it from the intruding ocean. Likewise, constructing a 60 story skyscraper
in the middle of Delft's central square might also suggest the future by way of
providing a means for providing living space in the face of decreasing opportunities
for land expansion and the need for alternatives to the traditional Dutch way of
living in single family houses. In so doing, what, on one view, could be seen as an
affront to Dutch cultural sensibilities, might, on this one, be a means for suggesting
solutions for historical problems.

One final example: the Guggenheim Museum in New York City. To put it mildly,
when first unveiled it raised a significant fuss. In a line with traditional town houses
facing Central park, it presents not a traditional flat face but a curved space clearly
descending in a spiral from top to bottom. In one sense it can be seen as totally out
of place in that environment. It breaks the line one's eye follows as you look up the
avenue. It sticks out and disturbs its surroundings. What was Frank Lloyd Wright
thinking?

Let me suggest that he was thinking about the history of art and demanding that
we reconsider how we think about it as well. Traditional art museums present their
displays in disjointed rooms. In this way we can look at 17th Century Dutch painting
in one room, and 19th Century American Romanticism in another, thereby allowing
us to capture a snap shot of art history. But what if that is the wrong way to view
the history of art? Is it really the case that we can draw clear boundaries between
the 16th and 17th centuries, or between American and Dutch art? What Wright said

to us *via* the Guggenheim is that the history of art is a continuum and to see it that way you need a different type building, and the rest is history, so to speak.

In sum: Common sense is a set of responses to the challenges of an environment based on an historical appreciation of that environment and what counts as successful action in it. To be successful means you need to be thinking not just about the history, but also about the problems that history has confronted, some of which remain unresolved. Common sense is, then a way of thinking about decision making which leads to actions that take into account the successes, failures, and values of the past and builds the future in light of those successes, failures, and values.[4] Finally, I would add that one of the hallmarks of common sense is its appropriation of new techniques as they are developed. It is not commonsensical to reject new materials, technologies, and techniques when they provide the means to solve problems we have been unable to resolve in the past. So, if common sense principles of architectural design insist the space must fit, what it takes to fit includes more than some kind of visual harmony; fitting also includes fixing problems. In so doing, we may be forced to acknowledge what we have been unwilling to do before, that older values have been supplanted. In that respect, common sense is not nostalgic, it always looks to the future.[5]

References

Bruegmann, R., 1985, Utilitas, Firmitas, Venustas, and the Vox Populi, in: *The Critical Edge: Controversy in Recent American Architecture*, T. A. Marder, ed., MIT Press, Cambridge, MA, pp. 1–24.

Goodman, N., 1955, *Fact, Fiction, and Forecast*, Harvard University Press, Cambridge, MA.

James, W., 1907 and 1981, *Pragmatism*, Hackett, Indianapolis.

Pitt, J. C., 2000, *Thinking About Technology*, Seven Bridges Press, New York, http://www.phil.vt.edu/HTML/people/pittjoseph.htm

Pitt, J. C., 2001, The dilemma of case studies, *Perspect. on Sci.: Hist., Philos., Soc.* 9(4):373–382.

Pitt, J. C., 2006a, Seeing nature: origins of scientific observation, in: *Conceptions de la Science: Hier, Aujourd'hui, Demain, Hommage à Marjorie Grene*, J. Gayon and R. M. Burian, eds., Ousia, Brussels, in press.

Pitt, J. C., 2006b, Successful design in engineering and architecture, in: *Creativity: Technology and the Arts*, H.-J, Braun, ed., Peter Lang, Frankfurt aM, in press.

Scott, Geoffrey, *The Architecture of Humanism: A study in the history of taste*, Constable and Company Ltd., London.

Venturi, R., 1972, *Learning from Las Vegas*, MIT Press, Cambridge, MA.

[4] For an elaboration of this view see the decision-making model developed in (Pitt, 2000).

[5] I wish to thank Carla Corbin and Thomas Staley for many helpful comments and corrections on earlier drafts and especially to Steven Moore and Thomas Staley for pushing me to the necessary conclusion. Of course, remaining errors remain my responsibility.

Cities, Aesthetics, and Human Community

Some Thoughts on the Limits of Design

J. Craig Hanks

> *In experience, human relations, institutions and traditions are as much apart of the nature in which we live as is the physical world. But there are multitudes of ways of participating in [nature], and these ways are characteristic not only of various experiences of the same individual, but of attitudes of aspiration, need and achievement that belong to civilizations in their collective aspect.*
>
> – Dewey (1980, 333)
>
> *Many, many human beings are not thriving in the city, in fact they are barely surviving ... It is obvious that [the late-capitalist city ls] eating its own children in order to satisfy the unquestioned demands of a market economy made manic by global greed.*
>
> – Grange (1999, 193)
>
> *In general, you can tell what really scares a society – its collective vision of the dangerous other – by examining its architectural arrangements for exclusion and isolation.*
>
> – Mitchell (2005, 49)

Over recent decades there has been much concern in the United States about the crisis of cities. Among the many problems facing us are: sprawl, loss of farm and wilderness lands, increasing racial and economic separation, increasing demands on infrastructure, time lost to commuting, loss of financial resources, and the waning of community.

In the following essay, two possible responses to this crisis are examined: New Urbanism and Civic Environmentalism. New Urbanism because it is the most visible and highly touted strategy, and Civic environmentalism because, I argue, it holds out the promise of helping guide a better response. I offer explications of the central ideas of each, examine how persons working within either framework might respond to the problems facing cities, and evaluate the proposed solutions.

J. C. Hanks, Texas State University

P. E. Vermaas et al. (eds.), *Philosophy and Design.*
© Springer 2008

1 Crisis of Cities

1.1 Introduction

Much has been written, especially in the United States, about the crisis of cities, about the many problems facing our largely automobiled cities. This is not the crisis of the late 1970s. It is not the crisis of cities burning, runaway inflation and cultural "malaise." Rather, the crisis is described as one of sprawl, loss of farm and wilderness lands, increasing racial and economic separation, increasing demands on infrastructure, time lost to commuting, loss of financial resources, the waning of community, and an ever more fractured political life.

I will begin by briefly discussing this crisis, and hint at the role of suburbanization in this process. I will then consider two possible responses: New Urbanism and Civic Environmentalism. In the end, I will suggest that of these Civic Environmentalism is a better response, better in large part because while the problems we face are problems of design and planning, they are neither exclusively, nor even mainly, such.

1.2 Sprawl

Over the last 75 years, cities in the United States have sprawled. The growth of population explains about 31 percent of the growth in land area of US urban areas in the last 20 years. Even those areas that experienced no population growth have increased in urbanized land area by an average of 18 percent (Ewing et al., 2000). Data collected by the U.S. Department of Housing and Urban Development for its State of the Cities 2000 report show that urban areas are expanding at about twice the rate that the population is growing (U.S. Department of Housing and Urban Development, 2000). Development patterns have emphasized single-use development, with pods of commercial, housing, public, and other spaces all developed independently. One of the reasons for sprawl, and one of the upshots of it, is our ever-continuing love affair with individual motor vehicle transportation (Boarnet and Haughwout, 2000; Heavner, 2000). The automobile carries people from one space to another, stringing out social experience and mapping a community with no center and no edge. Sprawling growth patterns eat land, increase travel time and cost, make walking both more difficult and dangerous, and lead to greater pollution levels (Surface Transportation Policy Project, 2002; Office of Technology Assessment, 1994; Moffet and Miller, 1993; MacKenzie et al., 1992; Litman, 1992; Ketcham and Komanoff, 1992). Sprawl also exacerbates social separations. Living patterns become increasingly segregated along racial lines (Berube, 2001), and along economic lines (Frey, 2001; Glaeser, 2001). Further, as the sprawl continues, older, inner ring suburbs now face many of the same problems as the central city (Boarnet and Haughwout, 2000; Heavner, 2000).

Consider Atlanta. From the mid-1980s to the mid-1990s, Atlanta grew 32%, in population. During the 1990s alone, the region doubled in size from 65 miles north

to south to a staggering 110 miles. This growth has not been evenly distributed. In 1998, growth in Atlanta's suburbs was 100 times the growth in the city. From the mid-1980s to the mid-1990s, Atlanta's property taxes increased 22 percent, vehicle miles traveled jumped 17 percent, and ground-level ozone, measured by number of days with unhealthy concentrations in the ambient air, rose 5 percent (Nelson, 2000; U.S Department of Housing and Urban Development, 2000; Bullard et al., 2000; Benfield et al., 1999).

1.3 The Meaning of Sprawl

Sprawl contributes to loss of land and more environmental degradation. Between 1992 and 1997 the loss of farmland in the U.S. accelerated. The U.S. Department of Agriculture Natural Resources Inventory for farmland lost shows a significant increase in suburban sprawl during the 1990s. During those 5 years in the mid 1990s, we lost 11.2 million acres worth of farmland and other open spaces to sprawl. This means the annual average rate of loss is 2.2 million acres. The total land lost to sprawl was 25 million acres in the 15-year period from 1982 to 1997 alone (USDA, 1997).

Perhaps sprawl is the American Dream, and perhaps any problems with it are easy to fix. There is plenty of land left in the United States, and congestion would go away if we would just build more roads. Wal-Mart and SuperTarget respond to our desire for convenience, and hold out the promise of everything we might need, in one place, often available 24 hours a day, with easy access. Further, sprawling development patterns are the result of the free market responding to people's true desires. Including the desire for a single-family residence and a patch of green. Further, people participate through neighborhood associations and through voting on bond issues and for local office holders. If more people do not participate, perhaps that is because they are satisfied with the state of things.

Perhaps, but I think not. This version of the American Dream is what Benjamin called a "phantasmagoria." The phantasmagoria is a deceptive image intended to dazzle and amaze; a thing which appears as itself while simultaneously hiding itself. (Benjamin, 1999) We have tract mansions and suburban subdivisions as key to making a home and a place that is so like others as to be placeless and is often only inhabited for a few years. We purchase individual vehicles as the key to mobility in order to sit in traffic on the freeway. We build gated communities as the key to security, and we fear the remainder of the city and leave it to fulfill our fears. All of these offer and undermine what they promise. And, these commodities remain, as they were for Benjamin, phantasmagorias – the "century's magic images" (Benjamin, 1996). Just as for Benjamin's Paris the 19th century was a nightmare from which the city needed to awaken, so now we live within the dream of both 19th, i.e., early suburbs, rapid westward expansion of the country, and 20th centuries, i.e., the American century, with booming economic and military might.

These phantasmagorias are also fantasy versions of citizenship. They are perhaps consistent with a highly formal account of citizenship realized primarily through

voting activity and consumption in pursuit of a narrow notion of self-interest. Narrow because a fuller sense of self and hence of self-interest would recognize the poverty of this model of citizenship and human living in which there is little connection to people or to place. But, the perpetuation of this very model as dream and ideal cuts against this recognition of a larger self-interest and citizenship.

Further, we have some evidence that the trajectory of sprawl is neither sustainable nor desired. 1998 and 2000 state-wide polls in Colorado found that 45% of citizens thought that addressing growth and transportation problems are the most pressing issues facing the state (Ciruli Associates, 2000). A 2001 poll by the U.S. Federal Highway Administration found that over 60% favor sidewalks, mass transit and bikeways, and fewer than 40% favored building more roads (Federal Highway Administration, 2001). Numerous national publications have examined the growth of suburban "mega-churches" as responses to the isolation and lack of community found in most U.S. suburbs.

2 Some Responses: New Urbanism and Civic Environmentalism

2.1 New Urbanism

The New Urbanism movement is a response to the out-of-control development of the American suburban landscape. Its founding figures, Andres Duany and Elizabeth Plater-Zyberg, have embraced commercial residential development opportunities like Celebration and Seaside, Florida, with a moral fervor. Hoping to use market forces to their advantage, Duany has said, we must "attack [the] enemy on [its] terms" and, as Plater-Zyberg has said, "improve the world with design, plain good old design" (The Congress for New Urbanism, 2005; NewUrbanism. org, 2005; Duany, 2000; Duany Plater-Zyberk & Company, 1997).

New Urbanism encourages the construction and renovation of diverse, walkable, compact, vibrant, mixed-use communities using the same components as conventional development. But rather than creating more sprawl, New Urbanism proposes to combine these elements in a more integrated fashion, bringing forth complete communities. These New Urbanist communities contain housing, work places, shops, entertainment, schools, parks, and other public facilities essential to everyday life. Further, all of these elements are within easy walking distance of each other. Rather than highways and roads, New Urbanism promotes the increased use of trains and light rail. In the last 20 years, urban living has again become desirable to a growing segment of the U.S. populace, in part because core urban areas are more dense, and have many of the characteristics New Urbanism hopes to foster. As of 2005, there are over 500 New Urbanist projects planned or under construction in the United States alone, half of which are in historic urban centers.

The principles of New Urbanism (NewUrbanism.org, 2005) are:

1. Walkability
2. Connectivity
3. Mixed-Use & Diversity
4. Mixed Housing
5. Quality Architecture & Urban Design
6. Traditional Neighborhood Structure
7. Increased Density
8. Smart Transportation
9. Sustainability

An important assumption of the New Urbanist movement is the tenet that architecture and the organization of space strongly influence social behavior. That is, New Urbanism, in spite of a certain postmodern cuteness in design elements, rests on the decidedly modern notion that the "built environment" can create democratic utopias. It is also a movement built upon a certain amount of nostalgia. For the New Urbanist architect and town planner the ideal form of human community is found in the ambience of the New England colonial village, town centers, green space, interconnected walkways, where people shared space intimately and nurtured social relations conducive to the free exchange of ideas perhaps best exemplified by town hall meetings. The goal of New Urbanist developments is to recapture, or even to recreate, these sorts of communities. New Urbanist developments attempt to create a space with an identifiable center and edge, in short, to create community through the manipulation of space.

Influential in the New Urbanist search for urban spaces with definable centers has been architect Charles Moore's (1965) article in the influential architectural journal *Perspecta*, "You Have to Pay for the Public Life". In this essay Moore addresses the lack of public pace and public sphere on the West Coast of the United States with particular focus on the city of Los Angeles. Moore argues that Los Angeles lacks an urban focus or center, and that "the houses are not tied down to any place much more than the trailer homes are, or the automobiles. [The houses] are adrift in the suburban sea, not so mobile as the cars, but just as unattached. ... This is ... a floating world in which a floating population can island-hop with impunity ..." Los Angeles is characterized by a lack of place (Davis, 1992; Jameson, 1992). Moore argues that a central characteristic of cities that are identifiable places is that there is a marked and celebrated center. Identifying a place and marking its center is a self-consciously public act where people come together to celebrate a place for particular reasons, and the marker then becomes the symbol of their shared values. In his article Moore claims that Disneyland is one of the few real public spaces in Los Angeles. Disney's new town of Celebration has its roots in the work of Charles Moore because he was the first to point out that Disneyland was a self-conscious attempt to create an interactive public space amid the disconnected suburban sprawl of Los Angeles. In Disneyland, we agree to pay for the public life we are missing out on elsewhere, just as in Celebration.

2.2 Civic Environmentalism

Unlike New Urbanism, Civic Environmentalism arose not in response to failures of planning, or lack of community in cities, but in response to three failures of the environmental movement: top-down organization, over-emphasis on abstract theoretical issues, i.e., does non-human nature have intrinsic value), and the deep anti-urban bias that means the movement does not address the places where most people live.

Civic Environmentalism is the idea that members of particular communities are the ones who should plan and organize to "ensure a future that is environmentally healthy and economically and socially vibrant" (Shutkin, 2000, 14). A central insight of this movement is that in order to have viable cities we need to (i) bring the broad interest in and support for protecting remote wilderness areas to bear on our immediate quotidian environment, and (ii) reinvigorate, or create networks of community and build social capital (New Ecology Inc., 2005; Sirianni and Friedland, 1999; Landy et al., 1999; John, 1994). The guiding principles (Shutkin, 2000) are:

1. Democratic Process
2. Community and Regional Planning
3. Education
4. Environmental Justice
5. Industrial Ecology
6. Place

Civic Environmentalism is not a planning or design paradigm, but a vision of engaged communities, organizing around common interests, working to direct their own lives. As I will suggest in my following discussion of some limits of a design model of responding to the crisis of cities, Civic Environmentalism represents an approach that is open to a variety of design models, because it is directed by stakeholder participation. By nurturing democracy it is more likely to be sustainable and effective.

2.3 What are Cities For?

What are cities for? Why should we care if cities are emptying out, if people are living in greater levels of economic and racial separation, if we sprawl across the countryside? And: What are we trying to do as we imagine responses to our existing urban situation?

Some reasons we should be concerned with the state of cities are:

1. Public Sphere, Public Life, and Political Community
2. Community Life
3. Services and Sustainability
4. Self Discovery and Creation

As many sociologists, political scientists, historians, and philosophers have noted, modern democracy, modern cities, and the "public sphere" arise together

(Habermas, 1991). Many argue that the public sphere is essential to modern democracy, and further that it is made possible by modern cities: by the social energy, economic power, division of labor, and quite importantly, the regular and unavoidable encounters with those whose ideas, beliefs, values, and lives are different from our own. One role of cities is to nurture this public sphere and political community.

In so far as suburbanized people rarely encounter directly those with different experiences of the city, and in so far as the primary mode of interaction is the intricate ballet of the automobile, these people might lack the intellectual and experiential resources to engage critically the direction of the city. We might consider the work of Harvard University political scientist Robert Putnam, who shows that the longer people spend in traffic, the less likely they are to be involved in their community and family (Putnam and Feldstein, 2003; Putnam, 2001). The experience of the city is often an experience of alienation from Nature, and also an experience of alienation from each other and from self. Once again Dewey has a relevant comment.

> Zeal for doing, lust for action, leaves many a person, especially in this hurried and impatient human environment in which we live, with experience of an almost incredible paucity, all on the surface. No one experience has a chance to complete itself because something else is entered into so speedily. What is called experience becomes so dispersed and miscellaneous as hardly to deserve the name. Resistance is treated as an obstacle to be beaten down, not as an invitation to reflection. An individual comes to seek, unconsciously even more than by deliberate choice, situations in which he can do the most things in the shortest time. (Dewey, 1980).

This points to the fourth reason: Self-discovery and creation. The modern city is an important site of self-discovery and self-creation. One that helps nurture citizen participants whose self-understanding is formed through face-to-face encounters with others. The second reason, Community Life, is also present here. Cities are places of work and play in ongoing, changing networks of family and friends. All of which lead to the third reason, Sustainability. A sustainable city, or community, is one that is open to change. Places, communities, people who are static tend to be overwhelmed or fragile, and thus unable to respond to the real exigencies of life.

3 Evaluating New Urbanism and Civic Environmentalism

Consider the following story about one of the showcase New Urbanist developments. The first crisis in Celebration, Disney's New Urbanist development, was the widespread recognition that the houses of Celebration are poorly built. It turns out that Celebration was built using unskilled migrant labor because that was the only labor available in the booming Orlando construction economy. The residents had very pricy homes with leaky roofs and pipes, cracked foundations, chimneys out of plumb, and doors that would not close. Eventually, the residents organized a Homeowners Association to bring pressure against Disney. Thus, a community began to form, but not because of the success of design and planning, but in

response to a common experience of a defective product. Disney had attempted to sell community as a commodity, one of those things purchased along with a garage door opener and highly regularized street front appearances.

While this is just a brief anecdotal account of why New Urbanism fails, we can more precisely lay out the problems by considering the following.

a) New Urbanism proposes to solve problems of community cohesion through design alone,
b) New Urbanism proposes a design solution that would in some ways replicate, and in other ways leave in place, existing design problems (e.g., preferences for single family dwellings),
c) New Urbanism proposes a top-down design solution that trusts existing market forces to resolve urban dilemmas, and
d) New Urbanist developments, within existing legal and economic frameworks, have increased commuting and economic segregation.

Thus, New Urbanist solutions will likely replicate, or even further, existing problems.

New Urbanism does work to create something like community life, even though, as the example of Celebration shows, that might come about not because of the success of the design but because of the recognition of a common problem. But, it fails to nurture public life, and thus fails as a site for the building of a genuine and sustainable democratic community. I offer three reasons.

(1) New Urbanism takes self and desire as either (i) fixed or (ii) infinitely malleable. New Urbanism attempts to resolve urban problems through an appeal to market forces responding to new design. One possibility is that New Urbanism assumes that our desires are fixed, but the existing market has failed us. If the latent desire for good design can be unleashed we will then have better lives. Or, it might be that New Urbanism understands desire as malleable and assumes that design alone will transform our desires. So, if we can just get these new design paradigms accepted either people will respond from their long submerged authentic desires, or the new settings will be so powerful that our desires will respond and embrace New Urbanist communities.

(2) New Urbanism embodies a problematic quest for certainty. New Urbanism is a static design model. And, one that is certain about what people need and want (or ought to want). Yet, New Urbanism as such is not flexible or revisable. One example is the response of Andres Duany to the new "Latino New Urbanism." He calls it "barrio urbanism" and criticizes it for valorizing the wrong aesthetic and for celebrating poverty. Latino New Urbanism starts with the real neighborhoods where many Latinos in the U.S. live. Alas, these neighborhoods fail to have the regular, harmonious, and predictable design features that New Urbanism specifies. Further, the residents of these neighborhoods use public transit and live in more modestly sized structures not by choice, but because they are poor. Duany suggests that these choices are virtuous only when chosen (Holtzmann, 2004). New Urbanism thus fails to be sustainable, and to nurture individual and community growth and creativity.

Finally (3) New Urbanism is a response to an urban crisis that represents a dislike and distrust of cities. The response of Duany to Latino New Urbanism also

points to one of the greatest limits of New Urbanism as a response to the problems of cities, New Urbanism is an anti-urban approach. In taking the colonial New England town as its model, it embodies the pastoralism of Thomas Jefferson over the urbanism of his rival Hamilton, but without Jefferson's emphasis on democratic community. By emphasizing the community sphere over the public sphere, New Urbanism can contribute to a loss of public life. As such, we lose an important avenue of individual growth (public life with strangers). We lose an avenue of political will formation that is outside of the state and corporation wand, we lose the marvel and wonder of the encounter with strangers Following Levinas, we become morally impoverished as the range of face-to-face encounters we have is ever more attenuated.

Civic Environmentalism proposes that design alone will not be the solution. Further, in terms of my earlier list of reasons to care about the fate of cities, I note that for Civic Environmentalism:

- Building the Public Sphere is central to any hope for transforming cities, communities, and ultimately selves.
- It does not take desire as fixed. Rather, Civic Environmentalists understand desires, selves, and communities as formed through on-going and interactive processes in which the quality of everyday experience is central. It does not have a predetermined idea of the design form, and so is open to contingency. Civic Environmentalists aim at "ends-in-view" which is the best we can think of and agree on given where we are now.
- Similarly, it does not assume a single way of living. Civic Environmentalists are open to the creative chaos of the city, but one made richer by political and community life.

I should note that Civic Environmentalism has thus far seldom been brought into direct dialogue with the practice and teaching of planning and architecture. As it is, it is quite likely that a codification of design principles will take place. However, given that the procedures by which Civic Environmentalism proposes responding to the problems of cities is one where the decisions are driven by those most involved, and that experts act as advisors, succumbing to the belief that design principles alone will suffice seems unlikely.

Note also that I am not arguing that New Urbanism has no place in responding to the crisis brought about by sprawl. The advocates of New Urbanism have been partially successful in placing the relationships between the form of cities and buildings and the quality of everyday life on the public agenda. New Urbanist design principles and practices embody many of the same values as Civic Environmentalism. What I am arguing is that in so far as New Urbanism is primarily a design paradigm, and assumes that through design alone we will solve social problems, it will fall short. Further, in so far as it trusts existing social relations and market structures to be sufficient to transform our urban areas, it risks reinforcing these problems. Civic Environmentalism is thus a more promising model with which to approach our urban problems.

References

Benfield, F. K., Raimi, M., and Chen, D., 1999, *Once There Were Greenfields*, Natural Resources Defense Council and Surface Transportation Policy Project, New York.
Benjamin, W., 1996, *Walter Benjamin: Selected Writings, Volume 1, 1913–1926*, Belknap Press, Cambridge, MA.
Benjamin, W., 1999, *The Arcades Project*, Belknap Press, Cambridge, MA.
Berube, A., 2001, Racial change in the largest cities: evidence from census 2000, *Brookings Institution* (21 July 2005), http://www.brookings.edu/es/urban/census/citygrowth.htm
Boarnet, M. G., and Haughwout, A. F., 2000, Do highways matter? Evidence and policy implications of highways influence on metropolitan development, *Brookings Institution* (21 July 2005)http://www.brookings.edu/metro/boarnetexsum.htm
Bullard, B. D., Johnson, G. S., and Torres, A. O., eds., 2000, *Sprawl City: Race, Politics, and Planning in Atlanta*, Island Press, Atlanta.
Ciruli Associates, 2000, Denver, CO. (21 July 2005); http://www.ciruli.com/polls/CO-issues1.htm
Davis, M., 1992, *City of Quartz: Excavating the Future in Los Angeles*, Vintage, New York.
Dewey, J., 1980, *Art as Experience*, Perigee Books, New York.
Duany Plater-Zyberk & Company, 1997, *The Lexicon of the New Urbanism*, Miami, self-published.
Duany, A., Plater-Zyberk, E., and Speck, J., 2000, *Suburban Nation: The Rise of Sprawl and the Decline of the American Dream*, North Point Press, New York.
Ewing, R., Pendall, R., Chen, D., 2000 (21 July 2005) Measuring sprawl and its impact: the character & consequences of metropolitan expansion, http://www.smartgrowthamerica.com/sprawlindex/sprawlreport.html
Federal Highway Administration, 2001, Washington, D.C., (21 July 2005); http://www.fhwa.dot.gov/reports/movingahead.htm
Frey, W., 2001, City families and suburban singles: an emerging household story from census 2000, *Brookings Institution* (21 July 2005), http://www.brookings.edu/es/urban/census/freyfamiliesexecsum.htm
Glaeser, E., 2001, Job sprawl: employment location in U.S. metropolitan areas, *Brookings Institution* (21 July 2005, http://www.brookings.edu/es/urban/publications/glaeserjobsprawl.pdf
Grange, J., 1999, *The City: An Urban Cosmology*, SUNY Press, Albany, NY.
Habermas, J. 1991, *The Structural Transformation of the Public Sphere* trans: Thomas Burger, MIT Press, Cambridge, MA.
Heavner, B., 2000, *Paving the Way: How Highway Construction has Contributed to Sprawl in Maryland*, Maryland Public Interest Research Group Foundation, Baltimore, MD.
Holtzmann, A., 2004, Latin invasion, *Architecture* **93**(3):21–23.
Jameson, F., 1992, *Postmodernism, Or, the Cultural Logic of Late Capitalism*, Duke University Press, Durham, NC.
John, D., 1994, *Civic Environmentalism: Alternatives to Regulation in States and Communities*, Congressional Quarterly Press, Washington, D.C.
Ketcham, B., and Komanoff, C., 1992, *Win-Win Transportation: A No-Losers Approach To Financing Transport in New York City and the Region*; KEA, New York.
Landy, M., Susman, M., and Knopman, D., 1999, *Civic Environmentalism in Action*, Progressive Policy Institute, Washington, D.C.
Litman, T., 1992, *Transportation Cost Survey*, Victoria Transport Policy Institute, Victoria.
MacKenzie, J., Dower, R., and Chen, D., 1992, *The Going Rate: What It Really Costs To Drive*, World Resources Institute, Washington DC.
Mitchell, W. J., 2005, *Placing Words: Symbols, Space, and the City*, MIT Press, Cambridge, MA.
Moffet, J., and Miller, P., 1993, *The Price of Mobility*, Natural Resources Defense Council, San Francisco, CA.
Moore, C., 1965, You have to pay for the public life. *Perspecta: Yale Architec. J.* **9/10**:57–97.

Nelson, A. C., 2000, Effects of urban containment on housing prices and landowner behavior, *Land Lines* **12**(3):1–3.

New Ecology Inc., 2005, Cambridge, MA. (21 July 2005); http://www.newecology.org/

NewUrbanism.org, 2005, Alexandria, VA (21 July 2005); http://www.newurbanism.org

Office of Technology Assessment, 1994, *Saving Energy in U.S. Transportation*; U.S. Congress, Washington, D.C.

Putnam, R., 2001, *Bowling Alone: The Collapse and Revival of American Community*, Simon and Schuster, New York.

Putnam, R., and Feldstein, L., 2003, *Better Together: Restoring the American Community*, Simon and Schuster, New York.

Shutkin, W. A., 2000, *The Land That Could Be: Environmentalism and Democracy in the Twenty-First Century*, MIT Press, Cambridge, MA.

Sirianni, C., and Friedland, L., 1999, *Civic Environmentalism*, Civic Practices Network, Waltham, MA.

Surface Transportation Policy Project, 2002, *Pedestrian Safety, Health and Federal Transportation Spending, http://www.transact.org/report.asp?id = 202*

The Congress for New Urbanism, 2005, Chicago, IL (21 July 2005); http://ww.cnu.org

U.S. Department of Housing and Urban Development, 2000, Washington, D.C. (21 July 2005), *The State of the Cities 2000*, http://usinfo.state.gov/usa/infousa/facts/states/socrpt.pdf

USDA, 1997, Washington, D.C. (21 July 2005); http://www.nhq.nrcs.usda.gov/NRI/1997/summary_report/original/body.html

Nature, Aesthetic Values, and Urban Design

Building the Natural City

Glenn Parsons

Abstract In this chapter, I consider the relationship between the aesthetic appreciation of the built environment and the aesthetic appreciation of the natural environment, with an eye to pursuing its implications for the role of design in urban planning. In section 1, I describe some ways of thinking about the aesthetic, common in traditional environmental thought, according to which very different forms of aesthetic appreciation are appropriate for each sort of environment. In section 2, I outline a somewhat different approach to understanding the aesthetic, one that holds out the promise of a more unified approach. In section 3, I attempt to deliver on this promise by pointing out a similarity between the 'visual order' of the natural environment and that of the built environment. This also reveals an important similarity in their aesthetic character. Section 4 consists of an effort to clarify this claim, and to draw out some of its ramifications for our broader understanding of urban design processes. In section 5, I conclude by considering three objections to my claim.

1 Some Traditional Thinking about Aesthetic Value, Nature, and the Built Environment

Much classic environmental thought rests on a sharp distinction between the natural environment, especially wilderness, and the human, or built, environment. In attempting to draw attention to the value and importance of pristine nature, many environmental thinkers have focused on what they take to be its unique qualities: ecological harmony and sustainability, for instance, as well its capacity to allow the realization of human values such as authenticity and freedom. As a contrast, they have often portrayed the human environment in a more negative light, as inherently unsustainable or ecologically destructive, for example, and construed life in the

G. Parsons, Ryerson University

P. E. Vermaas et al. (eds.), *Philosophy and Design.*
© Springer 2008

human environment as a technologically mediated, inauthentic, and spiritually crippling experience.[1] This dichotomy remains a powerful conception, tangible in everything from the symbolism used in advertising campaigns to the rising value of cottage real estate near highly urbanized areas.

One aspect of this traditional wilderness/built-environment dichotomy, and the one I will focus on here, involves the aesthetic character of these environments.[2] Whereas pristine nature, or certain parts of it at least, has become a paradigm of aesthetic appeal, the built environment is more frequently associated with 'eyesores', visual blight and other forms of ugliness.[3] Indeed, some environmental thinkers have gone so far as to assert that the aesthetic character of wild nature, unlike that of the built environment or of art, is universally and even necessarily positive: i.e., there is not, and perhaps could not be, anything ugly in wild nature. This view, often called 'Positive Aesthetics' about nature, remains controversial among philosophers.[4] Nonetheless, its endorsement by many within the environmental movement vividly illustrates the current tendency to see the aesthetic character of nature as categorically different from that of the built environment.

Even putting this radical view aside, one can find within the mainstream tradition of philosophical aesthetics important reasons to view the aesthetics of nature and the built environment as distinct. One of these is the central role played by the sublime in our conception of the aesthetic character of nature.[5] Emerging in the early eighteenth-century as a sub-category of aesthetic experience, distinct from the beautiful, sublime experience was typically associated with vast and/or powerful phenomena in nature. As Kant describes:

> Bold, overhanging, and as it were threatening, rocks; clouds piled up in the sky, moving with lightning flashes and thunder peals; volcanoes in all their violence of destruction; hurricanes with their track of devastation; the boundless ocean in a state of tumult; the lofty waterfall of a mighty river, and such like; these exhibit our faculty of resistance as insignificantly small in comparison with their might. But the sight of them is the more attractive, the more fearful it is, provided only that we are in security; and we willingly call these objects sublime ... (1790, §28)

[1] For a review of this tradition, see Cronon (1995).

[2] In keeping with common philosophical practice, I will use "aesthetic character" and "aesthetic appeal" as the most general aesthetic terms, taking "beauty" to be a specific form of aesthetic appeal. However, I do recognize that "beauty" is commonly employed as a generic term of aesthetic appraisal, and that some philosophers employ it in this way as well (Nick Zangwill, for example: see his (1995)).

[3] Perhaps, as Walter (1983) suggests, this is so for North American cultures more than it is for others. The view is evident, for instance, in E.O. Wilson's well-known 'biophilia' hypothesis. Wilson writes that "artifacts are incomparably poorer than the life they are designed to mimic. They are only a mirror to our thoughts. To dwell on them exclusively is to fold inwardly over and over, losing detail at each translation, shrinking with each cycle, finally merging into the lifeless façade of which they are composed" (Wilson, 1984, 115).

[4] For defenses of various forms of this idea, see: Carlson (1984), Hargrove (1989), Godlovitch (1998), Saito (1998), and Parsons (2002). For criticism, see Budd (2002).

[5] On the classical tradition of the sublime, see Monk (1960) and Hope Nicolson (1959).

As Kant's description indicates, pleasure in the sublime, unlike pleasure in the beautiful, involves a 'negative moment', a feeling of being overwhelmed or threatened. Yet through our removal from immediate danger, the overwhelming or threatening aspects of the object become elements in a pleasing experience, one typically described in terms of awe or rapture. In its classical form, as described by Kant, Edmund Burke, and other eighteenth-century theorists, the sublime has always been associated primarily with wilderness. Given that practical considerations mandate the removal of dangerous elements from the built environment, the sublime must be sought beyond its confines. Manicured parks, colorful songbirds, and even bustling city squares may be beautiful, but they cannot be sublime in the classical sense.

Even beauty, which is generally not taken to depend on any quality unique to either environment, has seemed to lead toward a distinction between them. For example, one influential way of understanding beauty is that offered by Formalists, who understand aesthetic experience in terms of a certain property of objects called 'Form'. As Clive Bell explains: "Lines and colors combined in a particular way, certain forms and relations of form, stir our aesthetic emotions. These relations and combinations of lines and colors, these aesthetically moving forms, I call 'Significant Form'" (Bell, 1913).[6] Accounts of aesthetic appreciation focusing on Form urge the appreciator to attend to, and take pleasure in, the particular arrangements of shapes, lines and patterns in an object. On this conception of the aesthetic, a distinction once more arises between the aesthetic character of the natural and built environments, given that these environments consist of quite dissimilar forms. It is true that there are resemblances: a skyscraper may loom above a commercial street as a mountain looms over a forest, for example (Berleant, 2005, 42–43). Architects have sometimes taken inspiration from natural forms and explicitly tried to mimic them. However, these instances are by and large exceptions, and generally, the resemblances between natural and built form remain weak. An obvious example of the pervasive and fundamental variance between them is the humble right angle, a form ubiquitous in the built environment but virtually non-existent in nature (Vogel, 1998).

As mentioned, these aesthetic considerations are but one facet of a broader view of the relationship between the wild and built environments, a view on which, in the words of Holmes Rolston, "civilization is the 'antithesis' of wilderness" (Rolston, 1991). However, recently there has been a move to re-evaluate this view. This movement has been driven by theoretical concerns regarding the viability of the traditional wilderness/built-environment distinction, as well as a growing awareness of the extent to which our conceptions of wilderness have been shaped by, and used to defend, various political views (Cronon, 1995). As well, Andrew Light has argued that there is a more practical motivation for re-evaluating this distinction: whatever its faults may be, humans are not abandoning the urban

[6]On Formalism as a general view of the aesthetic, see Carroll (2001). Note that some theorists include color in the concept of form as well (Zangwill, 1999).

environment. Rather, they are embracing it (Light, 2001). This means that, increasingly, the health of our overall environment will be determined by the character of cities. Consequently, any view that treats the built environment as an 'unnatural', and therefore unredeemable, place is unlikely to be helpful in addressing environmental concerns.

Although aesthetic concerns are not often accorded much weight in environmental discussions, I believe that the aesthetic dichotomy between the wild and built environments is particularly salient in regard to Light's concerns, because aesthetic preferences seem to be relevant factors in the determination of patterns of land and transportation use. In the Greater Toronto Area, where I live, the current population of five million is projected to increase by over three million in the next twenty-five years.[7] For environmental reasons, it is desirable to concentrate new residents within existing city boundaries, reducing their need for automobile use. This goal, however, is somewhat in tension with the lingering notion that residents of the city are 'trapped' in an 'unnatural' environment, and that true aesthetic appeal lies in more 'natural' areas somewhere beyond the pale of the built environment. More importantly, at the theoretical level, there is room to doubt whether the aesthetic character of nature and that of the built environment are as antithetical as has been believed. To pursue this idea, I need to briefly describe an alternative way of thinking about the aesthetic.

2 Knowledge, Order, and Aesthetic Appreciation

As mentioned, if one regards the aesthetic character of an environment solely in terms of form (i.e., shapes, patterns, and so forth) then nature and the built environment have little in common aesthetically. However, most current approaches to the aesthetic regard such formal elements as only one aspect of an object's aesthetic character. In addition, background knowledge about the object is thought to play a critical role. To illustrate this approach, it will be useful to discuss first the aesthetic appreciation of artworks. I will then discuss its application to environments, and explain how it opens up the possibility of an aesthetic character that is shared by both natural and built environments.

One well-known version of the view that background knowledge regarding an artwork is an essential element in determining its aesthetic character is due to Kendall Walton (1970).[8] His approach can be summarized as the view that possessing certain forms of knowledge about an object allows us to see a certain *order* in the perceptual qualities of the artwork, thereby affecting its aesthetic character.

[7]*GTA Population and Employment Projections to 2031*, Toronto Urban Development Services, June 2000; URL=www.city.toronto.on.ca/business_publications/gta_2031.pdf

[8]Related views on the role of background knowledge in the appreciation of art may be found in Dickie (1974) and Danto (1981).

When appreciating an artwork, such as a cubist painting, one's background knowledge about the genre of cubist painting makes a difference, not only to one's historical appreciation of it, but to one's *aesthetic* appreciation of it as well. According to Walton, to appropriately appreciate a particular cubist artwork, for instance, one needs to approach it with the understanding that certain sorts of properties, e.g., containing only geometric shapes, are, by convention, necessary or 'standard' for such works. Possessing this knowledge, we perceive the work to have different aesthetic qualities than it otherwise would: instead of looking chaotic and random, for example, the painting might appear calm and serene.

Walton's model can be applied to the appreciation of natural objects as well; in this case, knowledge about a natural environment can allow us to perceive order amongst its elements (Carlson 1981; 1993; Parsons 2002). For example, the combination of plants and animals in a given environment may strike us as chaotic and random until an understanding of the ecological and evolutionary forces at work in the area reveal the pattern and order obtaining among these various elements (Carlson, 1993, 220). Another example is provided by the biologist Richard Dawkins, who writes about bats that "their faces are often distorted into gargoyle shapes that appear hideous to us until we see them for what they are, exquisitely fashioned instruments for beaming ultrasound in desired directions" (Dawkins, 1986, 24). In each of these cases, knowledge drawn from natural history and ecology, by revealing the visual order manifest in appearances, plays a pivotal role in shaping our aesthetic responses.

Although the aesthetic character of the built environment has received less attention in philosophical aesthetics, Walton's approach to aesthetic character may also be applied here. Our understanding of which sorts of features 'belong' in a certain kind of structure, or in a certain kind of neighborhood, and which do not, is a powerful factor in determining whether a particular built environment looks, for example, ordered or chaotic. A neon sign flashing 'open' may look ordinary, until one learns that the window in which it hangs belongs to a church: the scene then takes on an 'out of place', somewhat askew character. In many cases, we fail to notice the role of background knowledge in generating sensory order because that knowledge is second nature to us. Power lines, for instance, are a ubiquitous feature of North American cities but, understanding that they are a necessary feature of the landscape, we are able to 'see through' them in appreciating urban landscapes. In the same way that we do not assess the aesthetic merit of a painting in light of its being 'only' two dimensional, or of its being 'cut off' at the edges, we do not focus on the patterns of power lines in our aesthetic assessments of a streetscape.[9] As in

[9] I do not mean to say that we *never* do this: we might, especially if the lines were particularly obtrusive or conspicuous, or interfered with some functional aspect of the environment. I also do not mean that power lines play no role whatever in our aesthetic appraisal of the streetscape. Rather, the point is that the role of power lines in determining our aesthetic assessment is altered by our acceptance of them as necessary elements of the streetscape: instead of standing out as distracting and extraneous elements that disrupt visual pattern, they occupy a peripheral or background place in our aesthetic experience.

the case of artworks and natural environments, a set of background beliefs about the built environment allows us to perceive an order in those elements that are manifest to us in sensory experience, and this order is key in determining the aesthetic character of that environment.

If we adopt this conception of the aesthetic, then, contrary to traditional wisdom, the aesthetic appreciation of the natural and built environment may have a significant element in common. For although the built environment lacks objects conducive to experience of the sublime, as well as the sorts of forms characteristic of nature, the sensory 'order' revealed by appropriate background knowledge may be similar to that of the natural environment. In this event, one might then claim that there is indeed an important continuity in aesthetic character across built and natural environments. However, one might wonder whether my line of thought really advances this claim, since the possibility of continuity that is opened up here rests on the claim that the natural and built environments are similar sorts of environments, requiring similar sorts of background knowledge for aesthetic appreciation. The advocate of the traditional notion that the built and natural environments are aesthetically divergent is likely to simply deny this. In order to support this claim, then, I must directly consider whether the perceptual orders manifested in natural and built environments are similar.

3 Perceptual Order in Natural and Built Environments

This concern is, in fact, a pressing one, because discussions of this issue have tended to emphasize the disparateness of the sorts of order manifested by the natural environment and the built environment. The latter is characterized often as possessing a *functional* order, given that it is composed of elements whose salient feature is their function in some aspect of human life. For example, the appreciation of the visual order in a streetscape, referred to earlier, is thought to take shape because we understand the function, and hence the necessity, of power lines, allowing us to 'see past' them. On this view, to see the harmony or chaos that is manifest in a crowded street or an assemblage of buildings, one must understand the purpose that its elements are meant to serve.

However, philosophers have been reluctant to employ the concept of functionality in describing the order manifest in the natural environment. Functionality, like other teleological concepts, such as 'purpose' and 'end', often have been thought to be conceptually tied to the presence of a designing intellect and thus to fit uncomfortably with a scientific description of the physical world. In light of this, characterizations of the natural order as a 'functional order' have been viewed by some as, at best, a lazy anthropomorphism and, at worst, a disguised form of theism. As Larry Wright put it, amongst philosophers, "wherever it appeared, the smoke of teleological terminology implied the fire of sloppy thinking" (1969, 211).

This general skepticism about the applicability of functional characterization to wild nature is reflected in discussions of its aesthetic character. One well-known

discussion by Allen Carlson, for example, describes the aesthetics of nature as 'order-oriented', in contrast to 'design-oriented' forms of aesthetic appreciation, because pristine nature does not have "as such, a purpose or a function" (2000, 134). On this account, the order displayed by the natural environment is revealed by understanding those physical laws and non-intentional processes of historical development that have led to the environment being the way that it is. Since the natural environment is not the product of a designing intellect, elements within it do not have functions or purposes. On this line of thought, the possibility that I introduced earlier, that of a continuity between the aesthetic character of built and natural environments, is closed off, since the perceptual order characteristic of each sort of environment is distinct: thoroughly functional in the former case, and decidedly *non*-functional in the latter.

However, I think that, ultimately, we need not accept this dichotomy. In fact, in later writings Carlson himself reconsiders it, introducing a notion of "functional fit" that can be applied not only to the built environment, but to the organization of certain sorts of ecosystems as well (2001, 13). Elsewhere I have suggested that we can further develop Carlson's approach by relating it to some well-developed conceptions of functionality that may be applied, unproblematically, to elements within the natural environment (Parsons, 2004). I will briefly describe two of these senses, and show how they may be applied, not only to natural environments, but also to the built environment.

These accounts of functionality arose because, despite the misgivings of philosophers, biologists continued to explain the existence and/or form of biological traits and structures by making reference to their function.[10] Perhaps the best-known 'naturalized' account of functionality is that of *selected function*: on this account, the function of an item or trait is that effect of the item or trait that explains the selective success, and hence survival, of ancestral organisms with that item or trait, and that consequently explains the current existence of the trait in their descendants.[11] The kidney, for example, has the selected function of removing metabolic waste from the blood because removing such waste is the reason that kidneys were favored by natural selection. Another important naturalized account of function is that of *causal role* functionality. On this view, the identification of X's function serves not to explain the existence of X, but rather to explain how some larger system, of which X is a component, works.[12] One important difference between the two conceptions is that causal role functions may characterize natural items that do not undergo natural selection, including non-living things. For example, a river may

[10] As Mayr puts it, "biologists have insisted that they would lose a great deal, methodologically and heuristically, if they were prevented from using such language" (Mayr, 1988, 41). On this issue, see also Godfrey-Smith (1994).

[11] This approach descends from Wright (1973). For discussion of selected functions, see Godfrey-Smith (1994) and Neander (1991a).

[12] This analysis was proposed by Robert Cummins (1975). For more on the view, see Davies (2001) and Amundson and Lauder (1994).

have the causal role function of flooding, within the ecosystem to which it belongs. By flooding, rivers cue the spawning behaviors of fish and spread nutrients to the surrounding floodplains, both of which are factors that can help explain the ecosystem's capacity to support the various species that it does.[13]

Another important distinction between the two concerns their normativity. Selected functions are normative, in the sense that an entity might have the selected function of performing X, due to its history, but currently be unable to do so, due to damage or disease for instance. In such cases, the entity in question is malfunctioning. In contrast, causal role functions are generally viewed as non-normative because they are defined in terms of occurrent powers: when those powers are absent, so is the causal role function. A useful way to capture this difference is in terms of different expressions that fit each most naturally. With selected functions, we speak of something having the *function of* doing so and so, but with causal role functions, it is more natural to talk of things *functioning as* a so and so (Wright, 1973, 147). Something may have the function *of* doing X although it is not actually doing X, but if something is merely functioning *as* an X, and then ceases to do so, it is unintuitive to say that it is no longer 'working'. For example, when the cloud that has been functioning as our shade from the sun moves on, we are not inclined to say that it is malfunctioning.

Most philosophers now view each of these analyses of function as capturing a naturalistically acceptable and important sense of 'function' used by biologists (Godfrey-Smith, 1994; Sober, 1993; Millikan, 1989). The point that I want to emphasize here is that they are equally applicable to the built environment. The functions that derive from the intentions of designers, and which characterize many artifacts in the built environment, can be understood as close relatives of selected functions: a bridge, for example, has the function of allowing pedestrian traffic across a river insofar as allowing pedestrian traffic is the reason that it was placed there by its designers. In this case, as in the case of selected functions in nature, the function of the object is the reason why it exists, or is the way that it is. In this sense, both kinds of function attribution are 'historical'.[14] The concept of a causal role function can also be applied to elements within the built environment, since elements in the built environment may come to function as certain things although they have not been intentionally placed there to do those things: public sculptures become nests for bird life, old cemeteries become picnicking grounds, the rumbling of a daily train becomes a time signal for local residents, and so on.

There is, then, something that may be shared between the aesthetic characters of natural and built environments: a common kind of perceptual order, manifest upon understanding the historical and causal role functions of the various elements. In light of this, one might claim there is a sense in which aesthetic appreciation in natural and built environments, despite superficial differences, displays a deep continuity and unity.

[13]This example is from Parsons (2004). For other examples of causal role functions in nature, see the case for the 'promiscuity' of causal role functions made by Neander (1991b) and Millikan (1989).

[14]That is, both fall under the general conception of function developed by Wright (1973).

4 Reconsidering Design in the Built Environment

Having made the claim that there is continuity between the aesthetic characters of the natural and built environments, I want to consider why it might be important to recognize this continuity, and its implications for our conception of urban design. One motivation for recognizing this continuity involves the fact, outlined in section 1, that, following the classic line of environmental thought, we often view the aesthetic appeal of nature as distinct from, and superior to, that of the built environment. By stimulating urbanites to leave the city in search of 'genuine' aesthetic experience, this attitude has potentially problematic environmental consequences. The possibility of taking the aesthetic character of built environments to be closely related to, rather than radically distinct from, that of natural environments is thus an appealing one.

This has not gone unrecognized by workers in fields concerned with the built environment, such as urban planning, landscape architecture, and the like. Indeed, prominent movements in these fields have been organized around the aim of making cities more 'natural'. These movements, often referred to with the term "ecological design", have a number of aims, including instantiating, in the built environment, processes found in nature and increasing our awareness of urban impact upon surrounding ecosystems.[15] In these efforts, the focus is generally upon producing cities that are more sustainable, via consuming less energy, producing less pollution, and working in greater harmony with surrounding ecological systems.

From the aesthetic point of view, however, such approaches to making cities 'natural' contain a fundamental limitation, which is that the processes that are implemented are generally the product of design. For even an ecologically designed city is still a *designed* city, and as we have seen, part of what is distinctive about the natural environment is that a large part of its functional order is *non*-historical in nature.[16] This causal role functionality is produced by various forces that drive pre-existing elements to *function as* something or other, regardless of how they came to be as they currently are. This is not to say that ecological design is undesirable, or incompatible with a more 'natural' built environment: on the contrary. The point, rather, is that this approach to ecological design *on its own* will not deliver built environments that are aesthetically contiguous with natural environments in the sense that I have outlined. What *is* required then? Somewhat paradoxically perhaps, what is needed is a moderation of the role of design, so as to allow causal role functionality to emerge, as well as, perhaps, greater attention to an already existing functional order.

[15] On ecological design, see Van der Ryn and Cowan (1996) and Todd and Todd (1994). For discussion of ecological design from a philosophical perspective, see King (2000) and Saito (2002).

[16] In their discussion of ecological design, Van der Ryn and Cowan write that "until our everyday activities preserve ecological integrity *by design*, their cumulative impact will continue to be devastating" (1996, 18; their emphasis).

This approach to planning is not novel: it has been argued for by, amongst others, Jane Jacobs, who urged that "the city is not put together like a mammal or a steel frame building", and should not be regarded as a completely designed entity (1961, 376). Rather, Jacobs emphasized the "complex systems of functional order" that arise out of the interaction of the various parts of the built environment. One of her examples of this order is the manner in which the apparently random flow of pedestrians serves, without any intention or design, to monitor and maintain peace and safety on residential streets (1961, 29–54). Jacobs argues that attending to this sort of functional order is key to understanding the ways in which cities actually work. Of primary interest here, however, is that this functional order involves the same sort of causal role functionality that we find in the natural environment, when, for instance, flooding serves to cue fish spawning and rejuvenate the soil of local floodplains.[17] The approach of Jacobs and others indicate that the toleration of causal role functionality, and the moderation of the role of intentional design that it involves, is not only possible, but also a highly desirable goal for urban planning. Furthermore, it is one that can translate into our aesthetic experience of the urban environment. Jacobs makes this explicit, comparing our experience of the city's "complex functional order" to more typical aesthetic experiences:

> Under the seeming disorder of the old city, wherever the old city is working successfully, is a marvellous order for maintaining the safety of the streets and the freedom of the city ... we may fancifully call it the art form of the city and liken it to the dance – not to a simple-minded precision dance with everyone kicking up at the same time, twirling in unison and bowing off en masse, but to an intricate ballet in which the individual dancers and ensembles all have distinctive parts which miraculously reinforce each other and compose an orderly whole. (Jacobs, 1961, 50)

I want to emphasize that my proposal for creating built environments that possess an important aesthetic unity with the natural environment is not simply to 'let nature take its course' and wait for the city magically to become aesthetically pleasing. A built environment with no design element is liable to be an aesthetic, not to mention practical, mess and would not mirror the distinctive aesthetic appeal that we cherish in our wilderness. Rather, the aim is to produce a built environment that mirrors the natural in its *mixture* of historical and causal role functionality. The challenge, though, is not only to find the right amount of design, but also to relate it in the proper way to the non-designed functionality at play in the built environment. Here we may look to nature, since in nature selected and causal-role functionality

[17] Jacobs also emphasizes that finding order in the built environment "takes understanding", and that this order is a *perceptual* one: "Once they are understood as systems of order, [complex systems] actually *look* different" (1961, 376; Jacob's italics). Jacobs does not, however, dwell on similarities between nature and the built environment, preferring to characterize cities on their own terms (1961, 376). Nonetheless, she does implicitly draw a connection between them when decrying the view that cities are "the malignant opposite of nature". In cases where natural beauty goes unappreciated, Jacobs says that "an all too familiar kind of mind is obviously at work a mind seeing only disorder where a most intricate and unique order exists; the same kind of mind that sees only disorder in the life of city streets, and itches to erase it, standardize it..." (1961, 447).

stand in a mutually informing relationship. It is precisely because a trait functions *as* an F, despite having been produced by random mutation, and F happens to be a fitness-enhancing characteristic in the organism's environment, that the trait is selected and ultimately given the function *of* performing F. Likewise, the development of a trait with the selected function of doing F often results in something that also performs other 'unintended' functions. In this counterbalancing process of exchange and mutual influence, perhaps there are lessons for bringing the perceptual order of our working and living spaces closer to that of nature.

5 Three Objections

I would like to conclude by considering three objections to my claim that the aesthetics of cities and natural environments should not be thought of as diametrically opposed, but rather as bearing an important similarity.

The first objection is that it is simply implausible to hold that nature and city are aesthetically alike. This thought could be reinforced by noting that, any functional analogy between the natural and the urban notwithstanding, these environments remain quite different at the level of perceptual appearance, of form, color, and so on. Since these differences will translate into prominent differences in the aesthetic qualities possessed by natural and urban environments, one might argue, they ought to be considered distinct types of aesthetic object.

It is true, of course, that nature and the built-environment differ in many of their aesthetic features. My claim is only that they also share something aesthetically, at least to the informed eye. Furthermore, this shared aspect can be a prominent and indeed central element in our aesthetic response to both kinds of environment. The prominence of this aspect is revealed, for instance, in Dawkins' description of how his appreciation of the functional order manifest in the appearance of bats overwhelmed and displaced his earlier aesthetic responses. The "marvelous order" that Jacobs also recognized in certain cityscapes does not seem to be a minor or restricted aesthetic quality, but rather a pervasive and prominent feature of that environment. Whether we decide to call the natural and built environment the same sort of aesthetic object or not, the salient issue is our recognition of this important shared dimension.

One might also object to my position, however, from the opposite point of view. That is, rather than arguing that there is too little aesthetic similarity between the natural and urban, one might claim that, on my view, there is *too much*. More specifically, one might articulate the environmental concern that people will be more inclined to replace wilderness with urban development if they see the two as aesthetically similar. The significance of this concern depends on the causes of the sort of urban development that destroys natural areas. There are two possibilities: either it is perpetuated because of aesthetic dissatisfaction with the urban environment, which generates desire for life outside the 'ugly' city, or it is generated by something else. Earlier on, I mentioned the first possibility and suggested that it

is at least a plausible one. If it is true, however, then the objection is clearly misguided, since pointing out that the aesthetic character of the urban environment resembles that of nature would, if anything, ameliorate aesthetic dissatisfaction with the urban environment, and so *undermine* the destruction of natural areas.

If the second possibility is true, however, then a different response is in order. If the urban development that erodes natural areas is driven by economic factors, for instance, then pointing to an aesthetic feature of the urban environment will not affect it. And insofar as preserving the unique beauty of a natural area is one reason to resist such economic forces, pointing to similarity between urban and natural beauty might, in fact, contribute to such development. This all assumes, however, that the urban development that destroys natural areas is the kind of urban environment that has a similarity in functional order to natural environments. But this is unlikely to be the case. The form of urban development that is most worrisome with respect to the destruction of natural areas is urban sprawl. Yet urban sprawl is a paradigm case of a built environment whose functional order is different from that which we find in nature: highly designed and regulated, lacking in density and a spontaneous interplay of elements, it is not rich in causal role functionality. So in many cases where we must weigh the potential loss of a natural area and its aesthetic qualities against economic (or other) benefits of development, my view would not lend support to development, since the aesthetic quality lost in nature likely would not be replicated in that development.

Finally, one might wonder: Why invoke nature at all? Would it not be better to base an aesthetic for the built environment on the nature of that environment, rather than appeal to analogies with 'the natural'? Indeed, analogies between nature and city (the 'concrete jungle', e.g.) have typically served to highlight the *negative* features of the urban. Arnold Berleant notes that, although "wilderness" has acquired a positive connotation during the past century, "when the wilderness metaphor is applied to urban experience ... the word reverts to its earlier, forbidding sense of a trackless domain uninhabited by humans" (Berleant, 2005, 42). But the fact that the analogy with nature has not been used to foster a positive attitude towards urban aesthetics does not mean that it cannot be. For, as I have tried to show, the city shares with the natural environment not only negative qualities, but positive ones as well. In fact, using the analogy in this way is appealing given the lack of work on the built environment in contemporary philosophical aesthetics. Given that a completely *de novo* account of the aesthetics of urban environments does not appear to be in the offing, I think we would be foolish not to use the abundant resources that have been developed for natural environments. We may measure their cut to the built environment and, even if the fit turns out to be poor, at least gain a better conception of our subject's true dimensions. A final and important consideration is that, for better or worse, our culture continues to hold nature as a paradigm of aesthetic quality. While this remains the case, relating the beauty of the built environment to that of nature is a promising strategy for its articulation.[18]

[18] An earlier version of this chapter was presented at the 2005 meeting of the Society for Philosophy and Technology in Delft, The Netherlands. I would like to thank those present, especially Andrew Light, for helpful comments. Financial support was provided by the Social Sciences and Humanities Research Council of Canada and Ryerson University.

References

Amundson, R., and Lauder, G., 1994, Function without purpose: the uses of causal role function in evolutionary biology, *Biol. and Phil.* **9**:443–469.

Bell, C., 1913, *Art*, Frederick A. Stokes Company, New York.

Berleant, A., 2005, The wilderness city: a study of metaphorical experience, in: *Aesthetics and Environment: Variations on a Theme*, Ashgate, Burlington, VT.

Budd, M., 2002, *The Aesthetic Appreciation of Nature: Essays on the Aesthetics of Nature*, Oxford University Press, Oxford.

Carlson, A., 2001, On aesthetically appreciating human environments, *Phil. and Geog.* **4**:9–24.

Carlson, A., 2000, *Aesthetics and the Environment: The Appreciation of Nature, Art and Architecture*, Routledge, New York.

Carlson, A., 1993, Appreciating art and appreciating nature, in: *Landscape, Natural Beauty and the Arts*, S. Kemal and I. Gaskell, eds., Cambridge University Press, Cambridge.

Carlson, A., 1984, Nature and positive aesthetics, *Env. Eth.* **6**:5–34.

Carlson, A., 1981, Nature, objectivity and aesthetic judgment, *J. of Aest. and Art Crit.* **37**:267–276.

Carroll, N., 2001, Formalism, in: *The Routledge Companion to Aesthetics*, B. Gaut and D. Lopes, eds., Routledge, New York.

Cronon, W., 1995, The trouble with wilderness; or, getting back to the wrong nature, in: *Uncommon Ground: Rethinking the Human Place in Nature*, W. Cronon, ed., W.W. Norton & Company, New York.

Cummins, R., 1975, Functional analysis, *J. of Phil.* **72**:741–765.

Danto, A., 1981, *The Transfiguration of the Commonplace: A Philosophy of Art*, Harvard University Press, Cambridge, MA.

Davies, P. S., 2001, *Norms of Nature: Naturalism and the Nature of Functions*, MIT Press, Cambridge, MA.

Dawkins, R., 1986, *The Blind Watchmaker*, W.W. Norton & Company, New York.

Dickie, G., 1974, *Art and the Aesthetic: An Institutional Analysis*, Cornell University Press, Ithaca, NY.

Godfrey-Smith, P., 1994, A modern history theory of functions, *Noûs* **28**:344–362.

Godlovitch, S., 1998, Valuing nature and the autonomy of natural aesthetics, *Brit. J. of Aest.* **38**:180–197.

Hargrove, E., 1989, *Foundations of Environmental Ethics*, Prentice Hall, Englewood Cliffs, NJ.

Hope Nicolson, M., 1959, *Mountain Gloom and Mountain Glory: The Development of the Aesthetics of the Infinite*, Cornell University Press, Ithaca, NY.

Jacobs, J., 1961, *The Death and Life of Great American Cities*, Random House, New York.

Kant, I., 1790 [2000], *The Critique of Judgment*, J. H. Bernard, transl., Prometheus Books, New York.

King, R., 2000, Environmental ethics and the built environment, *Env. Eth.* **22**:115–131.

Light, A., 2001, The urban blindspot in environmental ethics, *Env. Polit.* **10**:7–35.

Mayr, E., 1988, The multiple meanings of teleological, in: *Toward a New Philosophy of Biology: Observations of an Evolutionist*, Harvard University Press, Cambridge, MA.

Millikan, R.G., 1989, In defense of proper functions, *Phil. of Sci.* **56**:288–302.

Monk, S., 1960, *The Sublime: A Study of Critical Theories in XVIII-Century England*, University of Michigan Press, Ann Arbor, MI.

Neander, K., 1991a, The teleological notion of function, *Aust. J. of Phil.* **69**:454–468.

Neander, K., 1991b, Functions as selected effects: the conceptual analyst's defense, *Phil. of Sci.* **58**:168–184.

Parsons, G., 2004, Natural functions and the aesthetic appreciation of inorganic nature, *Brit. J. of Aest.* **44**:44–56.

Parsons, G., 2002, Nature appreciation, science and positive aesthetics, *Brit. J. of Aest.* **42**:279–295.

Rolston, H., 1991, The wilderness idea reaffirmed, *The Env. Prof.* **13**:370–377.

Saito, Y., 2002, Ecological design: promises and challenges, *Env. Eth.* **24**:243–261.

Saito, Y., 1998, The aesthetics of unscenic nature, *J. of Aest. and Art Crit.* **56**:101–111.

Sober, E., 1993, *Philosophy of Biology*, Westview Press, Boulder.

Todd, N. and Todd, J., 1994, *From Eco-Cities to Living Machines: Principles of Ecological Design*, North Atlantic Books, Berkeley.

Van der Ryn, S. and Cowan, S., 1996, *Ecological Design*, Island Press, Washington, D.C.

Vogel, S., 1998, *Cats' Paws and Catapults: Mechanical Worlds of Nature and People*, W.W. Norton & Company, New York.

Walter, J. A., 1983, You'll love the Rockies, *Land. Mag.* **17**:43–47.

Walton, K, 1970, Categories of art, *Phil. Rev.* **79**:334–367.

Wilson, E. O., 1984, *Biophilia*, Harvard University Press, Cambridge, MA.

Wright, L., 1973, Functions, *Phil. Rev.* **82**:139–168.

Wright, L., 1969, The case against teleological reductionism, *Brit. J. for the Phil. of Sci.* **19**:211–223.

Zangwill, N., 1999, Feasible aesthetic formalism, *Noûs* **33**:610–629.

Zangwill, N., 1995, The beautiful, the dainty and the dumpy, *Brit. J. of Aest.* **35**:317–329.

Index

A
Ackoff, R. L. 218
actor-network theory 111, 161
Adorno, Theodor 293
aesthetic values 342
affective design 145
Airbus A380 241
Alexander, Christopher 282
alienability 134
alienation of labor 276
alternative realities 299
ambient web 176, 179
analysis 221
Anders, Günther 181
appropriation 305
architect
 eco-social 289
 production 289
 star 7, 289
architectural
 design 1, 318
 production 280
 representation 287
Arendt, Hannah 263
artifact
 dual nature of technical
 23, 31, 303
 freedom of 96
 intentionality of 93
 moral agency of 93
artifactology 154
artifactual systems 262
artistic
 innovation 274
 production 279
assessment of uncertainty 127
ATR 146
Aunger, Robert 69
authority 280

authorship and design 3
autonomy 289

B
balloon frame 308
Basalla, George 65
Bauhaus 6
Behnisch & Behnisch 290
Bertalanffy, L. von 218, 222
biological design 233, 235
biology, human 198
biomimetic engineering 175
black box 177
Borgmann, Albert 155
Bostrom, Nick 215
Breazeal, Cynthia 143, 152
building
 codes 281
 culture 275
built environment 341

C
Carlson, Allen 345, 347
categorization 210
causal explanation 73
Challenger space shuttle accident 5, 121
choice, feeling of 250
civic environmentalism 330
client 3, 108
code
 building 281
 form-based 283
 genetic 237
 technical 115
commodification 138
common sense 319
communication 40, 44

component 234, 238
computer 138, 210
Connecticut Museum of Science and
 Exploration 290
construction plan 236
constructivist technology studies 111
consumers 41
consumption 305
contract in architecture 274
control at a distance 279
converging technologies 2, 186
counterfeit naturalism 265
creative using 41
critical theory of technology 110
culture
 building 275
 production 273
 technical 120
cyborg 187, 192, 203, 214

D
Davidson, Donald 33
Dawkins, Richard 62, 69
democracy 203, 334
design 22, 26, 31, 32, 39, 42, 219
 affective 145
 affective robot 149, 152
 and authorship 3
 and intentionality 22, 31, 40, 43, 51, 106
 architectural 1, 318
 biological 233, 235
 criteria 318
 discourse on 247
 effective 145
 engineering 1, 71, 77
 ethical values in 12, 77
 expert 299
 interface 183
 natural 255
 normal 79
 plans 40
 problem, nature of 253
 product 40
 professional 42
 radical 79
 requirements transformation 219
 robot 143
 space 115
 socio-technical system 237
 urban 9, 333, 349
design-construction barrier 283
designer
 fallacy 51, 128

intent 53
 proximate 107
deskilling 276
determinism
 genetic 198
 technological 250
device paradigm 155
dialogue 169
dignity, human 198
discourse
 analysis 248
 on design 247
 on technological development 248
disease
 complex 200
 Mendelian 200
DNA 199
dual nature of technical artifacts 23, 31, 303
duality of design and using 28
due care 125
Duffy, Brian 148, 153
Dupuy, Jean-Pierre 183

E
eco-social architect 289
effective design 145
efficient production 279
elitism 300
Emery, F. 260
engineering
 design 1, 71, 77
 ethics 253
 genetic 134
 systems 8, 219
enhancement 186
 genetic 197
environment, natural 341
epigenetic factors 200
cthical values in design 12, 77
ethics of technology 5, 9, 12, 77, 91, 99
etiological theory of function 28
evolutionary theories of technology 61, 306
 blindness 64
 differential fitness 64
 genetic reproduction 64
 heritability 64
 mutation and recombination 64
 phenotypic variation 64
exlusion cost 135
expert
 designer 299
 knowledge 299
 technological 287

expertise 42
explanation
 causal 73
 intentional 73
extended culture industry 167

F
feeling of choice 250
Feenberg, Andrew 112, 150, 303, 308
fit, of space 322
Ford Pinto case 125
for-ness of artifacts 22, 24
freedom 96
 of artifacts 96
function 218, 223, 234, 239,
 301, 346
 etiological 28
 intended 235, 240
 proper 28
 system 28, 34
 thick notion 303
 thin notion 303
 tight fit solution 303
functional kind 29, 34
functionalism 234
functionality 302
 loose fit solution 303

G
genes 197
genetic
 code 237
 determinism 198
 engineering 134
 enhancement 197
 reproduction 64
 use-restriction technologies 135
genetically modified food 176
globalization 182
goal 235, 240
Graves, Michael 323
greatest happiness principle 289
Guggenheim Museum, New York City 326

H
Hadid, Zaha 290
Harvey, William 225
health 289
Heidegger, Martin 161
Hooke, Robert 173
house construction 302, 306

human
 biology 198
 dignity 198
 nature 198
 systems 262
human-artifact relationship 123
humanization 210
humankind 185, 191
Huxley, T.H. 261

I
Ihde, Don 94
immortality 188, 201
improper using 42
information society 187
information technology 156
innovation 61, 252
 artistic 274
institution of control 282
institutions 131
instrumentalization 112, 308
intellectual property 136
intention 287, 301
intentional
 action 22
 description 22, 23, 29, 31
 explanation 73
intentionalism 40
intentionality 93
 and design 22, 31, 40, 43, 51, 106
 of artifacts 93
intentioned 302
interface design 183
International Style 279
Internet 138
intuitive judgment 278

J
Jacobs, Jane 350
Johnson, Deborah 12

K
kaizen 252
Kanda, Takayuki 146
Kant, Immanuel 180, 342
Kroes, Peter 301

L
Latour, Bruno 92, 94, 97
layperson 128

Le Corbusier 7
Lessig, Lawrence 139
linear perspective 287
lived experience 250

M
magic 184
malfunction 27, 28, 34
Man 210
 and difference 213
 and identity 214
 and relation 213
Marcuse, Herbert 137
materializing 297
McDonough, William 254
Media Lab Europe 152
mediation 92
Meijers, Anthonie 301
Meyer, Hannes 6
meme 69
metamedia 160
MIT Media Lab 152
Mitcham, Carl 154
Mokyr, Joel 66
moral agency of artifacts 93
multistable possibilities for technology 54

N
nanotechnology 174
natural
 environment 341
 kind 27, 29
 law 133
 system 261
nature 173, 341
 of humans 198
 of products 276
new urbanism 330
 and design 336
Nietzsche, Friedrich 193
normal configuration 79
normalization of deviance 124
normative practice 274
noumenal technology 180

O
obsolescence, planned 139
open source 165
operational principle 79
originality 251

P
Parfit, Derek 30
Pelli, Cesar 290
personification 210
physical description 22, 23, 31
policy 169
politics of representation 288
populism 300
post-human 187, 189,
 198, 215
pragmatism 295
product, nature of 276
production 305
 architect 289
 architectural 280
 artistic 279
 culture of 273
 efficient 279
professional
 design 42
 licensure 289
progress 250
properness 42
prototype 236
proximate designers 107
public
 choice 287
 nature of technology 125
 perception of reality 287
 sphere 334
 talk 298
purpose 22, 24, 32, 218

R
rationality 39
regulations, zoning 281
regulative framework 79
regulatory agencies 276
reliability 124
renderings 290
representation
 politics of 288
 technology of 288
responsibility 45, 86, 168
Ricoeur, Paul 216
risk
 acceptability of 119
 burden of proof 125
rivalry 135
robot 143
 affective design 149, 152
 design 143

sociable 152
therapy 151
Rogers, Isaiah 275

S
safety 78, 289
science and technology studies 8, 63,
 105, 110
SCOT 63, 111
self-organization 241
serendipity 42
Singer, E. A. 223
smart environments 176
social psychology 148
Social Systems Design 233, 242
socio-technical system 2, 9, 234, 237, 260
 design 237
soft system 242
software 162
 engineering 163
species 187, 192
sprawl 330
star architect 7, 289
structure-preserving transformation 282
STS 8, 63, 105, 110
sublime 342
sustainability 78
system 217
 artifactual 262
 engineering 8, 219
 function 28, 34
 human 262
 natural 261
 social 233, 242
 socio-technical 2, 9, 234, 237, 260
 soft 242

T
tacit knowledge 123
technical
 code 115
 culture 120
 element 113
Technical Object 210
technofantasy 55
technological change 61
technological determinism 250
technological development 247, 306
 discourse on 248
 evolutionary metaphor 306
 hybrid metaphor 306
 revolutionary metaphor 306

technological drift 250
technological expert 287
technology
 multistable possibilities 54
 of representation 288
terminator-genes 135
testimonial evidence 46
Thompson, E. P. 132
transhumanism 211
Trist, E. 260
trust 88
type fixation 236, 238
type-token distinction 27

U
ubiquitous computing 176
ultrasound 94
uncanniness 175
uncanny valley 148, 155
uncertainty, assessment of 127
underdetermination 33
unintended results 127
urban design 9, 333, 349
 and architecture 333
usability 302
use plan 26, 38
using 22, 25, 39, 301
 creative 41
 impoper 42
utopia 333

V
vagueness, metaphysical 29
values infrastructure 265
Van der Rohe, Ludwig Mies 6
Vaughan, Diane 121
Vickers, Sir Geoffrey 262
Vincenti, W. G. 79
Vitruvius 319

W
Weber, Max 177
welfare 289
Wetmore, Jameson 12
whistle blowing 5, 13
wilderness 341
Winner, Langdon 92, 137

Z
zoning regulations 281

Printed in the United States
99567LV00002B/179/A

9 781402 065903